The Essential Dürer

The Essential
DÜRER

Edited by

Larry Silver

and

Jeffrey Chipps Smith

PENN

UNIVERSITY OF PENNSYLVANIA PRESS

PHILADELPHIA

Copyright © 2010 University of Pennsylvania Press

Published by
University of Pennsylvania Press
Philadelphia, Pennsylvania 19104-4112

Printed in the United States of America on acid-free paper

10 9 8 7 6 5 4 3 2 1

Library of Congress Cataloging-in-Publication Data
The essential Dürer / edited by Larry Silver and Jeffrey Chipps Smith.
 p. cm.
 Includes bibliographical references and index.
 ISBN 978-0-8122-4187-7 (alk. paper)
 1. Dürer, Albrecht, 1471–1528—Criticism and interpretation. I. Dürer, Albrecht,
1471–1528. II. Silver, Larry, 1947– III. Smith, Jeffrey Chipps, 1951–
N6888.D8E88 2010
760.092—dc22 2009013838

CONTENTS

ILLUSTRATIONS

PREFACE

THE TITLE OF this volume clearly states its purpose. *The Essential Dürer* should provide newcomers to the artist as well as experienced viewers of his work an overview of the most important features of his oeuvre. Consequently, the organization of the essays begins with the major media and working methods of the artist, who excelled—even innovated—in painting, drawing, and the several media of printmaking, while also actively contributing designs for sculpture. The artist's complex personality and individual self-consciousness appear at every turn, from the biographical data that he provided as a personal memorial (even down to his recording of a nightmare!) to the subtle negotiations, both professional and spiritual, that he made within the tumultuous first decade of the Lutheran Reformation in his hometown of Nuremberg.

Of course, no man is an island. Albrecht Dürer interacted with the major artistic traditions of his day, both in the Netherlands and in Italy, especially Venice. He served as the familiar of princes, both the duke of Saxony and the Holy Roman Emperor, while maintaining close ties to the patrician elite of Nuremberg. Thus this volume investigates the artist's wider connections, even his interpretive fortunes in later German art history, as well as his individual artistic achievements.

Clearly large sections of libraries are already devoted to Albrecht Dürer, but several good reasons call for a new volume of such "essentials." For one thing, much of the important recent literature, including some major exhibitions and monographs, remains in German, inaccessible to the English reader. One of the ironies of twentieth-century Dürer scholarship is that the main foundational study of the artist's life and art, written by émigré Erwin Panofsky and first published during World War II in 1943, did not receive its translation from English into German until 1977 when it was undertaken by Lise Lotte Möller, who had been one of his last students at the University of

Hamburg before his firing in 1933 by the National Socialists. Moreover, a
topical yet broadly based essay approach to Dürer is not easy to find, and
there really is nothing comparable in that accumulated library of earlier schol-
arship.

The scholars who have contributed to this volume are among the acknowl-
edged experts on the artist who write in English. For the most part, they
come from a younger generation, whose academic training was forged in the
last quarter of the twentieth century. They consciously coordinated their
efforts, beginning with an intensive academic workshop, held in 2000 at the
Clark Art Institute in Williamstown, Massachusetts. Honing and revising
these contributions has been an ongoing process to ensure that the essays are
up-to-date with current art historical issues and Dürer scholarship. These
essays have been kept deliberately terse but with enough scholarly references
to assist the interested student to pursue research in various languages.
Through this close attention to one artist by multiple authors, using their
separate lenses of fundamental topics to address his manifold accomplish-
ments, this volume strives to be considerably more than the sum of its parts
or than any single author could provide.

Both editors are most grateful for the knowledge, judgment, and patience
of all the contributors over nearly a decade of preparation of this volume.
Crucially, the continuing support of our editor, Jo Joslyn, and director Eric
Halpern of the University of Pennsylvania Press has enabled us to reach the
completion of the project and produce the handsome volume that you now
hold. During the formative process, facilitation at the Clark in the research
workshop, coordinated by Darby English and promoted by director Michael
Ann Holly, generously provided indispensable, interactive group discussion
that shaped the entire project. Finally, the editors gratefully acknowledge
each other for mutual scholarly and collegial support at critical moments in
the process. At its culmination, they dedicate this book about one of art
history's greatest figures to the community of scholars—past, present, and—
especially in such an introductory volume—future.

ABBREVIATIONS

A. Fedja Anzelewsky, *Albrecht Dürer: Das malerische Werk*, rev. ed. (Berlin: Deutscher Verlag für Kunstwissenschaft, 1991)

B. Adam Bartsch, *Le peintre-graveur*, 21 vols. (Vienna: J. V. Degen, 1803–21)

W. Friedrich Winkler, *Die Zeichnungen Albrecht Dürers*, 4 vols. (Berlin: Deutscher Verein für Kunstwissenschaft, 1936–39)

I

Dürer—Man, Media, and Myths

Larry Silver

FEW ARTISTS HAVE ever been so fully exploited—and in so many different ways—by later admirers as Albrecht Dürer (1471–1528). Like a Rorschach inkblot, the imagery of this Nuremberg artist has been co-opted: to justify "Germanness" itself in both art and politics (including Nazi politics in the twentieth century) but also to celebrate a "Northern Renaissance" of dispersed classical culture as a form of cosmopolitan participation in (and sometimes competition with) Italy's concurrent "High Renaissance" of contemporaries Michelangelo and Raphael.[1] Dürer has been seen as an embodiment of urban, bourgeois culture in his home city, yet he also worked, albeit from a distance, throughout his career for emperors and prominent dukes, and he has even been claimed by modern socialist art historians as the partisan of peasants in the conflagrations of the Peasants' War of 1525. Documented in his own words as an ardent follower of Martin Luther and portraitist of Luther's Reformation lieutenant, theologian Philipp Melanchthon, Dürer's contemporary portrait artistry also included likenesses of Luther's principal antagonist, Cardinal Albrecht of Brandenburg, as well as the ambivalent church reformer (lowercase) Erasmus of Rotterdam (in an engraving issued in 1526, the year after Luther's pointed disputation against Erasmus, "The Bondage of the Will"). One recent study has even used a single work, depicting the artist himself—the celebrated Munich *Self-Portrait* (see Figure 12.3) from the watershed half-millennium year of 1500—as *the* key

image of transition from icon to artwork, from medieval to modern sensibility.[2] While hyperbolic in its claims, this study, like most works of art history about Germanic art, whether painting or graphic art, certainly situates Dürer as the indispensable and irreversible turning point, who reshaped art in both form and content, not only for his contemporaries but also for most of the other artists who came after him.[3]

As just one example of the multivalent and contradictory readings of Dürer imagery, we can examine one of his later works, a fictive monument to the German peasant, designed by the artist and dated on the print 1525 and included among his other illustrations in book 3 of his instructional manual for future artists, the *Instruction in Measurement*, published by the artist himself in Nuremberg in 1525 (Figure 1.1).[4] This image was timely, appearing in the very same year as the Peasants' War, in which Luther had sided in print with the ruling princes of Germany "Against the robbing and murdering hordes of peasants" (to quote the title of his May 5 pamphlet).[5] Perhaps unsurprisingly, this image has been read as both *supporting* and *attacking* the fruitless cause of the rebellious peasants, often with the conclusions of an author derived directly from his own prior politics. On face value the monument is actually an antimonument, a "fanfare for the common man" rather than for the customary hero. Its forms are aggressively humble: the base of the monument shows reposing cows, sheep, and pigs beneath baskets of produce, while the peasant figure appears atop a precarious and makeshift "column" of butter churn, pitcher, wheat sheaf with implements, and a final, ignoble throne of a chicken coop. Of course, all of these attributes are specific to the peasant and could be taken to be badges of honor for his worthy productivity (if one were so inclined), but their very humility and physical instability seem rather to point up the absurdity of such a monument to someone so anonymous and ordinary.[6] Dürer's earlier images of peasants, marketing or dancing, tend to portray the same subjects as distinctly ungraceful, even clumsy, suggesting a viewpoint from a critical distance of class superiority.[7] In this particular case, the sorrowful peasant (*traurende Bauer*) atop the designed monument sits in the position of brooding despair, which Dürer had already immortalized in his 1514 engraving *Melencolia I* (see Figure 3.1). Moreover, he is impaled with a broadsword, the two-handed weapon of contemporary German infantry, in his back! Of course, this pose has also been read, especially by East German scholars of the last generation, in revolutionary terms, but also by more recent commentators, such as the Luther catalogs of 1983, as a sympathetic response by the artist to the "betrayal" of the peasant

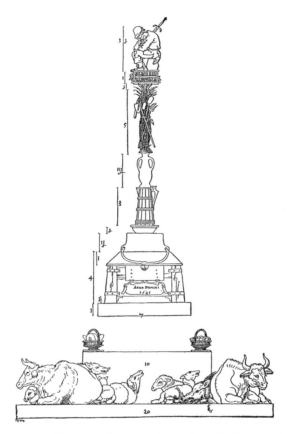

1.1. *Peasant Monument.* Montage of two woodcuts, 6.4 x 18.5 (base) and 22.2 x 7.5 cm (column). In Dürer's *Instruction in Measurement* (Nuremberg, 1525), fols. J1 recto and verso.

cause by Luther and others in a position to lend support at the critical moment of truth. Indeed, the pose has also been compared to contemporary religious images of Christ in Distress (*Christus im Elend*) as a cue to see the pathos of the peasant sympathetically, perhaps as a martyrdom.[8] Certainly the implements (hoe, flail, pitchfork) of the peasant can also be taken as his only available weapons, inadequate to the superior arms of the repressive infantry and contrasted to the giant sword in the back of the unequal victim.

Even an examination of the artist's authorial words in the *Instruction in Measurement* fails to resolve the ambiguity of the presentation.[9] In the setting of the geometrical designs, the *Monument to Commemorate a Victory over the Rebellious Peasants* sounds as if it is oriented toward the victors, who would

naturally characterize the peasants as "rebellious" and want to erect such a monument, but here, too, the text can be read (as can *any* text) as ironical rather than straightforward. It follows a proper design for a *Monument to Commemorate a Victory*, yet it precedes a *Memorial to a Drunkard* before another, neutral tower construction. Dürer's sheer excess of description about the animals and baskets, jugs, kettles, plates, kegs, and tools shows him to be designing with tongue in cheek, the more so with his drunkard's memorial, inscribed with an epitaph that mockingly praises his easy living. Next to be illustrated "for the sake of adventure/amusement [*Abenteuer*]," this unabashedly ignoble commemorative would start with a casket, then a beer barrel covered with a board game, and a "glutton's portion" in two joined bowls, surmounted by beer mugs and a basket with bread and cheese. Regardless of how one decides to read either the text or the image of the peasant memorial by Dürer, the artist has certainly chosen to evade responsibility for his (distinctly unrevolutionary) polemic by concealing it within a set of otherwise unrelated geometrical instructional designs (book 3 is devoted to "Solids"). Such ambiguity and irony, which contrast utterly with Luther's own bold, black-and-white characterization of "murderous" peasants and "martyrs" who fall at their hands, should make modern interpreters of Dürer cautious in advancing definitive readings of his imagery.

Issues raised for an urban citizen by the Peasants' War as well as Luther's clearly hostile attitude toward it provide at least some orientation in the interpretation of Dürer's imagery of the peasant memorial column. However, with this much ambiguity of resulting interpretation for a woodcut illustration, how much more can we despair of ever plumbing the depths of so detached and symbol-laden an image as *Melencolia I*, the work that has probably generated the largest output of analysis, both for the image itself and for the "rise of melancholy" as the fashionable disease of the sixteenth century (perhaps best epitomized by Robert Burton's massive tome of 1621, *Anatomy of Melancholy*).[10] Here, too, the work has been interpreted in contradictory ways, ranging from an image tinged with suggestions of evil or witchcraft to a "spiritual self-portrait" of the artist himself. It was Erwin Panofsky who famously put the print forward as an allegory of creativity, akin to the inspiration of the *furor poeticus*, in which the new and influential arguments of Italian humanists, led by Marsilio Ficino, transformed associations around the humors and the passions to a positive mental state, appropriate to intellectuals. Recently Keith Moxey has attacked this interpretation as a projection by the German-Jewish émigré scholar of his own ideal of creativity born out

of mental struggle and ambivalence, and he asserts that "the significance of *Melencolia I* is ultimately and necessarily beyond our capacity to define."[11]

Yet the greatest progress in understanding contemporary concepts—if not "genius" as portrayed by Panofsky, then at least the investigation of melancholy, which Panofsky ceaselessly investigated—has also emerged in the past few decades, not least from the work of historians of German culture. Frances Yates took up the imagery of this renowned print in the context of her own interest in occult philosophy, specifically the work of Agrippa of Nettesheim, seen by Panofsky as the crucial link of Ficino's ideas to Germany.[12] Yates, too, revisits Panofsky's interpretation of the print as a new kind of "inspired melancholy" and properly notes that the older, "black" tones of the still humor appear in the complexion and pose of the figure. Her connection to Agrippa's occult philosophy and its spiritual magic underscores the demonic/angelic (note the wings of the allegory) potential of this visionary state, connected to prophecy and angelic hierarchies. Yates was able to find a critical reaction against Dürer's imagery in the painted work of his contemporary Lucas Cranach, among whose derivative images is the 1532 painting in Copenhagen of a melancholic woman, which shows her as a witch.[13] Cranach's winged female sits before a landscape whose sky is filled with flying female nudes, certainly a cluster of evil witches.[14] Thus while the values inherent in Dürer's own image of melancholy as a meditative state and occult practice remain potentially contested, their perceived danger and potential for evil in the "corrective" reworking of witchcraft by Cranach is fully unambiguous. White magic can all too easily be corrupted into a "dark side," black magic, evil.

Recent research into details of the image reinforces this potential for a darker, or at least dangerous, environment. For example, the flying (and screaming) bat, which bears the title of the picture on its wings, is an animal associated with both the element of air and the night.[15] Moreover, according to astrological prognosticators in Dürer's Germany, elements in the sky of the print—the background rainbow and the falling comet—are portents, usually ominous, of potential disaster, such as the death of a great man or a catastrophic military defeat (for example, Halley's Comet was seen over the Battle of Hastings in 1066).[16]

Thus the torpor and flightless wings of the great allegorical figure in the print also seem to accord with Dürer's written warnings to young painters about the real dangers of melancholy associated with creative people. In his original outline for an instructional treatise, "Food for Young Painters," com-

posed shortly before 1512, the artist declares, "Whosoever, therefore, is not gifted in this manner, let him not undertake it; for it comes by inspiration from above."[17]

Dürer was certainly self-conscious about his own abilities and his permanent importance. His earliest self-portrait in the delicate medium of silverpoint dates from 1484, when the precocious artist was a mere thirteen years old (W. 1; Figure 1.2), and it is perhaps equally significant that the artist went back and labeled this biographical data in his own hand at a later date.[18] He was also one of the first artists ever to write out his own biography, once more assuming that remembrance of details of his life and his family origins would have lasting interest for posterity: "In the year 1524 [*recte* 1523] after Christmas, in Nuremberg, I, Albrecht Dürer the younger, have put together from my father's papers the facts as to whence he was, how he came hither, lived here, and drew to a happy end. God be gracious to him and us! Amen."[19] Moreover, Dürer freely portrayed himself in the guise of Christ, both as Salvator Mundi (A. 66, the Munich *Self-Portrait* of 1500) and as Man of Sorrows (W. 886, *Self-Portrait* drawing [see Figure 10.5], Kunsthalle, Bremen, and now stored in Moscow), and he even went so far as to depict a 1525 "portrait" of his own frightening dream of catastrophic, apocalyptic floods (W. 944, Kunsthistorisches Museum, Vienna; see Figure 2.13), with the following explanatory inscription: "In the night between Wednesday and Thursday after Whitsunday 1525, I saw this appearance in my sleep . . . and I was so sore afraid that when I awoke my whole body trembled and for a

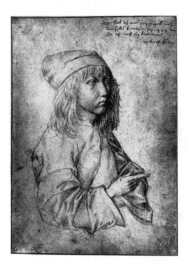

1.2. *Self-Portrait at Age Thirteen*, 1484. Silverpoint drawing, 27.3 x 19.5 cm. Albertina, Vienna. Photo: Foto Marburg / Art Resource, New York.

long while I could not recover myself. So when I arose in the morning I painted it above here as I saw it. God turn all things to the best. Albrecht Dürer."[20] In addition to his own self-portraits in both paintings and drawings, the artist depicted his parents in both media, beginning with a silverpoint of his father (W. 3, Albertina, Vienna) as well as a 1490 painted diptych of both parents (A. 2–4, 1490; now divided between the Germanisches Nationalmuseum, Nuremberg, and the Uffizi, Florence).[21]

Although Italian Renaissance art and Rembrandt have often remained the touchstones for art history over its century and a half of existence, beginning in Jakob Burckhardt's University of Basel, Dürer too formed an additional node of interest for some of the first German-speaking scholars of *Kunstwissenschaft*, the discipline of art history. Especially the figure of Heinrich Wölfflin (1864–1945), Burckhardt's protégé and successor at Basel, deserves credit for pioneering modern Dürer studies, chiefly with a general monograph (1905), but also with a later edition of Dürer's writings (1908) and a study of selected drawings (1914), prior to a summing-up contrast between German and Italian art, "Sense of Form" (1931). Citing a statement by Buffon, "le style c'est l'homme," Wölfflin's concerns always remained with the individual work and its place in the career evolution of an artist as well as his ongoing struggle to find a personal *Formgefühl* ("sense of form"). Though he considered it to be essential background preparation, Wölfflin still had little interest in the historical setting of an artist, in his friendship circles or intellectual contacts, or patronage, let alone the construction of meaning in his work. Instead, construction itself—in the sense of measure and order as well as essential beauty, always based in the study of nature—dominates his appreciation of the artist's achievement. Fittingly this fine, pioneering monograph concludes with "General Remarks on Style."

From the next generation, Erwin Panofsky offered almost the opposite end of the spectrum of interests, though he also compiled a systematic catalog of Dürer works in all media as well as a still-definitive "life and art" monograph, first published in 1943 in America and translated into German a full generation later.[22] Panofsky began his career in response to Wölfflin, considering the theoretical implications of Dürer's own favorite formal preoccupations of design: human proportion, linear perspective, and, more generally, meaning attached to such "symbolic forms."[23] But his ongoing studies of both meaning and cultural connections, under the influence of Aby Warburg's art history, led Panofsky early to investigate several of the artist's key engraved images: *Melencolia I* (in collaboration with Fritz Saxl, Warburg's

assistant and successor; 1923) and *Hercules am Scheidewege* (The Choice of Hercules; 1930), both published by the Warburg Library, as part of a larger project of "iconography and iconology."

Moxey is surely correct to point to Panofsky's "humanist bias" and his desire to associate Dürer with the classical culture of Renaissance Italy as an ultimate justification for the "high culture" status of German art in the era of Dürer and his followers. In that respect Panofsky as a German was surely no different from most nationalistic scholars of the early twentieth century, lionizing their own country's major artistic figures, especially through their successful emulation of prestigious cultural forms or themes, in this case classical forms and learned, often mythological themes as transmitted from Italy.[24] Panofsky's Dürer in fact epitomizes and fuses both of the finest achievements of the two dominant models before him, Renaissance Italy and early modern Flanders, which would be simultaneously celebrated in the introduction to Panofsky's other magnum opus, *Early Netherlandish Painting* (1953).[25] Theory admixed with naturalism, a sense of beauty founded upon acute observation. Dürer's actual travels to both Italy and Flanders encapsulated and abetted his ongoing study of their traditions and facilitated their absorption into his own composite art, chiefly in the field of graphics.

If we flash forward to the more recent Dürer scholarship, emerging from a major retrospective print exhibition and symposium in Melbourne (1994), we get a radically different snapshot of the kinds of questions being addressed to the artist and his work.[26] Dürer draws a notable presence of historians of various stripes, but particularly those with cultural preoccupations: Bob Scribner, a Reformation historian, on "ways of seeing"; Lyndal Roper, a feminist social historian, on courtship rituals; and Charles Zika, a historian of witchcraft, on Dürer's formative images of witch stereotypes within the emerging persecution. Dürer's own complex historiography in German culture is investigated anew by a German history professor, Paul Münch.

Conversely, art historians now often address issues with much broader cultural-historical significance than either Wölfflin or Panofsky ever imagined. Dagmar Eichberger interrogates Dürer as an empirical student of the natural world and participant in early *Wunderkammer* collecting, and she has also investigated the long-neglected phenomenon of Dürer the book publisher, his ultimate investment in a new medium by this most media-sensitive producer. Larry Silver considers Dürer's relationship to contemporary German patriotism and politics, with both the ideological program of the *Arch of Honor* on commission for Emperor Maximilian I and the artist's broader attention to

an emerging imagery of infantry soldiers and German military might.[27] Christiane Andersson's study of censored imagery expands the focus of attention from Dürer to his followers and to the later, Reformation period of art and propaganda imagery in Nuremberg. Taken together, then, this international sampler of authors (where historians and art historians are not so clearly distinguished) reveals a wide-ranging yet fluid set of cultural concerns—of art's purposes and of its various audiences. The defining frameworks include: religion, both late medieval piety as well as the religious changes of the emerging Lutheran Reformation, both in Nuremberg and beyond; politics, especially imperial politics and Germany's position in Europe; and natural philosophy, including images of astronomy and medicine, in addition to the more familiar animal and plant studies. Even media studies as such, including the history of the printed book, have begun to emerge from the perennial concerns of Dürer scholarship with watercolors, woodcuts, engravings, etchings, drawings, and paintings. Most recently a Dürer study focuses on these broader issues of the purposes of art, following the words of Dürer himself in his "Food for Young Painters": "For the art of painting is employed in the service of the Church and by it the sufferings of Christ and many other profitable examples are set forth. It preserves also the likeness of men after their death. By the aid of Delineation in painting, the measurements of the earth, the waters, and the stars have come to be understood."[28]

This current volume builds upon such solid foundations. It attempts to establish a more comprehensive and synthetic view of Albrecht Dürer at the start of the twenty-first century. It begins, as it should, with the works themselves, with separate and detailed studies of the paintings (Katherine Crawford Luber), prints (Charles Talbot), and drawings (Christiane Andersson and Larry Silver), plus a special section devoted to Dürer's designs for metalwork and relationship to sculpture (Jeffrey Chipps Smith). Issues of biography and personality, in a freshly contemporary variation on the archival heritage of the nineteenth-century biographers of Dürer, return here with a major new study of Dürer's personal relationships: both his marriage and his closest friendship, with Willibald Pirckheimer (Corine Schleif). Similar close scrutiny of a single work, the engraving *Knight, Death, and the Devil* (1513) shows the artist's working methods and the dialogue between practice and theory (Pia Cuneo)

Dürer's wider artistic relationships have also been newly reexamined for this occasion. Dagmar Eichberger revisits the neglected but continuous Netherlands connection, previously only explored in the dissertation by Julius

Held (1931) and mentioned, only to be taken for granted, in the great Panofsky monograph, where Italian connections occupy center stage. Those ties to Italy are tackled in a pair of novel ways. For one, Katherine Crawford Luber's analyses of Dürer paintings reinforce her own full-length study of Dürer and Venice to establish how much of the working method model of painting by the artist derives from Italian models, studied during his 1505–7 trip to Venice.[29] And Andrew Morrall specifically addresses Dürer's interactions with Venice in his own essay.

Issues of the broader culture of these artworks take center stage in essays that continue the approaches of the Melbourne symposium. Silver's essay on court patronage offers a reminder that despite his continuous residence in urban Nuremberg, Dürer also served as a court artist, not only through woodcuts for the overtly propagandistic emperor Maximilian I but also with fervent religious paintings and learned mythologies for the pious and sophisticated Saxon duke Frederick the Wise (who, however, also employed a more permanent and local court artist at Wittenberg, Lucas Cranach). Contextual study of the late period focuses on reexamination of the development of Dürer's religious art in relation to the nascent Lutheran Reformation (Donald McColl), which profoundly affected his hometown of Nuremberg in the 1520s.

The final essay of the book (by Keith Moxey) situates the historical construct "Dürer" within twentieth-century art historiography, demonstrating the degree of subjective input by the interests and outlooks of each scholarly investigator, as Moxey previously demonstrated with the core example of Erwin Panofsky. Of course, all scholarship offers the dialogue between the present and the past, with each individual and epoch seeking its own ancestry and identity in the earlier great creative works of the human spirit. In this respect, Joseph Koerner's study of the historical "moment" of self-representation and the origins of modernity in Dürer is profound and appropriate, but also inevitable and commonplace. All periods are "transitional." Thus, all meaning remains indeterminate to a certain extent, allowing for new insights to arise from new questions—by new investigators and with the clarity of hindsight.

Yet as all these essays show, the prolific, protean, and wide-ranging output of Albrecht Dürer will always draw attention and fresh analysis. If the essays that follow cannot serve as a final word or definitive interpretation of these works, especially as some important topics are covered well recently elsewhere or omitted for lack of space or lack of active current scholarship, they nevertheless aspire to offer both an introduction and a comprehensive overview of

our current knowledge and interest in the artist. These scholars are active, original investigators into Dürer, leaders of contemporary scholarship on the German artist. Taken together, they do provide a lively but still authoritative set of "essential" introductions to their versatile, epochal artistic subject—for both newcomers and the scholarly community alike.

Dürer's Drawings

Christiane Andersson and Larry Silver

IN ANY ASSESSMENT of Dürer's art, the role played by drawing can scarcely be overestimated.[1] It was his most basic, most constant, and most important form of expression, the graphic barometer of his life and artistic development. Throughout his life he drew continually and daily, unlike his work in other media; he painted or made engravings, woodcuts, or etchings only during certain phases of his career, and alternated between them. Drawing was the basic experimental tool with which he developed his ideas for all his work in all media. This was not necessarily the norm during the Renaissance: Titian, for example, seems to have drawn on paper rarely, preferring to sketch his compositions directly onto the canvas with the brush in order to create an underdrawing for the painted work. Thus only a few pen and chalk drawings are preserved from his long career.

Dürer was one of the greatest draftsmen in the history of art, and in his case, unlike Titian, we are immensely fortunate to have so many of his drawings preserved. His drawn oeuvre, unique in German Renaissance art for its sheer size and variety, consists of about one thousand single sheets in collections throughout the world. The largest groups are housed in the Albertina in Vienna,[2] followed by the Kupferstichkabinett of the Staatliche Museen in Berlin[3] and the British Museum in London.[4] Many others are preserved in books: about fifty sketches in pen and colored ink decorate the *Prayer Book of Emperor Maximilian I*, today in the Bayerische Staatsbibliothek in Mu-

nich.[5] In addition, the so-called *Dresden Sketchbook*[6] in the Sächsische Landesbibliothek in Dresden contains about 130 pages of studies of human proportion, the *Fencing Manual* in the Albertina has 70 pages of illustrations, and numerous technical, architectural and decorative sketches appear in his letters and other writings.[7]

With remarkable virtuosity Dürer expanded the significance and functions of drawing by exploiting fully the enormous potential and versatility of the medium, based on a profound understanding of the very particular characteristics and traditions of the medium. He experimented constantly with all the various contemporary techniques of drawing: pen, brush, chalk, and charcoal, silverpoint or metalpoint, watercolor and body color. Only red chalk, or *sanguine*, a medium rarely used at that time in Germany,[8] does not appear among his large corpus of drawings. Unlike many of his contemporaries in Germany, Dürer did not privilege one drawing type over others. Matthias Grünewald, for example, worked exclusively in black chalk and charcoal, heightened with white chalk, judging by the small body of about thirty-five known drawings.[9]

Dürer never engaged in such self-imposed limitations. He selected the drawing type most effective for a given task on the basis of its intended purpose. When making an anatomical drawing of a nude from the live model, he usually used the most versatile medium, pen and ink. If he set out to create a portrait sketched from life or worked in small format, in his earlier work he would have chosen silverpoint with its soft modeling effects. Later when he created much larger portraits, he used black chalk or charcoal to achieve a broader modeling. Quick jottings of an idea (*primo pensiero*) or an initial compositional sketch for a painting or a print would have been executed with pen and ink, but nature studies or the vast sweep of a mountainous landscape in Italy called for watercolor, using a brush, often in combination with opaque body color.

The human figure, including portraiture, was the focus of the great majority of Dürer's drawings, since he considered man created in the image of God to be the noblest theme in art. But beyond this important group of works, his drawn oeuvre displays an astonishing breadth of subjects, ranging from the sublime—such as the landscape watercolors with their vivid effects of sunlight and weather (W. 99, Ashmolean Museum, Oxford; see Figure 2.9)—to the mundane—as in Dürer's life-size design for a shoe (W. 938, British Museum, London)—or even the comical—such as his sketch of dancing monkeys (W. 927, Öffentliche Kunstsammlung, Kupferstichkabinett,

Basel). Highly unusual for his era and very "modern" was his use of drawing as a means to grapple with non-art-related issues, such as his despondent moods (W. 26, Graphische Sammlung der Universität, Erlangen; see Figure 2.1), feelings of religious turmoil as recorded in the *Dream Vision* (W. 944; see Figure 2.13), or his health problems, as in the self-portrait in which he points to his ailing spleen (W. 482, Kunsthalle, Bremen). Like his Italian contemporaries, Dürer used drawing in developing his theoretical interests in perspective, physiognomics, and the mathematically constructed proportions of the human body, both male and female, and later of the horse (see Chapter 7, the essay by Pia Cuneo in this volume).

Drawings in the Renaissance

Since the Renaissance, drawing has been prized as the most spontaneous and most personal form of expression in the visual arts. But the drawings of Renaissance artists are generally far less well known than their work in other media, such as painting or sculpture (see Chapter 5, the essay by Jeffrey Chipps Smith in this volume), which one can easily study in museum galleries. Due to their sensitivity to light, drawings can only be exhibited for brief periods to prevent fading. Yet nowhere are an artist's ideas, artistic intentions, and creative process more fully and intimately expressed than in his or her drawings, due to the minimal material obstacles that, for instance, pen drawing presents as compared with painting on panel. Drawings also often show more of an artist's style or "handwriting" than is possible in other media. In the early stages of drawing, an artist was frequently free from the need to take into account the wishes or expectations of a patron, as was so often the case when working in technically more complex media, such as painting an altarpiece or a portrait. Thus from an initial quick sketch through the clarification of ideas using detailed individual studies to the final form of a presentation drawing, made to be shown to the client and then executed, if the drawings are preserved, all phases of the creative process can be assessed. One can observe how an artist developed an idea step by step, what aspects were considered most essential, when and perhaps why changes were introduced, and sometimes even whether the artist was pleased or dissatisfied with the work.

German artists have always had a special affinity for the relatively abstract qualities of line compared with the more realistic and sensuous effects of

color and have made some of their most significant and lasting contributions to the history of art in those media that privilege line: in drawing and print-making. The essential role of drawing in German Renaissance art is evident in the fact that almost all German artists of this era were distinguished drafts-men; some, such as Urs Graf,[10] created their most important work in this medium. The German-speaking countries in the early modern era produced far more drawings than other parts of Europe, with the exception of Italy. Unlike Italian artists, however, who generally focused on the elaboration of an idealized canon of beauty, German draftsmen strove to capture in their drawings what they perceived as individual, specific, and characteristic in the world around them.

Drawing underwent a significant evolution during the period considered here. During the Middle Ages, drawings had served as the primary means for transmitting visual traditions from one generation to another; they copied existing works of art and in turn provided the basis for future works. Kept as individual sheets or drawn into sketchbooks or model books,[11] these visual records were amassed in artists' workshops as a storehouse of images and were frequently referred to when new works of art were to be created. Like other workshop utensils, they were passed along to subsequent generations. The medieval working method generally called for variations on a cherished tradi-tion rather than original ideas. Drawings were valued for their usefulness as models rather than for their intrinsic artistic merit, spontaneity, or distinctive personal style.

During the late fifteenth century, however, the uses of drawing changed with the new interest in study after nature, artistic individuality and original-ity of conception and style. Artists came to rely less on models and patterns and more on their own expressive impulses; a new way of depicting a tradi-tional theme was now valued per se. Previously drawing had mostly served a subsidiary function as studies for works executed in other media, such as designs for sculpture, stained glass, tapestries, goldsmith's work, or paintings. Around the year 1500 in Germany, drawing emerged as an autonomous art form, one of the crucial milestones in the history of the medium and a devel-opment in which Dürer played a major role.

Dürer's View of Drawings

Dürer must have valued drawing as a medium far more highly than contem-porary artists did due to his very personal criteria for assessing artistic value

in an artwork. Having grown up in a culture that esteemed more highly the expensive materials used in art, such as gold, lapis lazuli, or ultramarine, and the time and effort expended in creating a work rather than its originality or expressive force, Dürer had a great influence on reversing this medieval system of assessing value in art by the time he died in 1528. In his view even the simplest sketch could express what Dürer called "the spiritual essence of an artist's creative impulse." And it was the manifestation of this inner creative impulse that he believed determined the quality of a work of art, not its impressive size or lavish materials. He believed that the best artists can express this inner vision with greater artistic merit in a pen drawing sketched on paper in a day than any mediocre artist can in a finished painting worked on for a year.[12] He considered the creative gift of an exceptional artist to be miraculous (*wunderlich*), and even a simple pen drawing was a record of the miraculous, from which it derived its intrinsic value.

Dürer therefore treasured his own drawings as the manifestations of his God-given talent. Realizing their long-term value, he kept them in meticulous order in his studio, and in immaculate condition, still evident in those that have changed owners rarely and been kept away from damaging light and dirt. Like his paintings, he proudly signed and dated many of them, starting as early as the *Madonna Enthroned with Musical Angels* of 1485 (W. 4, Kupferstichkabinett, Berlin), a pen drawing in brown ink with subtle applications of watercolor for the flesh tones to enliven the figures' faces, created at the age of fourteen.[13] He placed his initials *Ad* and the year 1485 prominently at the bottom center of the sheet.

Early on he developed an acute self-awareness of his own outstanding stature as an artist, and many of the inscriptions he added, often many years later, to record the time and circumstances of a drawing's creation were intended to document his remarkable artistic development, probably with an eye to posterity. The most fascinating example is his *Self-Portrait at Age Thirteen* (see Figure 1.2), drawn in silverpoint in 1484, which he inscribed later with justified pride: "This I drew of myself in front of a mirror in the year 1484 when I was still a child. Albrecht Durer."[14] Dürer knew how precocious an achievement this was at a time when he was still a schoolboy, just as his father had begun training him as a goldsmith and two years before he was apprenticed to the painter Michael Wolgemut on November 30, 1486.

Dürer's annotations—the very fact that he signed and dated not only this first known work but the majority of his subsequent drawings—also suggest the new significance of drawings in his work, which to him must have been

just as important as his paintings on panel. Indeed, Dürer's use of his famous monogram, which became widely known primarily through the dissemination of his prints, stakes a personal claim to his drawings. This personalized and fully documented career in drawings was a singular innovation for the medium and a profound marker of the increasing self-consciousness of individual artistry, of the intrinsic value of the products of the artist's own hand. The signed and dated drawing became a desirable collectible, beginning with Dürer and his generation.

The artist's habit of annotating his drawings also included notations about the circumstances and locations where he drew them. Some of these he added many years later, for example, on some of the watercolor landscapes he drew during his first trip to Italy in 1494–95. In one such drawing the vague term *welsch pirg* (Italian mountain), with which he tried to identify the location he had sketched years earlier (W. 99, Ashmolean Museum, Oxford; see Figure 2.9), suggests he had by then forgotten the actual name of the place, the Valle di Cembra between Cembra and Segonzano. The same surely applies to the drawing he later inscribed *ein welsch schlos* ("an Italian castle," W. 101, Kupferstichkabinett, Berlin), instead of the name Segonzano.

Beyond their importance as documents of his artistic prowess, and their many other inherent functions, Dürer, like his contemporaries, kept his drawings for reuse in new works, sometimes many years later. For example, a magnificent drapery study for the seated figure of God the Father in the *Heller Altarpiece* for the Dominican church in Frankfurt, drawn with the brush on green prepared paper in 1508 (W. 457, Albertina, Vienna),[15] he ultimately decided not to use in that altarpiece but did so ten years later for the figure of the seated Virgin in his engraving of 1518, *Madonna Crowned by Two Angels* (B. 39).[16] Many more years separate the execution of his watercolor view of Innsbruck from the north (see Figure 2.10), sketched on his first journey to Venice in 1494–95, from his reuse of some of the buildings, first in a study for an unexecuted print with a mythological theme, the *Pupila Augusta* (W. 153, Windsor Castle, H.M. the Queen), and then a second time as the background for his engraving of *St. Anthony* (B. 58), dated 1519. Dürer obviously made his extraordinary watercolor landscapes for their own intrinsic value as records of beautiful and fascinating foreign places, but they also later provided motifs for the backgrounds in numerous other works, as the view of Innsbruck shows. He incorporated his *Weiherhaus*[17] of 1495 (W. 115, British Museum, London), a view of a small structure on the outskirts of

Nuremberg, into the background of his *Virgin and Child with the Monkey* (B. 42; see Figure 3.3), an engraving made about 1498.

Analysis of Individual Drawings

Dürer's oeuvre as a draftsman begins with two astonishingly accomplished, even revolutionary, self-portraits, created at a time when self-portraiture was almost unknown in German art. They stand at the beginning of an impressive series of images the artist created of himself throughout his life. Dürer made his first such work, mentioned above (Figure 1.2), in 1484 at the age of thirteen during his training as a goldsmith. One of the earliest self-portraits in the history of art, this remarkable drawing shows his keen interest in naturalistic rendering of physical likeness sketched from a mirror. The left hand holding the mirror has been hidden inconspicuously under the right sleeve. His inexperience is visible in pentimenti, changes he made along the edge of the hat and the right arm and on the overly long index finger. His rendering of the folds of the garment is not yet very successful in suggesting either three-dimensionality or the surface texture of cloth. Despite such small infelicities, this early work made a great impression on later German artists, as is evident from an early copy, attributed to Hans Hoffmann and typical of the late sixteenth-century Dürer revival (British Museum, London).[18]

The Albertina *Self-Portrait* demonstrates Dürer's youthful mastery of a difficult medium: silverpoint on prepared paper. It was the preferred technique for portraits in late medieval German art, one learned from Netherlandish precedents. Silverpoint or metalpoint drawings were made with the sharp silver point of a stylus on paper covered with an ivory-colored layer of gesso. Silverpoint produces a delicate, even stroke, oxidizing over time to a grayish-brown color, and lends itself well to works requiring meticulous detail and a high degree of finish. The disadvantage was that no corrections were possible; a change in the drawing would have required removing and replacing the gesso layer on the paper, meaning that the existing drawing would be lost. Since it was more practical to carry around than ink, Leonardo da Vinci recommended it for drawing outdoors in small sketchbooks (*taccuini*). Dürer presumably learned the technique from his father, who most likely encountered it in the Netherlands during his journeyman's years.

A second, undated self-portrait in Erlangen (W. 26; Figure 2.1), created in the artist's favorite medium of pen and ink, offers a far more powerful, dis-

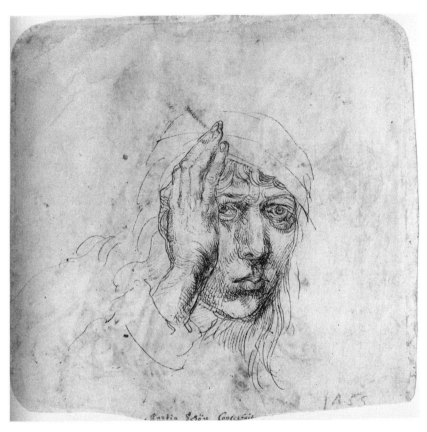

2.1. *Self-Portrait*, ca. 1491–92. Pen and black ink drawing, 20.4 x 20.8 cm. Universität Erlangen-Nürnberg, Graphische Sammlung, Erlangen.

turbing, and revealing image.[19] It must have been made about seven years later in 1491 or 1492, when Dürer was about twenty, during his journeyman's trip to the Upper Rhine region, where he visited Basel and Colmar. Dürer worked up the image selectively, focusing entirely on the face and left hand. He wears what may be a bandage rather than the customary leather beret seen in other self-portraits of this period.[20] Perhaps Dürer intended to record an illness, as he did also in later drawings of 1503 and about 1510.[21] But today's post-Freudian observer would be more inclined to read his distress as psychological, especially since the gesture of the upraised hand placed at or supporting the face traditionally signified melancholy in the highly specific body language of the early modern era. Dürer's depiction of an intensely troubled state of mind is remarkable; nothing like it is known from this

period. It is the first truly "modern" portrait in the way Dürer has captured a condition of angst or depression, or perhaps simply confusion and loneliness in a foreign place. The emotions of a young artist traveling far from home are commonplace, but how intimately Dürer records them is unique in the history of art before Rembrandt's self-portraits a century later. This drawing marks the beginning of a sustained process of self-assessment that continued throughout his life.

The sketch reveals numerous pentimenti in the contour under the chin, along the right edge of the face, and on the thumb. Typical of the early work, the sketch consists of short, rounded strokes with crosshatched lines only in the shadows. The light color of the paper is left in reserve to suggest areas where light falls on the face, such as the cheeks, chin, and hand. The sketch is typical of his use of the pen, or quill, a drawing instrument that yielded effortlessly to the pressure and calligraphic style of the artist's hand. Dürer valued the pen's simplicity and precision of line and its great versatility. It was his most basic and universal technique, employed with brown or black ink throughout his career. Unlike other instruments he used, such as charcoal, the pen line possesses a linear neutrality that made it endlessly useful for a great array of different purposes, from rapidly sketched impressions rendered with a few bold strokes to highly finished drawings, and permitted its use in combination with other materials, such as wash or watercolor.

The Erlangen *Self-Portrait* reveals how fully the young Dürer was able to extend his reach beyond the customary parameters of his period, even as a young artist. Usually he used pen drawing in more traditional ways to prepare his paintings and prints. His *Women's Bath* of 1496 in Bremen (W. 152; Figure 2.2) shows a highly finished and spatially impressive composition made as a preparatory study for a print that was never made.[22] Created soon after his first trip to Venice in 1494–95, it is one of the first instances of his use of one-point linear perspective as he located the vanishing point at the armpit of the woman holding up twigs.[23] His intense study of the nude human figure, also an interest cultivated by his study of Italian art, is equally evident. Six female nudes are shown from different points of view, in different poses and of different ages. Dürer reused these figures the following year, transposing the upper bodies of the left nude seen from the rear and of the young woman in the foreground into the nude figures he placed left and right in his *Four Naked Women* (B. 75), an engraving dated 1497, where they appear reversed due to the printing process.[24]

The *Women's Bath* shows a lively genre scene with women engaging in

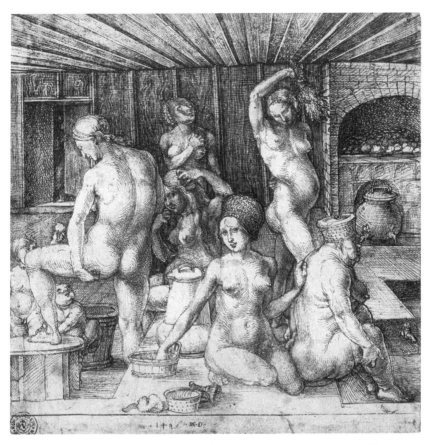

2.2. *Women's Bath*, 1496. Pen and black ink drawing, 23.1 x 23 cm. Kunsthalle Bremen–Der Kunstverein in Bremen.

various cleansing and grooming activities, including combing the hair and increasing the skin's circulation by beating with twigs. The scene offers voyeuristic pleasures both for the bearded Peeping Tom looking through the window in the left background and for the viewer of the drawing. Catering to the peeper's angle of vision, the nude shown from the rear lifts her left leg onto a hassock. She glances down at the small boy below her, indulging his gaze as well.

Perhaps the most unusual of Dürer's early pen drawings from a technical point of view is a group of 126 images sketched onto woodblocks that were intended to become woodcut illustrations for an edition of Terence's plays, commissioned by the Basel publisher Johann Amerbach (Öffentliche Kunst-

sammlung, Kupferstichkabinett, Basel).[25] Most likely the artist's godfather in Nuremberg, the publisher Anton Koberger, arranged for the young artist to work for Amerbach. The book project, however, was abandoned and the designs on most of the wood blocks were never cut. The preservation of late fifteenth-century wood blocks bearing the drawings but still uncut is extraordinarily rare. Although not all of these drawings were created by Dürer himself, they bear witness to his early activity as a designer for woodcuts and also demonstrate why his drawings for woodcuts were not preserved: they fell victim to the woodcutter's knife.

Drawing was often used in this era to lay out the imagery and structure of painted altarpieces for both artist and patron.[26] Called *Visierungen* (or *modelli*), these compositional sketches often served as the equivalent of a contract. Dürer's *Visierung* (W. 445; Figure 2.3) for the *Adoration of the Holy Trinity*[27] altarpiece included the elaborately carved frame with its semicircular tympanum. The artist used pen and brown ink to delineate the essential contours and then applied watercolor washes in various colors to distinguish parts of the composition. Three years elapsed between the creation of the compositional sketch, dated 1508, and the completion of the altarpiece in 1511 (Kunsthistorisches Museum, Vienna; the frame is in the Germanisches Nationalmuseum, Nuremberg; see Figure 5.6), evidently time enough for significant changes to be contemplated, such as in the design of the frame and the now arched form of the central panel. In the finished painting angels with the instruments of the Passion have been added, and at the lower right the artist appears as the only figure on the barren earth, holding a tablet bearing his signature and the date. The sheet is not in optimal condition; the small stains, or foxing, are due to humidity.

In his drawings Dürer also devoted considerable attention to details of figures or drapery in preparation for paintings. For this purpose he used brush drawing on a colored ground, a technique he had learned in Venice, where blue paper was favored. His *Head of an Angel* (see Figure 6.4), a study dated 1506 for the musical angel in the center foreground of his *Feast of the Rose Garlands* altarpiece (see Figure 6.3), shows the influence of contemporary Venetian drawings. With the point of the brush Dürer delineated the outlines, then he used the brush more broadly to lay in areas of shadow along the contour of the face and on the shoulder. Finally he applied the linear highlights with the point of the brush using white body color, resulting in one of his most beautiful creations. Once Dürer had returned to Nuremberg, where he no longer had access to blue Venetian paper, he imitated its effect

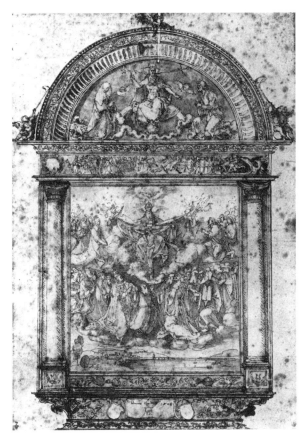

2.3. *Adoration of the Holy Trinity*, 1508. Pen and brown ink drawing with blue, green, and red washes, 39.1 x 26.8 cm. Musée Condé, Chantilly. Photo: Réunion des Musées Nationaux / Art Resource, New York.

by covering white paper with a blue ground, as for example in the famous *Praying Hands* (W. 461, Albertina, Vienna), a study for the central panel of the *Heller Altarpiece*.[28] No fewer than twenty different studies using brush on prepared paper (W. 448–65) survive for the *Heller Altarpiece*, most of them monogrammed and dated 1508.

Another major purpose of drawings was to create portraits. As a young artist Dürer used silverpoint with extraordinary finesse. Slightly later he executed self-portraits in pen and ink, such as the *Self-Portrait with Studies of the Artist's Left Hand and a Cushion* of about 1493 (W. 27, Lehman Collection, Metropolitan Museum of Art, New York).[29] But as the size of his portrait

drawings increased and he aimed for broader surface effects, greater chiar-
oscuro, softer modeling, and a less linear style, he switched to charcoal with
white heightening, as in two signed and dated works of 1503, the portraits of
his patrician friend Willibald Pirckheimer (W. 270; Figure 2.4) and his wife
Crescentia (W. 269), both in Berlin (Kupferstichkabinett). This humanist,
Dürer's childhood friend, who translated numerous Greek texts into Latin,
is best known for the revealing correspondence with the artist during Dürer's
second trip to Venice in 1506. The portrait, closely related to an earlier silver-
point sketch (W. 268; see Figure 11.6), captures Pirckheimer's intelligence
and strength of character with remarkable verve. In 1524 Dürer created an
engraved portrait of his friend (B. 106), which he used as a bookplate. Pirck-
heimer's portrait is an early example of the profile portrait, based on classical
sources, which would become important in Germany a decade later.[30]

Dürer again used the broader medium of charcoal in 1514 when he exe-
cuted the moving portrait of his gaunt, aged, and ailing mother (W. 559,
Berlin; Figure 2.5), which he inscribed when he created it, identifying the
sitter and giving her age as sixty-three, and again after her death two months
later, with a brief obituary.[31] In his *Gedenkbuch* (Kupferstichkabinett, Berlin)
the devoted son gave a touching description of his mother's death. The draw-
ing displays the acute powers of observation seen in all his work. It is a
milestone in the history of portraiture in representing an old, haggard, even
ugly woman in a positive light, without negative moral connotations, as Hans
Baldung Grien often did in his images of elderly women.

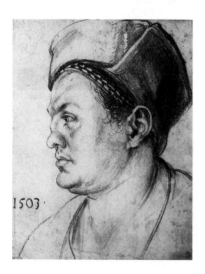

1503 ·

2.4. *Portrait of Willibald Pirckheimer*, 1503.
Charcoal drawing heightened with white
body color, 28.1 x 20.8 cm. Staatliche
Museen, Kupferstichkabinett, Berlin.
Photo: Bildarchiv Preussischer
Kulturbesitz / Art Resource, New York.

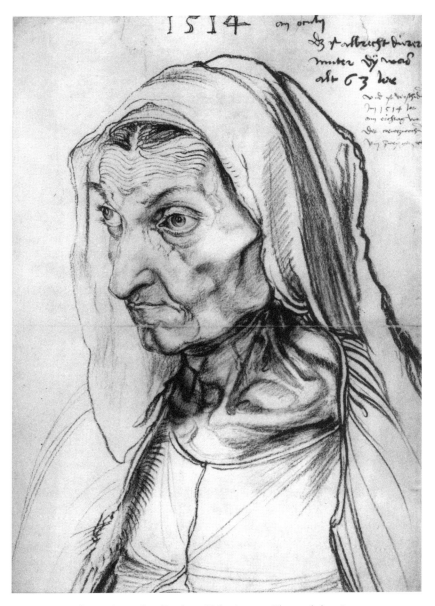

2.5. *Portrait of Dürer's Mother (Barbara Holper)*, 1514. Charcoal drawing, 42.1 x 30.3 cm. Staatliche Museen, Kupferstichkabinett, Berlin. Photo: Bildarchiv Preussischer Kulturbesitz / Art Resource, New York.

His most powerful portraits in charcoal Dürer created during his Nether-
landish trip in 1520–21, developing a type that usually showed the sitter in
three-quarter view and with an empty strip along the top bearing the mono-
gram and date, as in the putative portrait of Bernard van Orley (W. 810,
Louvre, Paris). These large-format portraits were intended as independent
works of art, akin to grisaille painting, and were often mounted like paintings
on wood panels. They rank among the most impressive portraits of the Ger-
man Renaissance. Dürer would not have thought of them as "only" draw-
ings.

For some portraits Dürer used black chalk with white chalk heightening,
as in his rendering of the Holy Roman Emperor Maximilian I (W. 567; see
Figure 8.7).[32] He sketched the face with many delicate lines, giving more
attention to the features than to the garment, chain, or biretta; he then added
red chalk to the face to enliven the features and white body color for high-
lights. The inscription records the precise date and location where the artist
made the study: June 28, 1518, "in a little room high up in the castle" in
Augsburg. Through careful measurement Katherine Crawford Luber con-
firmed Vinzenz Oberhammer's observation that Dürer used a mechanical
means of transfer in creating his subsequent painted portraits of the emperor,
one in 1519 on panel (A. 146, Kunsthistorisches Museum, Vienna), the other
on canvas (A. 145, Germanisches Nationalmuseum, Nuremberg), as well as
the woodcut (B. 154; see Figure 8.8), which reverses the direction of the
sitter's gaze. In all three the emperor's head and features are identical in
dimension to the original chalk drawing, which was incised for transfer, re-
vealing the use of a cartoon (lost) made from the prime portrait drawing.

Many of Dürer's drawings were created as costume studies, showing his
fascination with exotic garb. During his first trip to Venice in 1494–95, the
artist made a number of studies of Turks in their colorful dress (W. 78,
British Museum, London; W. 79, Albertina, Vienna) and of Venetian ladies
in their lavish gowns (W. 69, Albertina, Vienna).[33] When the artist wanted
to record details very precisely he used pen, adding watercolor with the brush,
as in the *Soldier on Horseback* (W. 176, Figure 2.6).[34] Inscribed "This was the
armor of the time in Germany," the study of 1498 displays a greater objectiv-
ity, as if to capture more accurately each detail. Nothing yet indicates that
Dürer knew Leonardo's studies on the proportion of the horse, as he surely
did in 1513 when creating his master engraving, *Knight, Death, and the Devil*
(see Figure 7.1), in which the soldier wearing armor reappears. Dürer reused
the soldier's horse in his engraving of 1500 *St. Eustace* (see Figure 3.7). For a

similar objective as his study of the soldier, Dürer in 1500 again used pen and watercolor for studies of Nuremberg women's dresses (W. 224–26, Albertina, Vienna) worn at church, at balls, or at home. Three or four years later the artist used the figure wearing church dress (W. 224, Albertina, Vienna), for which his wife seems to have served as the model, as a witness in the woodcut of the *Marriage of the Virgin* (B. 82) from the *Life of the Virgin* series.[35]

When making designs for stained glass, Dürer used pen, brush, or charcoal.[36] His most impressive preserved design is an almost fifteen-inch-high charcoal drawing of the *Madonna and Child* (W. 551; Figure 2.7) that served as the cartoon for the monumental window in St. Sebald in Nuremberg, commissioned by Emperor Maximilian's secretary and provost of the church, Melchior Pfinzing. Created in 1515, the window is the first in Nuremberg to be based on a unified central perspective and is considered that city's finest achievement in monumental Renaissance stained glass. The cartoon, unfortunately trimmed on all sides, shows tonal effects similar to Dürer's charcoal portraits.

One of Dürer's most important contributions to German art was his study of human proportions.[37] This lifelong interest is evident in numerous individual drawings as well as in the *Dresden Sketchbook* and related drawings (W. 648–57), and in his *Four Books on Human Proportion* (Nuremberg, 1528), published posthumously. He began in the 1490s with careful pen drawings of individual posed nude models.[38] In the *Women's Bath* (see Figure 2.2), he sketched a group of nude models in various standing and seated poses,

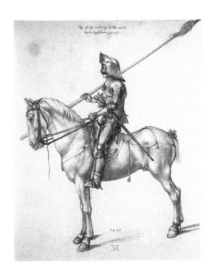

2.6. *Soldier on Horseback*, 1498. Pen and black and brown ink drawing with watercolor, 41 x 32.4 cm. Albertina, Vienna. Photo: Nimatallah / Art Resource, New York.

emphasizing different points of view, as in the well-known classical theme of the Three Graces, recently revived by Italian artists and perhaps familiar to the artist from his first Venetian trip. Around 1500 Dürer began to draw constructed figures, both male and female, consistently using pen and ink. Beginning on one side of a sheet, he sketched a mathematically constructed figure, segmented with compass and ruler to show the proportional body parts; on the verso he traced the same figure (*Reinzeichnung*), its orientation inverted, and then emphasized the figure's outlines by blackening the background with ink. Several preliminary drawings for the *Adam and Eve* engraving of 1504 (see Figure 5.8) were created using this process (e.g., *Adam*, W. 421, Albertina, Vienna; *Eve*, W. 335, British Museum, London; and *Adam and Eve*, W. 333, Morgan Library and Museum, New York).[39]

However, in the *Nude Woman with a Staff* in Ottawa (W. 265; Figure 2.8),[40] both the construction lines and the figure drawn from them are visible on one side of the sheet. The artist has calculated the proportions of this figure along a central axis that runs from the crown of the head to a point just below the feet. In constructing the head in profile and the face, which are 1/8 and 1/10 respectively of the body length, he followed the Vitruvian canon. The model, posed in contrapposto with the body's weight supported by the left leg, holds a walking stick for balance, suggesting that Dürer used a living model to study the musculature, which he delineated with many fine hatched lines. Like the verso of the double-sided proportion studies, he blackened the background with black ink to emphasize the body's contours.

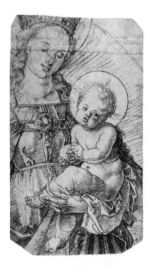

2.7. *Madonna and Child*, cartoon for the Pfinzing window in the church of St. Sebald, Nuremberg, ca. 1515. Charcoal drawing, 42.5 x 24.2 cm. State Hermitage Museum, St. Petersburg.

Dürer was the first great master of watercolor. Dürer's innovation was especially influential for this medium, particularly the landscapes, many created while traveling to Italy in 1494–95.[41] By far the most stylistically "modern" of these is his *Alpine Landscape* (W. 99; Figure 2.9), breathtaking in its utter simplicity and eloquence in capturing the clear light and colors of a spring day in the mountains. He used translucent washes in evocative greens and blues, working up in detail only the central hill with body color and giving the nearest hills almost abstract forms. Another exceptional example is Dürer's *View of Arco* (W. 94; see Figure 6.1) with its lively contrast of a North Italian fortified city and agrarian culture, bathed in sunlight. The cityscape *View of Innsbruck from the North* (W. 66; Figure 2.10),[42] Emperor Maximilian's de facto capital, sketched from across the river Inn, demonstrates the artist rising to the challenge of drawing the city's reflection in the water. Here Dürer focuses on a precise topographic record, with recognizable buildings, while the landscapes offer far more sweeping compositions, with remarkably free brushwork. Friedrich Winkler believed the view of Innsbruck to be the first cityscape of the modern era.

Despite the revolutionary landscapes, it was Dürer's watercolor images of animals that later became a hallmark of his artistic achievement and a subject for frequent imitation, ranging from copies to outright forgeries, particularly during the "Dürer Renaissance" at the end of the sixteenth century.[43] The famous *Hare* of 1502 (W. 248, Albertina, Vienna) with its exceptionally realistic rendering of fur and the virtuosity of control in his brushwork constitutes

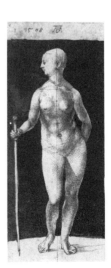

2.8. *Nude Woman with a Staff,* ca. 1502–3. Pen and brown ink drawing with brown wash, 23.5 x 9.6 cm. National Gallery of Canada, Ottawa.

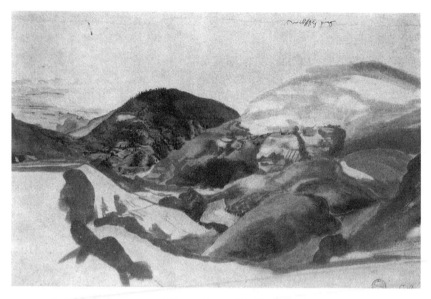

2.9. *Alpine Landscape*, 1494–95. Watercolor and body color drawing, 21 x 31.2 cm. Ashmolean Museum, Oxford. Photo: Erich Lessing / Art Resource, New York.

the high point of his study of animals.[44] The proudly signed and dated watercolor is a work of art in its own right; the artist shows that even this humble animal is part of God's creation. Similarly, in the *Large Piece of Turf* of 1503 (W. 346; Figure 2.11) Dürer's handling of various grasses lends an ordinary subject an astonishing monumentality, recalling the artist's words that one should "study nature diligently and not depart from it. For truly art is hidden in nature and he who can draw it out possesses it."[45]

The most fascinating drawings from Dürer's last decade were those in his silverpoint sketchbook (his little book, "mein Büchlein," as he called it) from his Netherlandish trip of 1520–21. Fifteen sheets of the sketchbook survive (W. 761–87), most drawn on both sides. The artist used the conveniently portable metalpoint medium for images of notable buildings, animals, costume studies, and portraits (see Figure 9.1). The last two types are vividly represented by the sketch of a young woman wearing the local costume of Cologne and—added somewhat later—a portrait of the artist's wife Agnes (W. 780, Albertina, Vienna; Figure 2.12), resulting in a telling contrast of youth and old age.

One late watercolor is a unique and very "modern" record of an extreme emotional state, comparable to the much earlier Erlangen *Self-Portrait* (Fig-

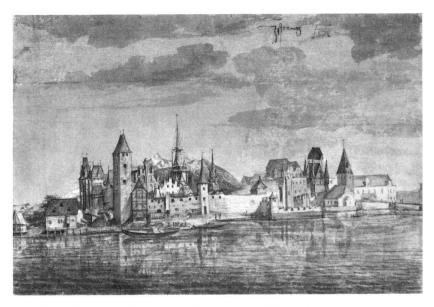

2.10. *View of Innsbruck from the North*, ca. 1494–95. Watercolor and body color drawing, 12.7 x 18.7 cm. Albertina, Vienna. Photo: Erich Lessing / Art Resource, New York.

ure 2.1). Like it, his *Dream Vision* (W. 944; Figure 2.13) functioned as a form of self-therapy during a period of religious turmoil. Dürer captured with a few stokes of the brush a nightmare that he experienced in June 1525, in which giant columns of water falling from heaven inundated the earth. Below the sketch he described it in his own words: "I was so sore afraid that when I awoke my whole body trembled and for a long while I could not recover myself. So when I arose in the morning I painted it above here as I saw it. God turn all things to the best."[46] Dürer used the broad effects of watercolor to commit to memory a very personal experience, subtly evoking atmosphere and space through powerful coloristic effects.

Given the profusion of ways he used drawing during a career spanning four decades from about 1484 to 1528, we must assume that Dürer made many times the number of drawings we know today. Far more delicate and more easily damaged or soiled than paintings, artwork on paper has considerably smaller chances of survival. Drawings had a good chance of being preserved if they remained in use as workshop material and as such were handed down from one generation to the next, as in the case of Jacopo Tintoretto's drawings, which were used in his successors' workshops well into the seven-

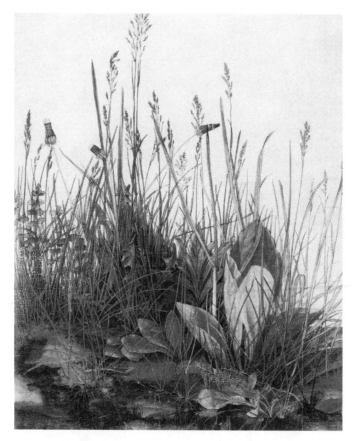

2.11. *Large Piece of Turf*, 1503. Watercolor and body color drawing, 41 x 31.5 cm. Albertina, Vienna. Photo: Erich Lessing / Art Resource, New York.

teenth century. Or drawings were kept due to the special esteem in which their creator was held, as was the case throughout the centuries for Michelangelo, Leonardo da Vinci, and also Dürer. Many drawings owe their survival to a few early collectors, such as Giorgio Vasari in Florence or Basilius Amerbach in Basel.[47]

Considering Dürer's preserved work, one can hazard some informed guesses about which drawings did not survive. Although many of Dürer's studies for his most famous paintings have come down to us, such as for the *Feast of the Rose Garlands* (see Figure 6.3), the *Heller Altarpiece*, and the *St. Jerome* of 1521 (see Figure 9.5), the complete absence of such studies for other paintings suggests how many must have been lost. Nor are any studies known

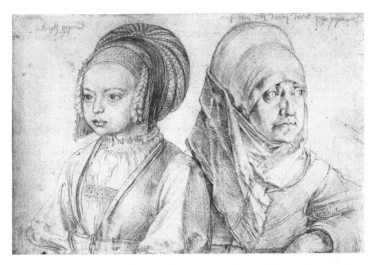

2.12. *A Young Woman from Cologne and Dürer's Wife*, 1521. Silverpoint drawing on prepared paper, 12.9 x 19 cm. Albertina, Vienna.

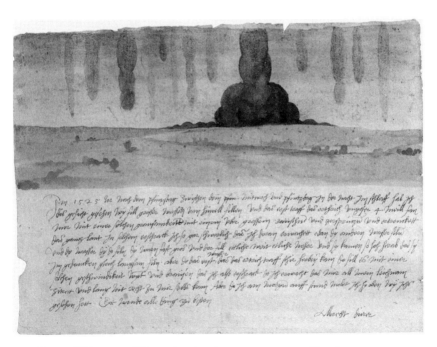

2.13. *Dream Vision*, 1525. Watercolor drawing, 43.7 x 30.1 cm (sheet). Kunsthistorisches Museum, Vienna.

for the great woodcut series the *Apocalypse* of 1498 or the *Large Passion* (see Figures 3.2 and 3.15), major projects that occupied Dürer for years and that must have gone through many stages of detailed studies. Dürer surely must have used pocket-sized sketchbooks of the kind preserved only from his last trip to the Netherlands in 1520–21 during earlier voyages; of these we have no trace.

Drawing was Dürer's universal language, the medium that captured his powers of expression most vividly and profoundly. His drawings reflect the entire breadth of his experience and interests and—most unusual for his time—record his own personal history, giving us a unique and extraordinarily intimate view of this artist and his times.

3

Dürer and the High
Art of Printmaking

Charles Talbot

WHEN DÜRER WAS still in his twenties, his contemporaries began to compare him with the great artists of antiquity.[1] We no longer take his measure in this way, but the analogy drawn by Erasmus of Rotterdam still serves as a touchstone in modern commentaries on his prints.[2] Dürer trumped Apelles, so Erasmus reasoned, because the latter required colors to accomplish what Dürer could do with black lines alone. Evocation of the name Apelles not only invites a question about the standards of great art in the sixteenth century but also, and especially on this occasion, about the capacity of prints to measure up to such standards. Among the qualities possessed by the art of Apelles and other celebrated painters of antiquity, mimesis inspired the most acclaim. Such imitation of appearances pertained both to a picture's truth to nature and to its persuasiveness that the things shown in it were actually present before a viewer's eyes. So did Erasmus express his wonder that Dürer could turn black lines into the appearance of fire or lightning as convincingly as could any painter with a brush.

Though Dürer seems to have realized early in his adult life that images replicated by the press were his and even society's way to the future, woodcuts and engravings, being late arrivals to the family of the visual arts, would need to achieve a higher standing as an art form if they were ever to be considered

in a class with the primary figural arts, painting and sculpture. There is no suspense now about the outcome, but the path of Dürer's thinking about this challenge remains less obvious. This essay means to glean some of his thoughts, and in so doing examines in particular the question of how he conceived of the print in relation to painting and sculpture.

For all his accomplishments in the field of engraving and woodcut, doubts must have lingered in Dürer's mind about their standing as prints relative to the other arts. When he arrived in Venice for the second time in the latter part of 1505, his reputation, like his prominent monogram, was inseparably attached to prints. Nevertheless, he produced not a single new example during his sojourn of more than a year, forgoing the opportunity to demonstrate in situ his unsurpassed mastery with the burin. Instead he concentrated on painting, his major project being the *Feast of the Rose Garlands* (A. 93; see Figure 6.3) As it turned out, this painting and the drawings for it were to reshape his thinking about prints after his return to Nuremberg in January 1507, and the remainder of that decade was a period of astonishing productivity in printmaking. But while in Venice, he was preoccupied with opinions regarding his ability as a painter. He peppered his letters to Willibald Pirckheimer, his friend in Nuremberg, with comments about the recognition he had received for painting. On February 7, 1506, he wrote that despite the criticisms of some Italian artists that he lacked a proper understanding of the "antique" manner, they nonetheless copied his work; and that the best among them, Giovanni Bellini, "came to me and asked me to paint him something and he would pay well for it."[3] Then on September 8, 1506, upon the completion of the *Feast of the Rose Garlands*, Dürer wrote, "I have stopped the mouths of all the painters who used to say that I was good at engraving but, as to painting, I did not know how to handle my colours. Now every one says that better colouring they have never seen."[4] On September 23, he continued, "there is no better Madonna picture in the land than mine; for all the painters praise it."[5] It is understandable that Dürer the painter was keen to demonstrate his prowess with the brush in this city of famous painters, and since Venice was an important distribution point for his graphic work, he reckoned that his new painting in the church of San Bartolommeo would be good publicity for his print business as well as for his reputation overall. But he mentioned nothing to Pirckheimer about prints, and he left it to Vasari to report on his anger over Marcantonio Raimondi's engraved copies of the woodcuts from the *Life of the Virgin* (B. 76–95; see Figure 3.13), complete with Dürer's own monogram. This, too, was a matter

of business as well as reputation. Yet for all these efforts while in Venice, his reputation in Italy remained firmly bound to prints, as partly evidenced by Marcantonio's continued copying of his work, albeit sans monogram, and by Vasari's ignorance of his pictures.[6]

There are indications in both his art and writing that after his return to Nuremberg, Dürer continued to be of two minds about the importance of printmaking in relation to painting. Considering the spectacular production of prints at this time and their new pictorial qualities, one can only assume that whatever limitations may have concerned him about prints also served as a challenge to his imagination and technical ingenuity. Nevertheless, back in his Nuremberg studio he became occupied with painting once more, accepting several commissions, one of which came from Jakob Heller, a rich merchant in Frankfurt. Frankfurt was then, as now, the most important center of book fairs in Germany. Dürer sold his prints there, so a major painting of his in Frankfurt could be expected to stimulate business, as he had surely supposed would be the case in Venice. The work in question was a triptych for which Dürer prepared the design and executed the central panel, *The Assumption and Coronation of the Virgin* (A. 115K).[7] The project dragged on for two years, exhausting Heller's patience and provoking an exchange of letters, of which nine by Dürer survive. On August 26, 1509, he reported that the work was finished and on its way. But he complained that such careful painting does not pay, and "henceforth I shall stick to my engraving, and had I done so before, I should today have been a richer man by 1,000 florins."[8] Dürer also complained about being underpaid for the *Feast of the Rose Garlands*, so his point must be taken in the context of haggling for an increase in the original price. Like every publisher, though, Dürer knew that the time he spent preparing a block or plate could potentially be rewarded many times over by a large and popular printing. Yet the fact remained that a good painting in a princely collection or in an important church still, in most minds, set the standard of a painter's worth.

It would never have occurred to Dürer to identify himself as a printmaker rather than as a painter. The former activity was a branch of the latter. This is apparent in the book for "Young Painters" that he was writing in 1512–13. Although these years immediately followed one of his most intense periods of printmaking, he kept silent on this subject. He discussed human proportions, harmony of parts, models of beauty and truth to nature, topics that pertain to all the arts, but he specifically addressed them to young painters. And, like other humanists, he called forth the names of the ancient painters Apelles

and Parrhasius (also sculptors Phidias, Polyclitus, and Lysippus) to illustrate the high esteem in which painting was and should be held.[9] However in the *Aesthetic Excursus*, a version of his general remarks on painting that was incorporated into the *Four Books on Human Proportion*, he did make a point about the potential value of prints. A person who lacks understanding, experience, and a true gift for art may work long and hard on a painting, he explained, and yet never achieve what a "powerful artist" can do "with his pen on a half-sheet of paper in one day or . . . with his little iron on a small block of wood."[10] Here was an acknowledgment that the intrinsic merit of his prints might well exceed that of many hard-wrought paintings by other artists, but this was in spite of the fact that the image on paper was a more modest thing by nature.

Compared to sculpture and painting or almost anything, prints were thin. Since the material was cheap, albeit indispensable, and prints were in multiples, the individual sheet stood little chance of possessing a value like that of a panel painting, let alone of a sculpture. The price of painting and sculpture always owed much to the cost of the materials from which they were made. Moreover, during the late Middle Ages in northern Europe, when painters and sculptors in wood owed their raison d'être largely to the production of altarpieces in the form of triptychs, there was a clear hierarchy between the two- and three-dimensional arts. Well into the sixteenth century in Germany, a top-of-the-line triptych would have sculpture in the central shrine, and painting would play supporting roles on the wings. It was never the other way round. From the time of Van Eyck in the Netherlands, the primacy of sculpture started to give way to painting, but in Germany this did not happen until the age of Dürer and to a large extent because of him.[11] The very fact that illusory representation in the form of painting could be preferred over sculptural figures signified a partial shift away from assessing a work by its material value in favor of its visual properties alone. Nevertheless, the print was still a relatively unprepossessing object: small, monochrome, and lightweight.

Lacking material worth or an imposing physical presence, the value of prints resided in their efficacy as images alone. Printed images could serve a great variety of functions, primarily religious, but also as documents, mementos, propaganda, and as illustrations to all manner of texts, to name only the more obvious. Their value as works of art was far from being considered the main reason for having them, at least in the beginning. But as the art-conscious public of the Renaissance began to see the image itself as the real-

ization of a creative and intellectual act, irrespective of craft and material, then images on paper, prints as well as drawings, acquired the potential for higher regard. For Dürer, this was obviously a critical development.

On occasion Dürer's remarks about painting were also an admission of its limitations, when compared to prints. "The art of painting," he was writing in 1512, "is employed in the service of the church and thereby shows the sufferings of Christ; it also preserves the likeness of people after their death."[12] This was the voice of a traditional, late Gothic artist. Although the same words do apply to much of Dürer's printmaking, they do not address the intellectual interests and artistic imagination that produced the *Men's Bath House* (B. 128), *The Sea Monster* (B. 71), *Hercules at the Crossroads* (B. 73), *The Dream of the Doctor* (B. 76), or *Melencolia I* (B. 74; Figure 3.1). Principally for the reasons he stated, these were subjects not yet to be found in German painting. Except for a few of the portraits and the projects for Maximilian, Dürer produced prints by his own entrepreneurial choice, rather than on commission, and that included the choice of subject. Unlike no other media, prints could reach a select and widespread audience for classical and other secular themes that were better suited to private than public contemplation. For the versatile and adventuresome mind of Dürer, the availability and artistic license of prints was a godsend.

Coloring woodcuts by hand was a common practice, especially book illustrations, since they followed in the tradition of illuminated manuscripts. Dürer learned about woodcut production during his apprenticeship to Michael Wolgemut, who ran an industry in book illustration. Dürer would have been accustomed to seeing handcolored woodcuts in some exemplars of printed illustrated books. Although he himself illuminated a number of Greek and Latin printed books for his friend Pirckheimer,[13] he colored none of his own prints, nor had them colored, not even experimentally, as far as we know.[14] If Dürer intended his prints to rival paintings, it was to happen on their own terms, not by coloring in the lines. Nor did he participate in making woodcuts with a supplementary tone block, known as chiaroscuro prints. A number of his contemporaries such as Lucas Cranach, Hans Burgkmair and his own former student Hans Baldung Grien made strikingly effective prints in this manner for a short time. These were printed from one or more blocks in color, usually in addition to a line block. Yet there is no evidence that Dürer had the slightest interest in joining this enterprise. For the chiaroscuro impressions of his *Rhinoceros* (B. 136) and *Portrait of Ulrich Varnbüler* (B. 155), the only two of his woodcuts to have been issued this way,

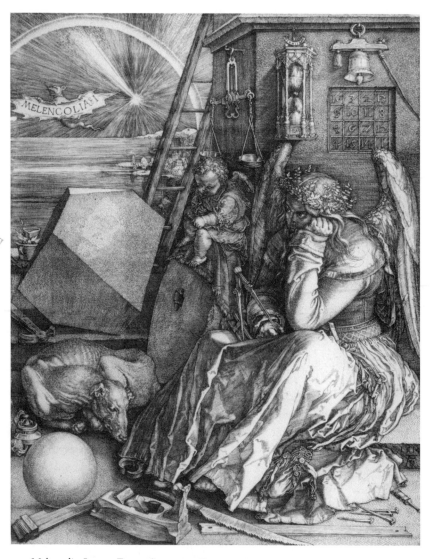

3.1. *Melencolia I*, 1514. Engraving, 24 x 18.7 cm.

the color blocks were added around 1620 by a publisher in Amsterdam who had acquired the original blocks. Although Dürer did not waver from the belief that prints were complete in black and white, for some they had the power to conjure the appearance of color through texture and tone, as if the ink might be refracted through a prism in the eye of the beholder. So keen an observer as Heinrich Wölfflin perceived "colored" appearances in the "master

engravings" *Knight, Death, and the Devil* (B. 98; see Figure 7.1) and *Melencolia*. The levels of darkness evoked not simply shadow, but the "light value of a color."[15]

This was entirely different from coloring prints, which in Dürer's mind would dilute the authenticity that was intrinsic to his engraved plate or block. The autograph and original print was to be unmistakably recognizable by its manner and signature. Marcantonio's engraved copies of the woodcuts from the *Life of the Virgin* were objectionable not only because they plagiarized but because they misrepresented the originals yet purported with a forged monogram to be the master's hand. The question of the autograph print had not previously applied to woodcuts in the same way as it did to engravings. As a rule, copper plates were engraved by the same hand that prepared the design, and consequently the engraver, as in the case of Martin Schongauer, would often identify his authorship with initials or other mark on the plate. Before Dürer, this had only rarely occurred with woodcuts, which involved the collaboration of different hands from one stage to another: drawing the design on paper, transferring it to the block, cutting the block, and finally inking and printing. The original artist's part might be limited only to the first stage, and the print would appear with the authorship anonymous. Dürer dispelled anonymity and subsumed the collaborative aspects of the production under his imprimatur. Woodblocks no less than his engraved plates were to be the bearers of a unique authorship and each impression held the claim to originality. The *Apocalypse* (B. 60–75; Figure 3.2) emphasizes this point in an unprecedented way. In addition to his monogram appearing on each of the fifteen woodcuts, the colophon states that the work was also published in Nuremberg by "Albrecht Dürer painter" (*Gedruecket zu Nurnbergk durch Albrecht duerer maler*).

In most respects prints resemble pen drawings more than they do any other media, and in light of Dürer's determination that prints be understood as authentic works by him, one might expect that he intended the monogrammed print to be associated in the viewer's mind with the signed, original drawing. However, prints and drawings apparently remained distinct in his mind. For one thing, he did not treat drawing as a commercial art. He neither finished drawings for their own sake, nor was it his practice to sell or give them away, as far as we know from most provenances. There were exceptions, to be sure, but primarily he made drawings for his own use, and that included those made in preparation for prints. None of the drawings used for transfer to woodblocks has survived. They were probably used up in the process.

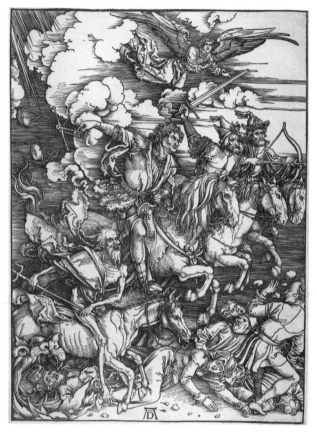

3.2. *The Four Horsemen*, 1498. Woodcut from the *Apocalypse*, 39.2 x 27.9 cm.

Although the print was their mirror image, Dürer did not conceive the print as a kind of facsimile. He did have in mind, it seems, that his painting, the *Feast of the Rose Garlands* and the *Heller Altarpiece*, among others, would provide a standard of reference for buyers of his prints, but if his drawings were not publicly known or considered in themselves as independent works of art, their importance remained behind the scenes. They served as a means of production but not of mediation for the viewers of prints. An exception to this would have been the reproduction by woodcut of the marginal drawings for Maximilian's *Prayer Book*, had that been the original plan, as most commentators suppose.[16] Yet such an edition would not have represented Dürer himself as printmaker in any case, since his designs were conceived as drawings, not woodcuts.

Prints had made Dürer self-reliant from the beginning of his career, and they were a primary source of his artistic education. Following his apprenticeship with Michael Wolgemut, he could readily find work designing book illustrations, as he did in Basel during his journeyman's years. As for his further education in art, three of his most important sources of instruction were printmakers: Schongauer, the Housebook Master, who presumably was not for Dürer the anonymous artist he is now, and Andrea Mantegna. He failed to meet Schongauer, who had died in 1491, a year before Dürer arrived in Colmar. Regarding the Housebook Master and Mantegna, we will never know whether he made their acquaintance personally. But thanks to prints, he had access to their work and could even carry it along with him. Among other things, he learned that engraving (including drypoint) was a versatile and thematically open medium with far-reaching expressive possibilities. It is an indication of his early artistic breadth that Dürer paid special heed to these particular three artists, each so different in his purpose and manner of using engraving.

Dürer's instinct for an art of natural appearances was reaffirmed by the Housebook Master, in whose hands the drypoint was an instrument for preserving a sense of immediacy and spontaneity associated with the pen sketch. This technique together with observations of life led to remarkably unpretentious and humane depictions of religious as well as secular subjects. Although such informality gave way to other values in Dürer's work by the late 1490s, his earliest engravings are full of reminiscence of the Housebook Master. And throughout his career Dürer made vivid, natural details a special attraction of his prints. With all their human insight and warmth of expression, the virtues of the Housebook Master's prints were best appreciated as an intimate, private experience. Again, like drawings, these are small-scale works and their expressive voice remains congenially soft. Dürer ultimately had something more monumental and vigorous in mind.

It was evident to any printmaker that the main drawback of the drypoint was that the soft metal plate of tin or lead readily flattened in the press causing the shallow lines to lose their clarity and the rich texture to fade. Consequently, effective impressions were few in number. Dürer wanted his plates to produce large editions with a high level of quality throughout the run. For this the drypoint needle was no match for the burin. Even the finest details and subtlest expression must reside in the precisely engraved, well-burnished, cleanly wiped plate. He was not unappreciative of some variation in plate tone from one impression to the next, and he clearly did value the

occasional tone and texture that came with an ink-retaining burr on the plate, as so wonderfully displayed by early impressions of the *Virgin and Child with the Monkey* (B. 42; Figure 3.3).[17] But generally speaking, the integrity of the plate was paramount. If properly engraved, it should endure with minimum deformation throughout the printing.[18] Skillful printing was essential, but the quality of the print did not depend upon creative inking. The true and complete image was preserved in the metal.

His misgivings about working in drypoint did not, however, prevent him from making three prints in just this technique. These present the exception that proves the rule about his usual inclination. As uncharacteristic as these are in his oeuvre, his mastery of the medium is less surprising than when he chose to make use of it. It was not in the 1490s when the influence of the Housebook Master was otherwise most pronounced. Two are dated 1512 and the third, though undated, is from about the same time. In 1512 he also produced with utmost precision ten of the sixteen plates for the *Engraved Passion* (B. 3–17). Then without warning he adopted a technique that had little commercial potential and one whose technical and expressive properties were distinctly different from his formal style of engraving. This digression cannot be satisfactorily explained simply as an urge to experiment with a different medium. Rather it springs from another aspect of Dürer's artistic and religious sensibility. For this reason the drypoints are an important reminder that for all his intellectual and pragmatic attitude about prints, Dürer also found them an outlet for personal expression.

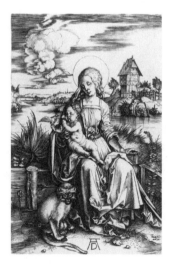

3.3. *Virgin and Child with the Monkey*, ca. 1498. Engraving, 19.1 x 12.2 cm.

In the drypoint of the *Holy Family* (B. 43; Figure 3.4) a deeply contempla-
tive figure of Joseph seems to be on his knees behind the Virgin's grassy
bench. His position, but not his state of mind, recalls a weary Joseph napping
unselfconsciously on the ground and leaning against another grassy bench in
the *Holy Family with the Dragonfly* (B. 44). The latter is one of Dürer's earliest
engravings and one that most pointedly reveals the equally early influence of
the Housebook Master in technique and in characterization of the figure, so
it seems clear that this later drypoint was at least in part an act of retrospec-
tion. But the allusion to the past also underscores a contrast with the lighter-
hearted earlier work. Now the tone has become grave, and it derives in large
part from the quality of lighting in the drypoint. By comparison, the lighting
of even the softly modulated drypoints by the Housebook Master looks neu-
tral. Here the illumination is diffused and casts a veil over the cluster of
figures. In this respect it is also an altogether different lighting from the
brilliant contrasts of the contemporary Passion engravings. If the lighting is
somber, so is the theme. There are, exceptionally, an additional three figures
on the other side of the Virgin in this *Holy Family*: St. John the Evangelist,
Mary Magdalene, and perhaps Joseph of Arimathea, all of whom, enclosed
in half shadow, adumbrate the infant's future Passion.

The other two themes that Dürer chose for the drypoints also involve
religious contemplation: *The Man of Sorrows* (B. 65) and *St. Jerome by the
Pollard Willow* (B. 59; Figure 3.5). The latter example invites comparison with
another depiction of the same church father, the renowned engraving, *St.*

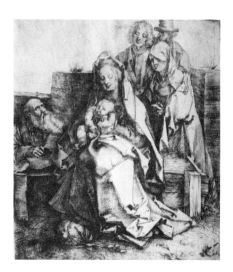

3.4. *Holy Family*, 1512–13. Drypoint, 21
x 18.1 cm.

Jerome in His Study (B. 60; Figure 3.6), dated two years later in 1514. In the drypoint, an Olympian figure of a Christian saint is concentrated in prayer, his harsh, rocky retreat offering no comfort other than a place to sit and a break from the wind. In the engraving, he is comfortably crouched over his writing, oblivious to the very interior that captivates every observer as being the perfect image of an old scholar's cozy study. The engraving shows Dürer at his most dominant. The room is informal, but not the execution. Nothing is left to chance, and the entire surface is covered with visual information, including layers of shadows and filtered light. Against that studied informality, the drypoint lets the burr distribute ink in a line-obliterating way, as if the shadows were an organic substance beyond the artist's complete control. Even the gigantic monogram, when seen in rich, early impressions, appears as a kind of growth on the irregular surface of the standing rock. Yet this monogram, too, proclaims what is Dürer's. These versions of St. Jerome present not simply contrasting choices in iconography and technique but two very different mentalities. The one was rarely revealed publicly, and here it is shown through a medium that was never intended for a large audience. The other has all the accomplishment of a major hit at the peak of a career.

The engraving technique of *St. Jerome in His Study* is a culmination of several stages in Dürer's work in the medium. The earliest of these returns us to his encounter with Schongauer and Mantegna, when he was just gathering his creative forces to redefine printmaking. From these two artists Dürer had quite different things to learn, and he had a very unequal knowledge of their

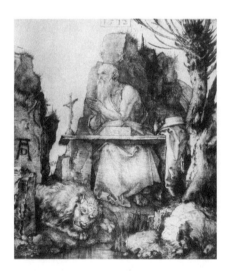

3.5. *St. Jerome by the Pollard Willow,*
1512. Drypoint, 21.1 x 18.3 cm.

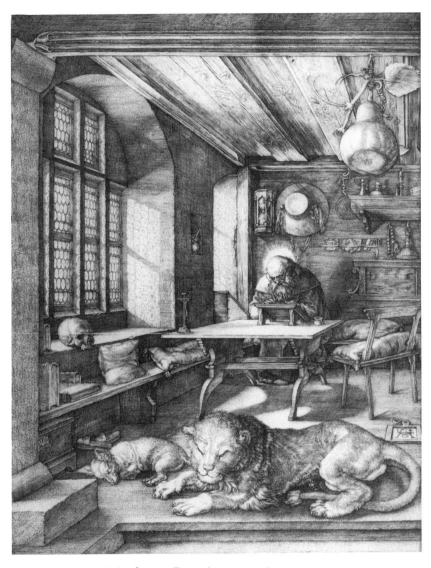

3.6. *St. Jerome in His Study*, 1514. Engraving, 24.3 x 18.7 cm.

work. Schongauer was a prolific engraver, and Dürer probably saw most of his prints, but just the two engravings by Mantegna that he copied in 1494 had a lasting impact. They provided him with a key source for classical figures, and if he had seen these prints in Nuremberg before leaving for Italy in the fall of 1494, they undoubtedly contributed to his motivation to make the

trip. Both Schongauer and Mantegna developed a system of engraving that gave coherence to the linear patterns while producing corporeality in their figures. Mantegna achieved this result by setting the figures against a darker ground and modeling their nude bodies with raking parallel lines. By their composition and relief, these prints resemble a living, sculptural frieze. Dürer did not adopt such a strict system of parallel hatching until around 1510, but he was clearly impressed by the sculptural quality of the representation and did apply a similar relief/ground principle in his prints of the 1490s. Schongauer's prints impressed upon Dürer indelible lessons in the use of the burin as a tool that could simultaneously describe and model a complex three-dimensional form and create a network of coherent, rhythmic lines. These were lessons that Dürer not only put to use in his engravings but also imposed upon woodcut, as improbable technically as that must have seemed to block cutters of the day.

Schongauer's prints demonstrated what Dürer's hand instinctively understood about the natural movement of the burin through copper. Because of the resistance of the metal, the burin turned in curves more readily than angles. The cutting blade, being lozenge-shaped and sharpened on the bias, begins and ends its incision with a fine point, and the line widens as it deepens. The result is a line with flex and elasticity. Its swelling and tapering modulate lights and darks on and within the contours of a form. The evenly spaced networks of lines that define the rise and fall of a three-dimensional surface, such as a complex passage of drapery, also create a sense of surface tension similar in effect to polished limewood sculpture. Not surprisingly, Schongauer's engravings frequently served as models for sculptors and goldsmiths as well as for painters. From seeing how Tilman Riemenschneider transposed Schongauer's engravings into unpolychromed, limewood reliefs, one can appreciate how much the burin was able to impart sculptural values to the two-dimensional image.[19] By the late 1490s, Dürer had clearly decided to follow Schongauer's example in using the burin as a precision instrument and as a means to give a clearly cut, sculpture-like corporeality to his figures. *The Promenade* (B. 94; see Figure 9.3) of about 1498 is still reminiscent of the Housebook Master where the theme is concerned but no longer in its style of engraving. There is now a close connection between the purity and control of the engraved line and the volumetric coherence of the figure. This is readily illustrated by the familiar comparison of the *Virgin and Child with the Monkey* of about 1498 with the *Holy Family with the Dragonfly* from only a few years before.

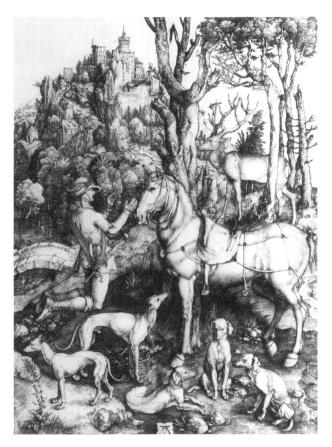

3.7. *St. Eustace*, ca. 1500–1501. Engraving, 35.7 x 26 cm.

Because the *Virgin and Child with the Monkey* and other contemporary engravings, such as *The Sea Monster* or the *Hercules at the Crossroads*, contain so much landscape and richness of detail, there can be no mistaking that Dürer cherished an ambition to rival painting with these prints. This led around 1500–1501 to the *St. Eustace* (B. 57; Figure 3.7), his largest (35.7 x 26 cm) and most elaborate engraving. The lines are still highly disciplined, but they are so fine that the burin could almost be mistaken for a miniaturist's brush. As engaging as the landscapes are, their relationship to the figures indicate that the pictorial aspects of the print had not yet become dominant.

The figures stand out as if they were conceived separately, which they most certainly were. Obvious examples of this are the *Nemesis* (B. 77) and *Adam and Eve* of 1504 (B. 1; see Figure 5.8). Given the overwhelming signifi-

cance of the nude figures in both cases, a different artist might have provided only the most perfunctory background, if any at all. Dürer's decision reveals two somewhat conflicting inclinations. First, he intended that the engraving not be simply an illustration sheet for figure studies, but rather a full-blown work of art with maximum visual and intellectual interest. And second, that the landscape remain subordinate to the human figure. That point would be sufficiently evident from the foreground positioning and scale of the figures, but the hierarchical distinction also resulted in a disjunction within the composition. The figures are so objectified in the engravings that the landscape appears set apart as a backdrop.

No artist in Germany of Dürer's generation, not even one destined from birth to be a great painter, could have mistaken the fact that among the figural arts, sculpture loomed largest. Moreover, where sculpture in the round was concerned, figures were conceived individually in most cases and placed in niches and shrines of altarpieces. Those settings were characteristically architectural in design rather than scenic. Such placement emphasized the importance of the figure in its isolation. In this respect Dürer's all-out emphasis on the significance and form of the human figure is consistent with the primacy and separation of the sculptural figure in its traditional placement. With his landscape backgrounds Dürer went to great lengths to join the figures with a natural setting, but the landscapes only partially mitigated the separateness of the figure. Just as landscape had not entered Dürer's mind as a subject in its own right, except in drawings for his personal use, so the figure, although now silhouetted against the natural world, did not submit to a state of unity with nature but ultimately remained, like its sculptural counterpart, in a quasi realm of its own.

Beginning around 1496, Dürer effectively made woodcuts an extension of engraving, or so it appears from the burin-like character of the lines and their capacity to render coherently a boundless variety of animate and landscape forms. The success of his technique was undoubtedly responsible for the surge in woodcut production during this time, from the early *Hercules Conquering Cacus* (B. 127) or the *Martyrdom of the Ten Thousand* (B. 117) and continuing through the years of the *Apocalypse*, published 1498, and the first seven blocks for the *Large Passion* (B. 6, 8–13; see Figure 3.9), from approximately 1497 to 1499. The critical step in this development was to transfer the quality of a burin line to a line cut in relief. The natural flex and taper of the burin line resulted from a single incision made into the copper plate, whereas a line of similar appearance in woodcut was the result of arduous imperson-

ation. The line was produced by cutting away the wood on either side of it; the thinner the line, the narrower the ridge of wood left standing to print it (see Figure 5.2). To duplicate the appearance of crosshatching, as rendered by intersecting strokes of the pen or burin, every minute interval between the lines had to be edged and removed. So complete is this achievement that the lines, as they appear when printed, seem to flow effortlessly, and the woodcuts give no hint of the fact that the knife was working against a constantly changing resistance, according to the angle of the cut in relation to the grain in the plank.

Once this level of precision had been achieved, it served as the standard. The blocks were in most cases, if not always, cut by another, specially trained hand, but that hand was effectively an extension of Dürer's own. The difficulty in settling the question of whether Dürer ever cut any of his own highly individualistic and refined blocks shows how consistently the quality of the design was preserved in the cutting and, when a professional *Formschneider* did the work, how invisible he remained. With his engraving skill Dürer might well have cut as many blocks himself as necessary to demonstrate what he expected from them, but the advantage to him of producing woodcuts had much to do with the fact that the time-consuming task of cutting could be turned over to a trained craftsman.[20] Dürer could then prepare many drawings for transfer to the blocks (if he did not actually draw the design for cutting on the blocks himself) during the same time required to engrave a single plate. Moreover, woodcuts allowed for larger editions and could be printed faster than engravings. These considerations of economy and production may account partly for the fact that during the latter half of the 1490s, Dürer was even more prolific in the production of woodcuts than engravings. Dürer was a visionary in printmaking, but that did not diminish his attention to the business of publishing.

Although practical advantages provided an incentive, they cannot explain how Dürer conceived the particular expressive potential of a design in this medium. Whatever linear properties of engraving informed the graphic style of his woodcuts, the two media were kindred only to the degree of cousins, not twins. The lay of the printer's ink on the heavier, toothier paper of the big woodcuts, embossed by the pressure of the relief blocks, gives these prints a distinctive physicality. The fine details and subtle textures that we experience in the engravings do not happen in the same way with the woodcuts. The woodcut lines, inherently heavier and wider by nature, assert themselves as lines even as they model and describe a three-dimensional form. Erwin

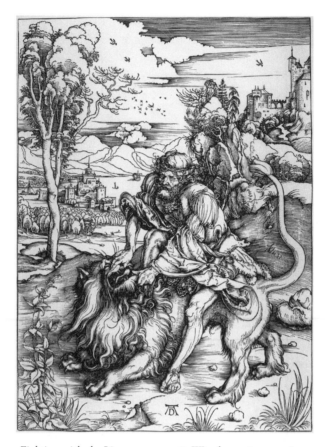

3.8. *Samson Fighting with the Lion*, ca. 1497–98. Woodcut, 38.2 x 27.8 cm.

Panofsky called this graphic system "dynamic calligraphy" because the same fluid lines that delineate shapes also control the appearance of light and shadow.[21] *Samson Fighting with the Lion* (B. 2; Figure 3.8) and *The Four Horsemen* (B. 64) from the *Apocalypse* from around 1497–98 show very well the visual effect of this synthesis of "optical" and "descriptive" properties.

As in many of the engravings discussed above, Dürer used the middle ground of the landscape as a foil against which to emphasize the corporeality of Samson and his lion. This was a familiar device, limited to no one medium, but its purpose was fundamentally to provide the figure with a relief-like appearance. In the *Martyrdom of St. Catherine* (B. 120) or *Christ on the Mount of Olives* (B. 6; Figure 3.9) from the *Large Passion*, it would be difficult not to see these prints in sculptural terms. The figures stand out against the

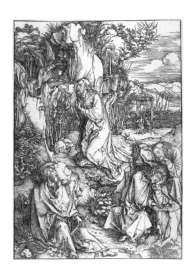

3.9. *Christ on the Mount of Olives*, ca. 1497–99. Woodcut from the *Large Passion*, 39.2 x 27.7 cm.

ground behind them in a way that occurs in actual relief sculpture, such as the roughly contemporary sandstone panels from the Volckamer memorial by Veit Stoss, completed in 1499 (Figure 3.10). Moreover, the vigorous modeling and movement of the draped figures appear very similar in examples of both media. The obvious differences narrow further when considering that the linear modeling of the woodcut has defined the shape of three-dimensional forms by creating the appearance of reflected light along the edge of a form next to a shaded recess, an optical phenomenon more pro-

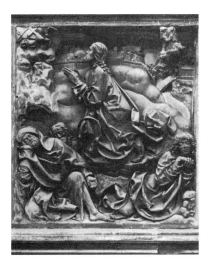

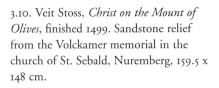

3.10. Veit Stoss, *Christ on the Mount of Olives*, finished 1499. Sandstone relief from the Volckamer memorial in the church of St. Sebald, Nuremberg, 159.5 x 148 cm.

nounced in sculpture than in nature. The omnipresence of sculpture in Nuremberg provided unlimited experience for Dürer to make this visual connection. It was a connection all the more probable at a time when sculptors were beginning to dispense with polychromy in favor of the wood's natural color. Perception of such sculpted form was a function of the monochromatic modulation of light and dark just as in the black-and-white print.

The landscape backgrounds in these woodcuts are just as beguiling as they are in the engravings. They are serene, light-filled vistas that by their faraway spaciousness contrast with the dense and often turbulent figural scenes in the foreground, such as one finds in the *Samson*. These landscapes are the offspring of the watercolor drawings that Dürer made in the Alps and around Nuremberg after his return home. The woodcut had no chance of duplicating the aerial perspective of watercolor washes, so Dürer had to devise another approach. And it is disarmingly simple. Except for the hatching of foliage and lighter areas of shadow on buildings or on the ground, the distant hills and mountains are defined only by thin running lines. Where the vista is bright and clear, a few clouds and small silhouettes of birds in flight transform the white paper above the horizon into sky. This economical use of line produces a kind of transparent armature. The closest parallel is to be found neither in nature nor in painting, but rather in the soaring and layered spaces of late Gothic architecture with intricate patterns of ribbed vaults, tracery, and rows of columns and colonnettes (Figure 3.11). Like the far spaces per-

3.11. Church of St. Lorenz, Nuremberg, interior view of the choir, 1439–77.

ceived in the woodcuts, the architectural interior is also experienced as defined and divided by lines.

The pictorial space in Dürer's woodcuts and engravings expanded with his increasing attention to the construction of linear perspective from the early years of the 1500s, as evident in the engraved *Nativity* of 1504 (B. 2; see Figure 3.14) and the first seventeen woodcuts from the *Life of the Virgin*, completed by 1505. Still, however, there are signs that the experience of late Gothic architecture and sculpture conditioned his design of some perspectival spaces. This pertains in particular to the series of narrative prints: the *Life of the Virgin*, the *Engraved Passion*, and the *Small Woodcut Passion* (B. 16–52). He varied the implied viewing position from one print to another and constructed some scenes with architectural elements that obscured part of the view. In such respects the prints recall what viewing is like in a late Gothic church interior or in the presence of a sculptural monument like Adam Kraft's *Tabernacle* of 1493–96 in the choir of St. Lorenz in Nuremberg. One moves from place to place. Observation of the several reliefs and groupings of figures on different levels behind colonnettes in Kraft's structure is a busy, neck-craning proposition. Very similar is the presentation of the *Nativity* (B. 20; Figure 3.12) from the *Small Woodcut Passion*, where the beholder seems to gaze steeply upward from a level below the figures. Or in the case of the engraved *Christ in Limbo* (B. 16) the viewer is positioned on the wrong side of those condemned to hell and barely above the level of their heads at the

3.12. *Nativity*, ca. 1509. Woodcut from the *Small Woodcut Passion*, 12.8 x 10.2 cm.

bottom edge of the picture. There is nothing this drastic in the woodcut of the *Presentation of Christ in the Temple* (B. 88; Figure 3.13), but the view of the interior is partially blocked by massive columns. This conforms not to the visual opening of an idealized picture space but to the obstruction of a physical structure.

Up through the years prior to the second trip to Venice in 1505, there is a certain fault line in Dürer's prints between references to optical and tactile experience, to adopt Alois Riegl's useful terminology.[22] As we have seen, landscape gave strong impetus for a graphic means linked to an epistemology of vision rather than touch. The theme of the *Apocalypse* had a special place where this question is concerned, because it brought Dürer face to face with the problem of depicting the visionary, and the impact of these woodcuts owes much to his visualization of how contrasting worlds of experience— earthly and celestial, material and ethereal—could coexist in a graphic medium. By 1510, the balance had decisively shifted in the direction of optical values. This shift came about through two unifying principles of design: perspective and tone. Dürer showed that both were intrinsic to graphic media, and they were to define the nature of his prints as predominantly pictorial.

In addition to its practical usefulness for the representation of solid objects within a coherent space, perspective brought the image to a state of inseparable unity with the technical and material reality of the print. The theoretical plane upon which the image was projected, according to the laws of perspec-

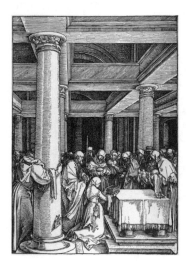

3.13. *Presentation of Christ in the Temple*, ca. 1504–5. Woodcut from the *Life of the Virgin*, 29.6 x 21 cm.

tive, was identical with the sheet of paper against which the plate or block imprinted that very geometric construction. The intellectual justification of this phenomenon was immensely important to the artist who was simultaneously at work on the theory of art, concerning both the mathematical basis of representation and the ideal proportions of the human figure. That these were lifelong concerns is evident from the treatises on these two topics published as late as 1525 (*Underweysung der Messung mit dem Zirckel und Richtscheyt*) and posthumously in the year of his death, 1528 (*Vier Bücher von menschlicher Proportion*). Now more than ever in Dürer's mind printmaking was distinguished as an art of the intellect. This status seems to be reflected by the designs for the woodcuts of the *Life of the Virgin*, which derive great monumentality from the perspective construction of architectural settings. But it is equally revealing of this artist that he would publish the results of his perspective studies in an engraving so modest in size (18.5 x 12 cm) and so intimate in feeling as the *Nativity* of 1504 (Figure 3.14). The intrinsic value of the print would be diminished neither by size nor material. And for his most intellectually challenging themes, such as *Melencolia I* or *Knight, Death, and the Devil*, the print was the essential and inevitable vehicle.

The conjoining of perspective with a new tonal system in prints was perhaps the most important consequence of Dürer's second Venetian sojourn. During a time when he was making no prints, the most painterly of his paintings, the *Feast of the Rose Garlands*, seems to have provided the basis for the development of his most pictorial graphic style and a highpoint in the

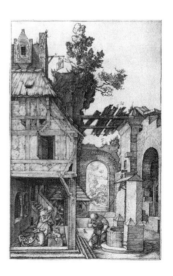

3.14. *Nativity*, 1504. Engraving, 18.5 x 12 cm.

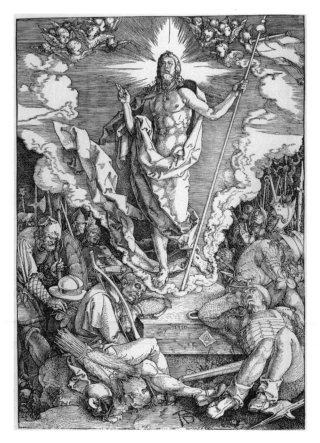

3.15. *Resurrection*, 1510. Woodcut from the *Large Passion*, 38.9 x 27.6 cm.

history of Renaissance printmaking. In 1510, following his return to Nurem-
berg, he completed and dated the remaining four woodcuts for the *Large
Passion* (Figure 3.15) and two for the *Life of the Virgin* in a new manner that
has been termed *clair-obscur*.[23] The term now refers less to a system of model-
ing than to the luminous quality of the prints, and even then it gives little
indication of their grandeur.

 To be more precise, it was not the painting of the *Feast of the Rose Garlands*
itself but rather the studies for it that stimulated Dürer's thinking about
prints. These drawings, made on *carta azzurra*, a blue Venetian paper, were
conceived so that the color of the paper provided a uniform middle value in
a chiaroscuro system.[24] The tonal range extended in both directions from the
middle value, down to the darkest passages drawn with black ink and up to

the lightest in white body color. Since the blue middle value also formed a plane identical with that of the surface of the paper, gradations of tone, by which the figures were modeled, appeared to be organized in planes parallel to that of the paper as well as being in accordance with a clarifying source of light. The organizational principle of this system was, therefore, in perfect agreement with the geometric basis of perspective.

The shift toward tonal unity of black-and-white prints involved considerable sacrifice on part of the highly refined system of modeling that Dürer had achieved previously. The beauty of that system lies in the cohesion of line to solid form; light, shade, and contour are synchronized in their flow over the surface of the form in all its variations. Now some of the virtuoso movements of line gave way to strict parallel hatching and crosshatching, fusing the plane of the paper with the all-important middle value now rendered in gray rather than by the blue of *carta azzurra*. The entire scene falls into a unified, coherent whole under these pictorial conditions, and with most of the paper surface toned by patterns of line, the smaller areas of unshaded white paper emerge with a heretofore unseen brightness.

So fully realized in conception and execution are these woodcuts and engravings of the years from 1510 through the middle of the decade, Dürer must have felt this to be a culminating period in printmaking, beyond which higher achievement was difficult to envision. Perhaps for this reason he chose to undertake something different. In 1514, or 1515 at the latest, he began to experiment with etching. It was a new technique at the time. He made only six prints in the medium, and even these sporadically. Preparatory drawings (W. 585 and 669) for two of the etchings, *Christ on the Mount of Olives* (B. 19), dated 1515, and *Abduction on a Unicorn* (B. 72) from the following year, make the point that Dürer carefully planned his design before going to work on the plate, even though etching allowed for a freer, more spontaneous execution. But the results are far from being equivalent to engraving. The tough, wiry-looking lines, produced by the etched iron plate, have an energy of their own that Dürer used to dramatic ends. Still, six essays with the medium did not make a confirmed etcher of Dürer. Perhaps he was put off by the fact that the plates were prone to rust, unlike copper. Or maybe the technique was too casual for this peerless engraver. Nevertheless, he made two etchings that in retrospect reveal an uncanny sense for what the medium was to become.

The *Landscape with the Cannon* (B. 99; Figure 3.16), dated 1518, was his final etching but the first by any artist to claim landscape for a predominant

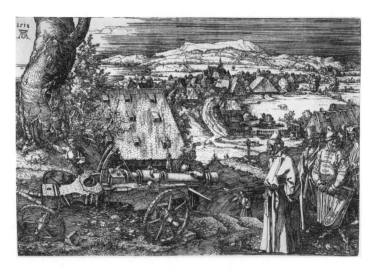

3.16. *Landscape with the Cannon*, 1518. Etching, 21.8 x 32.2 cm.

part of its subject. With its oblong format and panoramic vista it was land-scape enough for a demonstration of the natural affinity between the etching needle and the diverse shapes of the outdoor world. From this starting point began a continuing history of landscape etching leading to Altdorfer, Rem-brandt, Pissarro, and beyond. Dürer himself never shook the bias that art was about things corporeal, the human figure in particular, so an odd mixture of people and an antiquated cannon find themselves enigmatically occupying the foreground of this print, and the pure landscape etching was a field left to others. The undated etching known as the *Desperate Man* (B. 70; Figure 3.17) is unique among Dürer's prints for other reasons. It shows five unlikely characters, only one of whom—the eponymous madman in front—is seen in his entirety, and the relationship of these five to one another may be only that they share the confines of this one plate. There is no satisfactory explana-tion for this sketchlike print, unless it is just that, in which case Dürer antici-pated Rembrandt yet again.

With the possible exception of the *Desperate Man*, the informal, spontane-ous print was almost a non sequitur to Dürer's usual way of careful prepara-tion. Although he wrote that "no powerful artist should abandon himself to one manner only," he made clear that truthfulness in art came from knowl-edge, not by leaving matters to chance. His efforts to amplify and refine the language of prints was no less a search for the truth in art than were his studies of geometry and human proportions, even if printmaking was too

much involved with practice in order to have been a subject of discussion in his theoretical treatises. Still, he might as well have been speaking of his prints, when he remarked in the *Aesthetic Excursus*: "the practiced hand is obedient . . . and by your knowledge you gain confidence and full command of your work so that you make no touch or stroke in vain . . . thus your work appears artistic, graceful, powerful, free, and good, and will receive manifold praise because rightness is infused into it."[25]

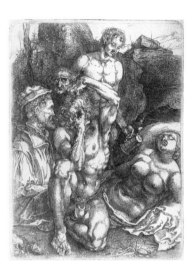

3.17. *Desperate Man*, ca. 1514–15. Etching, 18.6 x 13.5 cm.

4

Dürer as Painter

Katherine Crawford Luber

ALBRECHT DÜRER WAS celebrated during his lifetime for his skill as both a painter and a draftsman. Subsequently, his paintings have received significantly less critical attention than his graphic works, his theoretical writings, or his biography—with the artist cast as an exemplar of artistic genius living within a medieval guild-based society in northern Europe.[1] This has contributed, in turn, to the pervasive assumption that Dürer's paintings are inferior in quality to his graphic work, and that as a painter, Dürer was less accomplished (and less intriguing) than he was as a draftsman. The retrieval of the underdrawings hidden in Dürer's paintings promises to redeem for the paintings some of the admiration lost since the artist's lifetime. Yet the underdrawings can do more than just lay claim to the paintings for scholars of drawings. If studied contextually, they can provide a whole new realm of interpretation and insight into Dürer's activities and concerns as an artist, as well as revitalize the way in which we regard Dürer's paintings and the relationship they share with the artist's staggering graphic production. The comparison to and contextualization of the underdrawings to other drawings on paper, graphic works of art, and watercolors provides a way in which new ideas about Dürer's activities and concerns as an artist and with technique can be explored. Clearly, it is impossible to achieve so much in the space of this brief essay, but I summarize some of my findings and make suggestions that are more fully developed elsewhere.[2]

Now more than ever before, painting technique and the history of the use of different techniques can be studied because of the availability of advanced scientific tools adapted specifically for the investigation of the materials and procedures used in the production of paintings. The study of technique, encompassing the procedures utilized and adapted by artists at every step in the production of a work of art, has been largely overlooked as a source of material for the art historian committed to the reconstruction and interpretation of the past. Few successful explorations of the meaning inherent in the actual practice of painting have been made. Yet, there is widespread acceptance that paintings, as cultural images, are the source of a virtually endless stream of interpretations. The study of technique—like the study of style, elements of form, or iconography—can augment our knowledge of artistic development, and can also be used to form hypotheses about the meaning and importance of paintings.

The underdrawings that Dürer made directly on panel or canvas prior to painting provide a new way in which to explore and understand Dürer's activities as an artist. For many years, the only access to Dürer's underdrawings was through unfinished or damaged paintings, like the *Salvator Mundi* (A. 83; Figure 4.1). Pliny the Elder praised such unfinished paintings in the *Natural History* two thousand years ago. That naturalist wrote, "the latest works of artists, and the pictures left unfinished at their death are valued more than any of their finished paintings, for example, the *Iris* by Aristeides, the *Children of Tyndaros* by Nikomachus, the *Medeia* by Timomachus, and the *Aphrodite* by Apelles. . . . The reason is that in these we see traces of the design and the original conception of the artists."[3] The unfinished and heavily abraded *Salvator Mundi* has repeatedly drawn the attention of scholars because its complex, highly accomplished, and visible underdrawing promised insight into the creative "genius" of the artist and demonstrated that the great draftsman and printmaker responsible for such astonishing linear effects was somehow hidden inside.

The critical partition of Dürer's oeuvre into the graphic and the painterly occurred as early as the sixteenth century. In 1528, the year of the artist's death, Desiderius Erasmus described Dürer as the "Apelles of black lines."[4] Erasmus's description was written after Dürer had presented him with the engraved portrait of 1526, which Erasmus himself had requested Dürer to make. Although Erasmus's comments were intended as a broad humanist encomium about Dürer's skill as an artist, most modern scholars have interpreted his remarks as a critical judgment about the relative artistic merits of

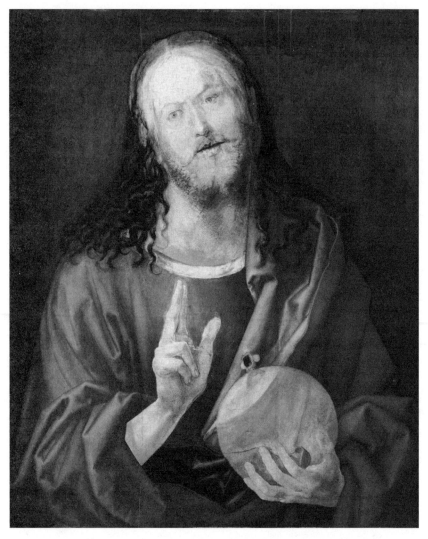

4.1. *Salvator Mundi*, ca. 1504–5. Oil and tempera on lindenwood, 57 x 47 cm. Image copyright © The Metropolitan Museum of Art / Art Resource, New York.

Dürer's paintings and prints. This Erasmian partition between Dürer's painted and graphic works reverberates compellingly with Giorgio Vasari's partitioning of Italian painting into *disegno e colore* in his book *Le vite de' più eccellenti pittori, scultori e architettori.*[5]

Vasari's distinction between *disegno* and *colore* helped to shape the critical

history of the classification of Italian Renaissance painting into regional schools. *Disegno* described the quality in painting that was representative of the highest aesthetic and intellectual achievement attainable by any artist.[6] *Disegno*, in Vasari's view, was married to the idea of invention and formed an integral part of the Tuscan tradition of painting. *Colore*, on the other hand, was regarded by Vasari as the forte of the Venetian painters of the sixteenth century. Although he admired the bravura color effects of Venetian painting, he regarded this school as a whole (and the quality of *colore* in particular) as less rigorous and intellectual than the paintings of the Florentine artists with whom he was so familiar.

Dürer's historical encounter with Venetian painting complicates the post-Vasarian critical division between *disegno* and *colore* within Dürer's oeuvre. Vasari's discussion of Dürer is included in his life of Marcantonio Raimondi, which Vasari used to explicate the history of engraving, the graphic form for which Dürer remains best known. Besides Dürer, Vasari included short sketches of many artists significant for their contribution to the graphic arts, including Martin Schongauer and Lucas van Leyden. Yet Vasari argued that Dürer was more gifted than any of his predecessors and credited him with the gifts specifically associated with the greatest Tuscan artists. Vasari compared Dürer to Martin Schongauer and wrote that "Albrecht Dürer began to give attention to prints . . . but with more design [*disegno*] and better judgment, and with more beautiful invention, seeking to imitate the life and draw near to the Italian manners, which he had always held in much account."[7] Ironically, Vasari's emphasis on Dürer's *disegno,* coupled with judgment and invention, echoes the language Vasari used to describe the accomplishments of Michelangelo, Raphael, and the other artists for whom Vasari reserved his highest praise.[8]

In fact, because so much is known about Dürer's presence in Venice in the years 1505–7, the artist has become a figure of particular interest for scholars of the Renaissance. His life and work have been interpreted as the embodiment of the confrontation of two distinct cultures with distinct visual and intellectual traditions. Dürer's unique position as a northern artist who experienced the Renaissance in Italy firsthand has led scholars to view him as a living conduit for the exchange of artistic ideals and theories between the two cultures. His artistic production has been interpreted as reflective of the tensions between Italy and the North. It is surprising, therefore, that so little attention has been given to Dürer's painted works, not only as an indicator

of his experiences in Venice, but as the primary source on which to base the critical study of artistic practice and experience.

In order to discuss the role of technique in Dürer's production of a painting with particular historical and iconographic meanings, I attempt to locate technique within precise historical contexts. Techniques are quite often tied specifically to particular geographic locations at particular times; identifying them makes it possible to trace regional influences. Dürer's primary source for learning about new, non-northern techniques as a mature artist was Italy, specifically Venice. In addition, I have discovered literary tropes to which Dürer may have been exposed that use painting technique as a metaphor to express the process of fulfillment promised by Christian sacrifice. This literary tradition strongly suggests that the practice of painting itself could be and was meant to be interpretable in its own right. Just as a Renaissance humanist might learn the form of iambic pentameter in order to express certain poetic ideas, I believe Dürer consciously appropriated specific Venetian techniques in order to express certain ideas in a work of art.[9]

In the process of collecting this body of technical material from almost one-third of Dürer's paintings, I came to some general conclusions about the presence, type, and role of underdrawing in Albrecht Dürer's paintings. Based on a limited, although carefully selected and significant sampling of paintings attributed to Dürer from all phases of his career, the following hypotheses were reached.

In the earlier part of his career, by which I mean those years before his travel to Venice as a mature artist in 1505, Dürer commonly depended on the execution of a fully worked-up underdrawing in his paintings. This underdrawing articulated the form and volume of the subjects depicted with a dense internal network of hatching and crosshatching. No preparatory drawings on paper survive for these paintings. The drawing that establishes the basic idea of the composition of the *Virgin with the Seven Sorrows* (A. 20–27), including the large-scale Madonna surrounded by smaller narrative scenes of the seven sorrows is an important exception. This drawing is small in scale and seems to function quite differently from the preparatory drawings that Dürer used later in his career.

Examples of Dürer's work that include fully articulated underdrawing from early in his career include the *Small Virgin* (A. 71) and the *Salvator Mundi*. In some early paintings, Dürer executed the final details on the surface of the painting in a highly graphic mode, as in the *Two Musicians* and *Job and his Wife*, constituting the *Jabach Altar* wings (A. 72–73), as well as

the *Paumgartner Altarpiece* (A. 50–54K).[10] This technique of "drawing" linear details on the surface of the painting with the brush is also found in the *Ober St. Veit Altar*, which was completed by Hans Schäufelein in Dürer's workshop after Dürer departed for Venice in 1505.[11] Recent investigations support my hypotheses for these larger narrative paintings. The *Virgin of the Seven Sorrows*, the *Adam and Eve* (A. 103–4), and the *Paumgartner Altarpiece* in Munich reveal densely worked-up, precise underdrawings.[12]

Besides the presumed absence of underdrawing in certain early portraits, the first clearly discernible technical innovation in Dürer's utilization of underdrawing coincides with his journey to Venice in 1505–7. In many of the paintings from the year 1505 and after, underdrawing as an element of design and invention is minimized and appears not to have been a significant contributing feature of his technique. In some cases underdrawing is limited to the indication of forms with mere contour lines, while in others, it seems to be completely absent. Apparently, Dürer did not make use of an underdrawing in the *Portrait of a Young Venetian* (A. 103) or in the double-sided *Portrait of a Young Man* and *Avarice* (A. 99–100). It is possible that Dürer used an underdrawing material in these paintings that is not detectable with modern technical means of investigation. In the major Venetian paintings, the *Feast of the Rose Garlands* (A. 93; see Figure 6.3) and the *Christ among the Doctors* (A. 98; see Figure 6.5), underdrawing is, for the most part, limited to the depiction of contours. Little internal modeling is executed in the underdrawing in these paintings. The underdrawing in these two paintings is significantly looser and the lines themselves are wider and less finely executed than in the earlier examples, such as the *Small Virgin* or the *Salvator Mundi*. Dürer's decreasing dependency on underdrawing is matched by his simultaneous—and sudden—utilization of preparatory drawings on *carta azzurra*, a blue-dyed Venetian paper (see Figure 6.4). The preparatory drawings on blue-dyed paper for the *Feast of the Rose Garlands* are well-known, as are those on green prepared paper for the destroyed *Heller Altarpiece*.

My investigation of his later paintings, which includes those executed during his stay in Venice in 1505–7 and those completed after his return to Nuremberg in 1507, indicates that Dürer was profoundly affected by the traditions of Venetian painting. He did not merely absorb what he saw; he adapted elements of Venetian technique in conjunction with his own native traditions in order to refine the meanings in his own paintings.

Later paintings in Dürer's oeuvre do not correspond as neatly as the Venetian and pre-Venetian paintings to general rules about the presence and

dependence upon underdrawing and preparatory drawings. Some later paintings by Dürer show no detectable underdrawing at all, for instance, the *Portrait of Michael Wolgemut* (A. 132) or the badly damaged *Portrait of a Man* (A. 157) or the *Portrait of a Clergyman (Johann Dorsch?)* (A. 133). Alternate methods of transferring the design were investigated in regard to these paintings but no evidence was found to support such a possibility. For instance, no incisions were visible on the surface of the paintings that would suggest that they had been traced. Likewise, no evidence was found that the underdrawing was covered up or concealed by painted contour lines on the surface.[13]

Yet at times late in his career, Dürer also made use of an underdrawing reminiscent of his earliest labors, as in the 1526 *Portrait of Johann Kleberger* (A. 182; see Figure 5.10). On occasion Dürer made use of preparatory drawings in the later paintings, most obviously for the *Heller Altarpiece* (A. 107V–115K), unfortunately destroyed by fire, but also for the *Adoration of the Holy Trinity* (A. 118; see Figure 5.6) and the later portraits of Maximilian I (A. 145–46). However, the most interesting paintings from late in Dürer's career show his unique combination of different techniques. For instance, in the *Virgin with the Pear* (A. 120; Figure 4.2, and underdrawing, Figure 4.3), the *Martyrdom of the Ten Thousand* (A. 105), and the *Adoration of the Holy Trinity*, Dürer explicitly combined the type of detailed underdrawing found in the pre-Venetian paintings with a minimal underdrawing similar to that found in the Venetian paintings, the *Feast of the Rose Garlands* (see Figure 6.3) and the *Christ among the Doctors* (see Figure 6.5).

Dürer's portraits should be considered as a group unto themselves. Many of them, although not all, seem to have been executed without dependence on much, if any underdrawing at all. This may indicate that Dürer relied heavily upon portrait sketches on paper, as he did in the case of the portraits of Emperor Maximilian (see Figure 8.7). Dürer was famed in his lifetime for his rapidly drawn portrait likenesses and may have found that a drawing on paper was simply easier to make from life than a painted portrait, which would require multiple, repeated sittings from the subject. My own investigations, together with recent publications, support this view for most portraits. The following portraits reveal no trace of underdrawing when investigated with infrared reflectography: the *Portrait of Oswolt Krel* (A. 56–58), the *Portrait of a Young Man* (A. 99), and the *Portrait of Jacob Fugger the Rich* (A. 143), the *Portrait of Michael Wolgemut*, the *Portrait of a Young Venetian*, and

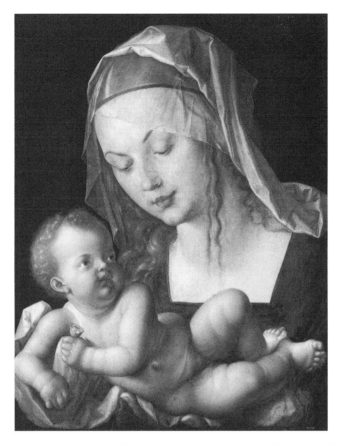

4.2. *Virgin with the Pear*, 1512. Oil on lindenwood, 49 x 37 cm. Kunsthistorisches Museum, Vienna. Photo: Erich Lessing / Art Resource, New York.

the *Portrait of a Young Man with Avarice* on the verso, the *Portrait of a Clergyman (Johannes Dorsch?)*, and the 1498 *Self-Portrait* (A. 49). On the other hand, a few portraits reveal extensive, fully worked-up underdrawing. These include the 1500 *Self-Portrait* (A. 66; see Figure 12.3) and the late *Portrait of Johann Kleberger* (see Figure 5.10). The chronology of the portraits seems to have little relationship to Dürer's method, especially concerning the use or independence from underdrawing. Both early and late portraits contain fully executed underdrawings, and likewise, both early and late portraits were executed without dependence on underdrawing. However, in some (but not all) portraits, no underdrawing seems to be detectable whatsoever, including in

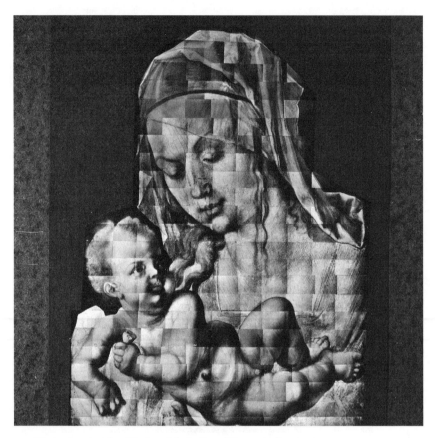

4.3. Underdrawing for *Virgin with the Pear* (Figure 4.2).

the 1498 *Self-Portrait* and the *Portrait of Oswolt Krel.* It may be that Dürer used a material not visible to present methods of investigation or that he did not always depend on underdrawings for his paintings.

Without further investigation of other late portraits by Dürer, it is still impossible to ascertain whether or not chronological distinctions could be made on the basis of these more complete, fully worked-up underdrawings alone. However, the underdrawing found in the 1526 *Portrait of Johann Kleberger* shares some graphic characteristics with the later engraved portraits like the 1524 *Portrait of Frederick the Wise* (B. 104; see Figure 8.9); the 1524 *Portrait of Willibald Pirckheimer* (B. 106); the 1526 *Portrait of Philipp Melanchthon* (B. 105); and the 1526 *Portrait of Erasmus* (B. 107). In all of these late prints, Dürer combined curving, very densely hatched and crosshatched areas with

areas completely lacking in graphic articulation. The result is a pattern of contrasting dark and light areas that play across the surface of the faces and forms. This seems to me to be different from Dürer's earlier use of hatches and crosshatches in the articulation of forms, for example, in the *Salvator Mundi* when he more uniformly described (and covered) the surface of the form with lines.

The technical evidence I have derived from the paintings calls into question Dürer's presumed early presence in Italy. My investigations also show that Dürer was not limited to the recitation of Venetian forms and iconographic motifs in the paintings he made while in Venice in 1505–7. He adopted specifically Venetian techniques in the paintings that he executed in Venice and reused those techniques later in his career. Yet he always combined elements of Venetian techniques with the techniques native to his early training in Germany.[14] Dürer incorporated these painterly innovations not only into his later paintings, but also into his later graphic works. The very visible impact of Venetian painting on Dürer's work alone during this period suggests that the observations he made at that time were fresh and absolutely new to him. Earlier paintings reveal no evidence of any such significant alteration in technique or the introduction of a new technique that would be the result of an earlier exposure to Venetian or Italian art.

My technical investigations of almost one-third of Dürer's entire corpus of paintings reveal the significant alterations that occurred in his painterly technique while he was in Venice during 1505–7, as well as his selective incorporation of some of those same innovations into his later works, both painted and graphic. This evidence is in striking contrast to the complete lack of any visual or technical evidence showing any awareness on Dürer's part of Italianate or Venetian painterly techniques before 1505. Taken together, this information invites a reappraisal of Dürer's relationship to Italian and, specifically, Venetian painting and casts doubt on the widely held assumption that Dürer was in Italy early in his career in 1494 where he was exposed to Italian art.

Outside of a contextual and theoretical basis, technical information about paintings is ultimately of limited interest to art historians. The primary problem in the critical use of technical material has been the belief that the objective importance of the findings is so great that it stands on its own and demands little if any interpretation. Only, I believe, when the information derived from the laboratory is integrated into the interpretive discourses of the art-historical tradition can any richer meaning be derived from its existence. In this regard, my attempt to interpret the material I have collected

here regarding the paintings of Albrecht Dürer is intended to contribute to our understanding of Dürer as a painter and an artist. More specifically, my investigations show that Dürer utilized particular elements of painterly technique to which he was exposed while in Venice in his paintings as well as in his later graphic works. This calls for a revision of the view ingrained in the history of art of Dürer as an artist primarily gifted in and ultimately limited to the graphic realm of production.

My investigations of Dürer's paintings indicate that Dürer's response to the stimulus of newly discovered works of art and techniques was fervent, especially while in Venice in 1505–7. In the paintings executed in Venice during those years, he adopted a particularly Venetian idiom. The *Feast of the Rose Garlands* (see Figure 6.3), the central commission of Dürer's Venetian sojourn, reflects Dürer's awareness and emulation of a distinctly Venetian manner of painting. The outdoor setting is typically Venetian, as is the general iconographic format, which is a modification of the typically Venetian Sacra Conversazione.[15] A similar, strongly Venetian idiom is found in the *Virgin with the Siskin* (A. 94)—a reprise of sorts of the *Feast*—as well as in the portraits associated with Dürer's Venetian sojourn, the *Portrait of a Young Venetian*, the *Portrait of Burkard von Speyer* (A. 97), and the *Portrait of a Venetian Woman* (A. 95). These works, and especially the two female portraits, have often been described as "looking" Venetian. Their costumes seem to reflect Venetian fashions, and their hairstyles have been described as "Venetian" as well. All of these portraits share the bust-length format, soft modeling, and dramatic lighting effects popularized by Giovanni Bellini and his followers in Venice. Conversely, paintings similarly informed by Italian motifs and themes are distinctly lacking from Dürer's early career, specifically from the years 1494–97.

Although Vasari did not devote an entire chapter to Dürer, his ideas about regional schools of art have shaped critical views of Dürer as a northern artist engaged with Italian art. Vasari lamented that Dürer would have been the best painter in Italy if he had only been exposed to the painterly traditions of Italy, particularly Tuscan ones. Vasari wrote that "[if] this man, so able, so diligent, and so versatile, had had Tuscany instead of Flanders [*sic*] for his country, and he had been able to study the treasures of Rome, . . . he would have been the best painter of our land, even as he was the rarest and most celebrated that has ever appeared among the Flemings."[16] Ironically, Dürer *was* exposed to the Italian painterly tradition, although his contact was with

Venetian painting and not the Tuscan tradition about which Vasari wrote so eloquently. Vasari's lament that Dürer was not exposed to the Tuscan artistic tradition provided the cornerstone for generations of arguments about the merits of Italian painting and the necessity for northern artists to study in Italy in order to achieve greatness.

5

Dürer and Sculpture

Jeffrey Chipps Smith

To the Painter Albrecht Dürer from Nuremberg.
Albrecht, most famous painter in German lands
Where the Frankish town raises its lofty head up to the stars,
You represent to us a second Phidias, a second Apelles
And others whom ancient Greece admires for their sovereign hand.

IN 1499 OR 1500, Conrad Celtis, imperial poet laureate, favorably compared Albrecht Dürer with antiquity's most renowned artists.[1] From a humanist, there could be no higher form of praise. During and after his life, Dürer was often dubbed the German Apelles or, in Erasmus's words, the Apelles of "black lines."[2] His association with Apelles, Alexander the Great's painter, makes sense. This short essay, however, will consider Dürer's Phidian side. The Greek Phidias (ca. 500–432 B.C.E.) was a painter and, far more important, a sculptor. Regardless of whether Celtis had anything definite in mind when he associated Phidias and Dürer, who was not a sculptor, the analogy is remarkably apt since Dürer maintained a lifelong creative dialogue with sculptors and sculpture.

Nuremberg's city council banned guilds and regulated all crafts following a rebellion in 1348–49.[3] Painting, printmaking, and wood or stone sculpture were designated as free arts, while more economically vital trades, notably goldsmithing, bronze or brass casting, and armor making, were called sworn

arts. Free artists in Nuremberg had far fewer restrictions (and fewer privi-
leges) than their counterparts in most other towns. This situation facilitated
collaborative interaction between practitioners of different media. In many
German towns, but not in Nuremberg, guild rules would have barred Dürer
from personally making sculptures. Nevertheless, from the outset of his ca-
reer, he recognized that his creative talents and his economic interests lay in
the two-, not three-, dimensional arts.

Dürer and the Aesthetics of Sculpture

The impact of sculpture on Dürer's work was most pronounced in the 1490s
when it affected how he structured some of his compositions and how he
conceived the interplay of light and line.[4] This influence is hardly surprising
given his exposure to sculpture during his training. Albrecht Dürer the Elder,
a master goldsmith, taught him the rudiments of the craft, including how to
use tools such as hammers, chisels, punches, and, for cutting or incising the
metal, a burin. Possibly he learned how to model and cast small silver figures,
such as the finial statuette that the elder Dürer holds in his hand in his
silverpoint *Self-Portrait* sketch (ca. 1484) in Vienna (Albertina).[5] Although it
cannot be proven that the youth sculpted such figures for his father, he did
include similar statuettes in his *Design for a Great Table Fountain with Soldiers*
drawing (see Figure 5.5).

While in Michael Wolgemut's workshop from 1486 to 1489, Dürer became
adept at drawing, painting, and designing woodcuts. There he witnessed the
collaboration of painters, sculptors, and joiners producing elaborate retables.[6]
In 1486, Wolgemut completed the *Peringsdörffer Altar* (now in the Friedens-
kirche, Nuremberg) for the Augustinian monastery located just a few blocks
from his studio. As in most contemporary retables, sculpture was accorded
the place of honor in the center or corpus of the altarpiece as well as often
on the inner wings and in the predella.[7] It is entirely possible that the young
Dürer participated in the production of such altarpieces and that he learned
to polychrome limewood sculptures, a common task for a painter.

Dürer excluded sculpture in his own altarpieces, except secondarily in the
Adoration of the Holy Trinity frame, yet his youthful contact with sculpture
shaped his early art (see Figure 5.6). Between about 1496 and 1498, Dürer
created a group of very ambitious woodcuts, including the *Holy Family with
Three Hares* (B. 102), which culminated in his famed *Apocalypse* series (Figure

5.1). These large, physically imposing prints, with few precedents in German art, stand as graphic rivals to smaller domestic paintings and sculptures, objects that typically were kept in chests or cabinets and brought out for private examination. The extant pearwood block of the *Holy Family with Three Hares* is itself an intricate relief sculpture (Figure 5.2).[8] A wealth of fine lines, each surrounded by delicately cut troughs, animates the surface and defines the respective forms. Careful hatchings and crosshatchings differentiate dark from light. The experience of viewing the woodblock is akin today to looking at a photographic negative. Did Dürer himself carve the block? For most of his career, Dürer employed a *Formschneider*, such as Hieronymus Andreae. Whether or not he cut his own blocks in the mid-1490s cannot be proven. Yet since these blocks are far more elaborate in their design and more sophisticated in their cutting than any known earlier German examples, Dürer must have been intimately involved in their actual production. Likely he did not personally wield the knife, but he refined the training of the artist(s) who did.

A brief comparison of the *Holy Family with Three Hares* with Veit Stoss's *Mary Altarpiece* (Figure 5.3), made for Nuremberg's Carmelite church, reveals Dürer's debt to sculpture.[9] Stoss's unpolychromed altarpiece is later in date but representative of his art. Dürer's highly plastic figures convey believable weight and tangible physical position. Mary and Joseph seem to emerge from the background as they project toward the viewer. Stoss does the same through his transition from low to high relief, a movement that culminates in Mary's fully conceived arms that thrust forward in prayer and cast their own shadows. The two compositions tilt upward sharply, yielding very high horizon lines. The principal action is packed into the dense foreground, where overlapping is employed to place the different figures. Both masters bisect their compositions with a wall. The secondary landscape and architectural features, summarily defined through simple contour lines, are relegated to the rear.

The draperies of the two Marys are conceived similarly. Voluminous folds of fabric spill downward across her body and onto the surrounding ground. More important, Dürer and Stoss construct drapery using line and light. Calligraphic lines forming the edges and the crisp angular folds of the cloth animate the Virgin. Stoss juxtaposes these passages with broad, flatter planes. The result is a delightful dancing of highlights and graduated pools of darkness across Mary's clothing. Stoss, of course, knows that all light striking the surfaces of his sculpture comes from outside the altarpiece. It is the natural

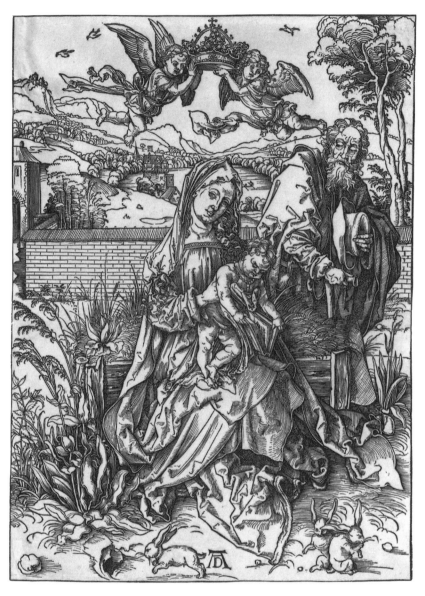

5.1. *Holy Family with Three Hares*, ca. 1497. Woodcut, 39 x 28.1 cm. Princeton University Art Museum. Photo: Princeton University Art Museum.

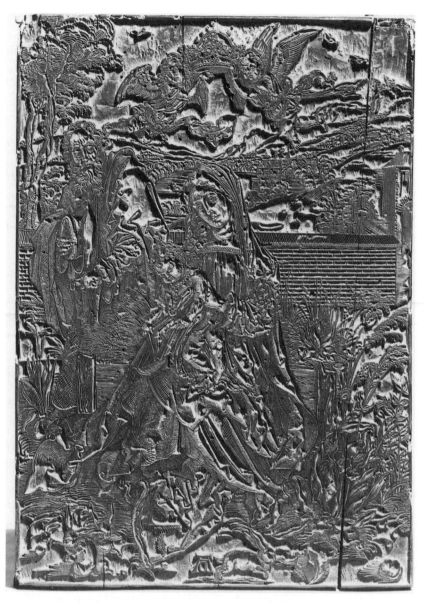

5.2. *Holy Family with Three Hares*, ca. 1497. Pearwood block, 39.2 x 28.1 cm. Princeton University Art Museum. Photo: Princeton University Art Museum.

5.3. Veit Stoss, *Mary Altarpiece*, 1520–23. Pinewood sculpture, 355 x 292 cm. Bamberg Cathedral. Photo: Art Resource, New York / Bildarchiv Foto Marburg.

light that shifts during the course of the day and season plus any illumination from candles on the altar table. Dürer relies upon hatching, crosshatching, and, critically, his materials of black ink on white paper to obtain much the same effect. Even though his figures and forms mimic the reflection of natural light, he employs the whiteness of the paper to achieve this radiance. Some passages are pure white, as if the intense light obliterates details much as occurs in the highlights of Stoss's surfaces. Dürer's varied network of hatchings modulates the light in a manner that is analogous to and, I believe ultimately, in imitation of the shifting depths and angles of the different sculptural planes.

When designing the corpus relief of the *Mary Altarpiece*, Stoss assumed that his viewers would move about. They might walk toward the retable or glance at it from the sides. Michael Baxandall refers to this aptly as the "arc of address."[10] Even though the frontal view is primary, the range of possible positions approaches 180 degrees depending on the siting of the sculpture. Experiencing Stoss's Mary is a cumulative process. An extreme left side view, with its stress on billowing drapery, yields different visual information about Mary than either the frontal or right-hand vantage points. A statue's mimetic power, its inherent aping of nature in this case, is fully resolved only when all of these different "views" are brought together in the onlooker's mind. In Master E. S.'s *Large Madonna of Einsiedeln* (Figure 5.4), pilgrims approach the sculpted cult image from all sides of the altar in order to quench their visual curiosity and spiritual thirst.[11] It may well have been a statue group

5.4. Master E. S. (German, active ca. 1450, died ca. 1467), *The Large Madonna of Einsiedeln*, 1466. Engraving, 20.9 x 12.5 cm, Clarence Buckingham Collection, 1972.1. Photo © 2001, The Art Institute of Chicago.

similar to this sort of seated Madonna and Child that Dürer had in mind when he designed his woodcut. His Mary, while produced in just two dimensions, is conceived as a three-dimensional form just as if it were possible to view her from different positions. Unseen (and never rendered) details on the left and the right sides are implied. The edges of the draperies and the figures as well as the momentarily fixed lighting suggest that they would change if we could move about Dürer's figures.

Although Dürer's later prints become increasingly painterly with stress on atmospheric effects, rational perspective schemes, and, in some cases, psychological intensity, the *Holy Family with Three Hares* typifies how his early contact with sculpture affected his aesthetic sensibilities. Dürer had to think sculpturally, since directly through his own actions or, more likely, indirectly through the efforts of his trained *Formschneider*, he was engaged in the art of relief carving. Like Stoss and other contemporary sculptors, Dürer manipulated cut lines to create forms and invoke the desired lighting characteristics.

His openness to specific sculptural models is evident in his *Adam and Eve* (see Figure 5.9). Dürer based his two figures on famous classical prototypes—the *Apollo Belvedere* (Vatican) and a *Venus pudica*, or modest Venus type, which he knew only through Italian intermediary prints or drawings.[12] He carefully emulated the poses and plasticity of these figures even while transforming the ancient gods into Adam and Eve. Wielding a burin rather than a chisel, Dürer emulated yet tried to surpass his sources using engraving, his chosen medium.

Dürer on Sculpture

Dürer, the most verbal German Renaissance artist, rarely remarks about artists whom he met or sculptures he saw. Living in the Netherlands in 1520–21, he befriended Conrat Meit of Worms ("the good carver in Lady Margaret's service") and Jean Mone of Metz ("the good marble sculptor"), but never comments on their art.[13] While visiting Bruges, he states "Then I saw in Our Lady's church the alabaster Virgin, sculptured by Michelangelo of Rome."[14] His comments about paintings by Jan van Eyck, Rogier van der Weyden, and Hugo van der Goes or by his contemporaries, notably Lucas van Leyden, Jan Gossaert, and Joachim Patinir, are equally cursory. Dürer is silent about Nuremberg's talented sculptors, including Peter Vischer the Elder, with whom he collaborated, or Veit Stoss, whose *Angelic Salutation* in Nurem-

berg's St. Lorenz church he assessed in 1518.[15] Before concluding that Dürer was disinterested in sculpture, we need to recall there was no prevailing tradition in Germany of writing about artists and their art.

Dürer spent much of his career thinking and writing about artistic knowledge. In the dedications to Willibald Pirckheimer in his *Instruction in Measurement* (Nuremberg, 1525) and his *Four Books on Human Proportion* (Nuremberg, 1528), Dürer stresses the broad utility of his ideas. In the former he observes, "It [the treatise] will not alone be serviceable to painters, but also to goldsmiths, sculptors, stone-masons, joiners, and all who require measurements."[16] He assumes an artful sculptor would benefit from his lessons on geometry (book 1), on the construction of two-dimensional figures (book 2), on the application of geometrical principles to such practical tasks as architecture, engineering, and decoration (book 3), or on the geometry of solid bodies (book 4). In book 3, he tells how to design different types of sculptural memorials, such as the *Monument to Commemorate a Victory over the Rebellious Peasants* (see Figure 1.1).[17] A melancholic peasant, with a sword piercing his back, sits on a tub of lard on top of a tall column that is made from farm objects. At its base are seated cows, sheep, pigs, and baskets with eggs, cheese, and other produce. Dürer probably never expected that anyone would use his woodcut to construct an actual monument; however, his print inspired reliefs on Peter Schro's Market Fountain in Mainz that Cardinal Albrecht von Brandenburg, one of Dürer's patrons, erected in 1526 to celebrate his victory over the peasants and local citizenry.[18]

The only substantive comments aimed directly at sculptors occur in the *Four Books on Human Proportion*.[19] In book 4 he presents a classification of human posture. Dürer describes six standing poses, each illustrated by lines, as "bent" (*gebogen*), "curved" (*gekruppt*), "turned" (*gewandt*), "wound" (*gewunden*), "stretched" or "squashed" (*gestreckt/gekrupft*), and "thrust" (*geschoben*). These pertain to the positioning of limbs in complex stances. The accompanying woodcuts depicting frontal and side views of male and female bodies in motion, such as striding forward or bending while looking upward, potentially were useful to sculptors. Dürer recommends that "beginning sculptors in wood or stone who wish to arrive at an exact duplication from life" first render their curved surfaces in a series of facets or connected flat planes. "By this method, one finds the correct way to chip away from the faceted sections what needs to be removed, without taking away or leaving too much."[20]

There is no evidence, however, that sculptors ever read let alone took his

theoretical lessons to heart. Even though Dürer fancied himself as a teacher, his language proved too complicated for most readers. Images rather than texts proved easier for artists to comprehend. In 1521, he sketched *St. Christopher Carrying the Christ Child* nine times on a single sheet of paper (Staatliche Museen, Kupferstichkabinett, Berlin), presumably for Antwerp painter Joachim Patinir.[21] Dürer conceived each grouping differently as if he had a jointed wooden mannequin that he slowly rotated as he drew the various poses. Thus we see the pair frontally, from the left and right profile views, and several in-between positions. A sculptor could easily have benefited from the highly plastic figures, the twisting masses of cloth, and the attention to light moving across the varied surfaces.

Dürer's Designs for Sculptors and Goldsmiths

Dürer's drawings evidence his sustained interaction with sculptors and goldsmiths. Throughout his career he sketched designs for sculpture, diverse types of metalwork including jewelry and armor, and even furniture, such as the carved throne for Cardinal Matthäus Lang, archbishop of Salzburg in 1521.[22] As the son of a goldsmith and the son-in-law of Hans Frey, a brass-smith, Dürer devised models for elaborate cups and other silver vessels. His *Design for a Great Table Fountain* (Figure 5.5) served as the prototype for an actual fountain.[23] A contemporary hand, perhaps that of Frey who specialized in such fountains, inscribed several practical notations on the verso. The first reads, "The mechanism which is silver and rises from the basin is equal in height to the length or height as in the design." Thus the scale of the fountain approximated the drawing, which measures 56 by 35.8 centimeters, though it has been trimmed slightly at the bottom. Below, a ruled line of about 13.8 centimeters is labeled "This is the height of the silver figurines, partly higher and longer, partly shorter." Three other texts relate the heights of different parts to the level of the liquid. Dürer's solution is eminently practical and highly decorative. He provides the portable fountain with a solid base and carrying handles in the form of entwined serpents. Since the water or wine spurts both upward and outward, the fountain had a catch basin. The landscape below is populated by minute figures of peasants, shepherds, hunters, and soldiers to be made in silver or brass and colored with enamel paints. The fountain's stem, resembling a trunk surrounded by thick vines, explodes into a riot of tendrils and fruit. Above rises a marvelous confection of micro-

architecture in the form of a Gothic-style tabernacle adorned with liquid-spouting figures.[24] Four other table fountain drawings by or attributed to Dürer testify to the demand for his designs.[25]

Dürer collaborated with local metalworkers and sculptors. His *Life of Hercules* (1511), a series of twelve roundel drawings in Bremen (Kunsthalle), provided the basis for carved shell reliefs adorning an elaborate gilt-silver cup (ca. 1515–20) by Ludwig Krug and his workshop.[26] Heinrich Kohlhaussen credits the men's association for the rise of more naturalistic forms, such as a drinking vessel in the form of an apple (Germanisches Nationalmuseum, Nuremberg) or pear, by local goldsmiths.[27] In 1521 Nuremberg's council commissioned Dürer to design a large commemorative medal honoring Charles V, the new emperor.[28] Pirckheimer and Lazarus Spengler, in consultation with Johannes Stabius, the imperial historian, helped Dürer with the her-

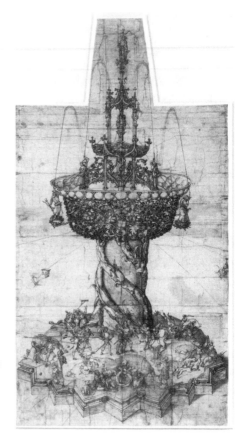

5.5. *Design for a Great Table Fountain with Soldiers*, ca. 1500. Pen and brown ink with watercolor and traces of chalk drawing, 56 x 35.8 cm. British Museum, London. Photo: British Museum.

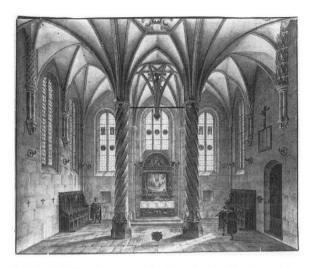

5.6. Georg Christian Wilder, *Interior of the Chapel of the Zwölfbrüderhaus in Nuremberg* (with Albrecht Dürer's *Adoration of the Holy Trinity*, 1511), 1836. Watercolor drawing, 28.9 x 36 cm. Germanisches Nationalmuseum, Nuremberg. Photo: Germanisches Nationalmuseum.

aldry. The resulting drawings, now lost, were given to goldsmith Hans Krafft the Elder, who then cast the medal in silver. The medal showcased Nuremberg's artist talent, since at 7.15 centimeters in diameter, it was, by contemporary standards, unusually large and exceedingly complicated to produce. The following year Anton Tucher, Nuremberg's treasurer, presented a chandelier in the form of a dragon to hang in the new Regimentsstube, or governing chamber in the city hall. The chandelier (Germanisches Nationalmuseum, Nuremberg), made of gilded limewood and a thirty-four-point reindeer antler, follows Dürer's drawing (Städtische Wessemberg-Gemäldegalerie, Konstanz). An accompanying inscription, added in the early seventeenth century, identifies the sculptor as Veit Stoss's son, Willibald.[29]

In 1501 Matthäus Landauer founded the Zwölfbrüderhaus, an almshouse for twelve aged Nuremberg craftsmen. Dürer devised its chapel's decoration including its centerpiece, the *Adoration of the Holy Trinity* (Figure 5.6).[30] The artist's 1508 presentation drawing (Musée Condé, Chantilly; see Figure 2.3) offers an inventive design for a single painting set into a highly ornate sculpted frame. The tympanum shows the Last Judgment with the Virgin Mary and St. John the Baptist interceding at Christ's sides. As two angels blow their trumpets, humanity moves joyously across the lintel toward heaven or,

opposite, in terror toward a gaping hell mouth. The unknown sculptor (Krug?) introduced only minor modifications, probably at Dürer's suggestion, such as reversing the two trumpet-wielding angels. This is the only instance of sculpture being incorporated as an integral part of any of the artist's altarpieces.

He supplied designs for elaborate funerary monuments. Sebastian Loscher (?) struggled somewhat unsuccessfully to translate into stone Dürer's dynamic compositions (1510) for the epitaphs of the Fugger Chapel, consecrated in 1518, in St. Anna's in Augsburg.[31] The shallow reliefs lack the sketches' emotional intensity of the grieving figures or the raw power of Samson, the Old Testament hero, who strides across the memorial to Georg Fugger. Dürer contributed at least four drawings for the bigger-than-life-size standing bronze figures planned to surround the tomb of Emperor Maximilian I (r. 1493–1519), now in the Hofkirche in Innsbruck.[32] His design for Albrecht of Habsburg, exhibiting a naturalistic weight shift, was modeled by Hans Leinberger of Landshut in 1514 and cast in 1517–18 by Stefan Godl in Innsbruck. Dürer worked with Nuremberg's Peter Vischer the Elder on the statues of King Arthur of England and King Theoderich, both cast in 1513 and arguably the finest of the series. In about 1510 Dürer collaborated with Vischer's workshop on the brass *Tomb of Count Hermann VIII von Henneberg and His Wife Elisabeth* in the Stadtkirche in Römhild.[33]

These represent just a few of the sorts of drawings that Dürer invented for use by sculptors and metalworkers. His range was remarkable since he was equally adept devising everything from tombs to medals to jewelry. An inscription on his drawing *Six Covered Cups* (ca. 1499), now in Dresden (Sächsische Landesbibliothek), suggests that he rather enjoyed the creative challenge.[34] It reads, "tomorrow I shall draw more of these." More than any other contemporary German painter, he possessed the facility to think three-dimensionally, much like a sculptor.

Dürer's Prints as Models

Dürer's prints inspired artists across Europe.[35] The greatest concentration of sculptures after his prints occurred in Franconia, Bavaria, and Swabia, yet examples are plentiful as far away as Gdansk (Danzig) and, to the west, Freiburg im Breisgau and Strasbourg.[36] Prints increasingly replaced traditional model books as sources for attractive compositions and an adaptable

repertoire of figures. Images based on his woodcuts and engravings appear
on church bells, baptismal fonts, pulpits, altarpieces, bookbindings, metal
plaquettes, small reliefs, tombs and epitaphs, goldsmith works, and a host of
other loosely sculptural settings.[37] For example, carved wooden reliefs repli-
cating his *Four Witches* (1497; B. 75), *Hercules at the Crossroads* (ca. 1498; B.
73), and *Satyr Family* (1505; B. 69) engravings adorn the doors of the so-called
Dürer-cabinet, a massive linen chest made in Nuremberg in about 1520 and
today in Wartburg Castle above Eisenach.[38] Most of the period's major sculp-
tors borrowed from Dürer. Hans Brüggemann based many of the reliefs of
his monumental *Bordesholm Altarpiece* (1514–21) upon Dürer's *Small Woodcut
Passion* series and some tendril decorations derive from the *Life of the Virgin*.[39]
Sometimes the appropriations are selective as in the *Flight into Egypt* relief of
Stoss's *Mary Altarpiece* where just the ox, ass, and a few other details derive
from Dürer's scene (B. 89) in the *Life of the Virgin* (see Figure 5.3).[40]

Loy Hering, active 1512/15–54 mainly in Eichstätt, carved at least thirty-
four stone reliefs inspired by Dürer's prints. He employs the *Coronation of
the Virgin* (1510; B. 94) from Dürer's *Life of the Virgin* as the prototype for
the main relief of his attractive *Wolfstein Altarpiece* (1519–20) in Eichstätt
Cathedral (Figure 5.7).[41] Schongauer's *St. John on Patmos* (1470s; B. 55) is
the source for the upper, thematically related scene. Hering picked subjects
appropriate to the functions of his reliefs, such as scenes of Christ on the
Mount of Olives, the Lamentation, Christ's Descent into Limbo, the Resur-
rection, and the Last Judgment, deriving from Dürer's three Passion series,

5.7. Loy Hering, *Wolfstein Altarpiece*, 1519–20.
Solnhofen limestone sculpture, approximately 335 x
167 cm. Eichstätt Cathedral. Photo: Author.

for tombs and epitaphs or the Last Supper for his sacrament house (after 1521) in the parish church in Auhausen.[42]

Sculptors copied prints from Dürer's series far more often than individual woodcuts and engravings. Only the *Apocalypse* woodcuts (1496–98, 1511; B. 60–75) rarely appear in sculpture. The narrative structures of the Passion cycles or the *Life of the Virgin* had obvious religious and artistic appeal. Furthermore, it was more convenient for an artist to acquire a whole series rather than amassing single prints to cover these popular themes. Dürer's Netherlandish diary records him selling, bartering, and giving away a huge quantity of prints.[43] Series are listed far more often than even his most famous engravings, such as *Adam and Eve* or *Knight, Death, and the Devil* (see Figure 7.1). His wife, mother, and hired agents likely experienced a similar demand for these series as they sold his prints regionally and abroad.

Adam and Eve (B. 1) proved most influential of his single prints (Figure 5.8). As the definitive German Renaissance depiction of this theme, sculptors mined the whole composition and its details. Ludwig Krug borrowed just Eve for his *Adam and Eve* red marble relief (ca. 1524) in Munich (Bayerisches Nationalmuseum).[44] Master I. P., who was active in the region of Passau and Salzburg during the 1520s and 1530s, returned to Dürer's engraving at least four times.[45] His most impressive version measures more than twice the size of the print (Figure 5.9). The sculptor expands Dürer's composition to show us what the two trees by Adam and Eve might look like if we stepped back for a broader view. The foliage, carefully rendered with unusually deep carving, is now far more animated. Master I. P. retains such nice details as the goat standing on the peak at the upper right, while inventing new side scenes of the Creation of Adam and Eve and their Expulsion from Paradise. Eve's body, though not her head, follows Dürer's figure; however, she is slightly more elongated and decidedly more erotically conceived. By contrast, Adam's head replicates its source but he has been turned around so that his right side and back face the viewer. The weight shift, indicated by the lifted heel, and general musculature echo Dürer's Adam. Here Master I. P. tries to match the engraving's obvious intellectual, compositional, and technical ambitions with his own virtuosity.

Dürer as Sculptor

Writers since the seventeenth century claim Dürer was a sculptor. Joachim von Sandrart championed this idea in his biographical treatise of 1675.[46] In

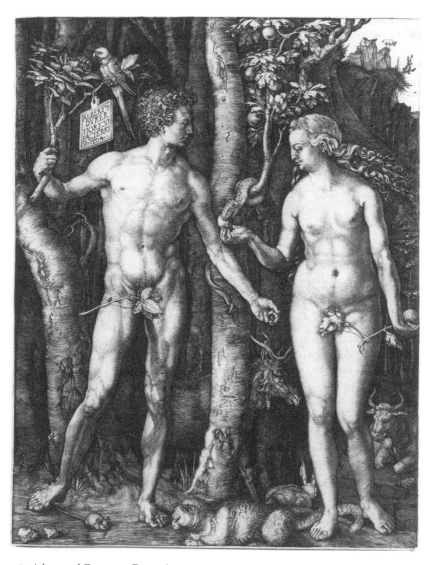

5.8. *Adam and Eve*, 1504. Engraving, 25.2 x 19.4 cm.

the foreword he introduces Michelangelo, Dürer, and Lorenzo Bernini as artistic geniuses who worked in multiple media, including sculpture. Sandrart makes Dürer into a universal man, the Teutonic counterpart to the two Italian masters. Heinrich Conrad Arend devoted a whole chapter to sculpture in his 1728 monograph on Dürer.[47] Several reliefs marked with Dürer's mono-

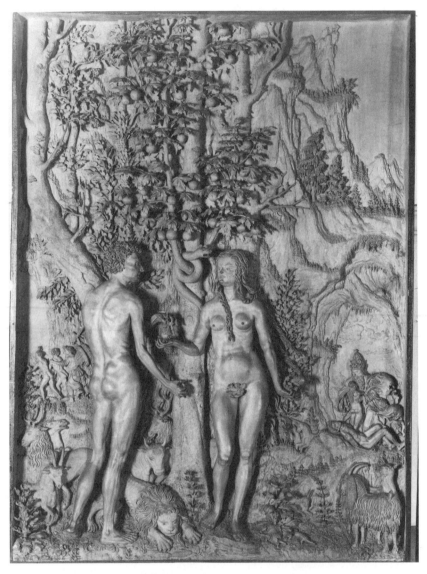

5.9. Master I. P., *Adam and Eve*, mid-1520s. Pearwood sculpture, 62.5 x 46.5 cm. Schloss Friedenstein, Gotha. Photo: Schloss Friedenstein.

gram survive. For example, in Berlin's Skulpturensammlung is a Solnhofen limestone *Adam and Eve* bearing Dürer's distinctive AD monogram plus the date 1515. A relief of a *Nude Woman Seen from the Rear* in New York (Metropolitan Museum of Art) is similarly signed and dated 1509. Today, these are respectively attributed to Martin Hering, working around 1535, and to a South German master active in the early seventeenth century.[48] Hering's *Adam and Eve* actually derives from a 1509 woodcut by Lucas Cranach the Elder while the *Nude Woman* was inspired by Dürer's 1506 drawing in Berlin (Kupferstichkabinett). Each relief is tied to Dürer's posthumous renown. Sometimes his monogram was added to establish the sculptor's links with Dürer's artistic heritage. In other cases, it was a conscious deception to make the carving more valuable since collectors avidly sought out anything possibly by Dürer. In 1627 Elector Maximilian I of Bavaria instructed his agents to pay special attention for and to acquire "anything by Albrecht Dürer's hand . . . or with the mark AD [his monogram]."[49] In 1677, the imperial Habsburg treasury in Vienna possessed a round box adorned with a carving of the *Birth of Christ* "by the consummate Master Albrecht Dürer, who has excelled in all arts."[50] Some reliefs were preserved because of their contemporaneity with the Nuremberg artist's career. Others are products of the so-called Dürer Renaissance of the late sixteenth and first half of the seventeenth centuries, when patrons valued both direct copies of and works made in the style of Dürer.[51]

Let us think about the issue of Dürer as a sculptor in a different way. His portrait of Johann Kleberger blurs the boundaries between painting and sculpture as well as between fictive and real spaces (Figure 5.10).[52] He presents Kleberger as a living sculptural bust. The nude body terminating just beneath the neck mimics the form found on many classical coins and German portrait medals.[53] In 1526, Kleberger ordered two profile portrait medals of himself *all' antica*.[54] While in Italy, Dürer may have seen Mantegna's *Self-Portrait* (ca. 1490) in Sant Andrea in Mantua or carvings such as the relief of a woman from the circle of Tullio Lombardo, now in Budapest, in which part of the body extends over the frame.[55] Yet Dürer opts for a three-quarter's rather than a profile or a frontal view. He places the bust on the lower rim of a circle cut through a square block of stone. The bottom edge of the disembodied neck projects forward slightly and casts a shadow on the vertical stone surface. The body seems to balance successfully in a limited space between the viewer and the green marble backdrop. Dürer emulates a stone bust yet uses his colors and talents as a painter to enliven Kleberger. He locates the

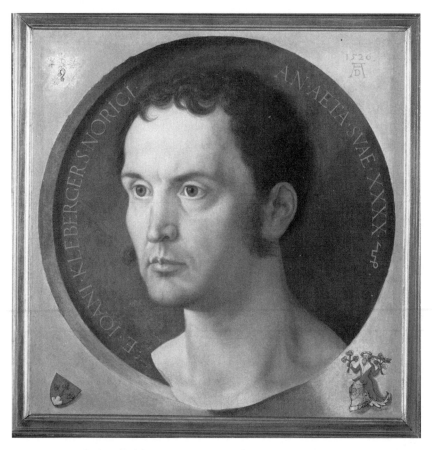

5.10. *Portrait of Johann Kleberger*, 1526. Oil on lindenwood panel, 36.7 x 36.6 cm. Kunsthistorisches Museum, Vienna. Photo: Kunsthistorisches Museum.

bust in a seemingly plausible setting but one that would be difficult to achieve in sculpture. Dürer clearly had fun devising this ambiguous image.

Was he, as others have suggested, offering his own playful entry in the *paragone* debate about the inherent superiority of painting or sculpture?[56] Through his probable contact with Luca Pacioli in Bologna in 1506, Dürer conceivably knew something of Leonardo da Vinci's thoughts on the visual arts' superiority to literature and, more specifically, painting's superiority to sculpture. In his *Treatise on Painting*, Leonardo writes,

> The painter has ten considerations with which he is concerned in fin-ishing his works, namely light, shade, color, body, shape, position, dis-

tance, nearness, motion and rest; the sculptor has only to consider
body, shape, position, motion and rest. With light and shade he does
not concern himself, because nature produces them for his sculpture.
Of color there is none. With distance and closeness he only concerns
himself in part, in that he only uses linear perspective [in reliefs] but
not the perspective of color which varies in hue and distinctness of
outline with different distances from the eye. Therefore sculpture has
few considerations and consequently is less demanding of talent [*in-
gegno*] than painting.[57]

If one allows for Kleberger's potential to move then Dürer's portrait does
indeed seem to stress Leonardo's ten considerations. Even if the Nuremberg
master did not have the *paragone* in mind, he was quite conscious of the
rivalry or, at least, dialogues between media since he used his own prints to
challenge painting.

A stone relief depicting St. John the Baptist preaching bears Dürer's
monogram and the date 1511 (Figure 5.11).[58] The reverse is inscribed "Georg
Schweigger . . . Nür[n]berg . . . 1646." This is one of several Dürer-inspired
reliefs and statues by Schweigger (1613–90).[59] The scene seems immediately
familiar; however, Dürer never illustrated this subject. Schweigger based the
core composition on Dürer's *Ecce Homo* (B. 9) from the *Large Passion*. The
three right-hand figures are fairly direct quotations, while many of the cos-
tumes mimic Dürer's. In place of Pilate, Christ, and the palace, he substitutes
St. John and a forest setting. John's pose echoes those of both Pilate and
Christ. Schweigger was not perpetuating a forgery. Rather, he explicitly ac-
knowledges that Dürer's art functions as a foundation for his own invention.

Was Schweigger offering his art as a sculptural response to Dürer's prints?
In the artistic theory of the late sixteenth and early seventeenth centuries,
emulation (*aemulatio*) "was regarded as the highest degree of living up to
classical paragons."[60] This level was achieved after the artist had learned to
copy (*translatio*) and next to imitate (*imitatio*) a master's style. Only then was
it possible to improve upon the prototype by creating a wholly new work
that emulated the art of an acknowledged master, here Dürer. Hendrick
Goltzius's famed six master engravings of 1593–94 done in creative mimicry
of prints by Dürer, Lucas van Leyden, and Italian artists is the best known
instance of this practice.[61] Schweigger's *St. John the Baptist Preaching* is one
of several sculptures that transcend the overly broad label of the Dürer Re-
naissance. Although there was indeed a market for works, including sculp-

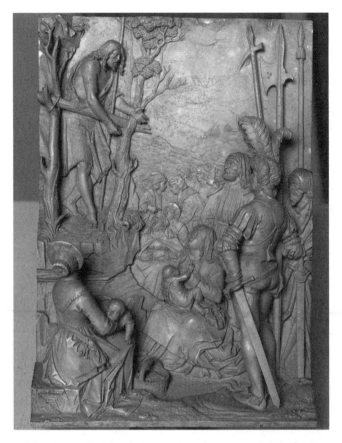

5.11. Georg Schweigger, *St. John the Baptist Preaching*, 1646. Solnhofen limestone sculpture, 20 x 14 cm. Herzog Anton Ulrich-Museum, Braunschweig. Photo: Herzog Anton Ulrich-Museum.

tures, by or in imitation of Dürer, Schweigger exhibits his own creativity to the discerning viewer.

Dürer as Sculpture

Dürer becomes sculpture during the 1520s.[62] While in Antwerp in September 1520, he authorized payment of two gold florins "for my picture" to Hans Schwarz.[63] This Augsburg master, Germany's first major medalist, carved the boxwood portrait of Dürer (Figure 5.12). His profile likeness with a hooked

nose and long, flowing hair offers a familiar, if now slightly older looking, variation of the painted self-portraits. Schwarz stresses the artist's intense gaze, much as Dürer would in his later engraved portrait of Philipp Melanchthon (B. 105). This model was cast, likely by Ludwig Krug, in at least two separate editions during Dürer's lifetime. He gave silver, bronze, and lead impressions of the medal as gifts. In 1519, Dürer sketched two alternative designs for the reverse of his own medal.[64] The text on this single sheet, today in London (British Museum), states this is the "image of Albrecht Dürer the German that he made with his own hand at age forty-eight in 1519." Unfortunately, if he prepared an accompanying obverse self-portrait, it has not survived. In 1527, Matthes Gebel, who had settled in Nuremberg four years earlier, cast a new portrait medal of Dürer at age fifty-eight.[65] This was reissued as a commemorative portrait with the inscription "His life shone forth in brilliance" following the artist's death in 1528.

Our artist stars in Hans Daucher's *Allegory with Albrecht Dürer* (Figure 5.13).[66] Daucher's monogram, designed in emulation of Dürer's, adorns a small tablet at right. The precise meaning of this scene remains elusive. As Emperor Maximilian I and other courtiers look on, Dürer, blade drawn, fiercely battles an armored foe. Is Dürer, whose likeness seems based on Schwarz's medal, fighting with a personification, such as Envy, or with a historical figure? Thomas Eser reads this relief as a historical panegyric honoring both Maximilian and Dürer for advancing German art. He wonders whether the opponent, clad in old-fashioned armor, is Apelles. If so, then

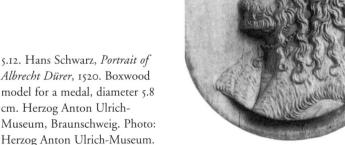

5.12. Hans Schwarz, *Portrait of Albrecht Dürer*, 1520. Boxwood model for a medal, diameter 5.8 cm. Herzog Anton Ulrich-Museum, Braunschweig. Photo: Herzog Anton Ulrich-Museum.

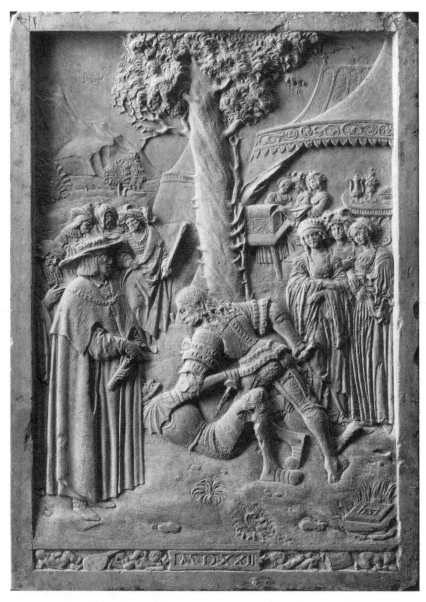

5.13. Hans Daucher, *Allegory with Albrecht Dürer*, 1522. Solnhofen limestone sculpture, 23.8 x 16.8 cm. Staatliche Museen, Skulpturensammlung und Museum für Byzantinische Kunst, Berlin. Photo: Staatliche Museen zu Berlin.

Dürer struggles, seemingly successfully, to dispatch and displace Apelles as the true paragon of artists. In turn, Maximilian, as a modern Alexander the Great, stands as Dürer's cultured patron. Does the relief allegorically reference some story linked with Augsburg's imperial diet of 1518, which Dürer attended? One could imagine Pirckheimer joking that Dürer, his best friend, was superior to all past artists, including Apelles. The 1522 date may tie this carving with four additional reliefs by Daucher honoring Maximilian and his successor, Charles V.[67] Regardless of the precise meaning of the relief, which Dürer probably never knew, it is a fascinating and, for the time, unique glorification of a living artist.

Dürer died on April 6, 1528. The day after he was buried in the St. Johannis cemetery outside Nuremberg, a group of friends opened his grave.[68] Writing in 1542, Christoph Scheurl reports they made a cast of his face. Commemorative death masks, whether of wax or clay, were rare in Italy and far rarer in Germany. A cast of Martin Luther, now in Halle, was taken in 1546. Either the original or a copy of the face and a separate cast of the artist's right hand were owned by the painter Frederick van Valckenborch in Frankfurt in the early seventeenth century and, after passing into the collection of Elector Maximilian I of Bavaria, are thought to have been destroyed in the devastating 1729 fire in the Residenz palace in Munich. A separate wax impression of the artist's hand, rendered quite naturalistically, is recorded in the collection of Christoph Weickmann in Ulm in 1659. Dürer's friends desired a tangible memento once the living artist was taken from their midst. This image soon morphed into a cherished relic of the famous master.

This death mask was just the first of the many posthumous sculpted portraits of Dürer. Sandstone busts of the Nuremberg master and Jan van Eyck once ornamented the house of Cornelis van Dalem in Antwerp.[69] A merchant and well-educated gentleman painter, Van Dalem purchased the house in 1559. The house's appearance, recorded in the 1830s, shows a female personification of Painting seated before an easel between the two busts, which are today in the Museum Vleeshuis. Also depicted are Mercury, god of trade, and Minerva, protectress of the arts. The decoration may be contemporaneous with the date of 1563 inscribed on the gable. If accurate, this allegory offers a remarkably early and quite public glorification of the two masters who were considered respectively to be the fathers of "modern" German and Netherlandish art in the nascent art historical literature of the mid-sixteenth to early seventeenth century.

The phenomenon peaked in the nineteenth century when sculpted busts

and standing statues of Dürer were erected in public squares, national memorials, and art museums in Germany and Austria.[70] In 1808 Crown Prince Ludwig of Bavaria commissioned Joseph Kirchmayer to carve a marble bust for his original conception of a temple honoring great Germans. When Ludwig became king of Bavaria, he built Walhalla near Regensburg and ordered a new marble bust of Dürer by Christian Daniel Rauch in 1836–37. Rauch authored the bigger-than-life-size bronze statue of the artist that was conceived for Nuremberg's 1828 Dürer Jubilee. When finally erected in 1840 in the newly renamed Albrecht-Dürer-Platz, it was Europe's first public monument honoring an artist. The nineteenth century was the great era of new museums. Busts of Dürer, dating to 1833, and Raphael adorned the staircases of the original Städelsches Kunstinstitut in Frankfurt and, in 1840, the Staatliche Kunsthalle Karlsruhe. Standing statues of Dürer were added in 1877 to the Frankfurt museum when it moved to its current location and to the park façade of the Karlsruhe museum in the late 1890s. Dürer was one of twenty-eight standing statues, now destroyed, completed in 1840 for the façade of the Alte Pinakothek in Munich. Gottfried Semper's Gemäldegalerie in Dresden, begun in 1847, matches statues of ancient artists on the museum's river façade with their Renaissance counterparts, including Dürer, on the Zwinger, or inner courtyard, side. Semper's Kunsthistorisches Museum in Vienna, constructed between 1869 and 1891, still displays the bigger-than-life-size stone statue of Dürer, carved in about 1880, standing proudly next to Raphael on the roof of the main façade, which is dedicated to the Renaissance. For these and other museums, Dürer embodied the greatness of German art.

* * *

Whether being acknowledged as a second Apelles or, perhaps more plausibly, as the first and only Albrecht Dürer, it is appropriately ironic that Daucher's *laudatio* occurs in sculpture, a medium that Dürer never actively practiced. Yet as we have seen, the Nuremberg artist interacted with many local sculptors and goldsmiths. Perhaps Conrad Celtis's flattering appellation of Dürer as Apelles and Phidias was more prophetic than even he could have imagined. Phidias's style, which is best seen today in the Parthenon sculptures from Athens, was emulated by Greek sculptors and painters. Dürer's art, rooted in his own early dialogue with sculpture, reached across the continent and exerted an unprecedented influence on artists of almost all media, including sculptors.

6

Dürer and Venice

Andrew Morrall

DÜRER'S "ITALIAN JOURNEYS" have consistently held an important place in the scholarship surrounding the artist's art and life. His first visit, usually dated 1494–95, came at a formative time in the artist's career, between the end of his *Wanderjahre* (1490–94) and his first great creative period as an established master. His second stay in Venice, between 1505 and early 1507, afforded him even more protracted contact with Italian Renaissance art and culture, allowing him to explore and respond to technical, aesthetic, and theoretical aspects of contemporary Italian painting. Writers of the Romantic period used Dürer's travels south to demonstrate his affinity with the great Italian Renaissance masters and to celebrate him as an indigenous artist in whom the qualities of northern art were nobly combined with those of Italy. Indeed it was their determination to find links with Italian civilization that led scholars of this generation first to posit the idea of an initial trip to Venice in 1495, a theory that has subsequently been largely (though not universally) accepted.[1] Under the increasing nationalism of the 1920s and 1930s, many German scholars saw Dürer's encounter with Italian art as more of a clash than a meeting of national styles, "an antithesis dangerous to the native tradition," as Heinrich Wölfflin put it in 1931, and blamed Dürer's interest in Italian art for the dilution of an "authentic," indigenous Germanic tradition.[2] By contrast, Erwin Panofsky, writing in exile in 1943, saw Dürer's encounters with Italian culture in an entirely positive light, as the beginnings of his

pursuit of rationality and his grasping of a humanist, Hellenic tradition that came from outside his own native culture.[3] Subsequent studies have tended to stress commonalities rather than cultural differences.[4] The importance to Dürer of Nuremberg's indigenous culture of literary humanism and attention to the artist's broader nexus of friendships and acquaintance has allowed a sense of Dürer's artistic personality to emerge from within the fabric of social and intellectual life, rather than treating it purely as an aggregate of abstract artistic or intellectual preoccupations.[5]

First Visit to Venice, 1494–95

All the evidence for a first visit is circumstantial and must be inferred from two stray textual references and from the testimony of the artist's own work. An obscure statement Dürer made in a letter written in Venice, dated February 7, 1506, to his friend, the Nuremberg patrician Willibald Pirckheimer, that "that thing which so pleased me eleven years ago, pleases me no longer," has been taken to refer to a work by an Italian artist that he saw in Italy in 1495.[6] A second reference—equally ambiguous—comes from Christoph Scheurl, a Nuremberg lawyer and friend of the artist, who in 1508 quoted Dürer as having spoken of his own "recent return to Italy" in 1505.[7] These references apart, the themes, subject matter, and handling of the body of work he executed between late summer of 1494 and 1495 strongly suggest direct contact with Venice and its artists.

It is assumed that Dürer set out for Italy in the late summer or early autumn of 1494, shortly after returning from his journeyman travels, setting up as an independent master, and marrying Agnes Frey (1475–1539) on July 7, 1494. A serious outbreak of the plague in Nuremberg in September 1494 may have prompted the trip.[8]

The most dramatic evidence of Dürer's travels is the series of landscape studies of the Alps and of northern Italy, executed in watercolor and gouache. From these it is possible to reconstruct in part the artist's itinerary, which probably followed the conventional trading route through Augsburg, Mittenwald, Innsbruck, and the Brenner Pass. Dating these works is problematic, but on the basis of comparison with watercolors of outlying views of Nuremberg that Dürer executed in the early summer of 1494, which display a more detailed, topographical approach (W. 62, *St. Johanniskirche*, 1494, Kunsthalle, Bremen [currently in Moscow, and W. 61, *Wire Drawing Mill*, 1494, Kupfers-

tichkabinett, Berlin), it has been usual to assign the majority of the more expressive and compositionally assured alpine views to the artist's return journey after the artist's engagement with Venetian landscape forms.[9]

Even so, three surviving watercolor views of Innsbruck, which one can assume were made at the same time, collectively show these dual tendencies: two describe aspects of the episcopal palace, or *Hofburg*, in the drier, more factual, manner of the Nuremberg watercolor studies (W. 67–68, both in the Albertina, Vienna), while the third, a shimmering, panoramic view from the northern aspect of the city (W. 66, Albertina; Figure 2.10), displays a virtuoso handling of light on water, suggesting the rapid development in Dürer's grasp of the possibilities of the medium, quite possibly without the stimulus of Venetian painting.[10] A further group of studies, including views of the valley and castle of Trento and of mountain vistas, plot the artist's route through the Brenner Pass.[11] His *View of Arco* (W. 94, Louvre, Paris) on the northern end of Lake Garda probably shows the nature of his homeward progress within Italy (Figure 6.1). The wider significance of these studies lies in the fact that they are among the earliest surviving, autonomous landscapes of place, atmosphere, and effect, made if not *en plein air* then from drawings made in situ. The degree of compositional invention they exhibit and the sophistication and synoptic flair with which Dürer could organize what he saw before him into a coherent aesthetic framework are remarkable testimony to the artist's seemingly effortless originality.

Other drawings of this period record peculiarly Venetian subjects in a spirit of objective reportage. He made a careful drawing of a lobster (W. 91, Kupferstichkabinett, Berlin).[13] Dürer also made a detailed costume study of a young Venetian woman (W. 69, Albertina, Vienna), whose gorgeously elaborate and brazenly low-cut dress clearly impressed the northerner, for this study spawned a number of variants.[14] A drawing, now in Frankfurt (Städel Museum, W. 75), contrasts a sedately dressed Nuremberg matron with a young Venetian woman in a similar, bare-shouldered costume. Dürer also used this dress to clothe both a kneeling St. Catherine of Alexandria in a pen drawing in Cologne (Wallraf Richartz Museum, W. 73), and the Whore of Babylon in his later woodcut *Apocalypse* series (B. 73).

The same interest in exotic dress is evident in several drawings and watercolor studies that Dürer made of Ottoman Turks, which appear mostly to have been copied or adapted from works by Venetian artists. The watercolor *Three Standing Orientals* (W. 78, British Museum, London) is adapted only

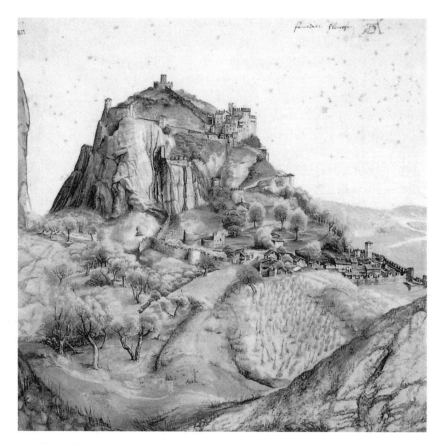

6.1. *View of Arco*, ca. 1495. Watercolor drawing, 22.1 x 22.1 cm. Musée du Louvre, Paris.

slightly from a detail in Gentile Bellini's *Procession in St. Mark's Square*, dated 1496 (Galleria dell'Accademia, Venice). Dürer's copy was presumably taken from a preparatory drawing or possibly the unfinished painting, indicating his contact with the most prominent workshop in the city.[15] In these studies, Dürer was responding to what Julian Raby called an "Oriental mode" among a group of Venetian painters, who, during a period of more than a decade that straddled the turn of the sixteenth century, attempted to make credible portrayals of the Muslim Near East, in terms of accurate dress, details of architecture, and exotic animals.[16] The studies of Gentile Bellini, to which Dürer evidently had access, were themselves made in Constantinople, during an embassy to Sultan Mehmet II.[17] Dürer carried over Bellini's ethnological

interest in costume into a number of religious works, but, unlike his Venetian counterparts, he used the heightened realism of actual contemporary Ottoman costumes to express more vividly the conventional idea of the enemies of Christ.[18]

Works of this period also register an intensification of interest in both classical subject matter and a fascination with the human body. Up to this point, Dürer's knowledge of the classical world had been more literary than visual. The first concrete Italian prototypes that Dürer copied and from which he gleaned some sense of the appearance of antique costume and drapery were a set of Ferrarese prints known (incorrectly) as the "Tarocchi" playing cards on which he based illustrations of the Muses and other mythological figures for an anthology of classical poets, orators, and historians, the *Archetypus Romae triumphantis*, produced in the workshop of his master, Michael Wolgemut.[19] As Panofsky demonstrated, two carefully drawn copies after prints by Andrea Mantegna (W. 59–60), one of which is inscribed with the date 1494, constitute a starting point in Dürer's attempt to assimilate the principles of Italian monumental form.[20] It is likely that he executed them while still in Nuremberg. The beautiful drawing of the *Death of Orpheus* (W. 58, Kunsthalle, Hamburg) is also possibly based upon a lost Mantegna, known today only through a simple Italian variant. Such works introduced Dürer to the idea of the nude, to mythological subject matter as a subject of art, and to a notion of ideal human proportions.

Dürer also found useful models of the human figure in action in the works of Antonio Pollaiuolo and his followers.[21] Dürer's assimilation of these sources can be vividly observed in a sheet of sketches (W. 86; Figure 6.2). The center study of the legs and torso of a nude male figure, with one arm raised, the other supporting a shield, follows, in morphology and in the specifics of anatomical interest, the central warrior of Pollaiuolo's print *Battle of the Naked Men*. It also has striking affinities with the figure holding a cornucopia in Mantegna's print of a bacchanal. To the left, a diagrammatic outline drawing of the same male form, from which the more detailed figure in the center has evolved, suggests that Dürer's approach to his Italian models was not merely one of surface emulation, but structural in its conception. In the saddle of muscle around the hips, in the schematic belt of the lower abdomen, which makes a clear separation of upper and lower torso, one may observe how Dürer has learned to construct his figure by dividing it into roughly proportionate, component parts—the basis on which classical art depends. Moreover, the rudimentary sketching of the left leg suggests an

interest in the bone structure of the knee and the bands of muscle of the thigh. This is the earliest explicit evidence that Dürer was learning to build his figures by the application of an underlying knowledge of anatomy and musculature, a principle central to the most advanced late fifteenth-century Italian artists' conception of the nude.

Dürer's most original statement of the human figure to date, however, is a drawing from life, seen from the rear (W. 85, Louvre, Paris), rare at this date for its use of a female model.[22] His focus upon the back, buttocks, and lower thighs, rendered in terms of dynamic plastic forms, shows the stimulus of Italian volumetric modeling and, specifically, the values of Venetian tonal modeling. The head, arms, and lower legs are only palely drawn in with wash. The suggestion of "breaks" at the juncture of the arms and the petering out of the modeling at the "edges" of the torso strongly suggest a study of classical sculpture.[23]

Dürer's sculptural conception of the body may also have owed something to the work of Lorenzo di Credi. A drawing also bearing the date 1495, of a recumbent infant Christ (W. 84, Louvre, Paris), shows in its uncharacteristic technique, the influence of the Florentine artist, who was then in Venice, supervising the completion of the Colleoni equestrian monument.[24] A variant of this child appears in the Uffizi sheet of sketches. These drawings served as the basis of the Christ Child in the single surviving painting to offer any reasonable evidence of Dürer's activity as a painter during this first stay in Venice. This is the *Madonna di Bagnacavallo* (A. 16, Mamiano di Traversetolo

6.2. *Diverse Figure Studies*, ca. 1495. Pen and ink drawing, 37 x 25.5 cm. Galleria degli Uffizi, Florence.

[Parma], Fondazione Magnani Rocca), a three-quarter-length Madonna and Child seated in front of a stone archway, so called because of its discovery in the Capuchin monastery of Bagnacavallo, near Bologna. Though the monastery was founded after Dürer's time, the Italian provenance provides circumstantial evidence of the painting's probable manufacture in Italy. In its conception and in details of handling, moreover, the work attests to the artist's close study of the Madonna types and painterly effects of Giovanni Bellini and Cima da Conegliano.[25]

This meager handful of surviving works shows the twenty-four-year-old Dürer experimenting with and responding to various artistic stimuli at hand in Venice, and, in the case of the landscape watercolors and his treatment of the human figure, making significant strides forward. The interests evident in works executed in 1494–95, namely, the direct recording of nature, costume studies, the idealized human body and its movement, and mythological subject matter, were developed further in a number of engraved and woodcut masterpieces of the following years, such as the *Virgin and Child with the Monkey* (B. 42; Figure 3.3), *The Sea Monster* (B. 71), and the *Hercules at the Crossroads* (B. 73). Dürer's incipient interest in human proportions also found particular stimulus through his contact with the Venetian artist Jacopo de' Barbari, who was resident in Nuremberg between 1500 and 1503. Years later, in the introduction to the second volume of his *Four Books on Human Proportion*, Dürer wrote that when he was young and had no acquaintance of such subjects, Jacopo "showed me the figures of a man and a woman, which he had drawn according to a canon of proportions."[26] But as Jacopo would not explain the principles on which they were based, he began to investigate the problem for himself by studying Vitruvius.

The Second Visit to Venice, 1505–7

When Dürer traveled again to Venice in 1505, therefore, he was preceded by an established reputation, based largely upon the series of sophisticated woodcuts and engravings that he had made in the intervening years. His powerful woodcut illustrations of the *Apocalypse* and his meticulously detailed engravings of devotional, mythological, and everyday subjects were already known and being copied by artists south of the Alps at least by 1500.[27]

Dürer's second stay in Venice is also well documented. The principal evidence consists of ten surviving letters, which he wrote during the course of

his stay to his friend in Nuremberg, the patrician Willibald Pirckheimer.[28] These provide vivid insights into Dürer's artistic activities there, his often thorny relations with Venetian painters, and his standing within the city as a visiting foreign artist. The private jokes, the often gossipy and self-deprecatory tone that the artist adopted in addressing his patrician friend, bear fascinating testimony to the nature of this rare friendship, of an intimacy bounded by the dues of social difference, ironically acknowledged. Indeed, the content and tone of the letters is conditioned by Dürer's constant awareness of the social differences between himself and Pirckheimer. Much of the content of the letters concerns Dürer's good-humored efforts to secure luxury and other goods for his wealthy friend. Among the things he was charged to purchase were new editions of Greek works brought out by the Venetian printing presses, jewels, carpets, glassware, crane's feathers, olive wood, paper, even paintings.[29]

In his letters, Dürer tells Pirckheimer how his company is sought by men of good sense and learning, connoisseurs in painting and music, and he expresses the wish that Pirckheimer could share with him such congenial intellectual company.[30] He relates how he was befriended by the elderly Giovanni Bellini, who recommended him before "many gentlemen," visited his workshop, and requested a work by him.[31] Joachim Camerarius in the preface to the Latin edition of Dürer's *Four Books on Human Proportion*, published posthumously between 1532 and 1534, offers a story, based upon a classical topos and therefore probably apocryphal, of how the aging Bellini, admiring Dürer's painting of hair, asked to be shown the brush with which he painted them, only to be shown one of regular thickness. He relates too, how Mantegna, on his deathbed, sent for Dürer upon hearing that he was in Italy, wishing to impart to him some of his knowledge, declaring that had Dürer had access to an Italian training, he would have been unsurpassed in his art.[32] This idea of an unschooled but consummately gifted northerner is later echoed by Vasari.[33]

The impetus to take such an extensive leave of absence would have been commercial and professional. From a letter of January 6, 1506, from Venice, it is clear that Dürer had been given the commission to paint an altarpiece for the German community's church of San Bartolomeo al Rialto only after he had arrived in Venice.[34] On his way south, Dürer had stayed in Augsburg, making contact there with the Fugger banking family, as the three life-size chalk drawings of the Fugger brothers, subsequently owned and recorded by Joachim von Sandrart in 1679, attest.[35] It is possible that the terms for the

altarpiece, his most important Venetian commission, were drawn up then.[36] Plans to rebuild and to redecorate the recently burned-down Fondaco dei Tedeschi, the large building that served as warehouse and living quarters for the German merchants in Venice, might have offered an additional inducement.

Another possible reason for Dürer's journey to Venice was his desire to seek legal redress for the plagiarism of his prints. This tradition begins with Vasari, who states that Dürer took the Bolognese engraver Marcantonio Raimondi before the Venetian Senate and won an injunction forbidding the Italian engraver from copying his monogram (although not the images of his prints).[37] As there are no surviving records of this case and no allusion to it in Dürer's letters, the story may be apocryphal. Yet the principle of protecting the artist's name or mark from copyists (rather than the images themselves), especially as in Dürer's case, when the artist was both maker and publisher of his works, is consistent with the Signoria's policy of granting exclusive privileges to individual entrepreneurs.[38] Certainly, Dürer's strained relations with many local artists emerges in a letter of February 7, 1506, where he expresses his annoyance at the fact that so many Venetians were "copying my works in the churches and wherever they can find them," even while criticizing him for not working in a sufficiently "antique" manner. He was advised not to eat with Venetian artists for fear that they might poison him.[39]

Such animosity seems to have been engendered by Dürer's contravention of the guild regulations governing foreign practitioners. In a letter of April 2, 1506, he tells how he was summoned three times before the magistrates of the painters' guild and fined four florins.[40] His letters reveal that he took at least six paintings with him to Venice and that by February 1506 he had sold all but one.[41] It is likely, too, that he took a great number of his prints with him to sell, as he did on his later trip to the Netherlands. Quite apart from securing the prestigious commission of a large altar panel for an important city landmark, he also painted and sold smaller works, such as portraits, which, he told Pirckheimer, were in great demand.[42] Five surviving painted portraits, dated variously 1505 and 1506, might be considered to have been made during his trip.[43]

The *Feast of the Rose Garlands*

The important commission mentioned above was the so-called *Feast of the Rose Garlands* (A. 93), an altar panel for San Bartolomeo al Rialto, the church

6.3. *Feast of the Rose Garlands*, 1506. Oil on poplar wood, 162 x 1945 cm. Národní Galerie, Prague.

of the German community in Venice (Figure 6.3).[44] It was commissioned by the recently founded German Confraternity of the Rosary and was originally placed in their chapel, to the left of the high altar.[45] Purchased by Emperor Rudolf II in 1606, it was taken over the Alps to Prague, where it was badly damaged during the Thirty Years' War, and survives today much impaired by paint loss and patched up by nineteenth-century restoration. The precise details of the commission are not known. Dürer referred to the commission as "the German picture" and to the patrons always in the plural as "they" or "the Germans." As suggested above, it is possible that the Fugger family, as the leading merchant and banking concern working out of the Fondaco dei Tedeschi, was instrumental in its commission.[46]

As Dürer's shorthand name ("the German picture") for the commission suggests, the altarpiece was intended to express the collective identity of the German community in Venice. It had to serve in the first place as a focus for the joint devotion of the confraternity, but more than this, it was intended

to reflect the political and economic status of the expatriate community as a whole. Dürer responded brilliantly to these demands. He took the idea of the Virgin and Christ Child dispensing rose garlands to the faithful from a woodcut in the printed statutes of the first Confraternity of the Rosary, drawn up by its founder, Jacob Sprenger, of the Dominican Order in Cologne in 1476. Dürer extended this idea to include the figure of St. Dominic, the notional founder of the cult, and angels hovering on clouds over the faithful, also handing out garlands. The gift of the garland symbolized in visual form the workings of the prayer of the Rosary itself, the reciting of which ensured the spiritual communion between the Virgin and the pious believer.

The large congregation has been arranged into secular and spiritual constituencies, placed on either side of the Virgin, and grouped behind the supreme representative of each: the pope and the emperor. Dürer conferred upon the theological and devotional theme an explicitly patriotic and political character by painting the features of the emperor as recognizably those of Emperor Maximilian I. The features of the pope, by contrast, are generic.[47] The decision to include a portrait of Maximilian, at that point still king of the Romans, was a topical one, for his coronation as Holy Roman Emperor was planned to take place later that year in Rome. Venice, together with France and the Papacy itself, opposed Maximilian's election as Holy Roman Emperor. Dürer's inclusion of the two figures therefore might be understood as a symbolic hope for reconciliation and peace between the factions, something much desired by the German merchant community. Despite anti-German feeling within Venice, Maximilian's inclusion appears not to have aroused particular hostility or comment among the Venetian patriciate when the painting was unveiled.[48]

A further, deliberate allusion to national community is the inclusion of a self-portrait in the upper right, with blond hair (rather than the brown hair he displays in other self-portraits), holding an inscription, "Exegit quinque / mestri spatio Albertus / Durer Germanus / MDVI / AD" ("The German, Albrecht Dürer, executed this in the space of five months"), and standing before a distant view of Nuremberg. Placing himself in the company of the German merchants, businessmen, and professionals, whose features he has also accurately portrayed, the artist makes an explicit assertion of German artistic ability and an enduring testimony to Germanic cultural standing.[49] More immediately, it offered a challenge to those Italian painters who had criticized his works. In a letter of September 8, 1506, Dürer proudly exclaims

that he has silenced "those who had said I was good at engraving, but did not know how to paint in colors. Now all say they have never seen finer colors."[50]

Dürer also described the impression the painting made within Venice, telling his friend how the doge Leonardo Loredan and the patriarch of the city Antonio Suriano came to see the painting, and how he was inundated with requests for further works, particularly portraits, turning down by his own estimation some two thousand ducats' worth of work.[51] Contemporaries would have been impressed with the degree of detailed naturalism that distinguishes every part of the work, a striking feature at a time when "advanced" Venetian painting was tending away from descriptive literalism and toward the muffled, atmospheric effects of sfumato. Giovanni Bellini's *San Zaccharia Altarpiece* of 1505, whose lute-playing angel Dürer self-consciously quoted, was the most monumental statement of this tendency to date. As with his inscription, Dürer may have been using style to make explicit the "German" character of the painting. Dürer in fact succeeded in reconciling brilliantly Germanic and Venetian artistic traditions. He adopted the modern Venetian altarpiece convention of a single panel without wings, with a centrally disposed Madonna on a raised throne before a baldachino and a centrally placed music-making angel below. He responded to Bellini's concern with atmospheric color, adopting the Venetian's palette of blue, red, and green, and infusing these hues with a richness, depth, and luminosity of light unprecedented in his own work.[52]

Little of the original brilliance of color is to be seen in the painting's present, much-restored condition. The acuity and psychological depth with which the original figures were drawn, however, is preserved in a series of remarkable preparatory studies. These are made in the *carta azzurra* technique, a Venetian manner of drawing, by which contour, relief, and tonality are realized by lines drawn in gray and white paint upon a blue-toned paper. The colored ground creates a unifying middle tone. Dürer brought this technique to a level of rigor and sophistication not achieved by Venetian draftsmen. To his study for the head of the foreground angel, for example (W. 385, Albertina, Vienna), he brought the methodical precision of the engraver, superimposing upon each other two networks of line, one dark, one white, regularly spaced and radially disposed, along the curved surfaces of his forms (Figure 6.4). As Katherine Crawford Luber has shown, this kind of preparatory drawing, by which he could establish the precise tonality of his subject,

was an innovation in his working practice, one which he continued once back in Nuremberg.[53]

The completion of the altarpiece seems to have signaled the moment for Dürer's return home. In the letter of September 8, 1506, he mentions having completed a further painting, "a *quadro* [he uses the Italian term] the like of which I have never painted before."[54] There are two surviving works to which this might refer. One is the so-called *Madonna of the Siskin* (A. 94, Staatliche Museen, Berlin), which is stylistically very close to the *Feast of the Rose Garlands*. It is perhaps his most overt homage to Giovanni Bellini, in which he has adopted the latter's formula of a three-quarter-length, frontally disposed Madonna and Child, placed close to the picture plane, in a composition divided into dominant fields of evenly toned blue, red, and green.

The other work is the panel of *Christ among the Doctors* (A. 98, Thyssen-Bornemisza Collection, Madrid; Figure 6.5). The story of the twelve-year-old Christ disputing with the elders in the temple, while his parents search for him, a drama Dürer had recently expressed in monumental narrative terms in his woodcut from his *Life of the Virgin* series, has in this instance been startlingly circumscribed within a composition of half-length figures, squeezed into oppressive proximity against a dark background. The elders are arranged around the central figure of Christ, the disposition of their heads, hands, and books creating a series of oblique angles, which press in on him with uncomfortable intimacy. Their glances are either trained intensely upon Christ or dart across the composition—even beyond its limits to engage the

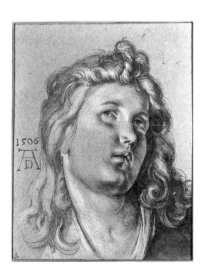

6.4. *Head of an Angel*, 1506. Brush drawing heightened with white on blue paper, 27 x 20.8 cm. Albertina, Vienna.

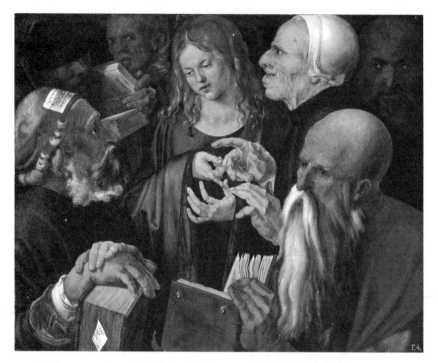

6.5. *Christ among the Doctors*, 1506. Oil on panel, 65 x 80 cm. Museo Thyssen-Bornemisza, Madrid. Photo: Scala / Art Resource, New York.

spectator—caging the youthful Christ within a psychological force field of invisible lines. The facial expressions and gestures are all carefully differentiated to express a range of attitudes and reactions—withered pedantry, discomfiture, hostility—that contrast dramatically with the calm features of the youthful Christ. The knot of disputing hands at the center of the painting powerfully symbolizes the drama. The interest in the physiognomic rendition of character and in the grotesque suggests Dürer's acquaintance with similar experiments by Leonardo da Vinci. The brutal juxtaposition of beauty and ugliness also accords with Leonardo's advice for narrative painting: "you should closely mingle direct opposites, because they offer a great contrast to each other, and the more so the more they are adjacent. Thus, have the ugly next to the beautiful."[55]

The strong Leonardesque overtones are indications that Dürer was addressing specific theoretical issues with which he had become involved during his stay in Venice. The convention of half-length figural compositions had

already been developed by Mantegna and Giovanni Bellini and his circle in works most likely intended for private collectors rather than for purely devotional purposes. Some of these works went beyond their narrative theme to demonstrate aesthetic ideas or to exemplify intellectual propositions. Cima da Conegliano's *Christ Among the Elders* (1513, Muzeum Narodowe, Warsaw), for instance, includes a Christian priest as well as the poets Dante and Virgil among the throng of elders, removing it from the sphere of straightforward biblical narrative and introducing both the broader theological theme of the Old and New Covenants, as well, it has been suggested, as the humanist conception of a concordance between poetry and theology as sources of divine knowledge.[56] Dürer appears to have chosen the theme specifically to engage with both Alberti's and Leonardo's instructions to painters on how to represent a person speaking to a group of listeners. He goes beyond Cima, particularly by means of the central motif of hands, in representing not just Christ's rhetorical exposition, but also the intense back-and-forth of argument.

The work is dated 1506 and inscribed "Opus q[u]inque dierum" (the work of five days). This has almost universally been taken to indicate the time taken to lay in the colors, rather than that taken for the conception and planning of the whole.[57] Nonetheless, the bravado of the inscription, like his equally unusual boast in signing the *Feast of the Rose Garlands* as "the work of five months", suggests that Dürer intended his work to be in some sense a demonstration of dexterity of execution. As Albert Boesten-Stengel has demonstrated, the inscription is a probable allusion to Alberti's "pictor celerrimus," to the idea that speed of execution is an attribute of the master hand.[58] Dürer might have been already acquainted with Alberti's as with Leonardo's ideas, mediated to him through artistic and diplomatic contacts between Milan and Nuremberg. It is also probable that he would have learned of them through the artistic and intellectual circles in Venice, where Leonardo had stayed some years earlier. Though nothing more than this is known of Dürer's patrons, the intellectual basis of the *Christ among the Elders* offers a strong indication of the kinds of aesthetic ideas and pictorial theory he was engaged in during his stay.

Two copies of the painting, one drawn, the other painted, each independently record the inscription (now abraded) to have originally read "F[ecit] Romae" ("Made in Rome"), adding the further probability that Dürer traveled to Rome in the last months of his sojourn.[59] In a letter of September 8, 1506, Dürer expressed the desire to join Maximilian's retinue, on his way

down to Rome, where the emperor expected to be crowned by the pope. Though Maximilian's passage to Rome was blocked by an alliance of the French and the Venetians, Dürer may have made the trip to Rome anyway, in order to try to recoup stock and avoid considerable financial losses, brought about by the death of his agent there.[60]

That he traveled as far as Bologna is known from his last surviving letter to Pirckheimer, of October 13 (?), 1506, in which he says, "I want to ride to Bologna to learn the secrets of the art of perspective, which a man is willing to teach me. I will stay there about eight to ten days and then return to Venice. After that I will come on the next messenger." He followed this with the famous exclamation: "How I shall freeze after this sun! Here I am a gentleman, at home only a parasite."[61] Independent testimony to the visit to Bologna is given by Christoph Scheurl, who was studying there at the time and who recorded how the city's artists prepared a festive welcome for him.[62] The teacher of perspective Dürer sought out is not known. Scipione del Ferro, professor of mathematics at the University of Bologna between 1496 and 1526, has been invoked as a possibility; so has the more famous Luca Pacioli, with whom Leonardo had closely worked, illustrating the former's geometrical treatise, *De divina proportione*. Certain drawings, some with inscriptions in Bolognese dialect, have been used to suggest that what Dürer learned in Bologna had more to do with the elements of geometry and architecture than with perspective.[63]

Dürer in fact returned to Nuremberg in early 1507. This is inferred from an inscription in a copy of an edition of Euclid that he owned: "I bought this book at Venice for one ducat in the year 1507—Albrecht Dürer."[64] The echoes of Leonardo and Alberti in the Thyssen painting, the desire to learn "secrets of perspective," his possible association with mathematicians, his acquisition of a Euclid, and the existence of a number of studies of human proportion are meager but strongly suggestive indications that Dürer used his stay in the Serenissima to pursue theoretical interests. The association in Dürer's mind between the high social status accorded Italian artists ("here I am a gentleman") and the acquisition of theoretical knowledge, implicit in his letter quoted above, also gives a strong suggestion of the intellectual tenor of the artistic circles in which he was moving. This experience strengthened his conviction that artists should no longer grow up "in ignorance, like a wild and unpruned tree," as he was later to characterize the condition of German practitioners, but rather be grounded in theory.[65] Perhaps more than any other, this was to be the most lasting legacy of Dürer's Venetian experience.

The Artist, His Horse, a Print, and Its Audience: Producing and Viewing the Ideal in Dürer's *Knight, Death, and the Devil* (1513)

Pia F. Cuneo

WITHIN THE OEUVRE of Albrecht Dürer, several works stand out as especially evocative. Laden with visual cues that seem redolent with significance, the images appear almost to hail the viewer and to demand attention and interpretation. Many scholars have hearkened to their call. Dürer's *Self-Portrait* of 1500 (A. 66; see Figure 12.3) and his engraving *Melencolia I* of 1514 (B. 74; see Figure 3.1) belong to this category of pictorially enticing images that have provoked widespread critical response; so does the artist's engraving of *Knight, Death, and the Devil* of 1513 (B. 98; Figure 7.1).[1] Like the two former images, *Knight, Death, and the Devil* combines elements that seem eminently understandable yet remain ultimately enigmatic: a man-at-arms rides through a landscape in which nature is as meticulously fashioned as his suit of armor. And yet, despite the plenitude of elements and details that appeal so seductively to all five senses, their meanings and their relationships to one another remain elusive, almost within our grasp and still unattainable. Even the print's putative title, first used in the eighteenth century, is the

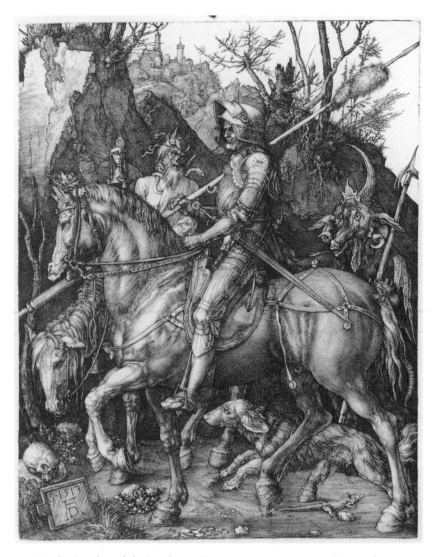

7.1. *Knight, Death, and the Devil*, 1513. Engraving, 24.3 x 18.7 cm. Metropolitan Museum of Art, Harris Brisbane Dick Fund, 1943.

result of an attempted interpretation; Dürer himself referred to the print only as "der Reuter" (the rider), an appellation that may well indicate what Dürer considered the main subject to be (a man on horseback), but that gives no hint of any intentionally conceived meaning beyond that.[2]

Beginning already in the sixteenth century and continuing to the present,

viewers' attempts to explain Dürer's tantalizingly naturalistic engraving have generated a body of literary and art historical discourse significant not only for what it might reveal about the print but also for what it unveils about the nature and function of interpretation.[3] To a significant degree, these interpretations converge around specific and at times opposing issues. For example, scholars argue about whether the print should be interpreted according to its religious or to its socioeconomic context. Under the former, the writings of Erasmus of Rotterdam (1466–1536) are marshaled to indicate that the rider stands for the steadfast Christian, girded by his faith, and thus staunch in the face of death and temptation.[4] Under the latter, the social and economic decline within segments of the German aristocracy is presented as evidence that Dürer's man on horseback is a renegade knight, for whom death and the devil are familiar companions, not sinister forces to be overcome.[5] Some have read the print as allegorical and iconic; Nietzsche, for example, likened it to "the pessimism of the Teutonic races," while the art historian Wilhelm Waetzoldt saw it as a manifestation of the Nordic soul.[6] Others have understood it as historical and narrative; for example, as a portrait of and commentary on Pope Julius II (pontificate 1503–13) or the Dominican monk Savonarola (1452–98).[7] For some scholars, the print reveals Dürer's embrace of Italian models, for others his fidelity to indigenous German traditions. These issues at play in the interpretation of *Knight, Death, and the Devil* are based on assumptions regarding the significance of national identity, the role of historical evidence, and the function of art. Such issues mark the very boundaries of art historical discourse in its theoretical and practical manifestations and thus underscore the art historical significance of the print that so persistently generates them.

This essay does not seek to refute earlier interpretations and does not claim to offer the one, definitive, and correct reading of the engraving. Instead, this essay draws attention to entities in and associated with the print that have previously received insufficient attention: the figure of the horse and the identity of the audience. The first part of my argument makes the case for understanding the horse in *Knight, Death, and the Devil* as the outcome of Dürer's efforts to construct an ideal figure of a horse, and then for recognizing the artist's mobilization of visual comparison in order to highlight that ideal in the engraving. Therefore, I examine Dürer's prior explorations of such an ideal that will come to find ultimate expression in the 1513 engraving; and I engage his notion of comparison as articulated in Dürer's writings on art and as manifest in the print. The second part of my argument consists of

an inquiry regarding the identity of the print's potential audiences. Here I introduce the reception of Dürer's studies and his print in artists' manuals as evidence of the engraving's role in artisanal practice and thus of an important segment of its audience: Dürer's fellow artists and a wider circle of artisans. In addition, I speculate about further reception according to who might have been particularly piqued by the print's visual offerings, especially by its magnificent horse. What this essay adds to literally centuries of discourse that circumscribe *Knight, Death, and the Devil* is: first, an accentuation of the role of the horse as a significant object of artistic theory and practice, and ultimately of commercial marketability; and second, an emphasis on the engraving's audience and reception. Ultimately, I seek to embrace rather than to bridle the print's multivalent potential.

Production: Constructing the Ideal and the Role of Comparison

A number of sources provide evidence—some albeit indirectly—of Dürer's theoretical and practical engagement with the issue of an equine ideal prior to 1513. First are Dürer's own writings, which include mention of studies of equine proportions among the lists of intended projects; and second are other images by Dürer that also seem to function as further formulations of idealized equines. The ideals constructed here seem to have been defined by a combination of proportions, both mathematically based (i.e., abstract and generalized) and empirically observed (i.e., real and individual). Direct evidence of Dürer's theoretical and practical explorations of equine proportions, such as those that exist for his study of human proportions, is no longer extant.[8]

Two manuscripts, both written around 1508 in Dürer's own hand, outline the contents of a book that the artist intended to write and would eventually refer to as "The Apprentices' Fare" (*Ein Speis der Malerknaben*).[9] Both manuscripts include a heading for "measurement of horses / a [system of] measurement of the horse,"[10] clearly revealing that an analysis of equine proportions would be part of Dürer's theoretical explorations. By 1513, however, Dürer still had not managed to write the book and in fact had decided to abandon that project in favor of another: his study of human proportions, which would occupy him for the rest of his life.[11] "The Apprentices' Fare" was never completed. Evidence suggests, nonetheless, that Dürer had found some time to pursue his interest in equine proportions. The Nuremberg humanist

Joachim Camerarius (1500–1574) translated Dürer's first two books on human proportions in 1532 from German into Latin. In Camerarius's introduction, he states that the artist had indeed made studies of horses but that these had been stolen from Dürer.[12] Perhaps the chronological proximity between the creation of *Knight, Death, and the Devil* and Dürer's decision to postpone indefinitely his work on "The Apprentices' Fare" with its section on the proportions of the horse is no coincidence; Dürer may have intended the print as a summation of his ideas and results to date before turning to another subject. The print would have functioned as a visual record for the artist himself in addition to its subsequent functions for a wider audience.

Certain images by Dürer give further evidence of the artist's interest, both practical and theoretical, in the horse. Equines appear in many works by Dürer as incidental characters and narrative necessities; some serve as transport for mounted saints, soldiers, and emperors, while others serve as recreation for riding out and hunting.[13] But some of Dürer's horses themselves attract and arrest the eye. Carefully fashioned, they pose patiently for our inspection, even in the midst of a frenetically forward trot. These are the images in which Dürer sought to understand, replicate, and then to idealize the equine form, as can be seen in *Soldier on Horseback* (W. 176, 1498; see Figure 2.6), *St. Eustace* (B. 57, ca. 1500–1501; see Figure 3.7), *Horse in Profile* (W. 247, drawing, ca.1502, Museum Boijmans Van Beuningen, Rotterdam), *Trotting Stallion* (W. 360–61, two drawings from 1503, Wallraf-Richartz-Museum, Cologne, and Accademia delle belle Arti, Venice), the *Small Horse* (B. 96, engraving, 1505), and the *Large Horse* (B. 97, engraving, 1505).[14] Naturalistic and seemingly individualized details abound in these images, and the proportions of each of these horses are unique in comparison to the others.

Dürer was certainly aware of different types of equines, as the Rotterdam *Horse* and the *Large Horse* belong to the heavier animals used to carry fully armored knights while wearing their own equine armor, a burden that could cumulatively weigh as much as 436 pounds.[15] In comparison to the drawings of other horses mentioned above, with their long backs, slender legs, and expressive heads, the bone structures of the Rotterdam *Horse* and *Large Horse* are more massive; their heads are large, and their legs (particularly the cannon bones) are thick, short, and sturdy. Their relatively short backs also make them better suited to their jobs of carrying heavy loads. A later drawing of 1517 depicts six grooms and their horses from different regions, in which careful attention is paid not only to the varying attire of each of the grooms but also to the disparate size, proportion, and tack of their horses, indicating

that Dürer was sensitive to equine variety.[16] But even so, Dürer seems in the above-mentioned images to be seeking the ideal conformation for each type of horse, akin to his understanding of human beauty as dependent on type and as multifarious.[17] Although certainly based to some extent on close observation of real animals, the horses in the drawings and engravings are not merely life studies; instead, their figures are carefully composed, either highlighted by completely blank backgrounds or embedded in classicizing or religious narratives, thus elevating them beyond the realm of the purely incidental.[18]

Four drawings in particular point directly to the constructed nature of Dürer's horses and to his theoretical quest for the ideal equine form based on mathematical proportion. Around 1505, Dürer sketched three horses, one seen in profile, one from behind, and one from a three-quarter angle.[19] Each of the figures is enclosed by a square grid. Dürer used the grid system as a guide for the placement and proportions of his horses' limbs, torso, neck and head. The grid appears again, albeit faintly and incompletely, on one side of the double drawing done by Dürer as a preparatory study for *Knight, Death, and the Devil*.[20] According to the system worked out by the artist, the horse's entire body is contained within a square made up of sixteen smaller squares. In practice, this means that the rendering of the horse is strictly subject to proportions defined and designated a priori by the geometry of the squares. Rather than fashioning the image of a horse according to individual and accidental details of nature, the artist tempers his vision according to a theoretical framework based on his study of equine proportions and on geometric ratios.[21] The grid used in the preparatory study for Dürer's print allows us to identify the horse therein as the product of the artist's theoretical vision and also to recognize his goal in the print as constructing an equine ideal.

In order that this ideal stands out all the more clearly in the engraving, Dürer provides an entire system of contrasts by which the viewer recognizes over and over again what is ideal by comparison to what is imperfect. However, both the ideal and imperfect contribute in concert with one another to the overall beauty of an image. In his notes made in 1508/09 and in 1512, Dürer writes about the connection between comparative harmony and beauty: "Things that are harmonious, one part to another, are beautiful. . . . One can find great harmony [even] in things that are dissonant" and "The harmony of one thing as compared to another is beautiful. . . . There is also great harmony in dissonance."[22] In these drafts for his manual for painters, Dürer is here trying to get at a workable definition of beauty and to suggest

ways to make a beautiful picture. One of the ways of displaying beauty, according to Dürer, is to juxtapose things, or parts of things, that are harmonious. However, he continues, one can still find harmony (*Vergleichung*)— and thus beauty—even in those things that lack harmony (*ungleich*) and that are therefore dissonant. Taken to their logical consequences, these sentences also mean that if there is beauty to be found in both the harmonious and the dissonant, and if the artist is to make a beautiful work of art, then there is a place and a role for both in the finished product. If the viewer is to recognize what is harmonious and what dissonant and, furthermore, how both contribute to the ultimate beauty of the work, then the viewer must perform the mental activity of comparison and contrast.

Looking at *Knight, Death, and the Devil* in terms of Dürer's aesthetic theory, the print seems to function as an extended exercise in comparison and contrast.[23] Perhaps most noticeable is the contrast between the armored rider's idealized horse and Death's mount. The first is powerfully built, his muscles rippling under the black, glossy coat and enhanced by the high quality of his elaborate and decorated tack. He trots energetically along on carefully shod hooves, his small ears pricked and his focused eyes directed forward, chewing the metal bit like a working horse listening to his rider. By arching his neck, he holds his head erect but surrenders his jaw to the rider's firm hold on the double reins. From what we can see of him, Death's horse is very different. His coat appears to be a light color,[24] and his bridle is primitively made of a piece of rope and a wooden or bone bit. He completely lacks the muscle tone and energy of the other horse. Although both horses are executing the same gait, as a comparison of their hooves reveals, Death's horse shuffles his unshod hooves along, barely lifting them off the ground. He lets his head droop at the end of his scrawny neck, and his large furry ears loll listlessly on either side of his head. He is all but oblivious to his nondemanding rider. Thus practically every component of one horse's rendering is opposite to the other's and surely would have elicited active comparison.

The two riders are also very different. The mounted warrior is armored and armed, taking notice of nothing in particular as he rides along. Death seems to be dressed in a simple white shift, armed only with his hourglass and intent on addressing the armored man. Instead of a helmet, Death's head bears a crown of metal and a wreath of snakes. The mounted warrior can also be contrasted with the devil, particularly in terms of their position and rank within an army. The man-at-arms with his powerful warhorse and full suit

of armor would have belonged to a rank superior to that of the devil who is here represented as a lansquenet, who were frequently recruited as mercenary soldiers from the peasantry and urban laborers and thus constituted the lower social ranks of the army.[25] To underline his subservient position, the lansquenet hails the passing rider with an outstretched claw, palm outward, as is visible in triumphal procession scenes featuring foot soldiers and their commanders.[26] Even the dog and the lizard invite comparison as well as admiration for Dürer's virtuosity. They are placed directly adjacent to one another, following exactly opposite trajectories. One is large and furry and bounds forward with energy; the other is small and scaled and scuttles away in the other direction. Their traditional interpretation as "zealous endeavor" (the dog) and as a creature of darkness (the lizard) can also be thought of as part of their opposition.[27] The landscape itself offers a rich variety of comparison as well: between bright highlights and dark shadows, high mountain and low ravine, limitless nature and walled city.

Knight, Death, and the Devil thus provides a demonstration of Dürer's developing theoretical explorations and his astounding technical facilities, especially their display in the figure of the horse. Indeed, two writers as chronologically, geographically, and methodologically disparate as the Italian artist Giorgio Vasari (1511–74) and the Swiss art historian Heinrich Wölfflin (1864–1945) recognized Dürer's focus on the horse as the engraving's essential component. Vasari asserts that Dürer made the print "to show what he could do" by overcoming such technical difficulties as rendering the sheen of the horse's glossy black coat, a real challenge in the medium of engraving.[28] Wölfflin maintains that for Dürer the most important aspect of the print was the constructed figure of the horse; the other elements of the composition, Death and the devil, were included merely as afterthoughts.[29] Both authors agree that the print's main emphasis was on the figure of the horse and rider and that Dürer was using the print as a showpiece for his talents and knowledge. It is indeed a virtuoso performance, and that performance surely constitutes one of the print's more important functions. In their haste to uncover metaphysical meanings beneath the engraving's seductive surface, art historians tend to take this perhaps simple but nonetheless powerful aspect of the print for granted.

Reception: Artists, Warriors, Patricians

But who attended to Dürer's performance? Whose eyes would have lingered appreciatively over that surface, and whose wallet would have supported the

personal possession of this visual feast? Surprisingly, the question regarding the potential contemporaneous audience of *Knight, Death, and the Devil* is rarely raised in the print's established scholarship. We know that in 1515 the Nuremberg merchant Anton Tucher (1458–1524) bought prints of *Melencolia I* and *St. Jerome in His Study* from Dürer for fifty-four pfennigs a piece (see Figures 3.1 and 3.6).[30] This is a handy bit of evidence, which can help us determine a general price for *Knight, Death, and the Devil*, since the prints purchased by Tucher were approximately the same format and size as the *Knight* and were bought at a time relatively close to this print's date. To put fifty-four pfennigs in perspective, David Landau and Peter Parshall cite workers' average daily wages in sixteenth-century Nuremberg as comparative data. These wages ranged from sixteen to eighteen pfennigs a day for an unskilled laborer to twenty-eight for a skilled laborer.[31] If *Knight, Death, and the Devil* also cost around fifty-four pfennigs it would have represented over three days' wages for an unskilled worker, and almost two days' for a skilled one. Landau and Parshall conclude that prints at that kind of price would have been beyond the reach of the lower echelons of urban and rural labor. In financial terms, then, the audience for *Knight, Death, and the Devil* as actual purchasers would have most likely come from the skilled artisan level up.

Since prints were for the most part made on speculation, not on commission, Dürer, as an astute businessman, must have given his potential audience some careful thought.[32] The artist's engagement of fantasy (in the composite figure of the devil, for example, not unlike the delightfully bizarre creature in his earlier *Sea Monster* engraving), his evocative creation of mood, and his references to general areas of concern (mortality, temptation, warfare) all can be seen as enticements for possible purchasers.

Compositionally, the print's most outstanding feature is quite obviously the figure of the mounted warrior. For whom would such a figure be meaningful? Heinrich Theissing suggests that his juxtaposition with the figure of Death renders the rider in the role of "der Mensch," or humankind in general.[33] This implies that, as such, he is accessible, understandable, and significant to all and that the print would thus find wide and broad appeal. We can be certain, however, of at least one group of sixteenth-century viewers who studied the idealized figure of the horse very carefully: other artists.

The reception of *Knight, Death, and the Devil* in contemporaneous artists' manuals has not been examined by other scholars, yet it provides strong indication that the engraving, or in some cases, the material used for its composition, was understood in the sixteenth century also in terms of its relation particularly to artistic practice. Dürer's horse appears, for example,

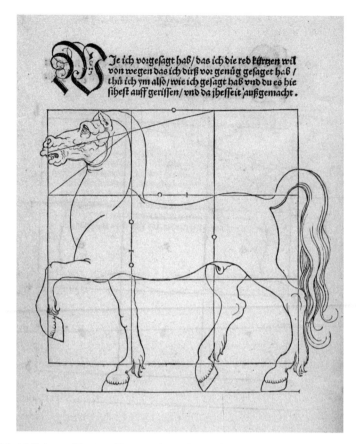

7.2. Sebald Beham, *Trotting Horse with Grid*. Woodcut, 12.6 x 12.6 cm. In Sebald
Beham, *Measurement or Proportions of the Horse* (Nuremberg, 1528), fol. 17v. Herzog
August Bibliothek Wolfenbüttel, Nb 123.

in the book by the Nuremberg artist Sebald Beham (1500–1550) on the mea-
surements and proportions of the horse (Nuremberg, 1528).[34] Camerarius's
hints combined with archival records indicate that it was Beham who was
suspected of plagiarizing Dürer's equine studies.[35] Beham's book contains
text and woodcut illustrations that instruct artists how to render the image
of a horse by inscribing its outlines within a square grid, a strategy obviously
related to Dürer's, although Beham reduces the number of squares from
sixteen to nine. Beham illustrates and demonstrates the construction of three
basic poses. One of these, a horse trotting with its head held high (Figure
7.2), is clearly informed by a combination of Dürer's horse in *Knight, Death,*

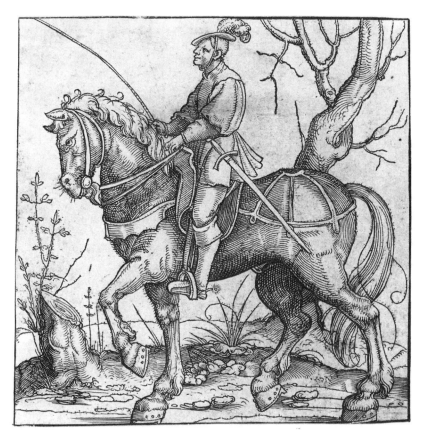

7.3. Erhard Schön, *Die ander Figur.* Woodcut, 11 x 11 cm. In Erhard Schön, *Treatise on Proportion* (Nuremberg, 1538; 1542 edition), fol. 34ii. British Museum, London.

and the Devil (the horse's gait and the length of its back) and the *Small Horse* (the position of the head above the vertical).

Dürer's horseman and his mount also reappear in a second artist's manual, this one written and illustrated by another Nuremberg artist, Schön (ca.1491– 1542). To the 1542 edition of his *Treatise on Proportion*, Schön added six new illustrated pages explaining the construction of equine images.[36] Two of these pages, one schematic and one in full detail, demonstrate how to render a horse and rider. The proportions, gait, and tack of Schön's horse, as well as the pose, proportions, and some accoutrements of the rider on the second page, are all essentially informed by Dürer's horse and rider (Figure 7.3).[37]

Clearly, Dürer was not alone in his interest in constructing an image of

the ideal horse. If Sebald Beham was indeed more than a putative thief, he certainly cared enough about the subject to lift Dürer's studies and publish the material as his own despite warnings from the city council about the dire consequences should he do so. Erhard Schön found it important enough to expand his manual in 1542 in order to include instruction on equine images. A third artist's manual, written by Heinrich Lautensack (1522–68) and published in 1563, also demonstrated how to fashion horses according to mathematical proportions.[38]

Unlike today, the role of the horse in early modern society was fundamental for agriculture, transport, commerce, warfare, recreation, and status.[39] In the same manuscript that contained Dürer's autographic notes regarding "The Apprentices' Fare," an entry written by an unknown hand praises the horse as "the most useful of all animals to man and also the most desired by him for pleasure and for the necessities of work."[40] Roughly a century later, the physician Peter Offenbach makes a sweeping yet succinct statement about the importance of the horse in the introduction to his translation of a book on equine anatomy: "In order to sustain political societies, and in order to preserve and protect the people who make up these societies, you cannot do without the horse."[41]

For related reasons, the artist could also not do without the horse. Many key and oft-repeated visual narratives, in which issues of military power, social prestige, and religious ideology are articulated, feature the horse.[42] Examples of these included: depictions of saints like George, Martin, Eustace, and Paul; equestrian portraits of nobility; and battle scenes. Artists were surely familiar, albeit in varying degrees, with horses, and, as the artists' manuals and the equine iconography pervasive in art production suggest, part of their livelihood depended on their ability to produce images of horses. During his travels in the Netherlands between 1520 and 1521, Dürer made note of particularly fine horses in his diary.[43] It is possible that the artist had a special personal affinity for the animals, since his paternal relatives were horse breeders,[44] but his theoretical engagement with the horse was also surely based on his recognition of the importance of equine imagery for the artistic professions.

Artists like Beham, Schön, and probably also Lautensack, who incorporated Dürer's techniques and insights into their manuals, facilitated the dispersion of Dürer's ideas among a potentially large group of craftsmen. It is more than likely that an artistic audience of Dürer's professional colleagues would have recognized and admired his carefully constructed, harmoniously

proportioned horse and his use of contrast and comparison in the print. Particularly important in the manuals, as evidence of the artisanal reception of Dürer's work, was the unabashedly practical application of ways in which to construct an idealized equine, since the manuals' texts provide procedural direction, not theoretical discussion. Part of Dürer's professional audience would also have included himself, as mentioned above, since the print might have served the artist as his own visual record of what he had learned thus far about equine proportions before he turned his attention to humans.

We should also ask ourselves about other groups of viewers who might have been especially struck by the figure of the horse and rider. Certainly the print would have appealed to men-at-arms, who could have easily identified with the main figure and who would have viewed his situation with sympathy and probably also with familiarity.[45] They would have appreciated Dürer's detailed portrayal of splendid armor, tack, and warhorse. Many of the sixteenth-century hippological tracts on the training of horses justify their publication by emphasizing the usefulness of such training for the warhorse in particular.[46] The way Dürer's horse is ridden in the print—in modern equitation terms, "collected and on the bit"—accords with that training.[47] In addition, the depiction of the devil as a lansquenet might have also greatly appealed to those of superior ranks, some of whom might have resented the inclusion of social inferiors at certain levels within the armies.[48] From their own experiences, and also perhaps prompted by the overall preponderance of military concerns around 1513,[49] men-at-arms might have fashioned their own narrative when viewing the print, using visual cues and props provided for them by the artist. By leaving the references to warfare vague instead of indicating a specific battle or encounter, Dürer allows for a maximum of personal interpretation by such a viewer by providing enough room for the engagement of the viewer's own experiences and fantasies.

Following his 1512 encounter with the Holy Roman Emperor Maximilian I of Habsburg (1459–1519), Dürer embarked on several projects for the emperor that dealt with similar themes (warfare, chivalry) and were most likely targeted at similar audiences.[50] Although these projects were completed after the engraving (if they were even completed at all), we know from Maximilian's notes that they were long in the planning process. These projects included pen-and-ink drawings for Maximilian's *Prayer Book* (1515), designed for the Order of the Knights of St. George, which had been founded in 1464 by Maximilian's father, Emperor Frederick III (1415–93).[51] It is in Dürer's marginalia in the *Prayer Book* that the figure of the man-at-arms and Death

return, although here Death actively pursues the rider with his sickle.[52] Dür-
er's work for Maximilian thus would have brought him into contact with
themes and—more to the point here—audiences that he might have hoped
to reach with his print *Knight, Death, and the Devil.*

Another related group of viewers would have been other court-related
bureaucrats, humanists, and wealthy urban patricians and merchants. Dürer
had contact with such men, not only through his work for Maximilian but
also through his friend, the humanist scholar and patrician Willibald Pirck-
heimer (1470–1530). Theissing has shown that, in Dürer's day, this group of
social elites had also embraced many of the chivalric ideals belonging origi-
nally to the knightly classes since the twelfth century.[53] Many of the hippo-
logical tracts mentioned above were either written by or dedicated to such
men, indicating that they too had a great appreciation for well-bred and well-
trained horses and might thus have derived knowledgeable pleasure from
studying Dürer's horse in the print. Marx Fugger (1529–97), heir to the Fug-
ger fortunes and head of the family firm in Augsburg, was educated as a
humanist and was passionate about horses. He commissioned several hippo-
logical treatises, including a German translation of Federico Grisone's treatise
on riding, and also wrote his own book on horse breeding and training.[54]
Another translation of Grisone was produced by Johann Fayser, a professor
of liberal arts educated at the university of Frankfurt an der Oder, and a
student of Camerarius, who himself translated Xenophon's ancient Greek
treatise on horsemanship.[55] The vital commercial, political, and intellectual
connections of such men were no doubt affected by warfare, so that they
would have shared with the men-at-arms a concern about the fate of Maxi-
milian's armies at the empire's various boundaries. Well educated, cosmopoli-
tan, and intellectually sophisticated, they were also likely to understand the
print beyond its more literal level; they might contemplate and converse over
its spiritual as well as its artistic dimensions, perhaps even discussing its classi-
cal/Italian components, its possible connection with contemporary political
events, and delighting in its satisfying juxtaposition of contrasts and its exqui-
site craftsmanship.

What exactly this print might have meant to its original audiences is still
open to question. That is perhaps what Dürer intended all along. Providing
enough signposts to stimulate contemplation and conversation, but not
enough to foreclose alternative narratives, Dürer has created a veritable play-
ing field for interpretation, not only for his contemporaneous audience but
for those of us in the twenty-first century as well. Like the figures of Death

and the devil who are forced to yield to the inexorable progress of the mounted rider, we too are simultaneously marginalized—relegated, as they are, to the compositional periphery—and centralized—as key witnesses to the forceful presence before our eyes that we may seek but ultimately fail to control.

8

Civic Courtship: Albrecht Dürer, the
Saxon Duke, and the Emperor

Larry Silver

IF WE FOLLOW Martin Warnke and take Italian Renaissance painters, espe-
cially Andrea Mantegna with the Gonzagas at Mantua, as the defining para-
digm of the court artist, the very opposite of the civic guild artist, then the
career of Albrecht Dürer in his native city of Nuremberg (like Van Eyck
before him in Bruges and Rubens after him in Antwerp) fails to conform.[1]
He never had to move to a court, and he worked for several princes, most
notably Frederick the Wise, elector of Saxony (r. 1486–1525), and Maximilian
I, Holy Roman Emperor (r. 1493–1519). The different art that Dürer crafted
for these discerning princes defined not only their own distinctive forms of
court life but also their opposing personal and historical roles.

Frederick the Wise

Frederick (Friedrich), first of the Ernestine line of Saxon dukes, transformed
Wittenberg into a sophisticated court and home to a newly founded univer-
sity.[2] He promoted humanist learning and religion. A deeply devout man,
who journeyed to the Holy Land in 1493, Frederick enriched the Wittenberg
castle church with thousands of saintly relics and a sumptuous array of art,

8.1. *Portrait of Frederick the Wise*, ca. 1496. Tempera on canvas, 76 x 57 cm. Staatliche Museen, Gemäldegalerie, Berlin. Photo: Bildarchiv Preussischer Kulturbesitz / Art Resource, New York.

much of which was created by Lucas Cranach the Elder (1472–1553), his official court artist after 1505.[3] While visiting Nuremberg in April 1496, the elector first met Dürer, who had only recently returned from Italy.[4] Frederick, the first notable German prince to recognize the young Nuremberger's talents, commissioned a half-length portrait (A. 19; Figure 8.1). Painted in tempera on canvas, likely to facilitate its portability, its design recalls Dürer's 1493 *Self-Portrait* (A. 10, Louvre, Paris). This half-length presentation anticipates (in reverse) the 1497 portrait of the artist's father (National Gallery, London) and his 1498 *Self-Portrait* (A. 49, Prado, Madrid) in having a strong pyramidal structure built on the visible arms and hands upon a foreground

8.2. *Hercules Killing the Stymphalian Birds*, 1500. Tempera on canvas, 87 x 110 cm. Germanisches Nationalmuseum, Nuremberg.

ledge, with the right shoulder thrust forward to present the head at three-quarters, here against a monochrome background on which the volumetric figure casts a shadow. Such portrait compositions derive from Netherlandish fifteenth-century models, including works by Jan van Eyck and Hans Memling in Bruges, but the formula was also adopted by Italians through their merchant communities in the Low Countries, so that the same formula reappears in Leonardo da Vinci's renowned *Mona Lisa* (ca. 1503–6; Louvre, Paris). The canvas support also is not unusual in itself, though it is rare for portraits and was usually a cheaper substitute for oils on panel, almost a separate medium, hence not likely to be the basis for the high payment to the artist.[5]

Perhaps on the same occasion, Frederick ordered the *Mary Altarpiece* (A. 20–38v), divided today between Dresden (Staatliche Kunstsammlungen) and Munich (Alte Pinakothek), and the wings depicting the popular plague saints Anthony and Sebastian for the so-called *Dresden Triptych* (A. 39–40).

Hercules Killing the Stymphalian Birds (A. 67; Figure 8.2), Dürer's only known mythological painting, may have adorned Frederick's Wittenberg cas-

tle.[6] Based upon a 1507 description of this residence by Andreas Meinhard, scholars surmise that this picture was one of four Hercules scenes once hanging in the *aestuarium*, or heated living rooms.[7] Drawn from the Labors of Hercules, this good-versus-evil subject forms a time-honored analogue for the restoration of order over chaos, an apt theme for a prince.[8] Perhaps this cycle was partially inspired by Dürer's *Hercules at the Crossroads* (B. 73), created in about 1498.[9] This engraving illustrates the demigod's allegorical choice between virtue and vice. Hercules' moral dilemma and his ultimate virtuosity offer a symbolic model for the wise prince.

In 1504 Dürer painted the *Adoration of the Magi* (A. 82) for the elector. This securely documented commission reveals the artist's keen awareness of Italian pictorial conventions, such as perspective and complex architecture, and his own taste for the natural world. Details like the stag beetle and iris in the foreground or the fortified hillside in the right distance, which is reminiscent of the landscapes of his *View of Arco* watercolor (W. 94, figure 6.1) or *St. Eustace* engraving (see Figure 3.7), attest to his delight in vivid verisimilitude.[10] Frederick owned elaborate silver gilt covered cups of the sorts held by the two standing magi. During their respective trips to Jerusalem and Venice, patron and painter saw turbans and other Ottoman attire, costumes deemed fitting for the magi's servants.[11]

The success of the *Adoration of the Magi*, which embodies a rich mix of contemporary artistic styles, prompted Frederick to order two more large paintings: the *Ober St. Veit Altarpiece* (Dom- und Diözesanmuseum, Vienna) and the *Martyrdom of the Ten Thousand Christians* (A. 105, Kunsthistorisches Museum, Vienna). Dürer prepared elaborate drawings (W. 319–23) for the former; however, because of his return to Venice in 1505, he delegated its execution and completion in 1508 to Hans Schäufelein, the Nördlingen artist working in Nuremberg during these years.[12] Frederick's coat of arms appears on both exterior wings. Perhaps Dürer's busy career and, less certainly, his wish to live in Nuremberg prompted the elector to hire Cranach as his official court painter in 1505. Upon returning from Italy in 1507, Dürer began work on the unusual subject of the *Martyrdom of the Ten Thousand Christians*, which was completed in early 1508 for the relic chamber in the Wittenberg castle church.[13] The artist's woodcut (B. 117, ca. 1496) recounting the grisly deaths of ancient Roman soldiers martyred for their conversion to Christianity appealed to Frederick, who owned two whole bones and twenty-three particles of these saints, and inspired his commission. In the center, Dürer portrayed himself standing by the recently deceased poet Conrad Celtis, who

may have first introduced the artist to Frederick, their mutual patron. The small pennant is inscribed 1508 and *Albertus Dürer alemanus* (the "German"). The painting testifies to the artist's association with the Saxon court.

Here, too, the renewed but now negative presence of Turkish costume gives a geographical marking to the locality of this scene in the Levant, which strongly suggests the contemporary conflicts between the Ottoman Turks and Christian Europe, especially with the replacement of the standing Roman emperor of the woodcut with a mounted, turbaned sultan. Here martyrdom is even further associated with Christ's own crucifixion. Compared to the woodcut, the painting presents a new emphasis on crosses, two of them already bearing victims in the left corner, as a third on the ground below is prepared for a standing figure—crowned with thorns. More than just an "imitation of Christ," as Erwin Panofsky characterizes it, this painting now uses the distant legend of saintly martyrs in order to present the current religious strife with Islam as if it were an all-out conflict of good versus evil, stirring a call for crusade for Frederick the Wise, former pilgrim to the Holy Land.

Emperor Maximilian I

Crusades, in fact, were the perennial battle cry of Emperor Maximilian, who was officially crowned as the leader of Christendom in Trent in that same year, 1508. To commemorate his new role and to reinforce his role as the commander of Christian crusade forces, Maximilian then issued a pair of woodcuts, by Hans Burgkmair of Augsburg, which featured an armored equestrian portrait of the new emperor under a Roman triumphal arch, complemented by a second woodcut of one of his patron saints, the embodiment of crusader valor, St. George.[14] As if in a changing of the guard of courtly patronage for Dürer, Maximilian soon came to supplant Frederick the Wise, who would also become Maximilian's chief political rival and nemesis, even seeking to succeed him as emperor after the emperor's death in 1519.[15] The commissions by these two princes to the same artist were complementary: while Frederick chiefly requested large-scale paintings with religious themes, Maximilian chiefly sponsored woodcut ensembles with political messages. Both men used art to reinforce their own personal aspirations. Frederick stressed his piety and Maximilian commemorated his political accomplishments and princely virtues.[16] Dürer never visited either prince's court. Rather

his initial encounters with both men occurred during their visits to Nurem-
berg. He met Maximilian during the emperor's last stay visit in Nuremberg
in February 1512. His final contact with Maximilian is recorded on June 28,
1518, at the Diet of Augsburg, when Dürer sketched the emperor's portrait.
This drawing provided the model for a series of portraits, both painted and
printed, which appeared only posthumously in the following year.[17] Most of
Maximilian's commissions were for woodcuts, which suited Dürer since tasks
such as the cutting of the blocks and printing could be delegated to workshop
assistants. He had tired of making costly and time-consuming paintings like
the 1509 *Heller Altarpiece* (A. 107V–115K).

This shift of Dürer's priorities and working method coincided perfectly
with the demands imposed by Maximilian. The emperor strictly microma-
naged and repeatedly reviewed vast projects that were coordinated by court-
iers and local humanists, notably in Augsburg and Nuremberg.[18] Inevitably
such work involved intensive collaboration, which permitted Dürer the prin-
cipal roles of making designs and supervising his own workshop productions.
Initially many of Maximilian's projects were created in Augsburg, a city with
special imperial ties and with a roster of talented artists, including notably
Hans Burgkmair.[19] Thus his projects involving Dürer started more slowly
and initially focused on more private interests, such as the collaboration be-
tween the artist and his humanist friend, Willibald Pirckheimer, on an illus-
trated manuscript, a Latin translation of Horapollo's *Hieroglyphs*, which the
two men presented to the emperor in 1514. A smaller, incomplete project for
a fencing manual with Pirckheimer's text and Dürer's drawn illustrations
survives (Österreichische Nationalbibliothek, Vienna); this might well have
been part of the emperor's ambitions to compile manuals on various forms
of princely activities, especially martial arts and hunting.[20]

The main Maximilian project for which Dürer accepted responsibility is
the *Arch of Honor* (Figure 8.3), usually known as the *Triumphal Arch*.[21] Com-
prising nearly two hundred woodcuts assembled into a composite image,
measuring almost three meters square, this *Arch* surely remains one of the
largest printed images. Scholars have wrestled with attributions to its parts;
most follow Joseph Meder and Campbell Dodgson in seeing considerable
workshop design of the parts, which are largely attributed to the mysterious
Hans Springinklee as well as the better documented Wolf Traut.[22]

The design for the *Arch* stemmed directly from the emperor. Indeed for
the related but uncompleted project of the *Triumphal Procession*, we can fol-
low dictations of the entire program from Maximilian to his private secretary,

8.3. *Arch of Honor (Triumphal Arch of Emperor Maximilian I)*, dated 1515, finished ca. 1518. Woodcut, 341 x 294.1 cm.

Marx Treitzsaurwein, as early as 1512 (with first verbal sketches appearing already around 1507).[23] Ultimately, the *Triumphal Procession* as well as the *Arch of Honor* were being produced simultaneously, the former in Augsburg (but with a substantial Dürer workshop contribution; see below) and the *Arch* by Dürer and his collaborators in Nuremberg and Regensburg, where Albrecht Altdorfer assisted. The supervisor of both projects, which Maximilian sometimes conflates under the name "Triumphwagen," was Johannes Stabius (1462–1522), trained as a mathematician but active as the emperor's court historian, working in particular on Habsburg genealogy.[24] A prelimi-

nary, possibly full-sized design for the *Arch* was drafted by Maximilian's court artist, Jörg Kölderer, and dispatched to Nuremberg. At the lower right of the completed *Arch* three coats of arms stand in order of descending size: Stabius, Kölderer, and only in the last—and least—position, Dürer himself.[25] Both the figural blocks and the elaborate calligraphic program text of Stabius (based on letters designed by the local calligrapher, Johann Neudörfer) were cut by the Nuremberg block carver Hieronymus Andreae, who received his own honorarium from the emperor in 1515.

The *Arch* presents a summa of the claims and accomplishments of Maximilian I, starting from a central image of the parents and the descendants of the emperor as well as a genealogical tree. Stabius's program divides the portions of the imaginary commemoration into three openings: Gate of Honor (family and genealogy plus territorial claims), Gate of Praise (previous Roman and Holy Roman Emperors), and Gate of Nobility (royal and princely relatives by birth or marriage). Each of the side portals is adorned with the major events of Maximilian's reign, both battles and dynastic marriage alliances. Altdorfer's flanking columns articulate the emperor's personal skills, interests, and princely pastimes. Amid all of these distinct programmatic portions, classical ornament (Victories, cupids, sirens, and harpies, interpreted allegorically by Stabius in the program) and heraldry of rank (including crowns) and princely orders (especially the Order of the Golden Fleece) adorn the *Arch*. Based on Dürer's earlier hieroglyphic investigations, a rebus-like "mystical tabernacle" in praise of Maximilian surmounts the structure.

Obviously Dürer took responsibility for the overall presentation of the ensemble as well as its ornamental details. We see his personal emendations to the model of what he received from Kölderer on behalf of the emperor in sketchy ink drawings of the griffon with flint and steel as well as the winged Victory with crown above the main doorway (W. 674 and 675, both in the British Museum, London).[26] These surviving contributions reinforce the connoisseurs' judgment that Dürer produced the decorations of the principal gate, marked by this same Victory, as well as the flanking columns. In some cases of symmetrical ornamental groupings, Dürer seems to have generated the model, presumably on the block prior to cutting, for the right side of the *Arch*, to be replicated in reverse on the left by his workshop assistant. The inner and outer columns with saintly ancestors and griffins on top are also ascribed to Dürer, along with a small number of historical scenes: the Burgundian Betrothal, the Spanish Betrothal, the Meeting of Maximilian with Henry VIII, and the Vienna Congress with Hungarian Betrothal. Clearly

Dürer took particular care with those scenes commemorating the emperor's dynastic marriage arrangements, which (more than his battles, often unsuccessful, inconclusive, or eventually reversed) secured Habsburg hegemony over the largest empire in Europe, inherited by his grandson and heir, Charles V.[27] Dürer also took charge of commemorating these most important events within the carts of the *Triumphal Procession*, but he delegated the execution of those carts to his workshop, presumably to Hans Springinklee.

In 1517 Stabius sent a proof impression from Nuremberg to the emperor, which elicited an angry letter in reply from Cologne: "The trial proof of the *Arch of Honor*, which we have now seen, is not according to our instructions and does not correspond to the model in your hands. We do not like it and are displeased. We ask you to suspend further work on it and to prepare yourself for a journey to meet us. You will bring along the original design of the *Arch of Honor* which was given to you. We will then show you where it is lacking and how we wish it to be corrected."[28] Thus there were two control designs for the *Arch* held by Stabius and Maximilian, whose style of careful editorial scrutiny and final approval is clear from this exchange. The completed ensemble bears the date 1515, but it is clear from the correspondence that revisions were still being made on its content up to 1518. In striking contrast to the *Triumphal Procession*, which remains a mere fragment of its own planned two-hundred-woodcut frieze, this imposing composite *Arch* wound up being one of the few Maximilian woodcut projects to be completed in his lifetime.[29]

In an undated letter, usually dated to 1515, Dürer wrote to Christoph Kress (1484–1535), the junior burgomaster of the Nuremberg city council, complaining that he had worked for Maximilian for three years until then without pay (hardly unusual for creditors of the perennially impecunious emperor). In response, Maximilian first exempted Dürer from his own tax debt (1512) but later directed the Nuremberg city council to pay the artist from its own revenues for the emperor (1515), on account of his "art, skill, and understanding": "because the same Dürer, as we have often been informed, is renowned above other masters in the art of painting, we are moved to favor him with special patronage and therefore earnestly desire you, for the sake of our honor, to free the said Dürer from all common civic imposts . . . in view of our patronage and his famous art, from which he should properly benefit among you. It is fitting that you should do this for our pleasure and the increase of the said art among you."[30] The resulting pension still was paid only sporadically, and its renewal after Maximilian's death in early 1519 surely

formed a strong motivation for Dürer's trip to the Netherlands to petition Margaret of Austria for a continuation of that grant (see the essay by Dagmar Eichberger).[31] This regular annuity forms a different kind of patronage from the individual works commissioned by Frederick the Wise. It amounts to something closer to a pension in the modern sense of the word, or a professional's retainer fee, however irregular in the actual payment.

Dürer had numerous other assignments for Maximilian that never achieved completion. He made drawing designs (ca. 1513/14) for full-scale bronze figures of the ancestors of the emperor for the planned tomb of Maximilian, of which only one, Albrecht, count of Habsburg, survives in extant drawings (W. 676–77); however, presumed lost drawings for figures of both King Arthur (!) and Theoderic the Ostrogoth were provided for the foundry of Peter Vischer in Nuremberg, and another (lost) design for the important figure of Charlemagne was never cast.[32]

Another unexecuted illustration cycle commissioned from Dürer by Emperor Maximilian survives in a suite of five woodcuts, circa 1512–16, four of varied forms of knightly combat and a fifth of festive dancing after a tournament; these works serve as a kind of sampler for the never-completed publication of the text of *Freydal*. Related to Maximilian's *Teuerdank* romance, *Freydal* was a fictionalized "prequel," emphasizing tournaments and jousts (and their concluding masquerades) instead of hunts and adventures.[33] The emperor originally dictated the text to Treitzsaurwein, his secretary, in 1512. A preserved codex (Sammlung für Plastik und Kunstgewerbe, Vienna) shows fully 255 illuminated miniatures, which would have served as the model book for the planned illustrations of the uncompleted text. By the time Dürer received the designs in 1516, he was immersed in other projects for Maximilian.

Connected to the emperor's keen interest in tournaments and festive armor, Dürer also performed some of the more traditional—and, to modern eyes, more mundane—activities associated with a court artist in making numerous designs for armor decorations (W. 678–84, ca. 1517).[34] As the Morgan Library drawing of a saddle design (W. 680; Figure 8.4) clearly shows, both hieroglyphic and classical motifs highlight these complex ornamental schemes, including such figures as the crane of vigilance dominating over the harpies of temptation, just as in the ornament scheme on the *Arch*. In addition, more vernacular figures of vain pleasure, such as a peasant bagpiper and a naked woman with a mirror, are paired with a mighty, monstrous unicorn, traditional emblem of strength.

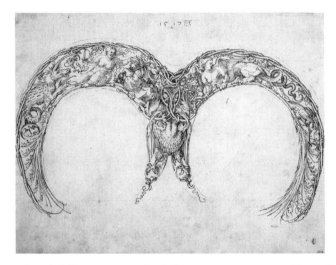

8.4. *Design for a Saddle*, 1517. Pen and ink drawing, 22.1 x 28.3 cm. Photo: Pierpont Morgan Library / Art Resource, New York.

Such a mixture also informs the marginal drawings in Maximilian's own *Prayer Book*.[35] The elaborate text was printed in new *Fraktur* orthography (based in this case on calligraphic models of Gothic script by Leonhard Wagner of Augsburg) in both red and black inks by Hans Schönsperger in 1513. The book was probably originally conceived as a common prayer book for the chivalric Order of St. George, after its 1469 foundation by Maximilian's father, Emperor Frederick III.[36] At least ten printed parchment texts rather than paper versions were produced of the *Prayer Book*, presumably for a more elite gift list. Conrad Peutinger, the regular project supervisor for Maximilian, intervened to circulate the emperor's own exemplar of this text for further decorative marginal designs among a constellation of current artistic "stars" of contemporary German artists, beginning with Dürer, who was surely first and who took the lion's share of fifty pages, but also including Cranach, Altdorfer, Burgkmair, Hans Baldung Grien, and Jörg Breu the Elder of Augsburg. Given the intricacy of the drawings by these various artists, modern scholars have debated but generally supported the likelihood that these sketches were intended from the start for woodcut illustrations rather than as unique ornament for the emperor's private delectation.[37]

For these 1515 ornamental decorations, all drawn in colored inks, Dürer again amalgamated a diverse roster of hieroglyphic, classical, and vernacular subjects for his decorations. Interpretations of these motifs have varied over

the years, although in many cases, they seem to have been prompted by imagery in the prayer texts, which include psalms, hymns, and prayers to particular saints, including George and other martial protectors, as well as the emperor's titular saint, Bishop Maximilian. Of course, a number of expressly Christian images correspond closely to the particular prayers on the page, as well as frequent images of death and warriors, ranging from knights to infantrymen (*Landsknechte*), as befits a military order—even a miniature version of Dürer's recent *Knight, Death, and the Devil* (see Figure 7.1). What one also notices among the varied figures and motifs of the marginal decorations are the artist's modification of the manuscript tradition of marginalia from the realm of the transgressive, carnivalesque, and parodic, as well as the monstrous and demonic.[38] Despite individual instances and complex particulars, the overall message seems clear: the valiant knights of Christ in the Order of St. George can and should use their spiritual fortitude to conquer evil and temptation, who appear in the form of harpies, sirens, and monstrous females. As if to exemplify wildness as the antipode to chivalry, Dürer even includes an Amerindian among his decorative figures.[39]

Of all the commitments by Dürer and his workshop to Maximilian, the largest was the complement to the *Arch of Honor*, the unfinished woodcut frieze *Triumphal Procession*.[40] This complex ensemble was based like the *Arch* on current knowledge of ancient Roman precedents that celebrated renowned military victories; however, the *Procession* adds numerous extra components to celebrate the family, territories, courtly entourage, and manifold princely interests (hunts, jousts, music).[41] Again, Stabius supervised the project completion from a Nuremberg base, following presumed lost Kölderer models, but more like the *Prayer Book* project drawings, a much more diverse roster of designing artists, divided between Nuremberg and Augsburg, took part: Burgkmair (who produced 67 extant woodcuts), Schäufelein, Leonhard Beck, plus Altdorfer (38 woodcuts), besides Dürer and his workshop protégé Hans Springinklee. Some 200 woodcuts were planned (estimated in part from the dictated program, in part from the executed miniatures and their pair of surviving copies in Vienna and Madrid), out of which a total of 138 woodcuts were executed, but most of them were only printed posthumously in 1526, at the request of Ferdinand, Maximilian's grandson and successor as ruler of Austria.

Dürer's involvement with the *Procession* only developed after his designs for armor and the basic completion of the *Arch of Honor* after 1517. His own personal woodcut contributions were few in number but major in significance. As in the *Arch* Dürer assumed responsibility for the key dynastic event

of succession in Maximilian's career, a float depicting the *Small Burgundian Marriage* (Figure 8.5; also known as the *Small Triumphal Car*).[42] Composed of two sheets, the figure group on its cart is drawn by a team of four horses, driven by Victory. Maximilian, in his archducal hat, and his first wife (1477), Mary of Burgundy (d. 1482), stand under a wedding canopy held up by a quartet of cupids. In front of the couple stands a vase of pomegranates, the personal emblem of Maximilian.[43] The couple is accompanied by the ladies and courtiers of their wedding-party retinues. This scene follows a suite of equestrian woodcuts by Altdorfer depicting riders, holding Austrian and Burgundian heraldic banners, and musicians.[44] Dürer's workshop, presumably Springinklee, also produced a companion scene illustrating the marriage of Philip the Fair, Maximilian and Mary's son, to Juana, heiress of the Kingdom of Spain.

This central role of Dürer in the core *Procession* images for Maximilian in these latter years of his reign focused especially on the emperor's succession and his heirs. As a result, the key drawing image of the *Procession* designs was an ink and watercolor sheet of an even more extended chariot (*The Large Triumphal Carriage*) on four sheets, dated 1518 (W. 685, Albertina, Vienna). This more definitive image was, in turn, based upon an earlier Dürer design (W. 671, ca. 1512, Albertina, Vienna), probably his first for the emperor, as well as an intervening illumination of almost identical content (presumably based upon a common Kölderer prototype from the court) by Altdorfer's workshop.[45] In the original drawing Maximilian is flanked at the back of the chariot (already shown under a canopy) by Mary of Burgundy, and just in front of them sits Philip the Fair and his wife, Juana of Castile, as well as his sister Margaret of Austria, regent of the Netherlands. The six grandchildren, led by Charles and Ferdinand, sit up front. By the time that the *Arch* was nearing completion—and in the wake of his complex and shifting researches into genealogy—Maximilian increasingly turned toward Pirckheimer to produce a more learned and timeless allegory of the imperial office rather than a specific outline of family succession, since Philip had died in the meantime and the actual succession remained unsettled. Indeed, Pirckheimer's 1518 letter from to Maximilian describes this triumph as "not an ordinary triumph, but one of philosophy and morality."[46] He notes that the elaborate construction of allegorical virtues pertains "not only to this present perishable life but also well and truly to adorn such a man after his mortal departure, being lasting and permanent." In the later Vienna drawing the imperial family is still present and in the same order, with the portrait of Maximilian updated

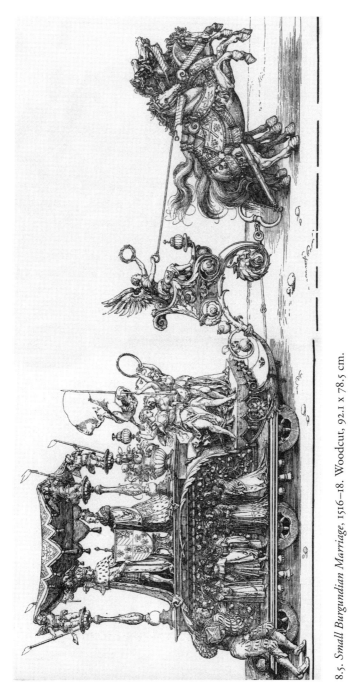

8.5. *Small Burgundian Marriage*, 1516–18. Woodcut, 92.1 x 78.5 cm.

on the basis of Dürer's careful charcoal and chalk drawing (W. 567; see Figure
8.7) taken on June 28, 1518, in Augsburg. Dürer and Pirckheimer heightened
the symbolic content by adding a bevy of female personifications of virtues,
wheels inscribed with princely traits, and a lion and an eagle, kings of beasts.
That Dürer and Pirckheimer planned for an even more elaborate expansion
of the *Procession* at this crucial point of the *Large Triumphal Chariot* can be
seen from the numerous additional drawings of courtiers and heralds (W.
686–700) conceived in 1518 as supplements to the chariot itself.[47]

Eventually, Dürer did issue the *Large Triumphal Chariot* as a completed
allegory, complete with Pirckheimer program, in an eight-block woodcut (B.
139, 1522; Figure 8.6) as a posthumous tribute to Maximilian, hence depicting
the emperor alone without his heirs. In part, the artist might have published
this work to recoup his considerable investment of time and trouble, like the
three years' effort (*mit* and *fleiss,* i.e., income and effort) he referred to in his
letter of complaint for nonpayment in 1515 to Christoph Kress about imperial
commissions. This remuneration would have been especially significant in
light of his continuing insecurities about the always uncertain pension prom-
ised to him by the emperor from Nuremberg imperial taxes. Eventually Dür-
er's *Large Chariot,* seen as a separate element, was eliminated from the 1526
publication of the *Procession* by Emperor Ferdinand. A workshop painted
copy of the entire *Large Chariot* reappears as part of the elaborate painted
decorations of the interior of Nuremberg's City Hall, in this case testimony
to the city's allegiance as an independent imperial city to her sovereign, espe-
cially her late (rather than current and living) emperor.[48]

The remaining images of his two great princely patrons consisted of por-
traits. As noted, Dürer's 1518 chalk portrait drawing of Maximilian (W. 567;
Figure 8.7) served him on several occasions: first for the profile of the emperor
in the *Large Triumphal Chariot,* in both the 1518 multisheet Vienna drawing
and the eventual woodcut publication of 1522. It also functioned as the traced
source of one woodcut portrait and two painted portraits, one on canvas (A.
145, Germanisches Nationalmuseum, Nuremberg), the other on panel (A.
146, Kunsthistorisches Museum, Vienna).[49] For the painted portraits a second
chalk drawing of hands holding a pomegranate (W. 635, Albertina, Vienna)
served to augment the bust study of the head in the production of a true
half-length.[50] The two portraits differ further in their orthography, which is
tied to the decorum of the language used for panegyric: for its Latin *laudatio*
(*potentissimus, maximus, et invictissimus*) the Vienna panel offers dazzling
Roman block letters in gold, whereas the Nuremberg canvas instead extols
the emperor in German (*Allergrosmechtigist, unuberwind-lichist*) by means of

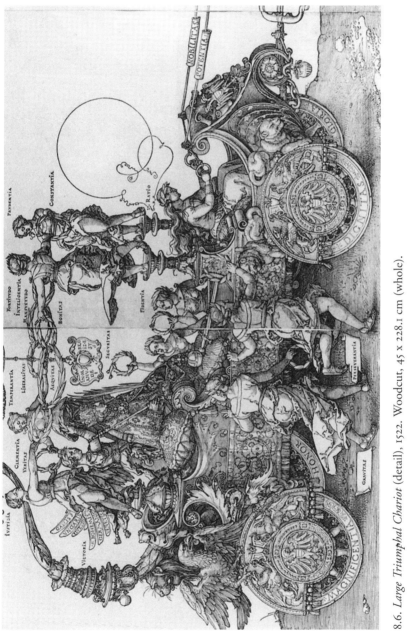

8.6. *Large Triumphal Chariot* (detail), 1522. Woodcut, 45 x 228.1 cm (whole).

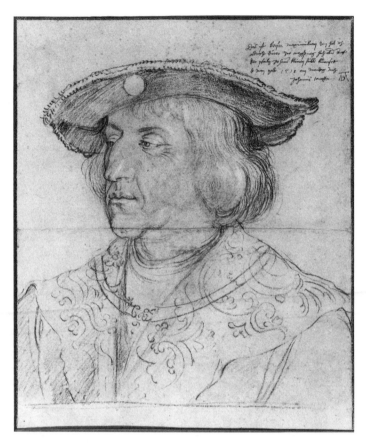

8.7. *Portrait of Maximilian I*, 1518. Charcoal drawing with red and yellow chalk, 38.1 x 31.9 cm. Albertina, Vienna.

his beloved *Fraktur* Gothic script, employed for his printed projects. The emperor's imperial double eagle appears in both paintings, framed as heraldic arms within the princely Order of the Golden Fleece and capped by the "bicuspid" imperial crown, often worn by Maximilian for official portraits, usually by Bernhard Strigel of Memmingen, during his lifetime.[51]

The woodcut *Portrait of Maximilian I* (B. 154; Figure 8.8) also includes a brief Latin inscription, modeled upon the precedents of ancient Roman coins, which features the term *divus*, usually applied only posthumously for deceased Roman emperors, in tribute to their deification after death. In at least one surviving instance (now in the Staatsbibliothek, Bamberg), this woodcut was enhanced by gold printing from a second block for the hat medallion, chain, and brocade.[52]

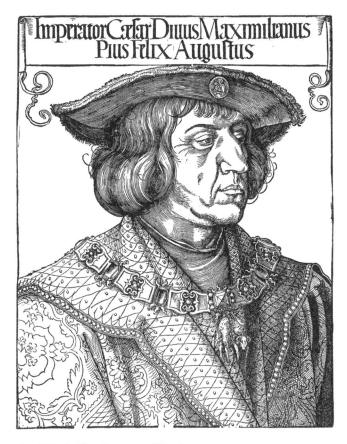

Imperator Cæsar Diuus Maximilianus
Pius Felix Augustus

8.8. *Portrait of Maximilian I*, ca. 1519. Woodcut, 41.1 x 32 cm.

In similar fashion, Dürer crafted a final memorial in print to his older
patron, Frederick the Wise, an engraving dated 1524 (B. 104; Figure 8.9), his
first work for the Saxon duke since painting the *Martyrdom of the Ten Thou-
sand* in 1508. Here, too, a preliminary drawing (W. 897, École des Beaux-Arts,
Paris), carefully delineated from life in silverpoint over charcoal, prepared the
print.[53] The inscription is revealing, clearly coming after Dürer's celebrated
conversion to Luther's Reformation and declaring the duke to be "Dedicated
to Christ. He loved the word of God with great piety, worthy to be revered
by posterity." The framed stone tablet for the inscription before the sitter
derives from Roman grave monuments and includes the initials B.M.F.V.V.
(*Bene Merenti Fecit Vivus Vivo*, or "For the man of great merit, made as a
living man for a living man"). Since the artist also produced another, similar
engraving of Pirckheimer (B. 106) in this same year, as well as a comparable

stone tablet in 1526 for his portrait engraving of the arch-Reformer Philipp
Melanchthon (B. 105), we can surmise that this image of Frederick the Wise
was at least as much elective tribute by the artist to an admired patron and
protector of Luther as it was a final commission from the prince.

Thus did Dürer come full circle as an artist for court patrons. He pro-
duced a portrait late in life for the same Frederick, for whom he had begun
his work with a youthful portrait. Now, however, at his own discretion he
portrayed his patron instead through the medium of engraving, for wider
distribution as well as a personal tribute, just as he had recently been commis-
sioned to celebrate the deeds and fame of Maximilian through prints, albeit
woodcuts for even larger editions.

Unlike many court artists, including Cranach and other German masters,
Dürer never relocated to the palace. Instead he produced his portraits and
other works in a city environment, on commission, expecting (though finding
some real disappointment from Maximilian) to be paid in the same fashion as
from non-noble patrons. He did consort with the loftiest lords of his era
and lived to hear his work praised by them. In 1515 Maximilian informed the
Nuremberg council, "We declare to all that we have regarded and considered
the art, skill, and understanding for which Albrecht Dürer, a dear and loyal
subject of ourself and the Empire is renowned." Nevertheless, Dürer always
remained an artist for hire, as well as a free citizen of his native Nuremberg.

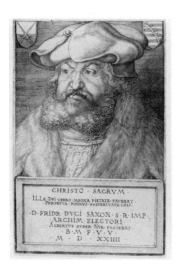

8.9. *Portrait of Frederick the Wise*, 1524.
Engraving, 18.1 x 12.8 cm.

Dürer and the Netherlands: Patterns of Exchange and Mutual Admiration

Dagmar Eichberger

WHEN ALBRECHT DÜRER decided to travel to the Habsburg Netherlands in the autumn of 1520, the painter-engraver from Nuremberg was no longer a young man seeking further training or visual inspiration. By then he had almost reached the age of fifty and was a mature artist of international standing. He had so far preferred to look to Italy for theoretical guidance and artistic inspiration. In the course of his artistic career, he had developed a personal style, had refined his method of painting, and was working toward a written theory of art.

The main aim of this trip was to secure his claims to an annual pension, which had been granted to him by Emperor Maximilian I in 1515 and which had come under threat by the premature death of his patron. Already in November 1520, Dürer's intensive lobbying and networking paid off, and he was given confirmation of his privileges by the new emperor Charles V.[1] As it turned out, he did not immediately leave the Netherlands, but decided to stay on for another eight months. Dürer's detailed notebook of his trip to the Netherlands and the body of work he produced during this period of his life provide us with some fascinating insights into what should turn out to be his closest encounter with Netherlandish art and culture.[2]

Like Martin Schongauer (ca. 1450–91) and Hans Pleydenwurff (d. 1472),

Dürer had long been aware of the artistic and technical achievements of painters like Jan van Eyck (ca. 1390–1441), Rogier van der Weyden (ca. 1399–1464), and Hugo van der Goes (ca. 1440–82). His father, Albrecht Dürer the Elder (1427–1502), had traveled to the Netherlands in the 1450s and had established close ties with fellow goldsmiths in the prosperous cities of the north. In his youth, Albrecht Dürer the Younger would have come across imported works of art by Netherlandish painters, sculptors, illuminators, or tapestry makers. In Germany, many churches housed both carved and painted altarpieces from the Netherlands. A few choice pieces had been brought to Germany by wealthy merchants and by leading patrons of art, such as the Tucher family and Cardinal Albrecht of Brandenburg. Occasionally, there were opportunities for artists to make contact with Netherlandish artists within Germany.[3] Jan van Scorel (1495–1562), for instance, came to Nuremberg in 1519 to visit Dürer, the older and more established artist. However, since Dürer had not traveled to the Netherlands before, it is not surprising that his last international trip turned out to be such an intense and rewarding experience for him.

Dürer chose Antwerp, the queen of all trading cities, as his permanent base, from which he undertook a number of side trips. In this town, he could meet people from all walks of life: contemporary artists, leading humanists, cosmopolitan diplomats, and representatives of the international trading companies and banking houses.[4] By 1520, Antwerp had become the commercial center of Europe and also a leading center for luxury items, such as art, precious objects, and exotica from the New World. Reading Dürer's diary suggests that all of these components appealed to him and swayed him to stay on for an extended period.

Cultural Tourism

Dürer's frequent comments on art and architecture are more than a dispassionate listing of places that the artist had visited or objects he had seen. Between the lines, one can observe indications of art criticism, a development signaling the increasing significance of aesthetic criteria in the evaluation of art. Dürer compared paintings or architectural monuments with familiar objects. He commented on positive or negative aspects of a specific work of art.[5] This phenomenon is paralleled by the differentiated evaluation of sixteenth-

century artists and art objects at the nearby Mechelen court of Margaret of Austria.[6]

Dürer paid his respect to the more traditional artistic centers of Brussels, Ghent, and Bruges by visiting each place for a few days at a time. This gave him the opportunity to study the masterpieces of Netherlandish art, housed in the main churches, private houses, and noble residences of these cities. In Bruges, for instance, he was taken for an extended cultural tour of the city by the goldsmith Mark de Glassere (fl. 1516–36) and others. As highlights of this tour, Dürer took notice of panel paintings by Rogier van der Weyden, Jan van Eyck, and Hugo van der Goes without describing the individual works in more detail.[7] Being fond of Italian art, he explicitly mentions Michelangelo's Bruges marble statue of the *Madonna and Child*.

In Ghent, Dürer was particularly impressed by the famous *Ghent Altarpiece* by Jan and Hubert van Eyck, which he describes as "an exquisite, highly knowledgeable painting." He refers to it as Jan's panel and makes no mention to the illustrious brother named Hubert van Eyck (d. 1426). In Brussels, Dürer visited the town hall, which housed Rogier van der Weyden's famous Justice panels.[8] He also went to the townhouse of Count Henry III of Nassau, where he looked at a painting by Hugo van der Goes and two rooms filled with precious objects and curiosities.[9]

On June 6 and 7, 1521, Dürer visited the court of Archduchess Margaret of Austria in Mechelen.[10] On the second day of his stay, he was given a personal tour of the residence by the regent herself, who took pride in showing him her outstanding collection of works of art and curiosities. From the details Dürer provides we can conclude that he was not just taken to Margaret's well-furnished library, but also that he was given access to her stately bedroom and her richly endowed study. These were the two rooms in which she kept her most valuable works of art. Dürer comments on art by Jacopo de' Barbari (1460/70–1516), Juan de Flandes (ca. 1465–1519), and Jan van Eyck. All paintings by Jan van Eyck, namely the *Arnolfini Double Portrait,* the *Madonna by the Fountain*, and the *Beautiful Portuguese Woman*, were kept in Margaret's private bedchamber.[11] In his detailed account of this visit, Dürer is particularly enthusiastic about Juan de Flandes's series of small panel paintings, which Margaret had acquired from the estate of Isabella of Spain.[12] There were few opportunities for Dürer to study the work of this fine Flemish artist outside the court of the regent, as Juan de Flandes permanently lived and worked in Spain.

Dürer's interests were by no means restricted to paintings. He was equally

interested in contemporary Flemish architecture, modern garden structures, exotic animals, and all things foreign or mysterious. The longest discourse to be found in his entire notebook comments on the skillfully crafted objects of gold, silver, and feathers from the new Americas. These artifacts seem to have amazed him more than anything else he saw on this trip. Dürer's unusually dramatic reaction can partly be explained by the novelty of the sights.

Honor and Glory

Wherever Albrecht Dürer went on his grand tour of the Netherlands, he was greeted with utmost respect and honor by the professional associations as well as by individual painters and goldsmiths. One day after his arrival in Antwerp he was officially welcomed with a banquet by the painters' guild and greeted by a delegation of the city. He writes, "they invited me to their guild hall with my wife and the maid, and had set the table with silver plate and other exquisite tableware and delicious food. . . . And when I was taken to the table, the people stood on both sides, as if they would guide a noble lord. Among them were several important men with a good reputation who humbly bowed down to show me their respect."[13] In Ghent, Dürer was greeted by the principal of the painters' guild, who was accompanied by the leading artists of the town. To Dürer's delight, his hosts paid for all his expenses and gave him a personal tour of the city. In Bruges, Dürer was officially welcomed by two representatives of the town council. The well-known painter Jan Provoost (ca. 1465–1529) even invited Dürer to stay in his house. On his last day the painters of Bruges proudly showed him to their guild chapel and organized a banquet for more than sixty people. On his second trip to Mechelen in June 1521, the association of painters and sculptors invited him to a meal in the inn where he stayed for the night.

On each of these occasions, Dürer reports that the artists did him great honor. He must have felt very contented indeed to be treated with such kindness and to receive such universal recognition in a foreign country. Four years after his return to Germany, Dürer proudly informed the Nuremberg city council that while in Antwerp its government had offered him an attractive position as city painter with an annual salary of three hundred guldens, rent-free housing, and a tax-free status should he shift his workshop to the commercial capital of the Netherlands.[14]

Encounters with Netherlandish Artists

Apart from studying outstanding pieces of art from the fifteenth century, Dürer also came in touch with contemporary art and with some of the leading Netherlandish artists of his time.[15] He mixed with painters, sculptors, and goldsmiths alike and personally met the following artists: Joachim Patinir (ca. 1480–1524), Jan Provoost, Bernard van Orley (ca. 1488–1541), Lucas van Leyden (1494–1533), Dirk Vellert (ca. 1480–1547), Conrat Meit (active 1506–1550/1), Jean Mone (ca. 1485/90–1549/50), Mark de Glassere, and Jan of Brussels. While Dürer reports a visit to the house of Quinten Metsys (1466–1530), he does not mention a personal meeting with Antwerp's most famous painter. There are only few significant artists whom he does not mention at all, such as Joos van Cleve (d. 1540/41), another successful painter from the city of Antwerp.

Good relations with fellow artists were cultivated systematically by giving works of art as a sign of mutual respect, by producing a portrait drawing of a certain individual, or by inviting one another out for dinner. In most cases, these donations, however, were nothing else but payments in kind, in order to return a favor or to acquire artwork by a colleague. The following examples may illustrate how these interactions worked.

In Antwerp, Albrecht Dürer was regularly in touch with "the good landscape painter" Joachim Patinir, a well-established artist of about his age. Dürer borrowed Patinir's assistant and pigments and gave him prints to the value of one gulden in return. Later on, Dürer produced a silverpoint drawing of Patinir for his own record. He presented his fellow artist with another of his own silverpoint drawings and with graphic works by his German colleague Hans Baldung Grien (1484/5–1545). He also drew a St. Christopher for Patinir.[16] Toward the end of his stay, Patinir invited Dürer to be his guest of honor at his wedding.

Dürer's relations with the goldsmith Jan of Brussels seem to have been more businesslike. Dürer first produced two charcoal portrait drawings of Jan and his wife and a working drawing for a seal, for which he received three guldens. Then he traded one of his oil paintings, a *Holy Face*, and a panel by another artist for two rings with precious stones. His desire for more jewelry, this time a ring with six precious stones, cost him a whole set of prints.[17]

There is no doubt that Dürer employed his favors strategically. He systematically nurtured contacts with those artists and art administrators who worked for the court of Margaret of Austria, the aunt of Emperor Charles V.

He interacted with her German court sculptor, Conrat Meit, her Flemish goldsmith, Mark de Glassere, and her court painter, Bernard van Orley. For the sake of good relations, he also made contact with Etienne Lullier, the assistant keeper of Margaret of Austria's collection, with Jan de Marnix, her treasurer, with Johannes Bonisius, her court physician, and with Florent Nepotis, her organist.[18] Initially, Dürer had required Margaret's support for presenting his case to the new emperor. Later on, he probably hoped for patronage by the art-loving archduchess. This may explain why he expressed such dissatisfaction about his contacts with Margaret of Austria. According to Dürer, she disliked his portrait of Maximilian I, then she withheld remuneration for his generous gift of prints and two drawings, which he had produced in response to her request.[19] His contacts with Margaret of Austria seem to have been the opposite of what Dürer experienced in the various townships.

Albrecht Dürer was flattered by the great respect he was paid by the Netherlandish towns and artists. He equally enjoyed looking at art by famous fifteenth-century artists from the southern Netherlands. But did he benefit artistically from his stay in the Netherlands? Those who have studied his painted work in more detail usually state with surprise that there are comparably few direct references to Netherlandish art, both before and after his trip. While Dürer purchased several pieces of Italian art on this extended journey, he hardly spent any money on Netherlandish art at all. The only exception is the work by one of the first documented women artists from the Netherlands, Susanna Horenbout (fl. 1520–50). Dürer was so impressed by the talent of the daughter of Gerard Horenbout (ca. 1465–1541) that he decided to buy her *Salvator Mundi* on parchment. In the course of his stay in Antwerp Dürer swapped prints with Lucas van Leyden, whose art appealed to him.[20] Adrian Herbouts, the official secretary and orator of the city of Antwerp, presented him with a small panel painting by Joachim Patinir of *Lot and His Daughters*.[21] It can be assumed that Dürer considered him to be a good artist and enjoyed his paintings.

Art Produced by Dürer during His Trip

The extensive body of silverpoint drawings that Dürer produced during his trip to the Netherlands is an additional indicator of what he himself wanted as a record. It seems as if he hardly ever sketched the composition or the

9.1. *Lazarus Ravensburger and the Tower of the House of Mayor Arnold van Liere*, 1520. Silverpoint drawing, 12.2 x 16 cm. Copyright © Kupferstichkabinett. Staatliche Museen zu Berlin, KdZ 35 recto.

outline of a work of art.[22] He mostly drew life around him, specifically portraits of people and their dress (see Figure 2.12), interesting architectural monuments, or exotic animals.[23]

A large proportion of his drawings depict sites he visited, such as the abbey of St. Michael in Antwerp (W. 769), the skyline of Bergen-op-Zoom (W. 768), the imperial residence and gardens in Brussels (W. 822). He was particularly impressed by Netherlandish towers with their onion-shaped roofs. These were characteristic of Netherlandish secular architecture from the early sixteenth century. Immediately after his arrival in Antwerp he was taken to the Prinsenstraat to look at the new house of Mayor Arnold van Liere (W. 774; Figure 9.1). In his notebook he praises the exquisitely decorated tower as well as the beautiful garden, and he comments he has never seen anything similar in the German-speaking countries.[24]

Another important body of work deals with Netherlandish dress and appearances. There are numerous half-length or shoulder-length portraits of anonymous female sitters of different ages wearing the distinctive Netherlandish hood or a local overcoat with tilted-up peak (W. 745–76, 770–71,

773, 775).[25] A full-length study of a young woman in Netherlandish dress equally reflects Dürer's intense interest in local dress (Figure 9.2). These drawings recall his habit of sketching married and unmarried women in his hometown of Nuremberg. Dress had always been important to Dürer both as an expression of local identity and as a symbol of status and personal pride. It seems as if his wife Agnes adjusted to their new environment by wearing a low-cut, fur-lined dress and the white hood of Netherlandish women. The explanatory text on a large metalpoint drawing of Agnes Dürer describes her explicitly as being dressed in the Netherlandish fashion (W. 814).[26]

Why then did Dürer not respond more enthusiastically to contemporary Netherlandish art in 1520/21?[27] In his formative years, Albrecht Dürer had been influenced first by early Renaissance art from the Veneto region and later on also by High Renaissance art. When he finally visited the cultural centers of the North, his ideas on color and composition were firmly fixed. Dürer critically applied his own set of aesthetic values to the art of contemporary Netherlandish artists. Recent research on the first decades of the sixteenth century has argued that Netherlandish artists did not immediately embrace the Italian manner wholeheartedly, but instead developed a highly ornate system of ornamentation, a local variation of the Gothic style that was employed profusely on public buildings and stately monuments.[28] During this period the artistic landscape of the Netherlands was characterized by an attitude that can best be described as stylistic pluralism. Objects in the early

9.2. *Woman in Netherlandish Dress*, 1521. Brush drawing, 28.3 x 19.5 cm. National Gallery of Art, Widener Collection, Washington, D.C.

Netherlandish and the Renaissance-Gothic manner existed side by side with objects in the newly imported Italian style.[29]

While this curious mélange may not have appealed to Dürer to the same degree as contemporary Italian art, he was impressed by the earlier generations of Netherlandish artists, especially Jan van Eyck, Rogier van der Weyden, and Hugo van der Goes. There is no doubt that Albrecht Dürer knew about early Netherlandish art well before he went on his trip north. One of Dürer's most famous prints, the *St. Jerome in His Study* (see Figure 3.6), is a reaction to the achievements of the so-called *ars nova* and can perhaps be called his most Netherlandish print. The mastery with which he renders objects from everyday life and depicts light and space in a most naturalistic fashion can be seen as an ambitious response to the art of these early masters. Dürer is not content with slavishly copying in oil the homely interiors of a Rogier van der Weyden or a Petrus Christus. He applies their innovations to a new theme, St. Jerome in his study, and translates their achievements into the technique of printmaking. In this print, Dürer achieves a similar effect yet with fewer means. Does Dürer challenge the supremacy of painting by taking the print to unknown limits? Are we looking at yet another example of the ongoing *paragone* between competing media?[30]

Up to 1520, Dürer did not have the opportunity to visit the Netherlands and to experience Netherlandish culture at first hand. Earlier in his career, he had been introduced to this popular painting style either through imported works of art or, even more important, through the interpretation of German artists, such as Michael Wolgemut (1434/7–1519) and Hans Pleydenwurff, both active in Nuremberg. Martin Schongauer and the Housebook Master (active 1470–1500), two important fifteenth-century painter-engravers, played an even more crucial role in introducing early Netherlandish painting to southern Germany and the Middle Rhine area.[31] These two artists had a strong formative influence on the talented young apprentice from Nuremberg before he began to explore Italian art. While there is no evidence that Dürer met either of these individuals in person, his early prints reveal that he had learned much from a close study of their work.

At the time of Dürer a substantial number of northern printmakers worked in or else traveled through Germany. Erhard Reuwich (ca. 1455–90) from Utrecht (sometimes identified with the Housebook Master) settled in Mainz, while Israhel van Meckenem (ca. 1445–1503) from Bocholt traveled through Germany and visited Franconia in 1470. Van Meckenem was familiar

with and frequently copied the artistic output of Martin Schongauer, the Housebook Master, Hans Holbein the Elder (ca. 1460/65–1534), and young Dürer.

Dürer's Influence on the Netherlands

Long before Dürer traveled north, his prints were transported along the international trading routes and reached the cultural and commercial centers of Europe. Israhel van Meckenem is one of the first northern artists to copy Dürer's fine prints systematically for commercial purposes. He transferred the designs to the plate without reversing them and thereby produced mirror images of Dürer's original prints. Completely unaware of modern concerns of creative ownership, Van Meckenem deleted Dürer's monogram and added his own name or initials to the bottom of the page, thus pretending to be the inventor of the image.[32] The success of this strategy can be seen in Carel van Mander's *Schilder-Boeck* (1604), where he incorrectly claims that Dürer's engraving of the *Three Witches* (1497, B. 75) is a copy after Van Meckenem.

Van Meckenem produced at least three reproductive prints, all of which are modeled closely after original engravings by Dürer: the *Madonna with the Dragonfly* (ca. 1495, B. 44), the *Three Witches*, and *The Promenade* (ca. 1498, B. 94).[33] The two engravings called *The Promenade* show a young stylish couple enjoying the rituals of courtship and love (Figures 9.3 and 9.4). While

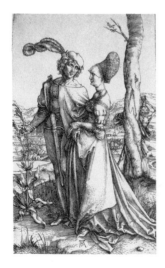

9.3. *The Promenade*, ca. 1498. Engraving, 19.5 x 12.1 cm.

Dürer had given meaning to his depiction of a pleasant outdoor scene by adding a macabre representation of death with the symbolic hourglass, Van Meckenem considered this message to be too subtle, so he added the moralizing text in order to accentuate Dürer's memento mori message: "Ten is niet al tzijt vastauent. Der doet kompt en brengt den Aeuent/ Israhel.V.M" (It is not always Shrove Tuesday, Death comes and brings the evening).

Van Meckenem was the first northern printmaker who copied Dürer's work with the intention of duplicating his designs as literally as possible. In the sixteenth century, a small number of Netherlandish artists were also involved in reproductive printmaking: Jan van Rillaer (ca. 1496–1568), Pieter Maes (ca. 1560–after 1591), and the brothers Jan (1549–ca. 1618), Hieronymus (1553–1619), and Anton II Wierix (ca. 1555/59–1604).[34]

The number of Netherlandish artists who were familiar with Dürer's prints and admired his skills as a designer and engraver was, however, much larger. Many artists took advantage of his designs in a much more general sense and used his woodcuts and copper engravings as a source of inspiration. Up to the late fifteenth century, individual artists and workshops had cautiously guarded their set of workshop patterns by keeping a close eye on their drawings and model books. By the sixteenth century, prints increasingly replaced model books and were used widely by painters, glass designers, and sculptors alike. Prints were thus treated as stock images, which provided general guidance for the execution of individual figures, specific parts of the human body, or for architectural settings. In 1931, Julius Held published a

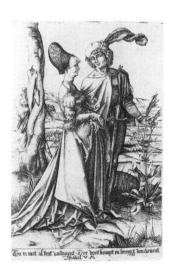

9.4. Israhel van Meckenem, *The Promenade*, after 1498. Engraving, 18.2 x 11.7 cm.

meticulous study on the ways in which artists from the northern and the southern Netherlands used Dürer's prints for improving their own designs.[35] This chapter does not aim at providing a similarly comprehensive overview, but will look at only two differing examples: Jan Gossaert (1478–1532) and Lucas van Leyden.

Jan Gossaert probably never met Albrecht Dürer in person. A closer look at Gossaert's body of paintings and drawings, however, leaves no doubt that the artist from Maubeuge studied Dürer's prints and used them for his own ends. Shortly after Gossaert first registered as a free master in the painters' guild of Antwerp in 1503, he was appointed court artist to Philip of Burgundy, regent of Guelders and Zutphen and later bishop of Utrecht. Gossaert accompanied his humanist patron to Rome in 1508, and he was one of the first Netherlandish artists to experience the power of High Renaissance art and to utilize classical models for working in the Italian mode.[36] After his return to the Netherlands Gossaert began to paint pictures with classical subject matter, which allowed him to experiment with modern renditions of the nude. In order to meet this challenge, Gossaert sought inspiration in classical models, either by studying the Roman originals or else via the prints of his contemporary, Albrecht Dürer.[37]

In about 1513, Gossaert painted a small Marian altarpiece in the late Gothic style, the so-called *Malvagna Triptych*.[38] The luxuriously painted architectural baldachins that frame the Virgin Mary and the two female saints on the opened triptych are not repeated on the outer wings of the closed altarpiece. There a depiction of Adam and Eve in the garden of Paradise extends uninterruptedly across both panels. The unusual posture of Adam and Eve is clearly derived from Dürer's woodcut, the *Fall of Man* in the *Small Woodcut Passion* (B. 17). In both cases, Adam and Eve are depicted in a most naturalistic fashion as an amorous young couple. The two lovers are depicted at the very moment when they give in to the temptation of the serpent. In Dürer's print Eve takes the apple from the mouth of the snake; in Gossaert's painting it is Adam who reaches out for the forbidden fruit. This is not the only deviation from the print by Gossaert. He presents the couple in reverse, places them on the left half of the picture plane, and models their naked bodies more distinctly with light and shade.[39] While Dürer sets his scene in a dark and mysterious forest surrounded by wild beasts, Gossaert places the couple in a much wider and deeper landscape, which opens up to a light sky. In the background on the far left, one can see an archangel chasing Adam

and Eve out of the Garden of Eden. The gate of Paradise is depicted as a monumental Renaissance structure with classical loggias and arcades.

While Gossaert was clearly inspired by the relaxed pose of Dürer's Adam and Eve, he did not copy the image literally. Instead in this case he used Dürer's motive as the starting point for his own version of the same subject. The same can be said for his response to other prints by the German. A close look at Gossaert's oeuvre shows that he was also familiar with Dürer's 1504 engraving of *Adam and Eve*, which presents the first human couple in a classical contrapposto pose (see Figure 5.8).[40] This engraving left its mark on generations of artists, including Jan Gossaert and the Master of Mansi Magdalene, a painter active in Antwerp between 1510 and 1530.[41] Gossaert's small panel painting of *Adam and Eve* is the artist's most obvious reference to Dürer's illustrated canon of human proportions.[42] Also his monumental picture of *Neptune and Amphitrite* (1516) reflects his familiarity with this print and presents another differentiated response to Dürer's image of Adam and Eve.[43]

It seems as if Gossaert was particularly attracted to Dürer's interpretations of the naked human body, as his images often combined anatomical study with a distinctly psychological element. The *Seated Christ as Man of Sorrows* on the title page of Dürer's *Small Passion* series (1511, B. 16) twice inspired Gossaert. His etching of the *Mocking of Christ* plays with Dürer's composition and also gives expression to strong human feelings, including sorrow, grief, and humiliation.[44] Gossaert's fascination with this subject also led to his painted version of the *Seated Christ as Man of Sorrows*.[45]

In his notable investigation of the varying Netherlandish responses to the art of Albrecht Dürer, Julius Held focused strongly on the cultural differences between the northern and the southern Netherlands and put forward the idea that printmaking played a much more prominent role in the Dutch provinces than in the south.[46] Given the political situation in the first half of the sixteenth century, the artistic split between the various parts of the Burgundian-Habsburg empire is perhaps less pronounced than he suggested.[47] Nevertheless, Dürer's models also left their mark on artists from the northern provinces, such as Lucas van Leyden, Jacob Cornelisz van Oostsanen (ca. 1470–1533), Cornelis Anthonisz (ca. 1499–1553), and others.[48]

The artistic relationship between Albrecht Dürer and Lucas van Leyden developed along quite different lines from the previously described links between Dürer and Gossaert. When the young printmaker traveled from the Dutch city of Leiden to Antwerp to meet his famous Nuremberg colleague in

June 1521, Lucas was already well established as the most gifted Netherlandish engraver. Comments in Dürer's notebook and his portrait drawing of Lucas van Leyden (W. 816) testify to the artists' mutual respect.[49] Nothing points in any way any competition in their relationship, as ascribed by later writers, especially Giorgio Vasari (1550 and 1568), Domenicus Lampsonius (1572), and Carel van Mander (1604).[50] In 1521, Van Leyden produced a series of twelve engravings, which clearly reflect his familiarity with Dürer's *Small Passion* (1509–10, B. 16–52) and *Engraved Passion* (1507–12, B. 3–19) series.[51] Compositional and narrative correspondences are noticeable in the *Lamentation*, the *Entombment*, and *Christ in Limbo*; however, Van Leyden never quotes Dürer directly. In this regard, his approach is far more eclectic than Gossaert's. In his printed oeuvre, Van Leyden and Dürer covered similar themes including New Testament scenes and parables, genre scenes, peasant life, saints, and mythological figures, as well as portraits, such as the likeness of Emperor Maximilian I. Even when Van Leyden was directly inspired by a work by Dürer, he never compromised his distinctly personal style and own thematic interpretation of the same subject.

Paintings on Wood or Canvas

Up to 1521, very little was known about Dürer's paintings in the regions north of Frankfurt. During his time in Antwerp and Brussels, Dürer produced about twenty, mostly small-scale pictures on canvas or panel.[52] The most influential of these was his famous painting of St. Jerome (Figure 9.5). This picture, which was completed by March 1521, was planned with much care ("mit fleiß gemahlt") as can be seen from Dürer's detailed preparatory drawings and compositional studies (W. 788–92). Dürer made such a special effort since he intended to give this panel to his close friend Rui (Rodrigo) Fernandez de Almada, the factor of the king of Portugal in Antwerp. While early writers like Friedrich Winkler and Max J. Friedländer argued that Dürer based his panel on a painting by Quinten Metsys, this position has been abandoned in more recent commentaries.[53] It is indeed remarkable how many Netherlandish artists used Dürer's painting as a starting point for their own interpretation of the popular saint. The painting remained in Antwerp until 1548.[54] Lucas van Leyden, Joos van Cleve, and Marinus van Reymerswaele (ca. 1490–1567) all prepared drawings or paintings of the erudite saint brooding in his study after Dürer's version of the same subject.

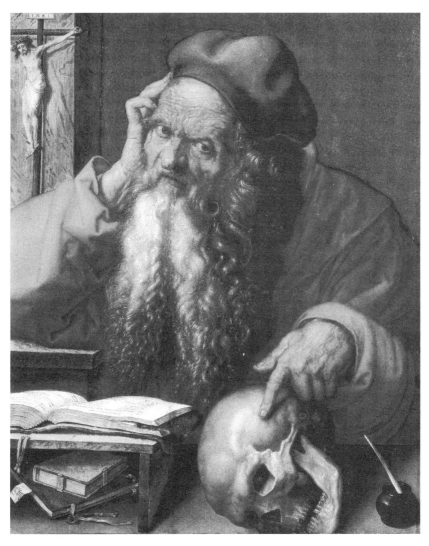

9.5. *St. Jerome*, 1521. Oil on panel, 59.5 x 48.5 cm. Museu Nacional de Arte Antiga, Lisbon.

The discussion of Dürer's diary and the inquiry into his impact on Netherlandish art has shown that the painter-engraver from Nuremberg was indeed a celebrated artist in the cultural centers of the North. However, it was his extended visit to the city of Antwerp that gave his reputation a final boost and turned him from a famous artist into an eminent celebrity. These events,

combined with the rising cult of artistic genius, helped to secure his fame for generations to come.

This helps to explain why Juan Luis Vives, the noted Spanish humanist working in the Netherlands, constructed a fictional conversation in which Dürer and two learned men discuss the qualities of portrait paintings. In this dialogue, published in Vives's *Exercitatio linguae latinae* (The Hague, 1538), Dürer's remarks wittily reveal the other men's ignorance about art.[55] Other even more tangible examples of Dürer's popularity in the Netherlands abound. In 1549 the St. Luke guild of Antwerp honored Dürer by commissioning a silver chalice with his portrait next to those of Raphael (1483–1520), Apelles (fl. late fourth to early third century B.C.E.), and Zeuxis (fl. late fifth to early fourth century B.C.E.).[56] In 1563 the Antwerp painter-entrepreneur Cornelis van Dalem (ca. 1530–73/6), a member of the Guild of St. Luke, redecorated the façade of his house in the Lange Nieuwestraat, which he had recently bought from his teacher Jan Adriaensz, with a sculptural program in a more modern style.[57] On the first level of a multistoried, classical structure, Mercury and Minerva, allegories of commerce and the arts, appeared in spandrels on either side of the entrance gate. On the next level up, a personification of PICTURA was framed by the shoulder-length portrait busts of two outstanding northern artists, Jan van Eyck on the left and Albrecht Dürer on the right. On the basis of their awkward position within the façade and the inscriptions on the back and front of these two sculptures Matthias Mende recently argued that the busts were initially conceived as independent sculptures-in-the-round and were made to fit the new façade as an afterthought.[58] This latter state is documented in a print by Jan Theodor Linnig dating from 1849. The Latin inscription *BELGARUM SPLENDOR* on the first portrait bust is complemented by an inscription in Gothic script which identifies the artist as "joannes eyck"; the inscription on the second bust *GERMANORUM DECUS* corresponds to a similar inscription which reads "albrecht durer." The Latin terms which were written in capital letters can be understood as a programmatic comment on the state of the arts in the middle of the sixteenth century. In 1563 Van Dalem publicly celebrated Jan van Eyck and Albrecht Dürer as two equally famous artists, who in his view represented the pinnacle of the artistic heritage in the countries north of the Alps.[59]

By the time that Carel van Mander drafted the artists' biographies for his *Schilder-Boeck* (1604), Dürer's role within the history of northern European art was beyond reproach. As Peter Strieder has shown in his analysis of the relevant passages, van Mander not only used secondary sources, such as Dür-

er's own treatises, the inscription on his tomb, and Vasari's account of the artist, but he also endeavored to study Dürer's paintings in Nuremberg, Vienna, Prague, and Frankfurt.[60] Van Mander familiarized himself with some of Dürer's original drawings by studying works in private collections. He cites the holdings of two Netherlandish collectors, Joris Edmheston in Brielle and Arnout van Berensteyn in Haarlem, about whom little is known today. In the 1560s Abraham Ortelius, the noted Antwerp cartographer, had already arranged his many prints by Dürer in a separate album, now in the Rijksmuseum in Amsterdam. The album's title page displays a drawing of Dürer's portrait in profile.[61] This likeness of the mature artist was modeled on the commemorative medal by the Augsburg artist Hans Schwarz (1492–mid-1520s [?]; see Figure 5.12).[62] Dürer had commissioned this medal while still in Nuremberg and paid for his portrait in 1520. It can be assumed that copies of this medal circulated in the Netherlands. While Schwarz's cast medal carries the inscription ALBERTVS DVRER PICTOR GERMANICVS, the drawing in Ortelius's album alters the text to read: ALBERTVS DVRER NORICVS PICTORVM PRINCEPS.[63] Instead of "Albrecht Dürer the German Painter," the savvy humanist Ortelius dubs him "Albrecht Dürer of Nuremberg, Prince of Painters," a fitting tribute to the famous artist by one of his Netherlandish admirers.

Agony in the Garden: Dürer's "Crisis of the Image"

Donald McColl

Let him also choose himself some secret solitary place in his own house, as far from noise and company as he conveniently can, and thither let him some time secretly resort alone, imagining himself as one going out of the world even straight unto the giving up his reckoning unto God of his sinful living. Then let him there before an altar or some pitiful image of Christ's bitter passion . . . kneel down or fall prostrate as at the feet of almighty God, verily believing him to be there invisibly present as without any doubt he is. There let him open his heart to God, and confess his faults such as he can call to mind, and pray God forgiveness.

THESE WORDS, UTTERED by the character Anthony in Thomas More's *A Dialogue of Comfort against Tribulation* (1534), were written while More himself was going though a crisis.[1] Caught in a struggle between his sovereign, King Henry VIII, and the pope, the head of the Roman Church, of which he was still faithfully a part, this chancellor of the realm would soon be put to death for his refusal to declare Henry the supreme head of the Church of England. But according to More, we must not despair, not merely because despair is a mortal sin, but also because Christ himself had modeled for all

humanity, for all time, the proper attitude toward suffering. Whoever "is utterly crushed by feelings of anxiety and . . . tortured by the fear that he may yield to despair," he wrote in *On the Sadness of Christ* (1535), "must contemplate Christ's sufferings in the Garden."[2] In a letter to his daughter Margaret in that same year, written while he was being held prisoner in the Tower of London, More prayed for the grace "devoutly to resort prostrate unto the remembrance of that bitter agony, which our Savior suffered before his Passion at the Mount."[3]

There is much to suggest that Albrecht Dürer, too, went through a series of "personal trials" before and after 1519 when his friend, the humanist Willibald Pirckheimer, noted that the Nuremberg master was in "bad shape" (*Turer male stat*). He felt tried by everything from the pressures of urban living to a dread of the Turk, and, like More and many others of the period, sought solace in Christ's example at Gethsemane.[4] In 1521 Dürer sketched the *Agony in the Garden* (W. 798; Figure 10.1), a scene intended perhaps to be part of a new Passion series, which the artist never finished. There Christ lies prostrate in the very manner recommended by More for solitary prayer— prayer to be undertaken in one's home, away from the cares of the world, in the presence of "an altar or image," and without any intermediary, such as a confessor or a priest. If nothing else, this kinship between a work of More, who could not bring himself to abandon the Roman Church, and a work of Dürer, who felt compelled to do just that, underscores the difficulty in assigning sectarian labels, let alone rigid theological stances, to the Nuremberg master, who died before the term "Protestant" was even coined at the Second Diet of Speyer in 1529 and before the age of confessionalism.

I want here to revisit Dürer's "personal trials," focusing especially on his conversion to Lutheranism and its relation both to his own image making and to the general "crisis of the image" of the period.[5] But I also want to consider the possibility of whether he may have altered the nature and frequency of his images in the early 1520s for other than strictly religious reasons.[6] These include the artist's failing eyesight, the malaria he contracted while in the Netherlands, his concern over his impending death, and the certain knowledge that he and his wife, Agnes Frey, would have no children. In addition Dürer worried about his finances, iconoclastic threats to religious images, and the general scholarly malaise of the period.[7] I take seriously the admonitions that one cannot easily look into the workings of another human being, that the artist did not necessarily intend for us to see all that he wrote, and that, in concentrating on Dürer, we may well, however unwittingly, be

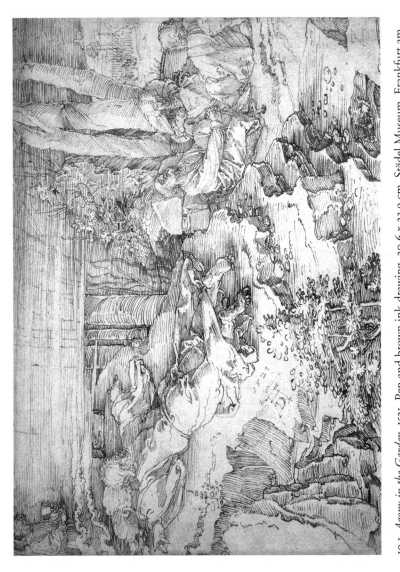

10.1. *Agony in the Garden*, 1521. Pen and brown ink drawing, 20.6 x 23.9 cm. Städel Museum, Frankfurt am Main, Graphische Sammlung. Photo © U. Edelmann–Städel Museum–Artothek.

supporting cultural ideologies, a point Keith Moxey makes forcefully else-where in this volume. Yet I also maintain that to give up trying to interpret historical questions is in some way to give up trying to learn from the past or, for that matter, from people of our own time and place. Like Richard Spear, "I take the position that the individual personality of the artist has left behind significant 'visible traces' and that they potentially are as meaningful to the historian as any other events or facts in the Baconian sense."[8] This ought especially to be true of the period under scrutiny here, when people began again to bare their "private" feelings, in the manner of Augustine's *Confessions*, and when histories of art were built around "artists," including the narrative by Nuremberg's own Johann Neudörfer (1547), written even before Giorgio Vasari's *Lives of the Artists* (1550).[9]

Dürer composed a history of his family and went back over his work, writing on selected examples in his own hand, sometimes more than once, as in the case of the drawing of his mother made just months before her death in 1514 (see Figure 2.5). Often, his retrospective annotations seem to under-score his precocity and seemingly meteoric rise, but they also articulate his express wish to "make himself seen in his works."[10]

According to Carel van Mander (1604), when the Dutch artist Jan van Scorel visited Nuremberg in late 1518 or 1519 in the hopes of studying with Dürer, he soon continued on his journey to Italy because he found the artist preoccupied with the "teachings by which Luther had begun to stir the quiet world."[11] But the world was far from quiet.[12] While Luther attacked the abuses of the Roman Church, the Ottoman Turks expanded their empire. They defeated Islamic rivals in Egypt and Syria (1516–17), and in 1517 took Jerusalem, where they were accused of stabling horses in the garden of Geth-semane where Christ underwent his Agony. Venice was forced to pay tribute to Istanbul. Hungary, traditionally Europe's bulwark against Islam, fell to the Turks following the conquest of Belgrade (1521) and the Battle of Mohács (1526), in which Louis II, king of Hungary and Bohemia and brother-in-law of Emperor Charles V, was killed. In 1529, the year after Dürer died, the Turks were finally stopped, following their unsuccessful siege of Vienna.

Dürer, whose father emigrated from Hungary and settled in Nuremberg, might well have been privy to the deliberations of the imperial diet at Nurem-berg of 1522, where delegates considered what was to be done about the seemingly inexorable advance of the Turks. As a member of Nuremberg's outer city council since 1509, he participated in local debates about this threat. Significantly, he dedicated his *Treatise on Fortification* (1527) to Ferdi-

nand, the new king of Hungary and Bohemia. Many hoped for a crusade that never came; however, Luther argued that before resorting to crusade against the Turks, whom he called the rightful "rod of God's anger," Christians must first wage war on themselves.[13] And that war required individuals to make a confessional choice—a choice that was perhaps most difficult for the first generation, after which being "Catholic" or "Protestant" was often a function of birth or legislation.[14]

Concerning Dürer's relationship with the "Reformation," we do know something in addition to what Jan van Scorel said of the Nuremberg artist. Dürer was remarkably early in acquiring the writings of Luther. He wrote about Luther's helping him out of a difficult period and wanted, largely out of gratitude, to make his portrait.[15] He was a member of the Sodalitatis Staupitziana (later the Sodalitas Martiniana), a group of Nurembergers who met to discuss matters of religion. In 1521 he penned the famous *Lutherklage*, or lamentation, on the reputed death of the reformer, thinking that Luther had been kidnapped and killed after his defiant performance at the Diet of Worms.[16] Andreas Bodenstein von Karlstadt, Luther's elder colleague and later his bitter enemy at Wittenberg, dedicated his treatise on the Last Supper to the artist in 1521. Indeed, Pirckheimer said that, unlike himself, Dürer never returned to Catholicism. When the artist's wife Agnes died in 1539, she endowed a fellowship at the University of Wittenberg, Luther's institution, for an artisan's son to study theology.[17]

Lest one take Dürer's seemingly long engagement with the new theology as ambivalence, recent scholarship suggests that despite the reformers and others likening their own conversions to those of such New Testament figures as Paul, which took could place in the "twinkling of an eye" (1 Corinthians 15:52), such conversions were commonly the result of sustained intellectual and emotional work, marked by considerable anxiety.[18] Sociologists from Weber on have been struck by the numbers of Lutherans who were successful in committing suicide in this period.[19]

Dürer had more to be anxious about than most. Beyond whatever concern he had for his own soul or those of Agnes and his siblings Endres and Hans, the artist, as a member of Nuremberg's council, was partially responsible for the city's adoption of religious reform in 1525. The government assumed control of all local churches, schools, and the populace's spiritual well-being. As one of the leading imperial free cities, Nuremberg's actions were watched carefully by others throughout the Holy Roman Empire. If Nuremberg failed, what chance would other towns have in adopting Protestantism? That

the price of failure was high was evidenced by recent bloody disasters, such as the Knights' Rebellion under Franz Sickingen (1522) and the Peasants' War (1524–25).[20]

Members of Dürer's own artistic "family" were affected directly. His former pupil Hans Leu the Younger of Zürich died in the skirmishes between Switzerland's Protestant and Catholic cantons at the battle of Gubel in 1531. Georg Pencz and the brothers Sebald and Barthel Beham, who while not his pupils were strongly influenced by his art, were dubbed the "godless painters" for doubting the scriptures and thus the historical role of Christ, and temporarily were banished from Nuremberg in 1525.[21] Even Dürer's *Formschneider*, Hieronymus Andreae, was jailed in 1525 for his involvement in the Peasants' War.[22] There is still question about how Andreae and the godless painters managed to get off so lightly in comparison to, say, the two Nuremberg artisans who, after merely attending meetings of the peasants, were banned for life or those who were publicly beheaded in the marketplace for questioning the right of the council to levy taxes.[23]

Iconoclasm threatened Dürer and his entire vocation. In Nuremberg only a few works of religious art were removed from local churches. In other towns, such as Zürich or Ulm, churches were systematically "cleansed" of their art. For centuries, image makers could turn to the example of St. Luke, who, besides writing one of the Gospels, was credited with painting the Virgin.[24] Cult images "made without hands" (*acheiropoetoi*), such as the image of Christ on St. Veronica's veil, were treasured. To make a sacred image was to educate the faithful, who, in turn, could earn indulgences while contemplating, perhaps even "seeing," the divine.[25] But one by one such ideas and then images themselves were attacked. Many considered the removal and destruction of religious art from churches and public settings as acts of piety taken for the spiritual "betterment of one's neighbor."[26] Carlos Eire has even argued that iconoclasm was a revolutionary tactic used to test the strength of the Catholic *cultus* in a given locale.[27]

How does Dürer square with such things? First, he steered a relatively cautious course, including perhaps slowing down his production of works of art in favor of his writings, which were not only less subject to attack, but might better ensure his legacy in the event of the destruction of any of his major works.[28] Moreover, when he made images, he concentrated largely on portraiture. Dürer recognized the abuse of images, such as his criticism of the cult of the Schöne Maria (Beautiful Virgin) at Regensburg, but these he blamed on people not the work of art.[29] Unlike some of his Nuremberg

colleagues or Lucas Cranach the Elder in Wittenberg, Dürer produced no anti-Catholic propaganda. It is unknown whether this is due to Nuremberg's strong censorship laws, administered until 1528 by his neighbor Lazarus Spengler, or by his desire not to upset patrons and friends, like Pirckheimer, or because of his humanist inclination to transcend sectarian strife in a spirit of "civilized discourse, reasoned argument, restraint, the willingness to entertain doubt and the need for accommodation, a dislike of dogmatic assertion, and above all a commitment to peaceful resolution and civic responsibility."[30]

Reform was nothing new to Dürer. In my view, he had already begun to "reform" himself as in his recognition of the limitations of sight. This physical sense was debated in the late medieval ages often around the question of how the devout would perceive God when, according to Revelation, one finally came "face to face" with the Lord. As Herbert Kessler writes, in relation to Dürer's *Sudarium Held by an Angel* of 1516 (Figure 10.2), in which the Holy Face is partially hidden, "The implication is clear: Dürer's own art is an aid, but only for this world; like its archetype 'not-made-by-hand,' it will cede to 'the invisible truth of [God's] face.'"[31] Dürer's engraved portrait of Erasmus (B. 107, 1526) includes the text: "the better image will his writings show" to imply that Erasmus's words, not his recorded physical features, offer the truest likeness. Luther remarks that "physical and rational seeing (imaging or mental conceptualizing) were *not* successive stages on a ladder leading to contemplation of God . . . the '*verstandig*' heart was one that

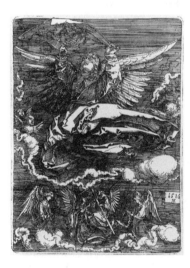

10.2. *Sudarium Held by an Angel*, 1516. Etching, 18.6 x 13.6 cm.

understood and accepted its limitations; it accepted that the gap between the creator and creation was unbridgeable in this world."[32]

Dürer's worry over the proper role of images may even be behind his *Dream*, or more properly, nightmare, of 1525 (see Figure 2.13). The world is assaulted by water, something God himself had promised would never happen again. Luther did liken Germany to the state of the world before the Flood.[33] This image has been connected with a conjunction of heavenly bodies (Pisces), which many expected to come soon and bring both a great flood and a new age of social justice.[34] However, it is also true that in the Bible, water destroyed images and, according to Revelation, would drown Babylon, including its craftsmen.[35]

Regardless of Dürer's own intentions, his art has inspired vastly different interpretations by his contemporaries and subsequent audiences. Was the potential ambiguity in reading his images an intentional strategy?[36] Many Catholics and Protestants alike became increasingly despondent about the prospects for religious reform.[37] A case in point is the artist's engagement, in the early 1520s, with the theme of the Agony in the Garden (W. 798 and 891; Figures 10.1 and 10.3), which Dürer worked and reworked. This subject was bound up in centuries of intense piety, centered not only around Gethsemane itself but also on *simulachra*, the sculpted and/or painted monuments like the Ölbergs (Mounts of Olives) that adorned most German churches and often public settings. These were the focus of quasi-liturgical celebrations, including processions, during Holy Week, and the locus of private prayer, often to the dismay of later Protestants, as in Ulm.[38] Worshippers could identify with Christ's doubts and sufferings. For Erasmus, "Christ's example in the garden shows that, though even the best men cannot avoid natural feelings of fear and sorrow, they can conquer their lower passions by attending to the needs of the spirit. In Christ's agony, then, Erasmus discovers an exemplary man who is also God, who is besieged with human afflictions yet triumphant though the strength of his divinely obedient spirit."[39] According to Luther's theology of the cross, Christ's moment of doubt illustrates an existential crisis leading to the realization that "salvation lies in complete submission to faith."[40]

The positions for praying in this period, as noted above with Thomas More, included kneeling, lying prostrate, and, in more extreme forms, hanging in the form of a cross for hours at a time on nails, as in the case of Dorothy of Montau, who also lay prostrate with only her forehead, nose,

10.3. *Agony in the Garden*, 1524. Pen and grayish ink drawing, 21.2 x 29.1 cm. Städel Museum, Frankfurt am Main, Graphische Sammlung. Photo © U. Edelmann–Städel Museum–Artothek.

fingers, and toes touching the ground.[41] Michael Ostendorfer's woodcut (ca. 1520) depicting the cult of the Schöne Maria at Regensburg catalogs several of these positions.[42] Is this a matter of appealing to those who knew that these postures accord with those recorded in the Gospels, marking what Jeffrey Hamburger calls not an innovation, but rather a radical return to scripture?[43] Or else do they relate to those articulating sculptures of Christ of the period that were used during Holy Week. Or both?[44]

Perhaps most extraordinary, however, is the presence of a crucifix in several of Dürer's *Agony in the Garden* scenes including the drawing dated 1524. While the Bible sanctions the cup or chalice, there is little to support the presence of a crucifix carried by an angel. This feature recalls that brought by another angel to St. Francis, an *alter Christus*, on another mountain in Dürer's woodcut of 1508 (B. 110). Such a crucifix favors sight over reading and hearing, in that Christ envisions his own Crucifixion, while the apostles sleep. In some images of the period Christ explicitly implores the viewer to "turn not away."[45] The need for one's obedience to divine will is stated in the inscription, quoting Mark 14:36, on a drawing of this subject (Figure 10.4) made around 1500 by a nun at the Benedictine convent of St. Walburg in Eichstätt. Hamburger remarks, "The rose, a symbol of Christ's sacrifice, presents the viewer with Christ as her exemplar contemplating his own Passion in the garden of Gethsemane, even as it reminds her to meditate on the same subject."[46]

Gardens are places of revelation and the source of one of the most power-

10.4. Anonymous, *Agony in the Garden*, ca. 1500. Colored pen and ink drawing. St. Walburg, Eichstätt.

ful *acheiropoietoi* of Christ, that from Kamuliana. One wonders whether
Dürer would have thought of this and of Adam and Eve, or of Augustine's
"agony" in his garden, while making his images of Christ's Agony in the
Garden or, for that matter, spending time in his own garden outside the walls
of Nuremberg.[47] The most popular book on dying in the early sixteenth
century was the *Hortulus animae* (*Garden of the Spirit*), which extolled
"deathbed contemplation of the Passion."[48]

Sometime in 1522, the year after Dürer returned from the Netherlands, he
made his startling *Self-Portrait as the Man of Sorrows* (W. 886; Figure 10.5).
Here again we have an image of the suffering Christ seated and holding the
instruments of his flagellation. This theme is central to late medieval piety
yet one that increasingly came to offend Protestants, though perhaps not yet
in 1522, because of its references to self-flagellation, transubstantiation, and
indulgences.[49] Not that Lutherans were above buying indulgences or, for
that matter, utilizing similar imagery when it came to their framing Luther's
persecution at Worms (1520), or even when it came to longing for a simple
piety linked to Christ.[50] In about 1525 Dürer depicted such piety in a pair of
drawings (W. 925–26; Figure 10.6) in the tradition of the *Imitatio Christi*, in
which the pious donor, perhaps Lazarus Spengler, takes up his cross and
follows Christ. Luther condoned the location of a crucifix in Protestant
churches but not scenes such as the Man of Sorrows because of their inherent
potential for idolatrous misuse.[51]

Some artists, perhaps manifesting a new self-consciousness, depicted
themselves in Passion scenes as Nicodemus, who in medieval legend was
thought to have carved his own crucifix.[52] But nothing in German art pre-
pares one for Dürer's self-portrait as Man of Sorrows, other than perhaps his
own deeply Christlike *Self-Portrait* of 1500 (see Figure 12.3).[53] Some of this
seems to have been bound up in art—the idea that the artist has godlike
powers of creation, a strand that would have to wait to receive fuller articula-
tion in the theory of the Zuccari, among others; a position, in turn, related
to Dürer's earlier argument that to honor God is the very end of art.[54] It may
also point to the artist's being bound up in the "premonition and actuality
of [his own] death." This is evident in the single surviving leaf of the *Ge-
denckbuch* (Figure 10.7). According to Peter Parshall, Dürer's seemingly ran-
dom notations over a decade, concerning a rain of crosses (complete with an
extraordinary illustration in watercolor, the bleeding of which resembles the
"image made without hands" that it records), Dürer's father's death, the
artist's sighting of a comet, his mother's death (1514), and a taking stock of

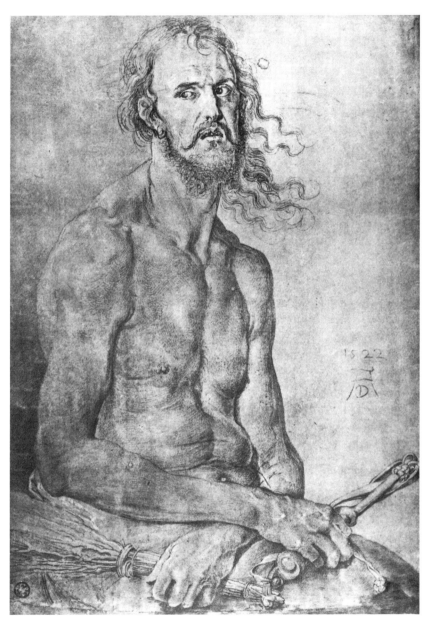

10.5. *Self-Portrait as the Man of Sorrows*, 1522. Metalpoint drawing on green ground paper, 40.8 x 29 cm. Kunsthalle, Bremen, though currently kept in Moscow.

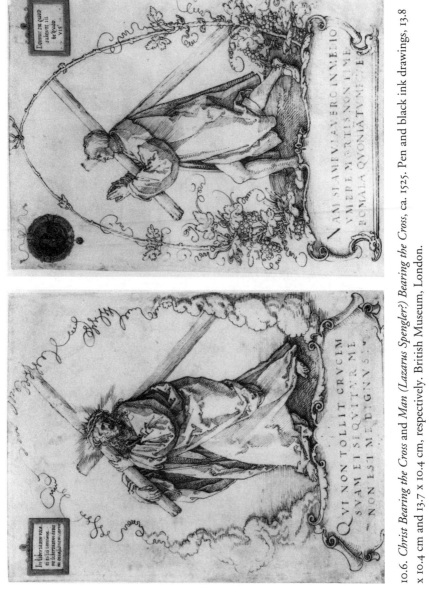

10.6. *Christ Bearing the Cross* and *Man (Lazarus Spengler?) Bearing the Cross*, ca. 1525. Pen and black ink drawings, 13.8 x 10.4 cm and 13.7 x 10.4 cm, respectively. British Museum, London.

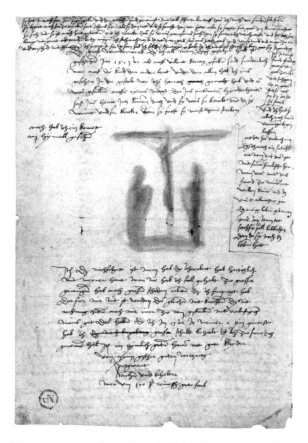

10.7. *Rain of Crosses* on a page from Dürer's *Gedenckbuch*, 1503 and later additions.
Brush drawing with brown ink plus gray and brown pencil, 31.1 x 21.5 cm (sheet).
Staatliche Museen, Kupferstichkabinett, Berlin.

his financial affairs are, instead, a meditation of sorts on the "numinous and
darkly unknowable determinants of his own destiny."[55]

The pride some have sensed in the *Self-Portrait* of 1500 is now gone.
Judging from the artist's posture alone, his "sorrows" are many. First, he had
health problems. Writing to Georg Spalatin in 1519, Dürer remarks, "As I am
losing my sight and freedom of hand, my affairs do not look well."[56] During
his trip to the Low Countries in 1520–21, he purchased three pairs of eye-
glasses. More critical, he contracted malaria while searching for a whale in
Zeeland.[57] As if this were not enough, there was his depression, or melan-
choly, which, although hard to assess by sixteenth- or twenty-first-century

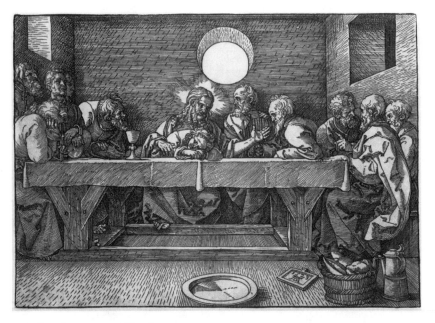

10.8. *Last Supper*, 1523. Woodcut, 21.4 x 30.1 cm.

standards, could have impacted his reaction to the religious situation of the period. Lazarus Spengler, for one, likened the state of late medieval piety to a diseased body.[58] Dürer had financial worries. He traveled to the Netherlands seeking the renewal of his annual pension, which, although granted by Maximilian in 1515, had to be reauthorized upon the emperor's death.

Whatever Dürer's other intentions, this drawing, though not his likeness, served as the model for a *Man of Sorrows* (A. 170K) painted for Cardinal Albrecht of Brandenberg's Neue Stift at Halle, where it hung near the pulpit.[59] Like Lucas Cranach the Elder, who designed much of this church's artistic program, Dürer continued to work for Catholic patrons, here the leader of the Roman Church in the empire, during the early 1520s.

In 1523 Dürer made one final *Last Supper* (B. 53; Figure 10.8), the subject that announces the Passion. Some scholars have asserted that this is a "Protestant" image of the Last Supper because of the lack of the paschal lamb and its emphasis on the clearly visible Eucharistic chalice. Such a reading is hampered by the existence of earlier depictions of this theme by Dürer that omit the lamb. Moreover, Luther himself, in a marginal note to his *Septembertestament* (his German translation of the New Testament published in 1523), de-

cried any Eucharistic significance to John 6:53ff. This text had long been used by exegetes to impute such a meaning to John's account of the Last Supper in order to bring it into line with the other synoptic Gospels. Instead, Dürer stressed Christ's commandment that "we love one another" (John 13), a text used prominently in Luther's *Septembertestament*.[60]

The potential ambiguity of Dürer's woodcut may have been intentional in order to appeal to both sides of the confessional divide.[61] There was precedent for pointing to Christ's commandment that we love one another in the writings of the Venetian reformer Gasparo Contarini, who attended the Diet of Worms in 1521 where Luther was condemned.[62] Furthermore, Jane Hutchison argues that to Catholics like Caritas Pirckheimer, abbess of St. Klara's convent in Nuremberg who remained cloistered until her death in 1532, the figure of John asleep on Christ's lap would have undoubtedly recalled "the venerable mystic theme of the *Johannesminne*," which "marks the [*Last Supper*] woodcut as still primarily targeted for convent and monastery use."[63] We are, in other words, a long way from Jakob Lucius's print showing Luther giving communion, or Lucas Cranach the Younger's *Epitaph for Joachim of Anhalt* (Dessau), with its recasting of the central characters as contemporary reformers.[64]

One clue that supports a "Protestant" interpretation of the *Last Supper* lies in its formal structure. Several critics, from Erwin Panofsky on, have seen in it a new simplicity coupled with a pronounced asymmetry. While Donald Kuspit has tied this simplicity to Dürer's concern with rhetoric, specifically, the ancient "simple style," Jordan Kantor argues that the very structure of the picture is meant to counter the problem of "presence."[65] The reserved demeanor of the participants in the Last Supper is certainly far from that associated with taverns of the period including those mentioned in Luther's *Tischreden*. In Thomas More's discussion of the subject, he stresses that we should be appropriately reserved before, during, and after taking the Host, and thereafter be off to prayer, like Christ's retreat to Gethsemane.[66]

While we cannot know what Dürer would have done had he lived longer, a good idea of his eventual position on images can be gleaned by considering the *Four Apostles* (A. 183–84; Figure 10.9) at Nuremberg.[67] Here, like the other images we have seen, the key to meaning lies not so much in the subject as in its context. This image, even if it does resemble a large diptych, was created for Nuremberg's Rathaus, where it would not only underscore the role of the council, which had already become a local issue, but also be relatively free from charges of idolatry or even attacks, which it might other-

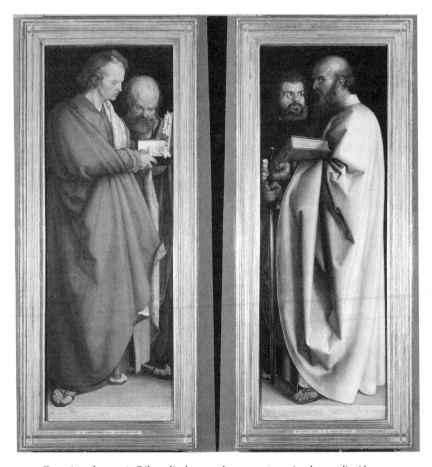

10.9. *Four Apostles*, 1526. Oil on lindenwood, 215 x 76 cm (each panel). Alte Pinakothek, Munich.

wise garner in a strictly ecclesiastical setting. David Price remarks, "From a cultural historical perspective, it is revolutionary that *The Four Apostles* is religious art that does not seek to support worship, veneration, or piety. Although Protestant in the extreme, it ironically does not elicit the faith or piety of an individual believer. Instead, it connects biblicism to civic authority and denies legitimacy to challenges to an official exegesis."[68]

The ostensible subject matter, which was never intended to be a Virgin and saints as Panofsky proposed, comprises SS. John and Peter and Mark and Paul. Pride of place is given to John and Paul, who figure so prominently in Reformation theology. These monumental figures, in turn, are seen to

stand for and, literally, stand on passages from the gospels quoted from Luther's *Septembertestament* (2 Peter 2:1–3; 1 John 4:1–3; 2 Timothy 3:1–7; Mark 12:38–40), concerning the dangers of false prophets. At the bottom of the left panel, Dürer added a warning, based upon Revelation 22:18–19: "In these dangerous times all secular rulers should exercise caution that they do not receive human deception for the word of God. For God wants nothing added to his word or taken away from it. Hear therefore these excellent four men, their warning."[69] Reminiscent of figures of fortitude, the four are exemplars in the chaos of this world. Paul's facial expression bespeaks danger, and the sword at his side shows a kind of *ecclesia militans*.

When Dürer presented his work to the council on October 6, 1526, he wrote that he intended "to honor your wisdoms with my insignificant painting as a memorial." The artist received an honorarium of one hundred Rhenish guldens plus twelve for Agnes and two for his unnamed servant. This might have allayed something of his financial worries. But few in the sixteenth century would have recognized Dürer's gesture as a gift. What Dürer did was more in the court tradition of presenting a gift to the sovereign to test his *liberalitas*.

I shall have succeeded here if the reader now doubts the reductive claims made for Dürer in much of the scholarship, which tends toward his being a staid Lutheran, progressing seamlessly from the *Lutherklage* to a fully formed view of theology and the role of art in it. Such a view not only benefits from hindsight but takes the work of "art" itself as normative. As I have tried to show, Dürer was receptive to many of Luther's ideas, which themselves could shift dramatically over time, and may himself have inspired some of the reformer's views on images. But he also maintained contacts with a wide variety of others in his quest for spiritual knowledge: from Erasmus and Melanchthon to Spengler, Staupitz, and Zwingli (whose writings were banned in Nuremberg in 1526). These men, some of whom became bitter rivals, were part of a broader move toward religious reform. The artist's "agony," I have argued, came as much from artistic and health issues as from spiritual concerns. He seems never to have doubted the role of the image in Christian devotion, even if his simple faith in the image—and people—was not shared by many of his contemporaries. In the end, even while caught up in Luther's movement, which was itself part of a heady nationalism of sorts, he stayed most loyal to his art and to Nuremberg, his native city. Unlike Thomas More, who went to his death at the Tower of London while the

bishops of England "slept" like apostles in Gethsemane, Dürer died in his bed surrounded by family in an imperial free city. This has to do with the contingencies of history, or, as the artist would have it, the unknowable providence of a God who, as the artist wrote in 1525, "turns all things to the best."

Albrecht Dürer between Agnes Frey and Willibald Pirckheimer

Corine Schleif

Sources of Tension

TWO SOURCES LEAVE telling traces of tensions in Albrecht Dürer's closest personal relationships. One, a letter that Dürer wrote to Willibald Pirckheimer, preserves for us a shocking and intimate exchange between the two men. Dürer sent the missive from Venice in 1506 and dated it "about fourteen days after St. Michael's Day," which places it in the middle of October. It subsequently remained lost and forgotten for centuries together with other letters and papers behind a secret panel in a Nuremberg house (Figure 11.1).[1] The subject of the discussion was the artist's wife, Agnes: "And as for what you wrote—that I should come back soon or you would clyster my wife—I will not allow it because you would *braut* her to death" (Vnd als jr schreibt, jch soll pald kumen oder jr wolt mirs weib kristiren, jst ewch vnerlawbt, jr prawt sy den zw thott).[2]

To understand the passage, explanations of the verbs used to connote and denote sexual intercourse are necessary. First of all, the verb *klistieren*, derived from a Greek word meaning "to clean" and related to the English noun *clyster*, was generally used to refer to the administration of either an enema or vaginal douche. As Laurinda Dixon has shown, the clyster was a prevalent medical remedy that was prescribed from the fifteenth to the eighteenth century for women without husbands or in the absence of their husbands, as an

11.1. Georg Christoph Wilder, *The House of Hans VI Imhoff and Felicitas Pirckheimer on St. Egidien Place in Nuremberg*, 1816. Engraving in *Erinnerungs-Blätter an Nürnberg und dessen Umgegend aus alter und neuer Zeit: Aus dem Nachlasse der Brüder Georg und Christoph Wilder, nebst Beiträgen von mehreren anderen Nürnberger Kupferstechern* (Nuremberg, 1860). Photo: Volker Schier.

antidote for unfulfilled desire.[3] The other word, *brauten*, a transitive verb used in early modern times as a euphemism for male-initiated coitus, is direct but less rude in tone.[4] There is no English equivalent.

Although Dürer otherwise appears to have self-consciously anticipated that his art and writings would be of interest to posterity, he would certainly have been discomforted to learn that these ribald jibes, so teasingly exchanged, would one day be the subject of scholarly analysis. From the voyeuristic standpoint of the modern scholar, one is likewise embarrassed by what one is allowed to read, especially because, by contrast, the woman Agnes Frey Dürer, who was made an object by the brash bantering, undoubtedly remained unaware that she was the butt of these crude jokes.

What does the dialogue in the letter reveal about relationships between Albrecht Dürer, Agnes Frey Dürer, and Willibald Pirckheimer? First of all, Pirckheimer, whose proposition certainly bore no serious intentions, has appropriated Agnes Dürer, almost as if she were a piece of (neglected) property, in order to convince Albrecht Dürer to return to Nuremberg. He does not write simply—come back because I want you back in Nuremberg—although this appears to be the unspoken agenda. Rather, the two men appear to bond

over the hypothetical and symbolic exchange of a woman's body. The dialogue may remind some modern readers of notions about bride exchange put forth in the middle of the twentieth century by the French anthropologist Claude Lévi-Strauss in his *Elementary Structures of Kinship*. Here it is not kinship with another family, clan, or village that is sought or secured, but friendship that transcends or even repudiates class differences.

Second, the letter may indicate that Agnes Dürer had expressed to Pirckheimer her longing for her husband, who at the time had been away in Italy for over a year, while she was in Germany managing the family business.[5] The topic of the couple's unwelcome separation had been broached in a different manner in a letter Dürer wrote to Pirckheimer several months before. At this time it was Dürer who expressed concern when he wrote on February 28, 1506, complaining that he had not heard from his wife for so long that he feared he had "lost her" (ich mein ich habs verloren).[6] It appears too that she was away from Nuremberg for a time selling his prints at the spring fair in Frankfurt. References in Dürer's letter of August 18 imply that Pirckheimer had attempted to intervene, but that he had been a bit heavy-handed: "Also, I thank you for taking care of things for me by speaking with my wife. I recognize much wisdom in you, but if only you were as gentle as I am! Then you would possess all virtues" (Item ich dank Euch, daß Ihr mit meinem Weib mein Sach also zum Besten geredet habt, denn ich erkenn viel Weisheit in Euch beschlossen, wenn Ihr nur so sanftmüthig wärt wie ich, so hättet Ihr alle Tugentden).[7] Dürer's ambivalence about returning to his native Nuremberg because of his artistic successes in Venice and continuous hunger to discover new ways of painting in Italy is, in fact, a recurring theme in his October letter. Later in the letter he voices his famous lament: "Oh how I will freeze, longing again for this sun. Here I am treated as a gentleman, at home as a parasite" (O wy wirt mich noch der sunen friren. Hij pin jch ein her, doheim ein Schmarotzer).[8] Nonetheless Dürer promises Pirckheimer that he will come back in a couple weeks, after he has traveled to Bologna to learn about the use of linear perspective. Other sources show, however, that Dürer did not return home until February. Obviously Dürer was torn between his needs to satisfy his further curiosities in Italy and his desires to be with his wife, family, and friends in Nuremberg.

Third, the passage shows that Albrecht Dürer and Willibald Pirckheimer were close enough to allow themselves verbal liberties in matters of sex and sexuality. This point calls for further exploration. It can be observed that Pirckheimer initiated the exchange and, if Dürer has quoted Pirckheimer's

rhetoric exactly, then it is Dürer who has chosen the less vulgar vocabulary. Here, as in all of his letters to the patrician Pirckheimer, Dürer refers to Pirckheimer as *Herr*, employing the polite and subservient plural form of address. At one point, in his letter of February 7, 1506, Dürer addresses the nature of their bond. After reporting that his mother has informed him in a letter that Pirckheimer is unhappy with him because he has not written for so long, Dürer tells Pirckheimer, "Therefore I humbly beseech you to forgive me, for I have no other friend on earth like you. I also cannot believe that you are angry with me, for I see you as nothing less than a father to me" (Dorum pit jch ewch vnderdenlich, jr wolt mirs verczeihen, wan jch hab dein anderen frewnt awff erden den ewch. Jch gib jm awch kein glawben, daz jr awff mich czürnt, wan jch halt ewch nit anderst den vür ein vater).[9] Nonetheless, here, as in previous letters, they discuss women on explicit and personal terms almost as if the two men were peers. Near the beginning of the letter Dürer asks Pirckheimer about several of Pirckheimer's female friends, whose names he rather cryptically abbreviates: *Rech* for *Rechenmeisterin, Ros* for *Rosentalerin, Gart* for *Gartnerin, Schutz* for *Schützin,* and *Por* for *Porstin.* Pirckheimer never remarried after the death of his wife in 1504, and the nature of Pirckheimer's relationships with these women remains unclear. In an earlier letter Dürer drew small pictures of a rose and a brush as well as a dog into the line of his script, creating a kind of rebus to refer, presumably, to Frau Rosenthaler, Frau Porst, and another woman in a kind of secret code, implying that their identities were a confidential matter for the two men.[10] It appears that in Pirckheimer's previous letter, he had bragged about his exploits with women. Dürer remarks that Pirckheimer had been "full of the pleasures of whores" (voll Huren frewd) and scolds his friend saying that he should be ashamed of himself, since he is old but still believes he is so good looking. Dürer then compares Pirckheimer's amorous adventures to those of a big shaggy dog playing with a young kitten (Ir solt ewch nundellung schemen des halb, daz jr alt seit vnd meint, jr seit als hüpsch. Wan daz pulen stett ewch an, wy des gros czottechten hunttz schympff mit dem jungen ketzle). Apparently Pirckheimer had likewise teased Dürer about his friendships with women as is evident from Dürer's boasting following his cryptic inquiries: "But more people ask about me than about you. You yourself wrote that whores and pious women asked about me. This is a sign of my virtue" (Aber man frogt mer noch mir weder noch ewch, als jr den selbs schreibt, wy huren vnd frum frawen noch mir frogen. Ist ein tzeichen meyner dugent). Clearly the two men engaged gleefully in debates over who was better look-

ing, more desirable, and more sought after by women. Their respective feelings of self and definitions of masculinity glimmer from the depths beneath this superficial chatter.

On this point it is useful to call attention to a few provocative comments in the letters of Lorenz Beheim. The learned humanist and canon at the collegiate church of St. Stephan in Bamberg carried on a lively correspondence with Pirckheimer in Latin. A native of Nuremberg and, interestingly, brother of Anna Porst, one of the women presumably referenced by Dürer's cryptograms, Beheim was a personal friend of both men and may have been an insider to at least some of the innuendos and jokes they exchanged. He likewise shared an enjoyment of dancing and partying. In a letter written on February 21, 1507, he regrets that he was not present in Nuremberg for carnival, when Dürer and Pirckheimer introduced new dances and participated exuberantly in the bacchanalia.[11] In this letter, as in nearly all of them, Beheim closes with greetings for Albrecht Dürer. Here, however, he expresses his surprise at learning that Albrecht had grown a beard, "Salutes meum, ymo nostrum Barbatum, ut puto, albertum Thurer." Subsequently Beheim makes the beard a recurring theme, mentioning it not fewer than six times: asking for a description, rendering it the object of ridicule, saying that it makes him laugh, and calling it ugly and misshapen, or simply referring to Dürer as bearded.[12] At one point, in a brief excursus in Italian, Beheim asserts that he has heard that Dürer's boy (*gerzone*) loathes the beard, a provocative reference that may indicate, as Erwin Panofsky puts it, that "Dürer was not unsusceptible to the charm of handsome boys."[13] Here suffice it to say that also these incursions into the intimate space of friendship that Pirckheimer and Dürer had created for themselves expose an ambience in which banter about sexual exploits, sexual prowess, and bodily signs of masculinity were common.

My last observation on the passage in Dürer's letter from October 1506 likewise concerns notions of masculinity. Clearly the letter demonstrates that Dürer felt the need to flatter his friend with a remark about his potency and virility and that this flattery took a drastic, even fatally violent direction. It is noteworthy that the passage presents a clear articulation of what Lawrence Kramer has proposed, "that the forms of selfhood mandated as normal in modern Western culture both promote and rationalize violence against women." Kramer asserts that "even if unacted, the possibility of sexual violence ripples in the air like rising heat, visible and invisible at the same time."[14]

A different letter, one penned by Pirckheimer in 1530 and likewise hidden

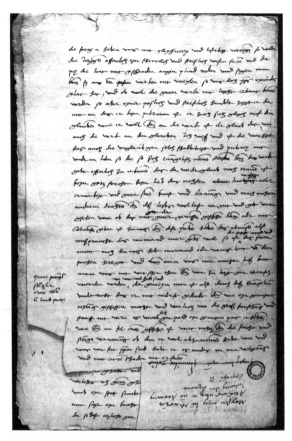

11.2. Draft of letter written by Willibald Pirckheimer in 1530 and addressed to Johann Tscherte. Stadtbibliothek Nuremberg. Photo: Volker Schier.

away within the same forgotten sheaf of Pirckheimer papers, provides another piece of the story of Dürer's relationships with Frau Agnes and friend Willibald. Ironically this letter exists only as a draft and was probably never sent. It is full of corrections, with a corner snipped out of the paper, and contains pen trials, sentences scrawled in the margins, and notes on other matters written upside-down in available spaces (Figure 11.2). Writing two years after Dürer's death, Pirckheimer addresses his scribblings to Johann Tscherte, the imperial architect in Vienna, who had also been an acquaintance of Dürer perhaps even before 1522, when the two met to discuss city fortifications. Not only had Dürer and Tscherte exchanged letters, but Dürer had often been the subject of discussion in previous correspondence between Tscherte and

Pirckheimer. For example, in a letter surviving from 1524, Tscherte had advised Pirckheimer to encourage Dürer to complete his treatise on perspective.[15] Pirckheimer begins his missive of 1530 with the customary salutations and mentions their deceased mutual friend, asserting that Tscherte loved Dürer because of his "art and virtue" (vmb seyner kunst vnd dugent willen). Then he launches into a diatribe:

> With Dürer I have truly lost the best friend I had on earth and I regret nothing more than that he died such a hard death. For God's sake, I can blame no one other than his wife, who made his heart heavy and tormented him, to the extent that he took leave of this life all the more quickly. He was dried up like a bundle of straw, he was allowed to seek courage nowhere, nor to go among the people. That evil woman was anxiety ridden, for which she certainly had no cause. What is more, she drove him to work hard day and night solely in order to earn money that he would leave to her when he died, because she wanted to ruin everything, just as she still does now, not seeming to appreciate that Albrecht left her with a worth in the range of six thousand guilders. But that isn't enough. And, all things considered, she alone is the cause of his death. I myself have often prayed for this combative and punitive creature. I had warned her, predicting what the end result would be, but for that I have had nothing but ingratitude, because she became the enemy of whoever wanted the best for this man and stayed close to him. So that truly she pestered him to the utmost and brought him to his grave.
>
> Since his death I have never seen her, and I have not wanted to have her come to me, although I have nonetheless been helpful to her in many ways, but there is no trust on her part. She is suspicious of whoever disagrees with her in any way or does not say that she is always right; she will always immediately become the adversary. This is why she would rather have me far away from her than close by. This is not to say that she and her sister are lascivious women but rather—I do not doubt—pious God-fearing women. But it would be better for a man to have a tart who is amiable than such a nagging, suspicious, fault-finding and sanctimonious woman, with whom he can enjoy peace neither by day nor by night.
>
> (Ich hab warlich an Albrechten der pesten freunt eynen, so ich auf erdreych gehabt hab, verloren, vnd dauert mich nichtz höher, dann das

er so eynes hartseligen todes verstorben ist, welchen ich nach der ver-
hengnus gotte niemandt dann seyner hausfrawen zu sachen kan, die im
seyn hertz eyngenagen vnd der maß gepeyniget hat, das er sich dest
schneller von hinen gemacht hat, dann er was ausgedort wie eyn
schaub, dorft niendert keynen guten muet mer suchen, oder zu den
leutenn geen; also het das pos weyb seyn sorg, das ir doch warlich nit
not gethan hat; zu dem hat sy ime dag vnd nacht anglegen, zu der
arbeyt hertiglich gedrungen, alleyn darumb, das er gelt verdienet vnd ir
das ließ, so er stürb, dann sy allweg verderben hat wollen, wie sy dann
noch thuet, vnangesehen das ir Albrecht pis in die sex tausent gulden
wert gelassen hat; aber da ist keyn genügen, vnd in summa ist sy alleyn
seins dodes eyn vrsach. Ich hab sy selbs oft für ier argwenig, streflich
wesen gepeten vnd sy gewarnet vnd ir forgesagt, was das end hie von
seyn würd, aber damit hab ich nichtz anderst dann vndank erlangt,
dann wer diesem man wol gewolt vnd vmb in gesest ist, dem ist sy
feynt worden, das warlich den Albrecht mit dem höchsten wekümert
hat vnd ine vnder die erden pracht hat.

Ich hab ir seid seynes dodes nie gesehen, sy auch nit zu mir wollen
lassen, wie wol ich ir dan noch in fil sachen hilflich gewest pin, aber da
ist keyn vertrauen; wer ir widerpart halat vnd nit aller sach recht gibt,
der ist ir verdechtlich, dem wird sy auch alspald feynt, dar vmb sy mir
lieber weyt von mir dann vmb mich ist. Es sind ja sy vnd ier schwester
nit pübin [Buben], sonder wie ich nit zweyfel, der eren fromm vnd
ganz gotzförchtig frawen, es solt aber eyner lieber eyn pübin, die sich
sunst freuntlich hielt, haben dann solch nagent, argwenig vnd kiefend
from frauen, pey der er weder dag noch nacht rue oder frid haben
kont.)[16]

To analyze the passage and inquire into its original meanings we must
peruse its context. The letter was written two months before Pirckheimer's
own death. Suffering from gout and kidney stones, he had become an invalid.
Generally the tone of the missive is one of extreme bitterness. Obviously
disgruntled at his loss of power and influence in Nuremberg, Pirckheimer
scorned the Marburg Colloquy organized by Philipp of Hesse a year before
in the hope of uniting the various Protestant groups, voiced displeasure with
the cities that had adopted the Reformation, and complained about the dan-
ger of the guilds taking over city governments in Augsburg and elsewhere. As
Julius Leisching observed, "the Turks, the German princes, the Lutherans,

the Catholics, the communists, the Nuremberg City Council, the new religious sects—nothing escaped his terrible wrath."[17]

The reason Pirckheimer was considering sending a letter to Johann Tscherte is, however, far more banal: He was in search of some large deer antlers for his collection. With Tscherte's help he had been sent two sets—for which he expresses his gratitude—but then in the same breath contends that they were not good enough to be displayed in the hall of his residence.[18] "Albrecht," he continues, "also had several sets of antlers, among which there was one that was particularly fine, which I would have loved to have had, but she [Agnes] has secretly given them away, for but a song, along with some other very nice things" (Albrecht hat auch etliche gehören gehabt vnd vnder denselben gar eyn schöns, welches ich geren gehabt het, aber sy hat sy heymlich vnd vmb eyn spott sambt andern fil schönen dingen hinweg geben). Moriz Thausing, the only Dürer biographer who has ever looked at the entire letter critically, points out that this fine set of deer antlers was the only subject in this lengthy epistle with which Pirckheimer expressed any pleasure![19] His disappointment over not receiving the antlers appears to be the catalyst for the character assassination of Agnes, with which he began the letter as we have seen in the passage quoted above. Clearly the letter speaks of Pirckheimer's jealousy. He asserts that Agnes kept Albrecht to herself, not allowing him to seek courage, implicitly from his friends, but it would appear that Pirckheimer means primarily himself. As for his statement that Agnes had not permitted Albrecht to go out "among the people," it appears that the accusations are indeed unwarranted, since it is clear from Dürer's Netherlandish diary that he relished contact with a great many people. This is further substantiated by the many letters that have survived from various contemporaries, who mention him.[20] Even during his last years, when he appears to have suffered acutely from malaria, Dürer communicated with many people, met with Philipp Melanchthon, and even attended a dinner at the Nuremberg city hall.[21] Interestingly, Lorenz Beheim had counseled that, because of his fragile health, Dürer should stay at home with his wife.[22]

With his claim that Agnes hastened Albrecht's death, Pirckheimer reverses Albrecht's earlier playful indictment that Pirckheimer would kill Agnes. Albrecht wished to prohibit Pirckheimer's potentially fatal advances toward Agnes; Pirckheimer now accuses Agnes of having brought about the death of Albrecht. Albrecht wanted to keep Willibald away from Agnes; Willibald wanted to keep Agnes away from Albrecht. Clearly Pirckheimer had attempted to force his way into the Dürer marriage. Pirckheimer's accusation—

unlike Albrecht's—was, however, more than a joke and, as we shall see, was taken very seriously by posterity.

By asserting that she hastened his death by forcing him to work hard in order to make money, Pirckheimer may be speaking both with the voice of the Nuremberg patrician and that of the Renaissance humanist. By self-definition the leading families of Nuremberg lived not by manual labor or from the actual exchange of finished products for currency, but rather through their investments, their holdings in land or in the mining industries. Moreover—aside from the time he devoted to his romantic involvements—Pirckheimer personally chose to occupy himself primarily with intellectual pursuits, particularly with reading and translating classical authors. The humanist motto he chose for the portrait that Dürer fashioned of him as a copper engraving in 1524 (B. 106) reflects this nonmaterialist attitude: "One lives through the intellect, everything else is subject to death" (vivitur ingenio caetera mortis erunt). Pirckheimer thus implies that it is folly to concentrate on the making of artifacts, since they are objects of *vanitas* and thus transient and mortal. This notion serves to veil the material realities of art and its production.[23] That which he disavows he projects onto Agnes. Clearly Pirckheimer believes that she was not good for Albrecht, and by comparison he—Pirckheimer—was a better friend and a more proper influence.

Through his expression of insult because he was deprived of the antlers, he seems, at least to a degree, to have displaced his sense of bereavement onto this object and redirected his feeling of anger toward Agnes as the putative cause of his loss. He makes clear that Agnes did not value the antlers, and he obviously believed that she had no right to Albrecht's antlers—antlers being, we may observe, a visible sign of masculinity and in many ways the animal equivalent of Dürer's much touted beard.

Subsequently in his letter, Pirckheimer addresses the relationship between himself and Agnes Dürer. He contends that he tried to help her and she spurned his attempts; here, however, his words are somewhat contradictory, since he likewise claims that he had never seen her since the death of Albrecht two years earlier, as she had not wished to see him. It is likely that Pirckheimer, lacking in sensitivity and understanding, had been a bit too patriarchal, which Agnes Dürer had perceived as arrogant and condescending. We need only recall Dürer's earlier admonition that his friend had shown too little gentleness when speaking with Agnes—not to mention the allusions to Pirckheimer's potential for doing her fatal bodily harm. Likewise we must remember that she had managed the workshop on her own and initiated

selling trips to Frankfurt. Clearly Pirckheimer's draft of a letter demonstrates that he was not as important to the Dürer family enterprise as he would have wished to be or as significant as history has made him. Apparently without help from Pirckheimer, the widow Dürer was able to handle many business matters, including having Dürer's *Four Books on Human Proportion* translated into Latin by the renowned humanist Joachim Camerarius and reprinted for a wider audience as well as taking action against those who were pirating her late husband's work and having it printed as their own in Strasbourg.

It is significant that Pirckheimer apparently never sent the letter. Perhaps even he found it too venomous. Other writings show that he was apparently quick to vent his emotions on paper and often later softened his sentences. In 1522, for example, he dedicated one of his translations to the prothonotary Ulrich Varnbühler, of whom Dürer fashioned a woodcut portrait (B. 155). Two earlier drafts of the dedication epistle survive and chronicle Pirckheimer's initial efforts to ridicule Dürer's comments about his imaginative fantasies—an endeavor from which only traces survive in the printed version.[24]

Reception of Relationships

Even relationships have reception histories. Interestingly, the literary reception of the relationship of Albrecht and Agnes began before the Pirckheimer papers were lost and forgotten, as the passage denigrating Agnes Dürer—and only this passage—became known in Nuremberg. These virulent and uncontrolled scratches of one person's pen somehow escaped from the private piece of paper that held them, they lost their personal connection with Pirckheimer, and they made their way into print, where they had an enormous impact on the biographical writings about Dürer.[25] Already Joachim von Sandrart published the passage in his influential *Teutsche Academie der edlen Bau-, Bild-, und Mahlerey-Künste* (1675). This publication was mostly responsible for the proliferation of the unflattering portrait of Agnes Dürer and negative image of the Dürer marriage painted by Pirckheimer. Sandrart further asserted that since Agnes Dürer would give her husband no rest, day or night, he secretly left for the Netherlands in 1521, primarily to escape her nagging. Dürer's own diary from the trip, in which he often mentions his wife, makes it clear that they made the journey together—but this document, although available in at least two handwritten copies, was not published until 1828. Further, although no correspondence between Albrecht and Agnes has

survived, it is now known that they wrote to each other while he was in Italy because he mentions letters from and to her in his letters to Pirckheimer. Nonetheless the notion that Dürer traveled frequently in order to get away from his wife has often been repeated in the biographical literature—even after the discovery of sources to the contrary.

The art historical practice of narrating artistic development against a backdrop of the artist's biography is very consistently applied in the case of Dürer. It is therefore almost amusing to recount both the manipulations of the written documents on Dürer's life—which are particularly abundant—as well as the maneuvers in the interpretation of Dürer's art that have been perpetrated on the basis of the ever-expanding myths of the evil wife Agnes. In his influential reference book on Nuremberg's important historical personalities, *Nachrichten von Nürnberger Mathematikern und Künstlern,* printed in 1730, Johann Doppelmayr went so far as to alter a quotation from Camerarius's foreword to his Latin translation of Dürer's *Four Books on Human Proportion.* By inserting the word *uxor* he made it sound as if Dürer's wife was the unwavering perfectionist rather than Dürer himself. Further, not only by interspersing the Pirckheimer diatribe printed by Sandrart, but also juggling the word order, he inverted the syntax to convey the thought that Dürer wished to die in order to escape the strictness of his wife—all of which was implicitly attributed to Camerarius![26]

Agnes Dürer was likewise written into the story of the artist Albrecht Dürer in other ways. For example, Theodor Hampe surmises that it was "Frau Agnes," who convinced Albrecht to devote himself to the more lucrative production of prints after his completion of the *Heller Altarpiece,* even though Albrecht himself lamented in a letter written in 1509, that if he had made more engravings instead of painstaking paintings he would have been one thousand guilders richer.[27]

Many other authors followed the lead of Johann Friedrich Roth, who, in his romantic biography of 1791, blamed Dürer's father for having arranged the marriage with Agnes Frey, a situation that Dürer himself describes in completely matter-of-fact terms in his *Family Chronicle.*[28] In the more recent literature, the custom of arranged marriages is faulted as the reason for Dürer's supposed unhappiness.[29]

Similarly, authors have (mis)interpreted the passages in Dürer's family chronicle in which he praises his deceased mother because she endured so many hardships and yet maintained a pleasant disposition. "My pious mother carried and raised eighteen children, often had the plague, many other serious

illnesses, suffered great poverty, ridicule, disrespect, derisive words, terror and scorn, but she never became bitter" (Diese meine fromme Mutter hat 18 Kinder getragen und erzogen, hat oft die Pestilenz gehabt, viel andre schwere merkliche Krankheit, hat grosse Armut gelitten, Verspottung, Verachtung, höhnische Worte, Schrecken vnd grosse Widerwärtigkeit; doch ist sie nie rachselig gewest).[30] Here authors have read the daughter-in-law into this text as the perpetrator of the scorn and derision.[31] More recently, textual analysis has however demonstrated that much of this tract followed set formulas and that Dürer's assessments—including his mother's alleged poverty—are not to be taken literally.[32]

Further, meanings were forced onto the enigmatic references or names that have eluded historians in the letters to Pirckheimer, in order to fashion them as expressions of Dürer's alleged hatred of his wife. For example, the nickname *Rechenmeisterin*, used for the wife of a prominent Nuremberg bookkeeper—a name that appears often in the letters, and, as stated above, is listed among those of Pirckheimer's women friends—was (mis)interpreted as a nickname for Agnes, used purportedly due to her miserly character. Likewise Dürer's use of the term *Unflat*, meaning "dirt" or "filth" in reference to a person no longer identifiable, was taken as an insulting term for his wife.[33]

Similarly, in the letter of October 1506, which was analyzed above, an anti-Agnes intention was forced onto an extremely cryptic passage near the end, in which Dürer tells Pirckheimer, "Let me know how it is to *braut* the *Ko'merle*, something that you wouldn't begrudge me either." Nothing meaningful for *Ko'merle* has ever been persuasively proposed. Could it be based on a family name? Could it be a nickname derived from the name of a bird—the *Kornmerle*, known in England as the roller? Could it refer to something abstract and draw on an analogy with the Virgin Mary—*Chormädel*, choir maiden? The meaning remains shrouded in the darkness of a male friendship, the encoded language and intertextuality of which did not outlive its two participants. Nonetheless, as recently as 1956, Hans Rupprich suggested that Dürer here refers to his wife with a derogatory word not unlike "old crow" or "old bird" and that this afterthought was connected to Pirckheimer's threat that he would take sexual liberties with Dürer's wife if he did not hurry home quickly.[34]

Even the shockingly explicit passage itself was manipulated by scholars to produce a meaning supposedly indicative of Dürer's own feelings of ill will toward his (unpleasant) wife. The conjunction in the sentence, spelled *den*,

is usually taken to function causally and mean "because then" (*dann*): "It is not allowed that you do this *because* you will kill her." Several scholars have however taken it to mean the conditional *unless* (*denn* or *es sei denn*): "It is not allowed that you do this *unless* you kill her."[35] Translators are also not innocent of refashioning meanings. For example, William Conway cleans up the statement, turning Dürer's flattery of Pirckheimer's male prowess into a more innocuous comment on his weight: "And as to your threat that, unless I come home soon, you will make love to my wife, don't attempt it—a ponderous fellow like you would be the death of her."[36]

The eighteenth-century Altdorf professor Georg Andreas Will committed one of the most misogynist interventions in Dürer's biography when he—in the course of his convoluted explication of a medallion showing the head of a woman and bearing Dürer's monogram—called Agnes Dürer a murderer.[37] Similarly, the French biographer Maurice Hamel asserted that Agnes had poisoned Albrecht.[38]

Dürer's art was likewise seen as a repository of his ill feelings toward his wife and as containing evidence of his unhappy marriage. One example is his copper engraving *The Promenade* (see Figure 9.3), in which Dürer depicted an amorous, fashionably dressed couple with a representation of Death as a skeleton holding an hourglass menacingly peering out from behind a tree in the background. Rather than reading the image as an allegorical motif following the *vanitas* theme, Will interpreted the picture as an expression of Albrecht's fearful premonition that Agnes would one day be the cause of his death.[39]

Throughout most of the years of their marriage, Albrecht Dürer affectionately recorded and carefully studied his wife's visage. In addition to the studies for figures in paintings and prints, in which scholars have recognized Agnes as the sitter or model, six autonomous portrait drawings survive, five of which bear labels in Dürer's own hand certifying that the images are those of his wife Agnes.[40] Ironically here too critics claim to see indications of Agnes's evil character traits. Of the earliest—the spontaneous and impulsively sketched ink drawing dated between 1494 and 1497 with Albrecht's intimate caption "Mein Agnes" (W. 151; Figure 11.3)—Gustav Pauli writes, "from the pose nothing more can be said than that the person represented is free of any suspicion of coquetry." Of the silverpoint drawing of 1504 bearing the title *Albrecht Dürerin* (W. 283), he contends, "the almost closed mouth with small upper lip and stark stare of the eyes convey more the feeling of energy than of intelligence." Albrecht also sketched Agnes while they were in the Low

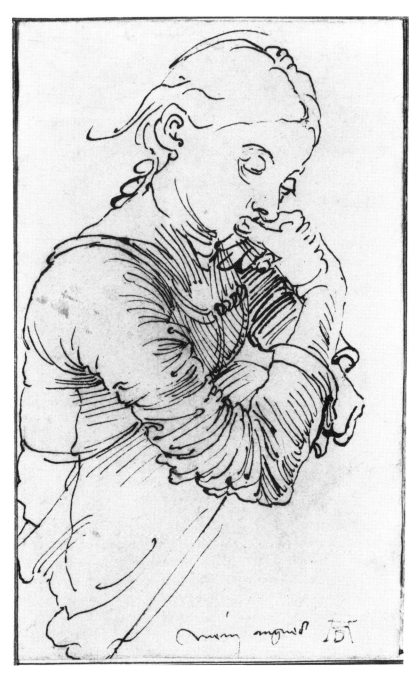

11.3. *Mein Agnes*, 1494/98. Pen and ink drawing, 15.6 x 9.8 cm. Albertina, Vienna.

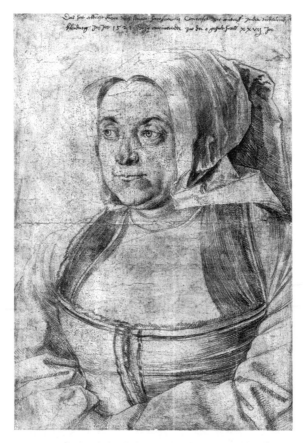

II.4. *Agnes Dürer in Netherlandish Clothing*, 1521. Silverpoint drawing, 40.1 x 27.1 cm. Staatliche Museen, Kupferstichkabinett, Berlin. Photo: Jörg P. Anders, Bildarchiv Preussischer Kulturbesitz.

Countries (W. 814; Figure 11.4). The sentence he scrawled at the upper edge of the sheet documents his appreciation of their marriage and his reflection on their travels together: "This Albrecht Dürer rendered of his wife in Netherlandish clothing at Antwerp in the year 1521, since they have had each other in marriage 26 1/2 years" (Das hat albrecht dürer noch seiner hawsfrawen Conterfet zw atorff in der niderlendischen Kleidung im Jor 1521 do sy aneinder zw der e gehabt hetten XXVI 1/2 Jor). Of this portrait Pauli writes, "In the features of the mouth one imagines the approach of a good mood, which one would like to understand as her expression of satisfaction with her substantial finery, but, of course, the eyes do not laugh along." Albrecht executed

another drawing of Agnes in 1521, this one during the return trip, as his caption informs us, while the couple was on the Rhine near Boppard (W. 780; see Figure 2.12). Here Pauli discerns "a face now changed and unfriendly," and a chin that is "ready for combat." Generally Pauli asserts, in his article written for a respected art historical journal in 1915, that she was "a woman from a good family, affluent enough, with regular facial features, parsimonious, pious, and disciplined, but unlovable and of limited mental capacity—one of a thousand," and on the basis of his analysis of the portraits he concludes that "her body was built by her spirit."[41]

The friendship between Albrecht Dürer and Willibald Pirckheimer has likewise had a reception history. By contrast this relationship was glorified. In the same reference work in which he had maligned the relationship between Dürer and his wife by altering a quotation by Camerarius, Doppelmayr elevated the friendship between Dürer and Pirckheimer by publishing a double portrait of the two together. In many biographies of Dürer's life and work as well as in separate articles, the friendship between the two men has been emphasized. Assessments such as those of Willehad Eckert and Christoph von Imhoff are not uncommon: "Dürer was still caught up in the Gothic era, and Pirckheimer made him into a modern Renaissance artist." Or, expanding their praise of the alleged symbiosis of the friendship: "It is hardly possible to think of the one without the other."[42]

We may further summarize that, in the humanist narrative of Albrecht Dürer's biography, Willibald Pirckheimer has been written in as a supporting character, and Agnes Dürer has been made to assume the role of the villain. For the fashioning of the great male genius not only the former but also the latter was absolutely necessary. In order to become a tragic hero, Dürer needed to suffer and to overcome tremendous obstacles for the sake of creating great works of art. For this purpose the character of the nagging Agnes was developed and perpetuated.

Dürer's Relationships Amid the Practicalities and Passions of Art and Life

Past relationships, like all of history, are not reconstructible. We can be sure, however, that Dürer's bonds to his two closest companions were many faceted. There were utilitarian sides to his relationships—not only to that with Agnes but also to that with Willibald (Figure 11.5). Not surprisingly, although

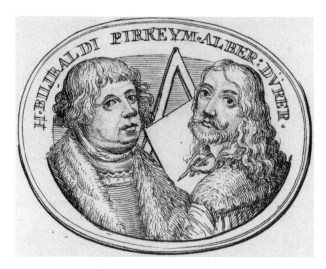

11.5. *Willibald Pirckheimer with Albrecht Dürer.* Illustration in Johann Doppelmayr, *Nachrichten von Nürnberger Mathematikern und Künstlern* (Nuremberg, 1730). Photo: Volker Schier.

Pirckheimer denied any materialist interests, he continuously relied on Dürer to further his collecting obsessions. Dürer's letters from Venice show that Pirckheimer instructed Dürer to find things ranging from birds' feathers, to precious stones, to rings, to carpets, to manuscripts of Greek texts. Moreover, although Pirckheimer never commissioned Dürer to fashion an autonomous, publicly visible work of art—neither an altar nor a print—he frequently employed Dürer to design such personal and private things as his ex libris as well as to provide illuminations and decorations for a great many books in his ever-expanding library. Dürer, on the other hand, borrowed money from Pirckheimer in order to make his trip to Italy in 1505, and the letters suggest that in Dürer's absence Pirckheimer also lent money to the family workshop in Nuremberg when necessary. What is more, Pirckheimer did read, correct, and critique the drafts of Dürer's theoretical writings prior to their publication—perhaps the strongest proof of intellectual friendship that one author can show to another.

The voices of historians are, however, not always in harmony with the voices that survive from contemporary sources. For example, the relationship may not have been as reciprocal as many scholars perceive it. Christoph Scheurl writes that "Pirckheimer treated Dürer like a brother,"[43] whereas Dürer, as we have observed, writes that Pirckheimer was like a "father" to

him. Much of the Dürer literature contends that the two were childhood playmates and that their friendship therefore was not inhibited by the constraints of class difference.[44] Recent scholarship, however, has questioned the assumption that the two grew up in neighboring houses.[45] The abovementioned mutual friend of the two men, Lorenz Beheim, compiled a horoscope for Dürer that he sent to Pirckheimer. Beheim contended that he had read in the stars that Dürer would dominate Pirckheimer: "the Lord would trust his servant" and the servant would "command his lord."[46]

Indeed the sources also present other provocative possibilities, even if they provide few definitive answers. Did Albrecht Dürer welcome Pirckheimer into his intimate sphere? Did the two maintain a merely homosocial bond, as we have seen from the letters, or was it also homosexual? In this respect, the Greek words scribbled by Pirckheimer into the upper margin of a silverpoint portrait that Dürer had made of him around 1503 (Figure 11.6) are indeed provocative: "with the erect penis in the anus of the man" (*Arsenos te psole es ton prokton*).[47] The phrase is unambiguous, but without a clearer context it will never be known if the author of the drawing was the object of Pirckheimer's erotic desire, and much less if the desire was reciprocated or consummated.

How separate did Dürer keep these two presumably close relationships in his life? The accidents of history have preserved for us Willibald's attitude toward Agnes; time, however, has obliterated expressions of her sentiments with respect to him—although such feelings are visible beneath the surface

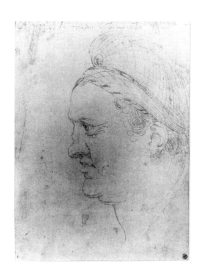

11.6. *Willibald Pirckheimer*, ca. 1503. Silverpoint drawing, 21.1 x 15 cm. Staatliche Museen, Kupferstichkabinett, Berlin. Photo: Jörg P. Anders, Bildarchiv Preussischer Kulturbesitz.

of his claims that she rejected his help. Clearly all three were persons of passion. Pirckheimer was known for his fiery temper, frequent feuds with many individuals—forcing him to leave the city council on two occasions—and fights, including at least one that led to a charge of "inflicting bodily harm" resulting in not only a fine but short-term incarceration. We have witnessed his polemic personality in the draft of a letter addressed to Tscherte. Perhaps his most noble moment occurred when he persuasively argued before the Nuremberg city council in defense of the nuns of St. Klara who wished to remain in their monastery at the time of the Reformation; and his darkest hour of infamy came about when he assumed leadership in expelling the Jews from Nuremberg in the pogrom of 1498 and 1499.[48]

Agnes Dürer emerges most distinctly in the documents that preserve her will and her voice after Albrecht's death. For example, she acted on the strength of religious convictions and class consciousness when she endowed a scholarship for sons of Nuremberg craftsmen who wished to study Lutheran theology in Wittenberg and then return to serve their city as pastors.[49]

Dürer's passions radiate through the surfaces of his pictures and prose. His letters, diaries, and sketchbooks bulged with his fascination for new places, people, and fashions; with his attraction for exotic objects from the New World as well as for strange and wonderful creatures from near and far. He was driven to learn new methods for his art, which he ardently attempted to pass on to other artists.[50] He thought and acted empirically, gathering data from many visual sources, including his thirty-year preoccupation with distilling the norms of anatomical proportions.[51] He enthusiastically accepted the new religious accents of the Reformation as an emancipatory experience.[52] He reveled in presenting male and female bodies—young and old, clothed and nude—for the scopic pleasure of his audiences. For example, in his copper engraving of *Adam and Eve* from 1504, next to the pleasantly rounded forms of a comparatively compact and rather immobile figure of Eve he presents the strongly articulated muscular physique of Adam standing astride, with arms extended—one holding a branch with Dürer's signature plaque and a parrot (see Figure 5.8). Likewise, he was strongly aware of his own attractiveness and delighted in presenting himself, both clothed in finery and unclad, for the onlooker's gaze.

Not only must the Dürer scholarship rebut the negative image of Agnes that has been received, but the positive character of Willibald and his all-encompassing influence on Albrecht must be revised. Stimulation and inspiration emanated from many quarters and at different times.[53] From Dürer's

words and pictures we can hear and see a man whose work profited from various platforms of support and collaboration as well as whose art was born of passion and of the tensions and challenges of one who did not remain undistracted by the desires and demands of life—but perhaps one who was open to them and gave in to them. Out of these passions and desires, graphic and painted representations were created that allow latter-day viewers to interface with their own passions and desires as they are drawn back to contemplate the people who produced them.

Impossible Distance: Past and Present in the Study of Dürer and Grünewald

Keith Moxey

BY WAY OF a case study of the changing historiographic fortunes of Albrecht Dürer and Matthias Grünewald (ca. 1475/80–1528), this essay reflects on an important assumption underlying the disciplinary activities of art history— the idea of *historical distance*.[1] The rich literature on this subject in the philosophy of history has prompted this consideration as to whether, and to what extent, the special circumstances of specifically art historical writing demand a different approach to its analysis. Art historical literature offers a number of ways in which the distance between the historical horizon under consideration and that of the interpreting historian might be conceived, and these ideas in turn have offered the discipline enduring models of methodological procedure.[2] My purpose here is not to evaluate these paradigms of historical distance, but rather to consider their function. What is their nature, what purpose do they serve, and how do they change over time?

The role played by the object that is the focus of art historical speculation cannot be ignored. The aesthetic power of works of art, the fascination of images and their capacity to dominate our response to them in the present, argues against treating them as if they were simply documents of particular historical horizons.[3] Works of art can appear so present, so immediately accessible, that it is often difficult to keep in mind that they are as opaque as any

other historical trace. Can we think dispassionately about objects that compel a phenomenological reaction? Is not the intensity of our confrontation with the art of the past such that we cannot easily articulate the nature of our relation to it?[4] The present imperative of the objects of art historical fascination inevitably shapes the way in which we think about their role in their own historical location. This reminder is not to suggest that art historians can do without a concept of distance—far from it—but to propose that every attempt at definition betrays our incapacity to stabilize its meaning.

My argument will depend for its force on remembering the historiography of German Renaissance art during the 1930s and 1940s. The use of the German past by the National Socialists, the conflation of historical horizons in the interest of nationalist propaganda, is an extreme example of the rejection of an objectifying distance between past and present. As a necessary reaction to the way in which the art of German Renaissance artists, such as Dürer and Grünewald, had been identified with the nationalist and racist doctrines of National Socialism, postwar historians emphasized the distance that separated the past from the present. The history of art had to be purged of its relation to the present so as to ensure an "untainted" view of the past. The success of this distancing project allowed postwar historians to imagine that they were separated from the historical horizons they studied by an absolute and unbridgeable gulf.

But I am getting ahead of myself here. Before we delve into the historiography of Dürer and Grünewald, I want to frame the argument in terms of the role of memory in historical writing. How do we keep the objects of the past at bay, while simultaneously insisting on their contemporary relevance? An insistence on our access to the past is as important a feature of historical writing as an acknowledgment of its absence, especially if it is to be a cultural medium for enabling the present to come to terms with the past. Like remembering and forgetting, historical writing appears to depend on the paradox of asserting the presence of meaning in the past, while simultaneously recognizing that its articulation by the contemporary historian transforms that meaning beyond recognition. The inherent power of history seems to lie in its capacity to create the past as much as to document it.

Since the work of Pierre Nora, Patrick Hutton, and others—especially those interested in the history of the Holocaust—the concept of memory has seemed to offer historians a notion more flexible than that of history, yet just as capable of suggesting the meaning of the events of the past.[5] As Freud suggested long ago, memories are themselves recast every time they are called

to mind. Memory, like history, cannot escape the effects of the context in which it is rehearsed. Both memory and history can be characterized as acts of will, impositions on the chaos of the past of an order and significance that cannot be found in "reality." Just as the meaning of a text depends on a Derridean "supplement" to convince us of its absent presence, both memories and histories depend on the illusion of being "found" rather than "made" in order to repress the creative role of agency in their construction.[6] Freud's purpose in attacking the Aristotelian theory of memory as the imprint of experience on the mind, of course, was not to suggest that experience left no traces, but to argue that far from being mechanically summoned to consciousness in its original condition, experience is actually transformed by memory in the process of recreating it. Rather than a memory cure—rather than simply enabling the patient to recall the traumas of childhood—psychoanalysis offers the patient a means of making those traumas accessible to consciousness, thus encouraging the formation of narratives that can enable him or her to come to terms with the past. The purpose of remembering is to offer the patient the capacity to forget.[7]

Memory, however, will not leave us alone. Despite our appreciation of the presentness of the task of interpretation and our consciousness of the fleeting validity of even the most persuasive analyses, we persist in trying to grasp what cannot and will not be pinned down. It is, perhaps, the knowledge that something escapes our understanding that makes both memories and works of art so fascinating. The ongoing need to construct historical distance in the face of the impossibility of ever keeping past and present wholly distinct is clearly exemplified in the historiography of German Renaissance art, particularly the writing on the two canonical artists of the period, Albrecht Dürer and Matthias Grünewald. The literature on these artists is so immense, however, that it needs be sampled rather than systematically reviewed. The political implications of the following story cannot be overlooked. This reflection on the impossibility of achieving the historical distance necessary to distinguish past from present in historical narratives is meant to enhance the importance of the historian's task, not to diminish it. The very excesses of the nationalist historiography I am about to review seem to guarantee a positivist rather than a relativist approach to the study of the past. In other words, why dignify this unfortunate historiographic episode with serious consideration? In response, I will argue that it is our very experience of the political uses of the past that allows us to be aware of not only the role of the present in the

construction of the historical narratives of others, but our responsibility for the shapes we give to our own.

During the Weimar Republic and the period of National Socialism, Dürer and Grünewald were often compared and contrasted as a means of articulating the competing agendas of different nationalist groups. Whereas Dürer had been appreciated and studied since the sixteenth century, an interest in the art of Grünewald surfaced only in the late nineteenth. All knowledge of his identity had been lost by the seventeenth century. When Joachim von Sandrart, himself a leading German painter, published his two-volume history of German art in 1675, he confessed that he had little to convey about this painter but hearsay. Indeed the name he bestowed on him, "Mattheus Grünewald," or "Mattheus von Asschaffenburg," has never been documented in archival sources.[8] A more telling reason for this oblivion, however, may have been the fact that the *Isenheim Altarpiece* was located in Alsace, a German-speaking province of France that became part of Germany only following the Franco-Prussian War of 1870.[9] It was thus in the context of the nationalist movement that led to the foundation of Germany as a nation-state that German scholars turned their attention to this little-known artist.

Wilhelm Worringer claimed in 1911 that there was an essential quality of German art that distinguished it from that of all other countries, a quality he discerned in the expressive linearity of German art of the Middle Ages. Similarly, the first monograph on the artist, Heinrich Schmid's two-volume work of the same year, argued that Grünewald was a quintessentially German spirit. His work supposedly united the northern traditions of late Gothic art with that of the Baroque while ignoring the intervening moment of the "foreign" (i.e., Italian) Renaissance.[10] In contrast to Worringer, who had regarded Dürer and Holbein as the supreme artists of the German Renaissance, Schmid insisted that Grünewald was a more fitting example of the German spirit because he had evaded the influence of Italy.

In the nationalist tradition of art writing that followed, the historical distance separating the age of Dürer and Grünewald from the present is invoked only to collapse it in the interest of a political ideology. The difference between sixteenth-century Germany and that of the early twentieth is brought to mind only to be sacrificed on the altar of an alleged continuity of national identity. The alterity of the past is elided in the interest of a transhistorical narrative that dramatizes the essential nature, the inalterable constancy of the German spirit. This new reading of Grünewald opened the doors to a flood of nationalist criticism that ultimately made his reputation equal, if not supe-

rior, to that of Dürer's. Heinrich Wölfflin, for example, was caught up in the desire to compare the two artists in terms of their Germanness. Writing in 1905, Wölfflin insinuates that Dürer's concern with the theory and practice of Italian art constitutes a betrayal of his Germanic heritage, for he believes that his art was riven by conflicting impulses arising from the clash of his native training with his cosmopolitanism: "After so many basic objections one hardly dares ask the question: can Dürer be extolled by us as *the* German painter? Rather must it not finally be admitted that a great talent has erred and lost its instincts by imitating foreign characteristics? Without doubt there is much in Dürer's art, and not only in his early art, that is original and delicious. But his work is interspersed with things which are alien to us. Samson lost his locks in the lap of the Italian seductress."[11] Comparing Dürer to Grünewald, Wölfflin engineers an art historical hydraulics. As one rises in his esteem, the other falls, according to a scale of values that depends on the relative intensity of their Germanic spirit: "New conceptions of the nature of German art have been formed and Grünewald has moved from the periphery to the center. He has indeed become the mirror in which the majority of Germans recognize themselves and his isolation has ended. . . . Now it is rather Dürer who appears to be the exception. . . . We demand living color. Not the rational but the irrational. Not structure but free rhythm. Not the fabricated object but one that has grown as if by chance."[12]

Critical attention to Grünewald increased during World War I, when Franco-German hostilities threatened the city of Colmar. In 1917, against the wishes of the city's government, the German military authorities transported the *Isenheim Altarpiece* to Munich for safekeeping.[13] Once there, it was restored and cleaned before being put on exhibition, when it immediately became the object of pilgrimage. According to Ann Stieglitz, "Special tours to see the altar were arranged for those coming from out of town, and wounded soldiers, many limbless, were wheeled in front of it, where religious services were held."[14] At war's end, the *Isenheim Altarpiece*'s return to France was accompanied by effusions of nationalist outrage on the part of the German press and by self-congratulatory cheer on the part of the Allies. An anonymous article in a Munich newspaper, dated September 28, 1919, captures the emotional intensity of the scene of impending loss:

Schoolboys of ten or twelve with colored caps, or bare heads; workers; citizens; . . . painters; old people; children. Like a procession, a stream flowed regularly passed [*sic*] the back of the altar, where St. Anthony's

visit to the Hermit and the Temptation were to be seen—and the awe-some drama of the split Golgotha picture: the one arm of the Crucified Christ detached from the crossbeam into the airThe red removal van stood below. A wretched reality: like a coffin and grave. The lost war. One cannot keep back this thought; and it is neither unobjective nor sentimental. A piece of Germany is being cut away, the most noble part: Alsace, Alemmania. Grünewald.[15]

The opening of the outer panels of the altarpiece (Figure 12.1), in which Christ's body appears to be torn apart, his arm rent from his torso—a feature that had caught the attention of many earlier (and later) commentators—is here invested with new meaning. A material vestige of the past, the *Isenheim Altarpiece* serves like an allegory of the role of memory in the production of contemporary meaning. Far from being exhibited for its own sake—rather than being the object of antiquarian interest—the image has become a means by which national identity can be crystallized and defined in the present. Grünewald's Crucifixion becomes a symbol of Germany's agony, the passion it suffered as a consequence of its defeat in World War I.

Just as the altar was capable of being used for nationalist purposes, it also proved amenable to those who rejected German militarism. In 1928, George Grosz was prosecuted for blasphemy for his published drawing of a crucified Christ donning a gas mask and boots (Figure 12.2). The illustration, cap-tioned "Shut Up and Do Your Duty," plays off the national obsession with the *Isenheim Altarpiece* in order to mock the church for support of the mili-tary. In this drawing, the emaciated body, the nail-torn hands, the twisted legs, and the ripped loincloth of the *Isenheim Altar* are juxtaposed with the gas mask and boots of trench warfare to produce a devastating comment on the function of the clergy in times of war.[16] These sensational events indicate that the nationalist rhetoric of German art historians is far more than a purely textual phenomenon. The social and cultural circumstances in which the rediscovery of Grünewald took place are part and parcel of the attitudes manifested in art historical criticism. In fact, they are inextricably meshed into a coherent worldview. Anyone writing on this subject in Germany at this time would have found it difficult to evade the nationalist rhetoric with which discussions of German culture had been invested. The counterexample provided by the works of George Grosz, which cast an ironic glance at the nationalist appropriation of Grünewald, proves the exception to the rule.

According to Oskar Hagen, perhaps the most nationalist author to write

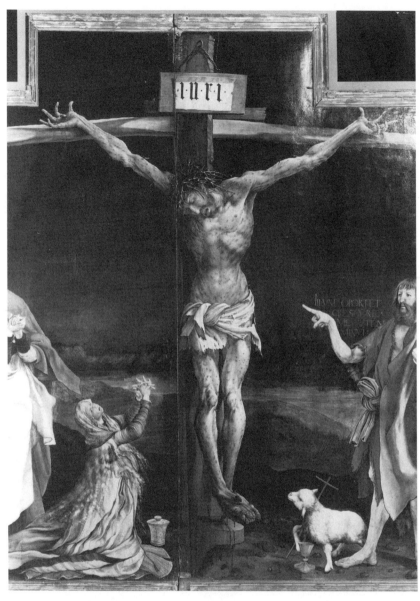

12.1. Matthias Grünewald, *Isenheim Altarpiece*, completed 1515. Oil on panel, 269 x 307 cm (center panel). Photo: Bridgeman-Giraudon / Art Resource, New York.

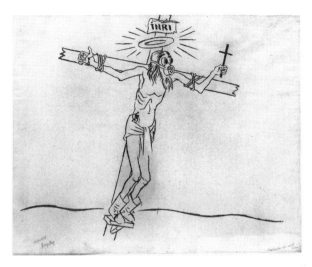

12.2. George Grosz, *Shut Up and Do Your Duty*, 1927. Drawing, 15.2 x 18.1 cm. Stiftung Archiv der Akademie der Künste, Berlin.

on Grünewald, the artist's capacity to penetrate the surface of appearances so as to grasp the reality that lay beneath served the religious transformations of the time. Instead of Grünewald's being a devout Catholic, as most have assumed, Hagen claims that Grünewald's work embodies the spirit of the Reformation that is yet to come. Luther's language and Grünewald's imagery register the realities of the spiritual life in the same way.[17] Whereas Dürer's mature work is dedicated to the concept of "beauty," Grünewald's art is never limited to a desire to be faithful to appearances. Echoing Worringer's claim that the basic characteristic of German art is its dedication to line, Hagen suggests that Grünewald's line must be regarded as a metaphor. He exploits the hidden potential of the ornamental dimensions of line to invest even the smallest silhouette with the expressive and poetic power of fantasy.[18] The contrast between Dürer and Grünewald animates his entire text. If Dürer's art is one of representation, in which the role of mimesis is paramount, Grünewald's is an expressive art akin to poetry or music. His art represents the uniquely German power responsible for the Reformation.

Friedrich Haack's book, of 1928, specifically invokes Grünewald as the patron saint of the most important German modernist movement of the period, Expressionism: "The present moment always reaches back into the deep well of the past in order to draw out that which corresponds with its own demands and requirements as well as its desires and ambitions. This

modern Expressionism has chosen a relatively unknown German painter, a contemporary of Albrecht Dürer, the great and mighty Matthias Grünewald, to be both its sworn companion and patron saint."[19] The Expressionists, according to Haack, find their inspiration in Grünewald, for he has bequeathed them a model of immediacy, rapture, and delirium as well as a "glowing, scintillating, orgasmic, symphony of color."[20] The expressive quality of Grunewald's color, the artist's willingness to bend the rules of mimesis—the spiritual freedom and the inner necessity that fuel this fantasy—are revived by contemporary artists as metaphors of national identity.

Nationalist criticism during the 1920s had favored Grünewald over Dürer as the most genuine representative of the German tradition in art, but nevertheless there were many authors who continued to plead Dürer's case in the nationalist cause. The fervor with which his candidacy was pursued intensified in the years preceding World War II when the Expressionist movement came under fire from theorists within National Socialism. Until 1933–34, the party seems to have by and large subscribed to the view that the German Expressionists constituted a manifestation of eternal German values. After that date, however, it turned its back on all aspects of modernism, a development that led to the infamous "Degenerate Art" exhibition held in Munich in 1937, at which both Expressionist art and artists were held up to ridicule.[21] Because Grünewald's status depended on the fate of Expressionism, both hung in the balance of National Socialist Party politics. The revival of interest in Dürer in the late 1930s and during the war, therefore, represents a rejection of Grünewald, an artist too intimately associated with degenerate modernism.

Some authors, therefore, approached Dürer's iconography with an eye to its nationalist potential. A striking feature of German writing on Dürer in the years immediately before and during World War II is the prominence ascribed to his famous engraving, *Knight, Death, and the Devil* (see Figure 7.1). Although the work had already been associated with German national identity in the nineteenth century, it had also been identified as a representation of the Christian knight.[22] Wilhelm Waetzoldt, the author of an influential book on Dürer, delivered a lecture on this image in 1936 in which he made it an icon of nationalist sentiment: "Dürer's high thinking epoch perceived the triumphant organ sound of the print. Fainthearted generations on the other hand heard more the harmonies of *memento mori*. Heroic souls love this engraving as Nietzsche did and as Adolf Hitler does today. They love it because it personifies victory. It is of course true that death will one day conquer us all, but it is equally true that a heroic man wins a moral victory

over death. This is the eternal message of this print, the spiritual bond that unites Dürer's time and ours. Dürer's clarion call sounds to us across the centuries and finds once more an echo in our German hearts."[23] The role of the past in this kind of rhetoric is to justify and validate the present. It is only "fainthearted generations" that have failed to see the print's reference to the victory of the German cause. The print is ascribed a transhistorical essence whose "truth" proscribes interpretive disagreement.

Rather than continuing to dwell on this sorry moment in the history of scholarship of the German Renaissance—rather than add further examples of its service in the cause of a racist nationalism—I want to reflect upon what we can learn from this historiographic review. To what extent has the fate of subsequent interpretation in this field depended on forgetting that this episode ever took place? What does this act of oblivion tell us about the nature of historical writing? How does postwar writing on this subject differ from that of the preceding period? What ideological purposes have the figures of Dürer and Grünewald subsequently served? What has happened to the binary oppositions and the critical hydraulics that animated the evaluation of Dürer and Grünewald in nationalist criticism? How can we characterize the approaches to these artists taken by art historians working today?

The extremism of the nationalist moment, its unconscionable brutality, led to a disavowal of the values and concerns of the present in accounts of the past. After World War II, the historiography of the German Renaissance has deliberately turned its back on politics, and the historical significance of Dürer and Grünewald is less often assessed in nationalist terms; art historians have ceased to decipher the essence of German identity encrypted in their work. The goal of postwar historians has been to insist that historical distance, the difference between the past and the present, in itself represents a safeguard to the infection of the past by the present. The past had proven too powerful a tool in the hands of the present and had once more to be banished to its proper historical horizon. The great architect of the new order was Erwin Panofsky. Having lost his professorship at the University of Hamburg because he was Jewish, Panofsky made his home in the United States. This exiled scholar was responsible for developing the most influential and lasting theory of historical distance in postwar art historical writing. According to Panofsky, the concept of historical distance appeared only in the Renaissance, because earlier periods had been incapable of integrating the visual forms and literary traditions of antiquity into the stylistic vocabularies of their own times. This integration was the great achievement of the later age:

"the two medieval renascences were limited and transitory; the Renaissance was total and permanent."[24] A powerful metaphor for the ability of the Renaissance to "see" the past correctly was, of course, one-point perspective. It is no accident that Panofsky also argued that one of the greatest achievements of the Renaissance was to have established the most persuasive principles for representing space illusionistically.[25] In fusing the capacity of the Renaissance culture to build a distance between itself and the past with its development of a geometric system that permitted a convincing representation of space, Panofsky gave this historical moment an unusually privileged place in European history. The spatial rationality of the Renaissance thus became a metaphor of objectivity. The new paradigm of art historical method achieved by these means was no less powerful because its metaphoric status was more often ignored than acknowledged.

Though Panofsky could not consciously have recognized this investment, the entire notion of historical distance was a defense of humanist culture and a means of keeping history safe from "ideologues." The need to keep "civilization" out of the hands of barbarians made him value his scholarship in the United States as a means of ensuring the survival of values that were threatened with obliteration in fascist Europe.[26] Whereas for the nationalist historians the collapse of historical distance was important as a way of claiming the continuity of national identity, for Panofsky historical distance was a means of validating the purportedly universal values of the humanist tradition. If nationalist critics working in a Hegelian tradition had exploited Hegel's view that the unfolding of the "Spirit" was best observed in the art of different peoples or nations, Panofsky's debt to this philosopher may be discerned in exalting the Renaissance as a decisive moment in the self-realization of humanity.[27]

Panofsky's magnum opus on Dürer fundamentally structured the course of postwar studies on this artist.[28] The nationalist epic of Dürer's encounter with Italy, the tragedy of the adulteration of his Germanic spirit with the imported values of Italian culture, was inverted and replaced with a more personal dichotomy. Rather than abandon his own artistic tradition in light of foreign models, Dürer was now seen as torn between the artisanal naturalism of his Nuremberg training, with its dedication to empirical observation, and an interest in Italian theory as a way of producing forms whose aesthetic guarantee lay in the realm of ideas rather than experience. The role of Italy in Panofsky's account of Dürer's work not only ruptures the alleged continu-

ity of the German national spirit but also symbolizes the enlightened tradition of humanist rationality.

Panofsky, then, rejects and recasts the binary opposition of the nationalist account so as to offer a different narrative altogether. The moral to be drawn from his life of the artist has nothing to do with the German essence of Dürer's personality, but rather with the agonizing conflict between two aspects of his artistic genius. Instead of *Knight, Death, and the Devil*, once again interpreted as an allegory of the Christian life, Panofsky's emblem for Dürer becomes *Melencolia I* (see Figure 3.1). The émigré art historian reads the print as an allegory not only of the emerging Renaissance consciousness of the artist as an exceptionally gifted individual, but also of Dürer's own struggle with competing dimensions of his personality.[29] The conflict between tradition and theory in Dürer's art is analogous to the clash of ideologies in Panofsky's own day. Dürer's inability to reconcile theory and mimesis, characterized by Panofsky as a "failure," may be regarded as a metaphor of the art historian's own alienation from German culture, and Dürer's defeat at the hands of tradition, a symbol of the rout of Enlightenment values in Nazi Germany. Panofsky's tale is thus supported by a double "supplement": on the one hand, its implicit criticism of the nationalist historiography—its insistence on historical distance—represents a political alternative to what had gone before; on the other, its unconscious expression of his deep melancholy at the loss of the ideals that inspired the German culture of his youth affords us access to the motives that inspired his own narrative.[30]

Panofsky's views on historical distance have not, of course, gone unchallenged in an age that has called Enlightenment humanism into question. Taking issue with the objectivist and quasi-scientific tradition of art historical writing that has its origins in his work, Georges Didi-Huberman has recently argued that art history is necessarily an "anachronistic" discipline. While purporting to be about the past, it cannot escape its involvement with objects in the present. Far from denying the possibility of historical distance, Didi-Huberman recognizes that art history fundamentally depends on it. This distance, however, cannot be fixed, for it is forever subject to a negotiation between past and present: "Too present and the object runs the risk of becoming nothing but the support of fantasy. Too past and it runs the risk of becoming nothing more than a mere residue, lifeless, killed by its own 'objectivity' (another fantasy). One should neither attempt to fix or eliminate this distance: one should make it work in the differential tempo of moments of empathetic proximity—anachronistic and unverifiable—together with mo-

ments of critical withdrawal—scrupulous and examined."³¹ Didi-Huberman's
comments recognize the tension between the lure of the object—the aesthetic
demands of the work of art in the present—and the need to register the
alterity of the past. In his attempt to do justice to the past, Panofsky failed
to acknowledge the inherent anachronism of the discipline to which he con-
tributed so much.

Postwar German scholars followed Panofsky in regarding Dürer's art as a
biographical rather than a national allegory. The relation of the artist's life to
his work, the Vasarian paradigm in which art history was born, was resusci-
tated as the most effective means to combat the ideological forces that had
employed these works as part of a sinister narrative of national identity. Both
Peter Strieder and Fedja Anzelewsky, for example, who produced immensely
learned contributions to the Dürer literature, emphasized the artist's life as
the driving force behind his art. While affording the reader an enormous
amount of information about the social and cultural circumstances in which
he lived, this material becomes a means of dramatizing the artist's artistic
achievements. These accomplishments are personal and timeless rather than
historical and collective.³² By emphasizing the role of the individual, by
stressing Dürer's incomparable gifts—gifts that set him apart from mere mor-
tals—these authors, consciously or unconsciously, supported the political
agenda of a democratic and capitalist Germany. Dürer's power of agency, his
capacity to transform the artistic conventions of his time, becomes an allegory
of the value of the individual over the collective, while simultaneously justify-
ing the commodity status of the aesthetic constituents of the canon. The
extraordinary claims made for the aesthetic quality of Dürer's work, claims
made on the basis of his exceptional talent, not only serve as a guarantee of
its market value, but this exaltation of the canonical male artist, of course,
constitutes a confirmation of gendered power relations. Just as Panofsky's
interpretation of *Melencolia I* depended on Dürer's access to the new concept
of melancholy forged in the Neoplatonic context of Renaissance Florence,
many of Anzelewsky's contributions to our understanding of Dürer's iconog-
raphy depend on the claim that Dürer was aware of the ideas of Marsilio
Ficino.³³ The suggestion that Dürer's works are to be approached as learned
allegories serves to remove them from the context of communal life so as to
embed them more deeply in his personal consciousness.

Panofsky's theory of historical distance, so effective a means of containing
the political and ideological in the unconscious of historical texts, could not,
however, prevent Dürer's appropriation for political purposes. The eruption

of political interests into the historical appreciation of Albrecht Dürer is most evident in the context of the celebrations that marked the four hundredth anniversary of his birth in 1971.[34] Both East and West Germany felt a nationalist compulsion to celebrate Dürer as a great German artist. In West Germany the government supported an extensive exhibition under the patronage of the nation's president, its chancellor, the vice president of the Bundestag, and the mayor of Nuremberg.[35] The location of the exhibition was certainly no accident. Nuremberg was not only Dürer's native city, but it had long been associated with the Holy Roman Empire, having housed the Habsburg crown jewels until the eighteenth century when they were transferred to Vienna. While Nuremberg's prestige as the city linked with medieval German majesty had been tarnished by the events of the Third Reich (Hitler held some of his major rallies there, and it was, of course, the site of the war crimes tribunal), its history was clearly important to the creation of a new sense of national identity.[36] In contrast to the national purpose discernible in the nature and location of West Germany's celebration of the anniversary of Dürer's birth, the exhibition's catalog offers an encyclopedic account of Dürer's life and times in which empirical information appears to outweigh an interpretative agenda. Because of its moral force, the basic outlines of the Panofsky interpretation remain unchallenged. His treatment of Dürer's life as an allegory of the struggle between reason and unreason, blind tradition and enlightened innovation, coincided with the political need to provide West German national life with an ideology that was both progressive and inspiring.

Panofsky's thesis, however, did not coincide with the motives of the East German celebration. Beginning in the 1960s, both Dürer and Grünewald became increasingly identified with what came to be known as "the early bourgeois revolution." Marxist theorists argued that the Peasants' War of 1525 had been an important precursor of class war, which was considered the inevitable outcome of the capitalist system of their own time. Because of the intimate connection between the demands of the serfs for both spiritual and economic freedom, it was possible to suggest that the Reformation and the peasant movement were one, and that there was unity between the spiritual transformations of the age and class warfare.[37] Both the German Democratic Republic's major exhibition in Berlin and its official publications fêted Dürer as an artist with a social conscience. The preface to a collection of essays published by the Karl Marx University in Leipzig claims that Dürer's genius stems from his consciousness of the artist's responsibility for social progress

and his utopian vision of the future of humanity.[38] According to Ernst Ull-mann, Dürer identified with the progressive forces that were responsible for the religious and social transformations of his time: "For Dürer the beautiful also included the true and the good, a proper understanding, and an educa-tional and uplifting effect on the viewer. Thus Dürer, himself one of the heroes of his age, did not just passively mirror one of the greatest revolution-ary processes in the transition from the Middle Ages to modernity, but through his work he took an active role in it—in freeing the individual from the chains of class that characterized the old feudal society and in the forma-tion of autonomous individuals."[39] Comparing and contrasting Dürer and Grünewald in the manner to which we have become accustomed, Wolfgang Hütt argued that while both artists identified with the peasant cause, Dürer followed the humanist tradition of Italy, but Grünewald rejected all things Italian because of his opposition to the Catholic Church.[40] His image of the Crucifixion represents his belief in the social justice for which the peasants fought: "For Gothardt Neithardt [Grünewald], the crucified Christ embod-ied a belief in the justice for which the peasants of 1525 had fought against the powerful of this world. The peasants, the proletariat, the intellectuals, and the artists, proved too weak, and the historical situation not yet ready, for them to realize the justice for which they strove."[41]

Such scholars trade Panofsky's interpretation for another of the "master narratives" of their own time. Rather than see Dürer as engaged in a personal struggle of reason and unreason, virtue and vice, he becomes a hero of the class struggle. Once more historical distance is sacrificed in the interest of a transhistorical principle. Dürer's role in asserting the value of the individual and his prescience in choosing the style best suited to the demands of a socialist culture allow him to be identified with the values of the Marxist narrative. Not only does the teleology of this narrative promise a utopian future to those who recognize and support its truth, but it also serves to enhance the national prestige of the East German state that sponsors it.

This brief analysis of the cultural function of the concept of historical distance in German historiography of the twentieth century cannot close without a look at the texts that could be said to define the critical situation in which the literature on Dürer and Grünewald currently finds itself (at least for the English-speaking world). What are the circumstances in which the literature on Dürer and Grünewald currently unfolds? What methodological tools do contemporary authors deploy in their writing, and how do these

differ from those of the past? What is the relation between the immediacy of aesthetic response and the objectifying impulse of the historian?

Among the most influential recent studies on Albrecht Dürer is that authored by Joseph Koerner.[42] In an ambitious analysis of his *Self-Portrait* of 1500 (A. 66; Figure 12.3), Koerner claims that Dürer consciously asserted the unique status of the artist as a divinely gifted creator. The artist emerges as the architect of a new age, one who calls into being a new era of art. Grounding himself in a phenomenological approach to his subject, Koerner self-consciously hints that he is as incapable of articulating the philosophical motivation of his narrative any more than Dürer was capable of articulating his. In other words, he explicitly acknowledges the problem with which we have been grappling, namely, the necessity for historical blindness in the pursuit of historical insight. Koerner offers us an argument for the idea that it is the power of the image, the immediacy of our response, that prevents us from ever fully articulating the grounds that animate the narratives we choose to spin about them: "Dürer proposes himself as origin; and in placing him at the start, indeed in arguing that he has already prefaced what I shall say about him, I underwrite his proposal."[43]

Koerner's answer to the problem of historical distance is thus the antithesis of Panofsky's. Instead of emphasizing the gulf that separates historical horizons—one that can only be surmounted by a Kantian "symbolic form" (in this case the metaphor of Renaissance perspective)—he collapses the distinction.[44] The art historian's access to the past is not to be accomplished by eliminating all traces of the present that might possibly affect our encounter with the past, but rather, he or she affords us access to it by erasing the distinction that keeps past and present distinct from one another. Engaging the past becomes the means of asserting the role of the present in the process of interpretation. In the writing of history, the past becomes, to all intents and purposes, the present.

Koerner's perspective introduces a new epistemological basis for historical writing. Rather than share Panofsky's belief in the objective power of reason to discern the nature of what happened in the past, Koerner collapses the subject/object distinction in order to make the works speak for themselves. An Enlightenment trust in rational objectivity is abandoned in favor of personal engagement. Like Panofsky's, Koerner's strategy tends to elide the philosophical, cultural, and political stakes of interpretation. Rather than being explicitly articulated, these remain, perhaps necessarily, embedded in the act of interpretation. This characteristic of his approach need not prevent us

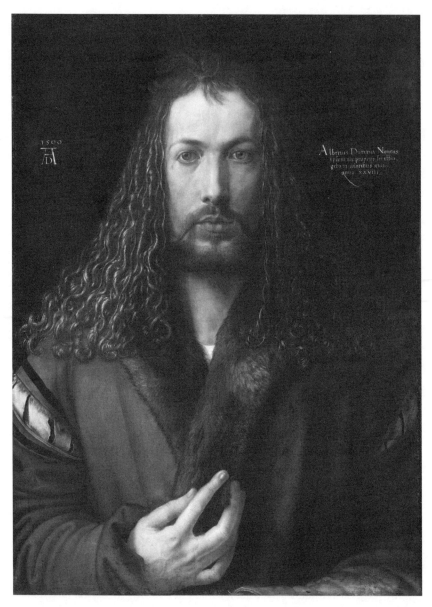

12.3. *Self-Portrait*, 1500. Oil on lindenwood panel, 67 x 49 cm. Alte Pinakothek, Munich. Photo: Bridgeman-Giraudon / Art Resource, New York.

from speculating about the values that may inform the writing. Koerner writes at a historical moment that has witnessed a theoretical challenge to the positivistic idea that scholarly "objectivity" can be guaranteed by a unified and autonomous subjectivity.[45] It is only appropriate that Koerner should have written a paean of praise to the creation of this mythic subject of the humanist tradition at the moment of its dissolution. His invocation of reception theorists, such as Hans Robert Jauss and Wolfgang Iser, who emphasize the historical continuity of aesthetic response between the moment of the work's inception and its reception, is crucial to the idea of the "fusion" of historical horizons.[46] In this case, the very concept that purports to enable the present access to the past serves to obscure the nature of that transaction.

It goes without saying that Koerner's attitude serves to sabotage the biographical paradigm on which so much of the postwar scholarship has been based. The epoch-making quality he finds in Dürer's art is located as much in the work as in the figure of the artist. In Dürer's *Self-Portrait* of 1500, both artist and work merge as they call the age of art into being. While his book could be (and probably has been) used to support the value ascribed to Dürer's work in the capitalist marketplace, Koerner is more interested in the philosophical stakes of characterizing art history as a transpersonal process in which the role played by the object is at least as important as that played by its creator.

As a methodological foil to Koerner's Dürer book we might cite Andrée Hayum's on Grünewald. Citing Michael Baxandall's celebrated work on Florentine art of the fifteenth century, she indicates that her concern is to develop an anthropological approach to the interpretation of Grünewald's *Isenheim Altarpiece*.[47] Baxandall envisions the social history of art as a way of understanding a work of art within the full complexity of its cultural and social relations. In doing so he emphasizes the alterity of the past, the way in which it exceeds our powers of comprehension. By insisting on the difference of the past, Baxandall creates a critical distance between the historical horizon in question and the interpreting historian. If the past could be encountered in its totality, undistorted by the values of the present, then the essential "truth" of history might be established. Like Panofsky, his vision of the relation between the horizon of the past and the horizon of interpretation is meant to ensure that historical accounts are untainted by values extraneous to it.

Hayum's debt to Baxandall is principally evident in her discussion of the possible function of the altarpiece as part of the healing program of the An-

thonite order. She suggests that the work's graphic depiction of pain was the focus of an empathetic identification: the altarpiece permitted those afflicted with skin diseases (St. Anthony's fire) to relate their own suffering to that of Christ in a way that enhanced its promise of salvation. Her discussion of the altar's subject matter emphasizes the sacramental and therefore the Catholic program of the image, a conclusion that contradicts some of the earlier nationalist literature claiming that Grünewald was a pictorial equivalent of Martin Luther. She offers us an account of the role of the altar in its original cultural circumstances, one that focuses on the role of the work in an age for which the idea of aesthetic experience was unknown. Where Koerner explicitly acknowledges the importance of the historian's response to the image, Hayum does not draw attention to her own role in the creation of her narrative.

The contemporary literature on Dürer and Grünewald therefore presents us with two very different ways of dealing with the issue of historical distance. On the one hand, Koerner fuses the location of the historian with the past horizon by offering an account of the aesthetic import of past works of art. On the other, Hayum insists on the distance that separates past from present by establishing the "otherness" of the devotional object that is the object of her study. One gesture offers us an immediate response to a work that belongs to the past by approaching it as a *presentation*, an object that is accessible to our unmediated understanding, while the other conceives of the work as resistant to insight, one that must therefore be treated in a more circumstantial and indirect manner by focusing on its status as a *representation* of cultural and social values. The gesture that naturalizes our access to Dürer's image—that which minimizes the difficulties afforded our understanding by historical distance—also calls attention to the work of interpretation by emphasizing that the response in question is that of a particular historian working at a specific moment in time. By insisting on the ahistorical nature of his response to Dürer's compelling self-portrait, Koerner locates himself in time. His text draws attention as much to the age of his own response as it does to the time of the image's creation. Hayum's approach tends, on the other hand, to efface the identity of the interpreting historian. In an effort to be "true" to the historical horizon under investigation, her own temporal location is elided. The self-effacement that characterizes her attitude to the image serves to obscure the history of her own history.

One conclusion to this essay might be that in the history of art the power of its objects of interpretation significantly affects the historian's notion of

historical distance. The structural relation of art historians to the past seems markedly different from that of other historians. Rather than depending on documentary traces located in archives, the art historian confronts images that have been invested with power both in the past and the present. If the religious and magical functions they once served are no longer with us, if the power they once possessed for the cultures that created them has been diluted and obliterated by the passage of time, they now possess the power invested in them by the idea of the aesthetic.[48] The relation between the art historian and the art of the past appears to be one of mutual attraction. Undoubtedly there is "something" about the art of the past that calls for the attention of the present. The art historian's evidence is at once more engaging and more demanding than that of documents in an archive, or even the literary historian's books on the shelf. Insofar as they encounter images at a glance, rather than through the medium of time, they meet the intellectual character and the imaginative quality of the past with particular force. The very presence of images seems to suggest that no creative process of historical reconstruction is called for in order to comprehend their significance. They consume our attention and insist on an immediate reaction.

The demands of past art—the continuing need for interpretation and reinterpretation—returns us to the question of memory with which I began. If, like memory, the object's call for our attention means that its significance must forever be renegotiated, what is the relation of remembering to forgetting in the project of art historical writing? Is every historical interpretation condemned to oblivion as soon as the historical circumstances in which it was formulated have altered? Must forgetting be as much a part of the historian's approach to the past as remembering? If Dürer and Grünewald, for example, are to be memorialized today, is it crucial to set aside the debate as to which one was the most German of German artists?

Regardless of how much we may detest the uses to which historical writing was put by historians of the Nazi era, if we do not remember that the episode took place, we run the risk of essentializing, and therefore rendering ahistorical, our own interpretations. Needless to say, recalling this episode in the historiography of German Renaissance studies is not to validate it. Far from it. The way in which we interpret Dürer and Grünewald in the present can utilize this historical moment in the past to call attention to the double-edged nature of the scholar's task. That enterprise must somehow do justice to the work's appeal—its apparently transcendental quality as art—and its status as a historical artifact. These two poles are symbolized in this analysis by the

contrast in the ways in which Koerner and Hayum conceived of their inter-
pretations of the artists Albrecht Dürer and Matthias Grünewald. Can both
of these agendas be served by the same discipline? Is it possible to relativize
the intensity of aesthetic experience by locating it in its historiographic con-
text without losing the immediacy of its appeal? Must a phenomenological
response to past art blind us to the need to historicize it?

Like the patient in psychoanalysis, the historian must remember in order
to forget. New meaning can only be made of the past if the patterns discerned
there can be reworked in the context of the present. Yet the value of the new
pattern will only be revealed if those earlier traces can still be brought to
mind. An awareness of the importance of aesthetic response in art historical
interpretation should not obscure the recognition of historical distance and
the ever-changing nature of our interpretations. The acknowledgment that a
particular point of view is subject to the contingencies of time and place, not
to mention the subject position of the interpreter, is indispensable. In the
writing of art history the tension brought about by the past's power to shape
us, and our power to shape the past in return—the power of the work and
our need to tame it (so as to constitute the narratives by which we organize
our lives)—finds one of its most fascinating manifestations.

NOTES

CHAPTER 1. DÜRER—MAN, MEDIA, AND MYTHS

1. A good conspectus of many divergent viewpoints regarding the artist is given by Jan Białostocki, *Dürer and His Critics* (Baden-Baden: Verlag Valentin Koerner, 1986), 189–242, especially for the Germans' utilization of their native son; Jane Campbell Hutchison, *Albrecht Dürer: A Biography* (Princeton, N.J.: Princeton University Press, 1990), 187–206; Paul Münch, "Changing German Perceptions of the Historical Role of Albrecht Dürer," in *Dürer and His Culture*, ed. Dagmar Eichberger and Charles Zika (Cambridge: Cambridge University Press, 1998). The classic overview of the artist is Erwin Panofsky, *The Life and Art of Albrecht Dürer*, rev. ed. (Princeton, N.J.: Princeton University Press, 1955; subsequent references are to this edition unless noted otherwise), which particularly celebrates the connections between Dürer and the Italian Renaissance, the classical past, and the *ars nova* of fifteenth-century Flemish painting. Also see Erwin Panofsky, "Albrecht Dürer and Classical Antiquity," in Panofsky, *Meaning in the Visual Arts* (Garden City, N.Y.: Doubleday Anchor Books, 1955), 236–94; Arnold Nesselrath, "Raphael's Gift to Dürer," *Master Drawings* 31 (1993): 376–89; and, on the artist and his city, Dagmar Eichberger, "Albertus Dürer Noricus: A European Artist in the Context of His Native City Nuremberg," in *Dürer and Cranach: Art and Humanism in Renaissance Germany*, ed. Fernando Checa, exh. cat. (Madrid: Museo Thyssen-Bornemisza, 2007), 65–81.

2. Joseph Leo Koerner, *The Moment of Self-Portraiture in German Renaissance Art* (Chicago: University of Chicago Press, 1993).

3. Julius Held, *Dürers Wirkung auf die niederländische Kunst seiner Zeit* (The Hague: M. Nijhoff, 1931); Hans Kauffmann, "Dürer in der Kunst und im Kunsturteil um 1600," *Anzeiger des Germanischen Nationalmuseums* (1940–53): 18–60; *Dürer through Other Eyes*, exh. cat. (Williamstown, Mass.: Sterling and Francine Clark Art Institute, 1975); *Albert Dürer aux Pays-Bas*, exh. cat. (Brussels: Palais des Beaux-Arts, 1977); Leonie von Wilckens and Peter Strieder, eds., *Vorbild Dürer*, exh. cat., Germanisches Nationalmuseum, Nuremberg (Munich: Prestel, 1978); Gisela Goldberg, "Zur Ausprägung der Dürer-Renaissance in München," *Münchner Jahrbuch der bildenden Kunst* 31 (1980): 129–75; Herbert Beck and Bernhard Decker, eds., *Dürers Verwandlung in der Skulptur zwischen Renaissance und Barock*, exh. cat. (Frankfurt: Liebieghaus, 1981); Thomas DaCosta Kaufmann, "Herme-

neutics in the History of Art: Remarks on the Reception of Dürer in the Sixteenth and Early Seventeenth Centuries," in *New Perspectives on the Art of Renaissance Nuremberg: Five Essays*, ed. Jeffrey Chipps Smith (Austin, Tex.: Archer M. Huntington Art Gallery, 2005), 22–39.

4. On Dürer as a book publisher, perhaps his least examined activity as an image producer, see Dagmar Eichberger, "Dürer and the Printed Book," in *Albrecht Dürer in the Collection of the National Gallery of Victoria*, ed. Irena Zdanowicz (Melbourne: National Gallery of Victoria, 1994), 63–82; Rainer Schoch, Matthias Mende, and Anna Scherbaum, eds. *Dürer: Das druckgraphische Werk*, 3 vols. (Munich: Prestel, 2001–4), vol. 3. For some significant interpretations of the image, see Wilhelm Fraenger, "Dürers Gedächtnissäule für den Bauernkrieg," *Von Bosch bis Beckmann* (1953; Dresden: Verlag der Kunst, 1977), 25–39; Jan Białostocki, "La Mélancolie paysanne de Albrecht Dürer," *Gazette des Beaux-Arts*, 6 ser., no. 50 (1957): 195–202; Stephen Greenblatt, "Murdering Peasants: Status, Genre, and the Representation of Rebellion," *Representations* 1 (1983): 1–29; and especially Hans-Ernst Mittig, *Dürers Bauernsäule: Ein Monument des Widerspruchs* (Frankfurt: Fischer, 1984).

5. For an anthology of the diverse interpretations of the Peasant War, notably by East and West German scholars, see Bob Scribner and Gerhard Benecke, *The German Peasant War of 1525: New Viewpoints* (London: Allen and Unwin, 1979); Peter Blickle, *The Revolution of 1525* (Baltimore: Johns Hopkins University Press, 1981). For peasant and Reformation literature that includes this image, see Linda Parshall and Peter Parshall, *Art and the Reformation: An Annotated Bibliography* (Boston: G. K. Hall, 1986), 134–40; Hans-Joachim Raupp, *Bauernsatiren* (Niederzier: Lukassen, 1986), 132–33; Werner Hofmann, *Luther und die Folgen*, exh. cat., Kunsthalle, Hamburg (Munich: Prestel, 1983), no. 56; *Martin Luther und die Reformation in Deutschland*, exh. cat. (Nuremberg: Germanisches Nationalmuseum, 1983), no. 338; *Kunst der Reformationszeit*, exh. cat., Staatliche Museen, Berlin (Berlin: Elefanten Press, 1983), 68–69, no. A 21.1.

6. These interpretative conflicts about attitudes toward the peasantry recall the heated debate about Pieter Bruegel's peasant images, best summarized in Walter Gibson, *Pieter Bruegel the Elder: Two Studies* (Lawrence, Kans.: Spencer Museum of Art, 1991), 11–52; and Ethan Matt Kaveler, *Pieter Bruegel Parables of Order and Enterprise* (Cambridge: Cambridge University Press, 1999). Hofmann, *Luther und die Folgen*, 185, reads the animals of the base as images of innocence and sacrifice, which seems to diminish any possibility of irony in the presentation by Dürer.

7. Raupp, *Bauernsatiren*, 132–33, draws a distinction between this particular artistic interpretation and the caricatured representation of peasants in the earlier German satirical printmaking tradition. He writes, "Dürer foregoes the attributes of fools and the physical deformations of his predecessors. . . . Dürer founds no new iconography of the peasant. That the man Dürer took peasants as humans more seriously and defined his place relative to them with more understanding than the Housebook Master we can conclude on the basis of other circumstances: the famous sketch of a sarcastic triumphal column for the peasant sacrifices of 1525 is certainly no manifesto of partisanship for the rebels, but probably a sign of critical consciousness."

8. Gert von der Osten, "Christus im Elend und Herrgottsruhbild," *Reallexikon zur deutschen Kunstgeschichte* 3 (1954): col. 644, who argues that the type of the suffering Christ is related to the prototype of Job.

9. Mittig, *Dürers Bauernsäule*, 70–71; translation in *Albrecht Dürer: The Painter's Manual*, trans. and ed. Walter L. Strauss (New York: Abaris Books, 1977), 233, figs. 16–17.

10. The classic study of both the print and its larger cultural context, suggested by the title, is Raymond Klibansky, Fritz Saxl, and Erwin Panofsky, *Saturn and Melancholy: Studies in the History of Natural Philosophy, Religion, and Art* (New York: Basic Books, 1964). Most recently the definitive study of German outlook toward melancholy and other mental syndromes is H. C. Erik Midelfort, *A History of Madness in Sixteenth-Century Germany* (Stanford, Calif.: Stanford University Press, 1999); and a broader outlook is Stanley Jackson, *Melancholia and Depression: From Hippocratic Times to Modern Times* (New Haven, Conn.: Yale University Press, 1986). The most exhaustive study of the print is Peter-Klaus Schuster, *Melencolia I: Dürers Denkbild*, 2 vols. (Berlin: Gebr. Mann, 1989). Also see Konrad Hoffmann, "Dürers Melencolia," in *Kunst als Bedeutungsträger: Gedenkschrift für Günter Bandmann*, ed. Werner Busch, Reiner Hausherr, and Eduard Trier (Berlin: Gebr. Mann, 1978), 251–79; Philip Sohm, "Dürer's *Melencolia I*: The Limits of Knowledge," *Studies in the History of Art* 9 (1980): 12–32.

11. Keith Moxey, *The Practice of Theory* (Ithaca, N.Y.: Cornell University Press, 1994), 65–78, 88–93, accuses Panofsky of anachronism in his use of the concept of "genius" (92), which he locates instead as originating only at the end of the eighteenth and nineteenth century with Kantian aesthetics, "Art" in capitals. Thus Panofsky's ratification of "culture" becomes the mission of the exiled Panofsky through the figure of Dürer and his engraved allegory, which is then read as an "allegory of the struggle between reason and unreason in the German spirit." For the original argument, see Panofsky, *Dürer*, 156–71.

12. Frances Yates, *The Occult Philosophy in the Elizabethan Age* (London: Routledge and K. Paul, 1979), 49–59, 136–38. Like Moxey, Yates argues that "Panofsky wishes to move Dürer's image in a modern, or perhaps a nineteenth-century, direction, expressive of the sense of suffering and failure of the creative artist" (54). This slightly different, more focused, "romantic" notion of "genius" surely derives from the modern period. Yates in contrast returns to the hermetic and cabalistic elements of Agrippa's cosmology, linking magic and religion into an occult synthesis.

13. Yates, *Occult Philosophy*, 59 n. 20. This connection had already been made by Klibansky, Saxl, and Panofsky, *Saturn and Melancholy*, 382–84, and Yates's own argument was reinforced by Kaufmann, "Hermeneutics in the History of Art," 23, 33–35, n. 47, fig. 13. Also Bodo Brinkmann, *Cranach*, exh. cat. (London: Royal Academy, 2007), 316–19, nos. 97–98.

14. Charles Zika, "Dürer's Witch, Riding Women and Moral Order," in Eichberger and Zika, *Dürer and His Culture*, 118–40; and Charles Zika, *Exorcising Our Demons: Magic, Witchcraft and Visual Culture in Early Modern Europe* (Leiden: Brill, 2003), 333–74.

15. Hoffmann, "Dürers Melencolia," associates the bat with medieval personifications of Despair, caused by Pride, which shuns the light. Colin Eisler, *Dürer's Animals* (Wash-

ington, D.C.: Smithsonian Institution Press, 1991), 64–65, 98–99, cites Nicolas of Cusa in the fifteenth century: "Just as the eye of a bat hides itself from the light of day, so does our soul's eye hide from an understanding of what is clearest in nature." Surely this common association with evil of the bat as a "fly-by-night" creature needs little verbal documentation, and the use of bat wings for devilish demons, e.g., *Knight, Death, and the Devil* (Figure 7.1), remains consistent in Dürer's creations; see Eisler, 303–5.

16. Roberta Olson, *Fire and Ice: A History of Comets in Art* (Washington, D.C.: Smithsonian Institution, 1985), 26–49; Wilhelm Hess, *Himmels- und Naturerscheinungen in Einblattdrucken des XV. bis XVIII. Jahrhunderts* (Leipzig: W. Drugulin, 1911); *Zeichen am Himmel*, exh. cat. (Nuremberg: Germanisches Nationalmuseum, 1982); Jean-Michel Massing, "A Sixteenth-Century Illustrated Treatise on Comets," *Journal of the Warburg and Courtauld Institutes* 40 (1977): 318–22; Larry Silver, "Nature and Nature's God: Landscape and Cosmos of Albrecht Altdorfer," *Art Bulletin* 81 (1999): 194–214.

17. Wolfgang Stechow, *Northern Renaissance Art, 1400–1600: Sources and Documents* (Englewood Cliffs, N.J.: Prentice Hall, 1966), 112.

18. Koerner, *Moment of Self-Portraiture*, 35–37, 42–49. The inscription ("This I drew of myself in front of a mirror in the year 1484 when I was still a child. Albrecht Dürer.") dates only to the 1520s some four decades after he made the drawing.

19. Stechow, *Sources and Documents*, 86. On traditional artists' biographies over time, see Rudolf Wittkower and Margot Wittkower, *Born under Saturn* (New York: Random House, 1963); for an analysis and critique of this concept and its role in art history, see Catherine Soussloff, *The Absolute Artist* (Minneapolis: University of Minnesota Press, 1997).

20. Christopher White, *Dürer: The Artist and His Drawings* (London: Phaidon, 1971), no. 102.

21. Lotte Brand Philip with Fedja Anzelewsky, "The Portrait Diptych of Dürer's Parents," *Simiolus* 10 (1978–79): 5–18; Fedja Anzelewsky, *Albrecht Dürer: Das malerische Werk*, rev. ed. (Berlin: Deutscher Verlag für Kunstwissenschaft, 1991), 16, nos. 2–4; Michael Roth, ed., *Dürers Mutter: Schönheit, Alter und Tod im Bild der Renaissance*, exh. cat. (Berlin: Kupferstichkabinett, 2006), 3.

22. Erwin Panofsky's dissertation on Dürer's art theory and its relationship to Italy was completed in Freiburg in 1914 and published the following year as *Dürers Kunsttheorie, vornehmlich inihrem Verhältnis zur Kunsttheorie der Italiener* (Berlin: G. Reimer, 1915). Because of his historiographic importance to the discipline of art history, Panofsky has received much more study as an intellect than Wölfflin. See Michael Ann Holly, *Panofsky and the Foundations of Art History* (Ithaca, N.Y.: Cornell University Press, 1984), 46–68; Silvia Ferretti, *Cassirer, Panofsky and Warburg: Symbol, Art and History*, trans. Richard Pierce (New Haven, Conn.: Yale University Press, 1989), 142–236, esp. 188–92, 197–202, for early studies of Dürer; Keith Moxey, "Panofsky's Concept of 'Iconology' and the Problem of Interpretation in the History of Art," *New Literary History* 17 (1985–86): 265–74, esp. 269–70; Keith Moxey, "Panofsky's Melancholia" in his *Practice of Theory*, 65–78; Carl Landauer, "Erwin Panofsky and the Renascence of the Renaissance," *Renaissance*

Quarterly 47 (1994): 255–81; and, for a historiographic assessment of Panofsky's engagement with Dürer, see Jeffrey Chipps Smith, "Introduction," in Erwin Panofsky, *The Life and Art of Albrecht Dürer*, Princeton Classic Edition (Princeton, N.J.: Princeton University Press, 2005), xxvii–xliv, and his "Panofsky's Dürer," in *Dürer, l'Italia e l'Europa*, ed. Sybille Ebert-Schifferer (Rome: Bibliotheca Hertziana, in press). For more on Wölfflin and on art historiography in general, see Michael Podro, *The Critical Historians of Art* (New Haven, Conn.: Yale University Press, 1982), 98–151, 178–208; also Joan Hart, "Reinterpreting Wölfflin: Neo-Kantianism and Hermeneutics," *Art Journal* 42 (1982): 292–300.

23. Panofsky, *Dürer*, 242–84 ("Dürer as a Theorist of Art,"); Erwin Panofsky, "The History of the Theory of Human Proportions as a Reflection of the History of Styles" (orig. pub. 1921) and "Albrecht Dürer and Classical Antiquity" (orig. pub. 1921–22) in his *Meaning in the Visual Arts*, 55–107 and 236–94; Erwin Panofsky, *Perspective as Symbolic Form*, trans. Christopher Wood (New York: Zone Books, 1991).

24. Thus Panofsky underplays the religious art of Dürer both in general and in specific cases, such as the demonstration piece of ideal humanity, the 1504 engraving *Adam and Eve,* which Panofsky, *Dürer*, 84–87, reads as a cultural sellout to (still) nonclassical German viewers of what should have been an Apollo and Diana image, his own definition of the Renaissance as "reintegration of classical themes with classical motifs." See Erwin Panofsky, "Iconography and Iconology: An Introduction to the Study of Renaissance Art," in Panofsky, *Meaning in the Visual Arts*, 26–54. For a critique of Panofsky's benign notion of nudity, specifically in Dürer's print but also more generally for northern artists, see Larry Silver and Susan Smith, "Carnal Knowledge: The Late Engravings of Lucas van Leyden," *Nederlands Kunsthistorisch Jaarboek* 29 (1978): 239–98, esp. 245–48; Koerner, *Moment of Self-Portraiture*, 251–66, interprets Baldung's subsequent Eden images as inverting and subverting any ideality professed for the fFirst pParents by Dürer.

25. Erwin Panofsky, *Early Netherlandish Painting* (Cambridge, Mass.: Harvard University Press, 1953), 1–20. Note the telling passage from Panofsky's *Dürer*, 3–4: "the Renaissance and Baroque originated in Italy and were perfected in cooperation with the Netherlands. . . . In this great fugue the voice of Germany is missing. . . . It was by means of the graphic arts that Germany finally attained the rank of a Great Power in the domain of art, and this chiefly through the activity of one man who, though famous as a painter, became an international figure only in his capacity of engraver and woodcut designer: Albrecht Dürer." See again Moxey, *The Practice of Theory*, 66–69. It is for this reason that Panofsky's remarks on the celebrated 1498 *Apocalypse* concentrate chiefly on the graphic evolution of the woodcuts, concluding (with remarkable short-sightedness about their religious theme and millennialist context) that what is distinctive about these works is their naturalistic representations of visions. He remarks (*Dürer*, 55), "It was thanks to Mantegna, or rather to classical models transmitted through him and his followers, that Dürer was able to 'realize' the visions of St. John without destroying their phantasmagoric quality." To "realize" these visions, Dürer has to be at once an accomplished master of northern "naturalism" as well as Mantegnesque classicism for figural motion and emotion in order to show the suspension of natural laws in "miracles," but he also has to be able

to show the miraculous as an imaginary experience, which in this case is achieved through the "dematerializing" of the woodcut medium.

26. See the essays in Zdanowicz, *National Gallery of Victoria*; and in Eichberger and Zika, *Dürer and His Culture*, which includes a detailed bibliography of publications between 1971 and 1997 (237–50).

27. For a wider view of this issue, see J. R. Hale, "The Soldier in Germanic Graphic Art of the Renaissance," in *Art and History*, ed. R. Rotberg and Theodore Rabb (Cambridge: Cambridge University Press, 1988), 85–114; J. R. Hale, *Artists and Warfare in the Renaissance* (New Haven, Conn.: Yale University Press, 1990); Geoffrey Parker, *The Military Revolution* (Cambridge: Cambridge University Press, 1988); Keith Moxey, *Peasants, Warriors, and Wives* (Chicago: University of Chicago Press, 1989), 67–100.

28. Stechow, *Sources and Documents*, 112. On the issue of media as well as purposes of art, see Lydia Hilberer, *Iconic World: Albrecht Dürers Bildbegriff* (Würzburg: Königshausen & Neumann, 2008).

29. Katherine Crawford Luber, *Albrecht Dürer and the Venetian Renaissance* (Cambridge: Cambridge University Press, 2005); also Martin Kemp, "The Mean and Measure of All Things," and "Leonardo and Dürer," in *Circa 1492*, ed. Jay A. Levenson, exh. cat., National Gallery of Art, Washington, D.C. (New Haven, Conn.: Yale University Press, 1993), 95–111 and 270–302.

CHAPTER 2. DÜRER'S DRAWINGS

Both authors separately prepared different texts. The best features were combined and expanded by Christiane Andersson with extensive input from Larry Silver. —Ed. J. C. Smith.

1. W. numbers refer to Friedrich Winkler, *Die Zeichnungen Albrecht Dürers*, 4 vols. (Berlin: Deutscher Verein für Kunstwissenschaft, 1936–39), a catalogue raisonné of the artist's drawings. Winkler updated his catalog in Heinz Ladendorf, ed., *Festschrift Dr. H. C. Eduard Trautscholdt* (Hamburg: Hauswedell, 1965). Drawings more recently added to the oeuvre are found in the much less reliable Walter L. Strauss, *The Complete Drawings of Albrecht Dürer*, 6 vols. (New York: Abaris Books, 1974). See also Christopher White, *Dürer: The Artist and His Drawings* (London: Phaidon, 1971); Edmund Schilling, *Albrecht Dürer Drawings and Watercolors* (New York: Harper, 1949); Friedrich Winkler, *Albrecht Dürer, 80 Meisterzeichnungen* (Zürich: Atlantis Verlag, 1949); Heinrich Wölfflin, *Drawings of Albrecht Dürer*, trans. Stanley Appelbaum (New York: Dover, 1970). On the watercolors, see Fritz Koreny, *Albrecht Dürer and the Animal and Plant Studies of the Renaissance* (Boston: Little, Brown, 1988); Walter Koschatzky, *Albrecht Dürer: The Landscape Water-Colours* (New York: St. Martin's Press, 1973).

2. Walter Koschatzky and Alice Strobl, *Dürer Drawings in the Albertina* (Greenwich, Conn.: New York Graphic Society, 1972).

3. Fedja Anzelewsky and Hans Mielke, *Albrecht Dürer: Kritischer Katalog der Zeichnungen* (Berlin: Staatliche Museen Preussischer Kulturbesitz, Kupferstichkabinett, 1984);

Hans Mielke, *Albrecht Dürer: 50 Meisterzeichnungen aus dem Berliner Kupferstichkabinett,* exh. cat., Kunstmuseum, Düsseldorf (Berlin: Staatliche Museen Preussischer Kulturbesitz, Kupferstichkabinett, 1991).

4. Giulia Bartrum, ed., *Albrecht Dürer and His Legacy: The Graphic Work of a Renaissance Artist,* exh. cat. (London: British Museum, 2002).

5. Walter L. Strauss, ed., *The Book of Hours of Emperor Maximilian the First* (New York: Abaris Books, 1974).

6. Walter L. Strauss, ed., *The Human Figure by Albrecht Dürer: The Complete Dresden Sketchbook* (New York: Dover, 1972).

7. Hans Rupprich, *Dürer: Schriftlicher Nachlass,* 3 vols. (Berlin: Deutscher Verein für Kunstwissenschaft, 1956–69).

8. Susan Lambert, *Drawing: Technique and Purpose,* exh. cat. (London: Victoria and Albert Museum, 1981), 15–16. See Saskia Durian-Ress, ed., *Hans Baldung Grien in Freiburg,* exh. cat., Augustinermuseum, Freiburg (Freiburg: Rombach, 2001), nos. 35 and 49.

9. Eberhard Ruhmer, *Grünewald Drawings: Complete Edition,* trans. Anna Rose Cooper (London: Phaidon, 1972); Michael Roth et al., *Matthias Grünewald: Zeichnungen und Gemälde,* exh. cat., Kupferstichkabinett, Berlin (Ostfildern: Hatje Cantz, 2008).

10. Christiane Andersson, *Dirnen, Krieger, Narren: Ausgewählte Zeichnungen von Urs Graf* (Basel: GS-Verlag, 1978).

11. Robert Scheller, *Exemplum: Model-Book Drawings and the Practice of Artistic Transmission in the Middle Ages, ca. 900–ca. 1470* (Amsterdam: Amsterdam University Press, 1995); Ulrike Jenni, "Vom mittelalterlichen Musterbuch zum Skizzenbuch der Neuzeit," in *Die Parler und der schöne Stil, 1350–1400,* ed. Anton Legner, exh. cat. (Cologne: Schnütgen Museum, 1978), 139–50.

12. Konrad Lange and Franz Fuhse, *Dürers schriftlicher Nachlass* (Halle: Max Niemeyer, 1893), 221.

13. *From Schongauer to Holbein: Master Drawings from Basel and Berlin,* exh. cat. (Washington, D.C.: National Gallery of Art, 1999), no. 43.

14. Koschatzky and Strobl, *Drawings,* no.1; and Klaus Albrecht Schröder and Maria Luise Sternath, eds., *Albrecht Dürer,* exh. cat., Albertina, Vienna (Ostfildern: Hatje Cantz, 2003), no. 1.

15. Koschatzky and Strobl, *Drawings,* no. 67.

16. Ibid., 180 (with illustration).

17. Bartrum, *Dürer,* no. 193.

18. Ibid., no. 2.

19. Elfried Bock, *Die Zeichnungen in der Universitätsbibliothek Erlangen,* 2 vols. (Frankfurt: Prestel Verlag, 1929), no. 155; Rainer Schoch, ed., *100 Meister-Zeichnungen aus der Graphischen Sammlung der Universität Erlangen-Nürnberg,* exh. cat. (Nuremberg: Germanisches Nationalmuseum, 2008), no. 38.

20. Compare the *Self-Portrait,* ca. 1493, in the Lehman Collection at the Metropolitan Museum of Art, New York (W. 27), also done in pen and black ink.

21. Compare the charcoal drawing of 1503 *Head of the Dead Christ* (W. 272, British

Museum, London) and the *Self-Portrait Pointing to His Spleen*, ca. 1510 (W. 482, Bremen Kunsthalle). Bartrum, *Dürer*, no. 82; Schröder and Sternath, *Dürer*, no. 53.

22. Anne Röver-Kann, *Albrecht Dürer: Das Frauenbad von 1496*, exh. cat. (Bremen: Kunsthalle, 2001).

23. Compare Dürer's early use of perspective in his *Flagellation of Christ*, in Christiane Andersson and Charles W. Talbot, eds., *From a Mighty Fortress: Prints, Drawings, and Books in the Age of Luther, 1483–1546*, exh. cat. (Detroit: Detroit Institute of Arts, 1983), no. 21.

24. Schröder and Sternath, *Dürer*, no. 56.

25. *Albrecht Dürer, 1471–1528*, exh. cat., Germanisches Nationalmuseum, Nuremberg (Munich: Prestel, 1971), 88–89, no. 152 and 155; Rainer Schoch, Matthias Mende, and Anna Scherbaum, eds., *Dürer: Das druckgraphische Werk*, 3 vols. (Munich: Prestel, 2001–4), vol. 3, no. 262.

26. Hans Huth, *Künstler und Werkstatt der Spätgotik* (Darmstadt: Wissenschaftliche Buchgesellschaft, 1967), 26–42. For examples, see *From Schongauer to Holbein*, nos. 14, 20, 89.

27. White, *Drawings*, no. 50. The altarpiece was commissioned by Matthäus Landauer, a Nuremberg merchant, for the chapel of the Zwölfbrüderhaus, an almshouse for elderly craftsmen, which he established in Nuremberg. Karl Schütz, ed., *Albrecht Dürer im Kunsthistorischen Museum* (Vienna: Kunsthistorisches Museum, 1994), 12–39, nos. 5 and 10. Dürer's portrait study of Landauer (W. 511), dated 1511, is in Frankfurt (Städel Museum).

28. Schröder and Sternath, *Dürer*, no.111.

29. White, *Drawings*, no. 6; Charles W. Talbot, ed., *Dürer in America*, exh. cat. (Washington, D.C.: National Gallery of Art, 1971), no. 1.

30. White, *Drawings*, nos. 26–27; *From Schongauer to Holbein*, no. 60. Compare Dürer's metalpoint portrait of Pirckheimer (Figure 11.6, and see Corine Schleif's essay in this volume). On profile portraits, see Larry Silver, "The Face Is Familiar: German Renaissance Portrait Multiples in Print and Medals," *Word and Image* 19 (2003): 6–21.

31. White, *Drawings*, no. 63; Anzelewsky and Mielke, *Zeichnungen*, no. 79; Michael Roth, ed., *Dürers Mutter: Schönheit, Alter und Tod im Bild der Renaissance*, exh. cat. (Berlin: Kupferstichkabinett, 2006), nos. 1 and 2.

32. White, *Drawings*, no. 73; Katherine Crawford Luber, "Albrecht Dürer's Maximilian Portraits: An Investigation of Versions," *Master Drawings* 29 (1991): 30–47; Schröder and Sternath, *Dürer*, no. 164; Katherine Crawford Luber, *Albrecht Dürer and the Venetian Renaissance* (Cambridge: Cambridge University Press, 2005), 149–63; Vinzenz Oberhammer, "Die vier Bildnisse Kaiser Maximilians I von Albrecht Dürer," *Alte und Moderne Kunst* 14 (1969): 2–14; and Larry Silver's essay "Civic Courtship," in this volume.

33. Bartrum, *Dürer*, no. 38. Also see Julian Raby, *Venice, Dürer, and the Oriental Mode* (London: Sotheby Publications, 1982).

34. Koschatzsky and Strobl, *Drawings*, nos. 11 and 17; Schröder and Sternath, *Dürer*, nos. 23 and 137.

35. Schröder and Sternath, *Dürer*, nos. 35–37; Koschatzsky and Strobl, *Drawings*, nos. 18–20; White, *Drawings*, no. 22.

36. Barbara Butts and Lee Hendrix, eds., *Painting on Light: Drawings and Stained Glass in the Age of Dürer and Holbein*, exh. cat. (Los Angeles: J. Paul Getty Museum, 2000), nos. 10, 19–20, 27, and, for the Pfinzing window, fig. 28.

37. For Dürer and art theory, see Erwin Panofsky, *The Life and Art of Albrecht Dürer*, rev. ed. (Princeton, N.J.: Princeton University Press, 1955), 242–84. For a survey of Dürer's rendering of the human body, see Anne-Marie Bonnet, *"Akt" bei Dürer* (Cologne: Walther König, 2001); and Berthold Hinz, "Dürers 'Nackett Pild': Affekt und Abwehr," in Schröder and Sternath, *Dürer*, 57–67.

38. *Female Nude* in 1493 (W. 28, Musée Bonnat, Bayonne) and *Female Nude with a Staff* in 1498 (W. 947, Crocker Art Museum, Sacramento, Calif.). White, *Drawings*, no. 5; William Breazeale et al., *The Language of the Nude*, exh. cat., Crocker Art Museum, Sacramento (London: Lund Humphries, 2008), no. 45.

39. Talbot, *Dürer in America*, no. xii; see also Bartrum, *Dürer*, nos. 84–90; Schröder and Sternath, *Dürer*, nos. 63–67.

40. Talbot, *Dürer in America*, no. viii. The monogram and date are spurious; a date of 1508 is too late for a constructed figure leading up to the *Adam and Eve* engraving of 1504 (Figure 5.8).

41. Koschatzky, *Landscape Water-Colours*; Hermann Leber, *Albrecht Dürers Landschaftsaquarelle: Topographie und Genese* (Hildesheim: G. Olms, 1988); Kristina Herrmann Fiore, "Dürers neue Kunst der Landschaftsaquarelle," in Schröder and Sternath, *Dürer*, 27–43.

42. Koschatzky and Strobl, *Drawings*, no. 7; Schröder and Sternath, *Dürer*, no. 15. For G. Ulrich Grossmann's later dating of this watercolor to 1496–97, not 1494–95, see his "Albrecht Dürer in Innsbruck: Zur Datierung der ersten italienischen Reise," in *Das Dürerhaus: Neue Ergebnisse der Forschung*, ed. G. Ulrich Grossmann and Franz Sonnenberger (Nuremberg: Germanisches Nationalmuseum, 2007), 227–40.

43. Koreny, *Animal and Plant Studies*. For the "Dürer Renaissance," see Gisela Goldberg, ed., *Dürer-Renaissance*, exh. cat. (Munich: Alte Pinakothek, 1971); and Bartrum, *Dürer*, 266–82, esp. nos. 224–25, 227–28.

44. Dürer used a different pen sketch of hares (W. 359, British Museum, London) for the one in the foreground of his *Adam and Eve* (see Figure 5.8).

45. Rupprich, *Nachlass*, 3:295.

46. Translation in White, *Drawings*, no. 102; Schütz, *Dürer im Kunsthistorischen Museum*, 101.

47. Licia Ragghianti Collobi, *Il Libro de' disegni del Vasari*, 2 vols. (Florence: Vallecchi, 1974); Christian Müller, *Das Amerbach-Kabinett: Zeichnungen alter Meister*, exh. cat. (Basel: Öffentliche Kunstsammlung, Kupferstichkabinett, 1991).

CHAPTER 3. DÜRER AND THE HIGH ART OF PRINTMAKING

1. Dieter Wuttke, "Unbekannte Celtis-Epigramme zum Lobe Dürers," *Zeitschrift für Kunstgeschichte* 30 (1967): 321–25; Jan Białostocki, *Dürer and His Critics* (Baden-Baden: Verlag Valentin Koerner, 1986), 16–18.

2. Thus does Rainer Schoch begin his lead essay for the new catalogue raisonné of Dürer's prints; Rainer Schoch, Matthias Mende, and Anna Scherbaum, eds., *Dürer: Das druckgraphische Werk*, 3 vols. (Munich: Prestel, 2001–4), 1:9. See also Hans Rupprich, *Dürer: Schriftlicher Nachlass*, 3 vols. (Berlin: Deutscher Verein für Kunstwissenschaft, 1956–69), 1:296–97; Erwin Panofsky, *The Life and Art of Albrecht Dürer*, rev. ed. (Princeton, N.J.: Princeton University Press, 1955), 44–45; Białostocki, *Critics*, 15–35; Philipp P. Fehl, "Dürer's Literal Presence in His Pictures: Reflections on His Signatures in the *Small Woodcut Passion*," in *Der Künstler über sich in seinem Werk*, ed. Matthias Winner and Oskar Bätschmann (Weinheim: VCH, 1992), 191–244, here 211–25; and Herbert Beck and Bernhard Decker, eds., *Dürers Verwandlung in der Skulptur zwischen Renaissance und Barock*, exh. cat. (Frankfurt: Liebieghaus, 1981), 398–405.

3. William Martin Conway, trans. and ed., *The Writings of Albrecht Dürer* (New York: Philosophical Library, 1958), 48; Rupprich, *Nachlass*, 1:43–44.

4. Conway, *Writings*, 55; Rupprich, *Nachlass*, 1:55; Fritz Koreny, "Venice and Dürer," in *Renaissance Venice and the North*, ed. Bernard Aikema and Beverly Louise Brown, exh. cat., Palazzo Grassi, Venice (New York: Rizzoli, 2000), 240–49, here 246.

5. Conway, *Writings*, 56; Rupprich, *Nachlass*, 1:57.

6. Vasari discusses Dürer in his life of Marcantonio Raimondi. For a translation and discussion, see Lisa Pon, *Raphael, Dürer, and Marcantionio Raimondi: Copying and the Italian Renaissance Print* (New Haven, Conn.: Yale University Press, 2004), 39–41, 140; also Białostocki, *Critics*, 37–51. Marcantonio made some seventy-four copies of Dürer's prints; see Innis H. Shoemaker, *The Engravings of Marcantonio Raimondi*, exh. cat. (Lawrence, Kans.: Spencer Museum of Art, 1981), 62.

7. Dürer's painting, having been destroyed by fire in 1729, survives only in a copy. See Doris Kutschbach, *Albrecht Dürer: Die Altäre* (Stuttgart: Belser Verlag, 1995), 70–80.

8. Conway, *Writings*, 70; Rupprich, *Nachlass*, 1:72.

9. Elizabeth Holt, *A Documentary History of Art*, 2 vols. (Garden City, N.Y.: Doubleday Anchor, 1957–58), 1:314; Rupprich, *Nachlass*, 2:100.

10. Holt, *Documentary History*, 1:321; Rupprich, *Nachlass*, 3:293.

11. Dürer himself seems never to have painted the wings of an altarpiece with a carved shrine. The triptychs for which he received commissions, such as the *Paumgartner Altar* (A. 50–54K) or the *Heller Altar* (A. 107V–115K), involved painting throughout, including the central section.

12. Holt, *Documentary History*, 1:313; Rupprich, *Nachlass*, 2:109, 113.

13. Peter Strieder, *Albrecht Dürer: Paintings, Prints, Drawings*, trans. Nancy M. Gordon and Walter L. Strauss (New York: Abaris, 1982), fig. 212; and Erwin Rosenthal, "Dürers Buchmalereien für Pirckheimers Bibliothek," *Jahrbuch der preussischen Kunstsammlungen* 49 (1928): Beiheft, 1–54.

14. Susan Dackerman, ed., *Painted Prints: The Revelation of Color*, exh. cat., Baltimore Museum of Art (University Park: Penn State Press, 2002), 9. Although the inventories of Willibald Imhoff's collection from 1573 and 1574 cite colored impressions of prints by Dürer that the collector believed were painted by the artist himself, no autograph examples

of such coloring are known today. Where coloring is found on Dürer's prints, it is only attributable to later hands.

15. Heinrich Wölfflin, *The Art of Albrecht Dürer*, trans. Alastair Grieve and Heide Grieve (London: Phaidon, 1971), 208.

16. For a history of the *Prayer Book*, see Larry Silver, "Prints for a Prince: Maximilian, Nuremberg, and the Woodcut," in *New Perspectives on the Art of Renaissance Nuremberg: Five Essays*, ed. Jeffrey Chipps Smith (Austin, Tex.: Archer M. Huntington Art Gallery, 1985), 7–21, esp. 11 and 13; Joseph Leo Koerner, *The Moment of Self-Portraiture in German Renaissance Art* (Chicago: University of Chicago Press, 1993), 224–31.

17. For observations on variations in the inking of plates and other distinctions in the quality of impressions, see especially *Albrecht Dürer Master Printmaker*, exh. cat., Museum of Fine Arts, Boston (Boston, 1971; reissued New York: Hacker Art Books, 1988).

18. According to a letter by Dürer, he printed five hundred impressions of his *Portrait of Albrecht of Brandenburg* (the *Large Cardinal*, B. 103) in 1523. Such a large edition indicates the care with which he prepared and printed the plate. Rupprich, *Nachlass*, 1:96.

19. I spoke on the relationship of Schongauer's engravings to sculpture at the Schongauer colloquium in Colmar in 1991. A revised version of that paper with bibliographic references, together with illustrations, was submitted to the editors of the subsequent publication, *Le beau Martin, études et mises au point: Actes du colloque* (Colmar: Musée d'Unterlinden, 1994). Much to the regret of all concerned, the revised version and the accompanying illustrations were mistakenly thrown out, and the preliminary version of the paper, which was never intended for publication, was the one printed.

20. Dürer's remark about what a powerful artist can do with a little iron on a small block of wood sounds as though he did indeed know about cutting blocks, although not all commentators think that the passage should be understood in such a literal way. See Rupprich, *Nachlass*, 3:298–99 n. 25. For recent comments and references on this question, see Giulia Bartrum, ed., *German Renaissance Prints, 1490–1550*, exh. cat. (London: British Museum, 1995), 26–27; also Peter Parshall's review in *Print Quarterly* 13 (1996): 199–200.

21. Panofsky, *Dürer*, 47–48.

22. Alois Riegl, *Late Roman Art Industry*, trans. Rolf Winkes (Rome: G. Bretschneider, 1985), xx, 51–131.

23. Panofsky, *Dürer*, 133–34.

24. Some thirty drawings (W. 380–409) in this manner survive from Dürer's Venetian period.

25. Holt, *Documentary History*, 1:329; Rupprich, *Nachlass*, 3:297.

CHAPTER 4. DÜRER AS PAINTER

1. The most thorough catalog is Fedja Anzelewsky, *Albrecht Dürer: Das malerische Werk*, rev. ed. (Berlin: Deutscher Verlag für Kunstwissenschaft, 1991).

2. Katherine Crawford Luber, *Albrecht Dürer and the Venetian Renaissance* (Cambridge: Cambridge University Press, 2005). A somewhat different version of the present

essay is Katherine Crawford Luber, "Zwischen 'Disegno' und 'Colore,'" in *Albrecht Dürer*, ed. Klaus Albrecht Schröder and Maria Luise Sternath, exh. cat., Albertina, Vienna (Ostfildern: Hatje Cantz, 2003), 81–87.

3. *Natural History. The Elder Pliny's Chapters on the History of Art*, trans. K. Jex-Blake and intro. E. Sellers (Chicago: Argonaut, 1968), 169, chap. 35, line 145.

4. Jan Białostocki, *Dürer and His Critics* (Baden-Baden: Verlag Valentin Koerner, 1986), 31 and 43.

5. Giorgio Vasari, *Le vite de' più eccellenti pittori, scultori e architettori, nelle redazioni del 1550 e 1568,* ed. R. Bettarini, commentary P. Barocchi (Florence: Sansoni, 1966–76).

6. David Summers, *Michelangelo and the Language of Art* (Princeton, N.J.: Princeton University Press, 1981).

7. For this translation, see Giorgio Vasari, "Life of Marc' Antonio Bolognese and of Other Engravers of Prints," in *Lives of the Most Eminent Painters, Sculptors, and Architects,* trans. G. du C. de Vere (London: Medici Society, 1913), 6:92.

8. Summers, *Michelangelo and the Language of Art.*

9. G. W. Pigman III, "Versions of Imitation in the Renaissance," *Renaissance Quarterly* 33 (1980): 1–32.

10. Gisela Goldberg, Bruno Heimberg, and Martin Schawe, eds., *Albrecht Dürer: Die Gemälde der Alten Pinakothek* (Munich: Braus, 1998), 389–90.

11. Maryan Ainsworth, "Schäufelein as Painter and Graphic Artist in the Visitation," *Metropolitan Museum Journal* 22 (1987): 135–40, here 139. Ainsworth noted a similar graphic addition of details in Schäufelein's Vaduz *Visitation.*

12. Goldberg, Heimberg, and Schawe, *Dürer,* 138–415; and Carmen Garrido, "Albert Dürer: Deux manières différentes de travailler," in *Le dessin sous-jacent et la technologie de la peinture* [Colloque XI], ed. R. Van Schoute and H. Verougstraete (Louvain-la-Neuve: Peeters, 1997), 61–66.

13. Maryan Ainsworth, "'Paternes for phiosioneamyes': Holbein's Portraiture reconsidered," *Burlington Magazine* 132 (1990): 173–86, for a comparable method in Holbein.

14. For instance, Dürer used a chalk ground in the *Portrait of Burkard von Speyer* (A. 97). This technique was typical of northern European, not Italian, painting practice.

15. Peter Humfrey, "Dürer's *Feast of the Rosegarlands*: A Venetian Altarpiece," *Bulletin of the National Gallery in Prague* 1 (1991): 21–33.

16. Białostocki, *Critics,* 37–51. He also pointed out that Vasari focused on Dürer's graphic production and did not know much about his painted production.

CHAPTER 5. DÜRER AND SCULPTURE

I benefited from helpful comments, notably by Willibald Sauerländer and Thomas Eser, when I presented this material at the Bode-Museum in Berlin and the Zentralinstitut für Kunstgeschichte in Munich in 2007, and a reference from Karl Schütz. I wish to thank the Kimbell Art Foundation of Fort Worth for its support of my research.

1. Jan Białostocki, *Dürer and His Critics* (Baden-Baden: Verlag Valentin Koerner, 1986), 17.

2. Białostocki, *Critics*, 15–35.

3. Rainer Brandl, "Art or Craft? Art and the Artist in Medieval Nuremberg," in *Gothic and Renaissance Art in Nuremberg*, exh. cat., Metropolitan Museum of Art, New York, and Germanisches Nationalmuseum, Nuremberg (Munich: Prestel, 1986), 51–60.

4. On this general topic, see Charles Talbot, "Hans Schäufelein's Woodcuts and the Arts of Sculpture and Painting," in *Hans Schäufelein: Vorträge* (Nördlingen: Verein Rieser Kulturtage, 1990), 273–307.

5. W. 3; Walter L. Strauss, *The Complete Drawings of Albrecht Dürer*, 6 vols. (New York: Abaris Books, 1974), no. 1484/4. See John F. Cherry, *Goldsmiths* (Toronto: University of Toronto Press, 1992), on training; and Heinrich Kohlhaussen, *Nürnberger Goldschmiedekunst des Mittelalters und der Dürerzeit, 1240 bis 1540* (Berlin: Deutscher Verlag für Kunstwissenschaft, 1968), figs. 286–87, 289, 294, 297, 299, on finials.

6. Rainer Kahsnitz, ed., *Veit Stoss in Nürnberg*, exh. cat., Germanisches Nationalmuseum, Nuremberg (Munich: Deutscher Kunstverlag, 1983), 309–33; Stefan Roller, *Nürnberger Bildhauerkunst der Spätgotik* (Munich: Deutscher Kunstverlag, 1999), 99–115, 234–66.

7. Michael Baxandall, *The Limewood Sculptors of Renaissance Germany* (New Haven, Conn.: Yale University Press, 1980), 62–68, 116–22.

8. Walter L. Strauss, ed., *The Illustrated Bartsch*, vol. 10, *Commentary: Sixteenth Century German Artists—Albrecht Dürer* (New York: Abaris, 1981), 378, no. 102. Erwin Panofsky, *The Life and Art of Albrecht Dürer*, rev. ed. (Princeton, N.J.: Princeton University Press, 1955), 46–47, argues, without evidence, that Dürer cut his own early blocks.

9. Kahsnitz, *Stoss*, no. 30, 333–50; Jeffrey Chipps Smith, *German Sculpture of the Later Renaissance, c. 1520–1580: Art in an Age of Uncertainty* (Princeton, N.J.: Princeton University Press, 1994), 38–39.

10. Michael Baxandall, "The Perception of Riemenschneider," in *Tilman Riemenschneider: Master Sculptor of the Late Middle Ages*, ed. Julien Chapuis (New Haven, Conn.: Yale University Press, 1999), 83–97.

11. Holm Bevers, *Meister E.S.: Ein oberrheinischer Kupferstecher der Spätgotik*, exh. cat. (Munich: Staatliche Graphische Sammlung, 1986), no. 32.

12. Phyllis Pray Bober and Ruth Rubinstein, *Renaissance Artists and Antique Sculpture: A Handbook of Sources* (London: Harvey Miller, 1986), nos. 14 and 28.

13. J.-A. Goris and Georges Marlier, *Albrecht Dürer: Diary of His Journey to the Netherlands, 1520–1521* (Greenwich, Conn.: New York Graphic Society, 1971), 63, 82, 93.

14. Ibid., 86.

15. Kahsnitz, *Stoss*, 202.

16. William Martin Conway, trans. and ed., *The Writings of Albrecht Dürer* (New York: Philosophical Library, 1958), 212; Walter L. Strauss, trans. and ed., *Albrecht Dürer: The Painter's Manual* (New York: Abaris Books, 1977), 37.

17. Strauss, *Painter's Manual*, 227–37.

18. Smith, *Sculpture*, 216, 218–19, fig. 182.

19. 1528 ed., pp. V I b.–2a; Hans Rupprich, *Dürer: Schriftlicher Nachlass*, 3 vols. (Berlin: Deutscher Verein für Kunstwissenschaft, 1956–69), 3:125–37; Baxandall, *Limewood Sculpture*, 156–57.

20. Rupprich, *Nachlass*, 3:144; Strauss, *Drawings*, no. 1519/18.

21. W. 800; Strauss, *Drawings*, no. 1521/14; *From Schongauer to Holbein: Master Drawings from Basel and Berlin*, exh. cat. (Washington, D.C.: National Gallery of Art, 1999), no. 76.

22. For example, see W. 174, 177, 233–36, 490–501, 678–82, 708–9, 722–23, 729–36, 738, 742, 920, 933–34, 939, 946; Strauss, *Drawings*, nos. 1495/49, 1499/1–7, 1511/21–32, 1513/28–29, 1517/3–8, 1517/25–36, 1521/64, 1526/12–23; *Albrecht Dürer, 1471–1971*, exh. cat., Germanisches Nationalmuseum, Nuremberg (Munich: Prestel, 1971), 364–84; and Jeffrey Chipps Smith, "Albrecht Dürer, Cardinal Matthäus Lang, and the Throne of Invention," in *Tributes to James H. Marrow*, ed. Jeffrey F. Hamburger and Anne S. Korteweg (Turnhout: Brepols, 2006), 477–84 and 639.

23. W. 233; Kohlhaussen, *Goldschmiedekunst*, 258–60, and, on table fountains, 255–65; Strauss, *Drawings*, no. 1499/1; Smith, *Sculpture*, 199–215; Giulia Bartrum, ed., *Albrecht Dürer and His Legacy: The Graphic Work of a Renaissance Artist*, exh. cat. (London: British Museum, 2002), no. 62; Hildegard Wiewelhove, *Tischbrunnen* (Berlin: Deutscher Verlag für Kunstwissenschaft, 2002), 62–70.

24. The tabernacle form recalls contemporary Nuremberg monstrances; see Kohlhaussen, *Goldschmiedekunst*, nos. 313–27.

25. W. 235–36, 946; Strauss, *Drawings*, nos. 1499/2–5; *Gothic and Renaissance Art in Nuremberg*, no. 113; Bartrum, *Dürer*, nos. 63–64.

26. W. 490–501; Kohlhaussen, *Goldschmiedekunst*, no. 398 (until 1922 in the Raudnitz Palace near Prague); Strauss, *Drawings*, nos. 1511/21–32. The drawings, while monogrammed, may be by one of Dürer's assistants. On Krug, see Jeffrey Chipps Smith, *Nuremberg: A Renaissance City, 1500–1618*, exh. cat., Archer M. Huntington Art Gallery, Austin (Austin: University of Texas Press, 1983), 64, 214–18; Smith, *Sculpture*, 381–82.

27. Kohlhaussen, *Goldschmiedekunst*, 351–407, esp. no. 390; Smith, *Nuremberg*, no. 116; *Gothic and Renaissance Art in Nuremberg* (1986), no. 208.

28. *Gothic and Renaissance Art in Nuremberg*, no. 141; Hermann Maué, "Die Dedikationsmedaille der Stadt Nürnberg für Kaiser Karl V. von 1521," *Anzeiger des Germanisches Nationalmuseums* (1987): 227–44.

29. W. 708; Strauss, *Drawings*, no. 1513/29; Kahsnitz, *Stoss*, no. 13; Rainer Kahsnitz, "Veit Stoss in Nürnberg: Eine Nachlese zum Katalog und zur Ausstellung," *Anzeiger des Germanischen Nationalmuseums* (1984): 48–49; *Gothic and Renaissance Art in Nuremberg* (1986), nos. 149–50.

30. A. 118. The painting is in Vienna (Kunsthistorisches Museum) and the carved limewood frame is in Nuremberg (Germanisches Nationalmuseum). W. 445; Strauss, *Drawings*, no. 1508/23; Karl Schütz, ed., *Albrecht Dürer im Kunsthistorischen Museum* (Vienna: Kunsthistorisches Museum, 1994), 13–47, figs. 3–4, and no. 5.

31. W. 483–88; Strauss, *Drawings*, nos. 1506/40–41, 1510/19–23; Fedja Anzelewsky and Hans Mielke, *Albrecht Dürer: Kritischer Katalog der Zeichnungen* (Berlin: Staatliche Museen Preussischer Kulturbesitz, Kupferstichkabinett, 1984), nos. 61–62; Bruno Bushart, *Die Fuggerkapelle bei St. Anna in Augsburg* (Munich: Deutscher Kunstverlag, 1994), 115–42; Smith, *Sculpture*, 171–74; *From Schongauer to Holbein*, no. 66.

32. Elisabeth Scheicher, "Das Grabmal Kaiser Maximilians I. in der Hofkirche," in *Österreichische Kunsttopographie*, vol. 47, *Die Kunstdenkmäler der Stadt Innsbruck: Die Hofbauten* (Vienna: A. Schroll, 1986), 359–425; Fritz Koreny, "'Ottoprecht Fürscht': Eine unbekannte Zeichnung von Albrecht Dürer—Kaiser Maximilian I. und sein Grabmal in der Hofkirche zu Innsbruck," *Jahrbuch der Berliner Museen* 31 (1989): 127–48.

33. Strauss, *Drawings*, nos. 1510/16–18; Sven Hauschke, *Die Grabdenkmäler der Nürnberger Vischer-Werkstatt (1453–1544)* (Petersberg: M. Imhof, 2006), 48, 309–12, figs. 26, 344–75.

34. Strauss, *Drawings*, no. 1499/6.

35. Herbert Beck and Bernhard Decker, eds., *Dürers Verwandlung in der Skulptur zwischen Renaissance und Barock*, exh. cat. (Frankfurt: Liebieghaus, 1981), nos. 1–9; Kristina Hegner, "Die Verarbeitung der Druckgrafik von Albrecht Dürer, Lucas Cranach d. Ä. und Hans Schäufelein in den deutschen Schnitzwerkstätten des 16. Jahrhunderts," in *Der Bordesholmer Altar des Hans Brüggemann: Werk und Wirkung*, ed. Uwe Albrecht et al. (Berlin: D. Reimer, 1996), 165–79. On influencing other printmakers, see Leonie von Wilckens and Peter Strieder, eds., *Vorbild Dürer*, exh. cat., Germanisches Nationalmuseum, Nuremberg (Munich: Prestel, 1978); Christine Vogt, *Das druckgraphische Bild nach Vorlagen Albrecht Dürers (1471–1528)* (Munich: Deutscher Kunstverlag, 2008).

36. For example, see Wally Wallerand, *Altarkunst des Deutschordensstaates Preussen unter Dürers Einfluss* (Danzig: Kafemann, 1940); Hegner, *Verarbeitung*, 175, figs. 24–25; Beck and Decker, *Verwandlung*, no. 2; and Sophie Guillot de Suduiraut, *Sculptures allemandes de la fin du Moyen Age dans les collections publiques françaises, 1400–1530*, exh. cat. (Paris: Musée du Louvre, 1991), no. 32A.

37. Matthias Mende, *Dürer-Bibliographie* (Wiesbaden: Otto Harrassowitz, 1971), nos. 8763–889.

38. Heinrich Kreisel, *Die Kunst des deutschen Möbels*, 3 vols. (Munich: Beck, 1968–73), 1:66, figs. 146–48.

39. This retable was moved to Schleswig Cathedral in 1666. See Christine Kitzlinger, "Die künstlerische Umsetzung graphischer Vorlagen im Passionszyklus des Bordesholmer Retabels," in Albrecht et al., *Der Bordesholmer Altar des Hans Brüggemann*, 109–35.

40. Hegner, *Verarbeitung*, figs. 22–23.

41. Peter Reindl, *Loy Hering* (Basel, 1977), no. A16; Smith, *Sculpture*, 58.

42. Reindl, *Hering*, no. A21.

43. Goris and Marlier, *Diary*.

44. Smith, *Sculpture*, 283–84, fig. 248.

45. Anton Legner, "Plastik," in *Die Kunst der Donauschule 1490–1540*, exh. cat., Stift St. Florian and Schlossmuseum Linz (Linz: OÖ Landesverlag, 1965), nos. 678–84; Smith, *Sculpture*, 49, 284–86, 386, figs. 27, 250.

46. Joachim von Sandrart, *Teutsche Academie der Bau-, Bild-und Mahlerey-Künste*, 3 vols. (Nuremberg, 1675–80; reprint [with intro. by Christian Klemm], Nördlingen: Verlag Dr. Alfons Uhl, 1994), 1:5, (Foreword) and part 2, book 3, chap. 3, 222–29; also Beck and Decker, *Verwandlung*, 468–78.

47. Heinrich Conrad Arend, *Das Gedächtnis der Ehren Albrecht Dürers* (Goslar: J. Ch. König, 1728), chap. 17 (folios G2v–G4r).

48. Reindl, *Hering*, no. D2; Beck and Decker, *Verwandlung*, no. 74.

49. Beck and Decker, *Verwandlung*, 481–82.

50. Rudolf Distelberger, "The Habsburg Collections in Vienna during the Seventeenth Century," in *The Origins of Museums: The Cabinet of Curiosities in Sixteenth- and Seventeenth-Century Europe*, ed. Oliver Impey and Arthur MacGregor (Oxford: Clarendon, 1985), 39–46, here 41.

51. Gisela Goldberg, "Zur Ausprägung der Dürer-Renaissance in München," *Münchner Jahrbuch der bildenden Kunst* 31 (1980): 129–75; Schütz, *Dürer im Kunsthistorischen Museum*, 49–57.

52. A. 182; Ernst Rebel, *Die Modellierung der Person. Studien zu Dürers Bildnis des Hans Kleberger* (Stuttgart: Franz Steiner, 1990); Schütz, *Dürer im Kunsthistorischen Museum*, 86–88.

53. Jeffrey Chipps Smith, "A Creative Moment: Thoughts on the Genesis of the German Portrait Medal," in *Perspectives on the Renaissance Medal*, ed. Stephen K. Scher (New York: Garland Publishing, 2000), 177–99, esp. figs. 10.1–2, 4, 7.

54. Matthias Mende, *Dürer-Medaillen* (Nuremberg: Verlag Hans Carl, 1983), nos. 28–29; Rebel, *Kleberger*, 32–33, 96, figs. 3–4.

55. Rebel, *Kleberger*, 42–43, fig. 19; Kristina Herrmann Fiore, *Dürer e l'Italia*, exh. cat., Scuderie del Quirinale, Rome (Milan: Electa, 2007), no. 1.17.

56. Rebel, *Kleberger*, 73–77.

57. Martin Kemp, *Leonardo da Vinci: The Marvelous Works of Nature and Man* (Cambridge, Mass.: Harvard University Press, 1981), 209–11; Claire Farago, "Paragone," in *The Dictionary of Art*, ed. Jane Turner, 34 vols. (London: Grove, 1996), 24:90–91.

58. Beck and Decker, *Verwandlung*, no. 217.

59. Ibid., 325–53.

60. Olga Kotková, ed., *Albrecht Dürer: The Feast of the Rose Garlands, 1506–2006*, exh. cat. (Prague: Národní Galerie, 2006), 150–51 (comments by Eliska Fucíková).

61. Huigen Leeflang and Ger Luijten, eds., *Hendrick Goltzius (1558–1617)*, exh. cat., Rijksmuseum, Amsterdam (Zwolle: Waanders, 2003), 203–15.

62. Dürer often depicted his monogram as if carved; see Lisa Oehler, "Das 'geschlenderte' Dürer-Monogramm," *Marburger Jahrbuch für Kunstwissenschaft* 17 (1959): 57–192.

63. Mende, *Dürer-Medaillen*, 57–68, 187–93; Smith, *Sculpture*, 326–27, with additional literature.

64. W. 720; Strauss, *Drawings*, no. 1519/17; Bartrum, *Dürer*, no. 6.

65. Mende, *Dürer-Medaillen*, nos. 31–32, 34–46; *Gothic and Renaissance Art in Nuremberg*, nos. 225–26; Bartrum, *Dürer*, nos. 10–11.

66. Beck and Decker, *Verwandlung*, no. 47; Smith, *Sculpture*, 339–40; Thomas Eser, *Hans Daucher* (Munich: Deutscher Kunstverlag, 1996), no. 8.

67. Eser, *Hans Daucher*, nos. 5–7, 15.

68. Rupprich, *Nachlass*, 3:297–98; Michael Roth, "Eine Dürerreliquie in Ulm?" in *Aus Albrecht Dürers Welt: Festschrift für Fedja Anzelewsky*, ed. Bodo Brinkmann, Hartmut Krohm, and Michael Roth (Turnhout: Brepols, 2001), 189–98.

69. Attributed to Willem Paludanus (Van den Broeck); Jan Van der Stock, ed., *Antwerp: Story of a Metropolis, 16th–17th Century*, exh. cat., Hessenhuis, Antwerp (Ghent: Snoeck-Ducaju, 1993), no. 16.

70. Białostocki, *Critics*, fig. 97; Beatrix Kriller and Georg Johannes Kugler, *Das Kunsthistorische Museum: Die Architektur und Ausstattung* (Vienna: Edition Christian Brandstätter, 1991), 67–69, fig. 50; Gisela Goldberg, Bruno Heimberg, and Martin Schawe, eds., *Albrecht Dürer: Die Gemälde der Alten Pinakothek* (Munich: Braus, 1998), 30, fig. 2.9; Bernhard Decker, "Dürer und Raphael in Marmor: Die Museums-Büsten in Frankfurt am Main und Karlsruhe," *Anzeiger des Germanischen Nationalmuseums* (1998): 79–87; James J. Sheehan, *Museums in the German Art World* (Oxford: Oxford University Press, 2000), 127–31.

CHAPTER 6. DÜRER AND VENICE

1. Johann Dominicus Fiorillo, *Geschichte der zeichnenden Künste etc.*, 4 vols. (Hannover: Hahn, 1815–20), 2:340ff. See Alistair Smith, "Germania and Italia, Albrecht Dürer and Venetian Art," *Journal of the Royal Society of the Arts* 127 (April 1979): 273–90, who attempts to refute Fiorillo's theory of a first visit; and Katherine Crawford Luber, *Albrecht Dürer and the Venetian Renaissance* (Cambridge: Cambridge University Press, 2005), 40–76.

2. Heinrich Wölfflin, *Italien und das deutsche Formgefühl* (Munich: F. Bruckmann, 1931), translated as *The Sense of Form in Art: A Comparative Psychological Study* by Alice Muehsam and Norma A. Shatan (New York: Chelsea, 1958), 13.

3. Erwin Panofsky, *The Life and Art of Albrecht Dürer*, rev. ed. (Princeton, N.J.: Princeton University Press, 1955).

4. Bernard Aikema and Beverly Louise Brown, eds., *Renaissance Venice and the North: Crosscurrents in the Time of Bellini, Dürer, and Titian*, exh. cat., Palazzo Grassi, Venice (New York: Rizzoli, 2000).

5. Jan Białostocki, *Dürer and His Critics* (Baden-Baden: Verlag Valentin Koerner, 1986); Fedja Anzelewsky, *Dürer-Studien* (Berlin: Deutscher Verlag für Kunstwissenschaft, 1983); Jane Campbell Hutchison, *Albrecht Dürer. A Biography* (Princeton, N.J.: Princeton University Press, 1990).

6. Hans Rupprich, *Dürer: Schriftlicher Nachlass*, 3 vols. (Berlin: Deutscher Verein für Kunstwissenschaft, 1956–69), 1:44.

7. Christoph Scheurl, *Libellus de laudibus Germaniae et ducum Saxoniae* (Leipzig, 1508); Rupprich, *Nachlass*, 1:290–91. Smith, "Germania," 290 n. 8, reasonably translated

the word *rediisset* not as "returned" but as "has come down recently," arguing that the sentence therefore offers no evidence of a first journey.

8. Walter L. Strauss, *The Complete Drawings of Albrecht Dürer*, 6 vols. (New York: Abaris Books, 1974), 1:212; Hutchison, *Dürer*, 42.

9. Antonio Rusconi, "Per l'identificazione degli Acquarelle Tridentini di Albert Dürer," *Deutsche Graphischen Künste*, N.F. 1 (1936): 127–37; for discussion and further bibliographical details, see *Albrecht Dürer, 1471–1971*, exh. cat., Germanisches National-museum, Nuremberg (Munich: Prestel, 1971), 26–27, 301–5, and passim.

10. Walter Koschatzky dated the *View of Innsbruck from the North* between 1494 and 1495 on the basis of scaffolding visible on the "Wappenturm," which had been damaged by fire in 1494. Recently G. Ulrich Grossmann has argued that the earliest possible date of the state of repair recorded by the watercolor was 1496. He cautiously proposes a date of 1496–97 for Dürer's first Italian journey. See Walter Koschatzky and Alice Strobl, *Dürer Drawings in the Albertina* (Greenwich, Conn.: New York Graphic Society, 1972), no. 7; and G. Ulrich Grossmann, "Albrecht Dürer in Innsbruck: Zur Datierung der ersten italienischen Reise," in *Das Dürer-Haus: Neue Ergebnisse der Forschung*, ed. G. Ulrich Grossmann and Franz Sonnenberger (Nuremberg: Verlag des Germanischen Nationalmu-seums, 2007), 227–40.

11. *View of Trent* (W. 96, Kunsthalle, Bremen), the *Castle at Trent* (W. 95, British Museum, London), and the *Fortress of Dosso di Trento* (W. 97, Kunsthalle, Bremen). The depiction of the castle of Segonzano in a watercolor of the Italian alps (W. 99, Ashmolean Museum, Oxford) indicates that he took a detour into the Cembra Valley, not far from Trent.

12. Hutchison, *Dürer*, 47.

13. A drawing of a crab (W. 92, Museum Boijmans van Beuningen, Rotterdam), often associated with Dürer's first Venetian visit, is in a strikingly different technique, leading to the suggestion that it is the work of a later sixteenth-century Italian naturalist. See *Albrecht Dürer, 1471–1971*, no. 561; Colin Eisler, *Dürer's Animals* (Washington, D.C.: Smithsonian Institution Press, 1991), 126.

14. Though such Venetian dresses were known within Nuremberg as early as 1483 (Luber, *Dürer*, 58), Dürer's drawing nonetheless has the character of a study from life.

15. Bernhard Degenhart, "Ein Beitrag zu den Zeichnungen Gentile und Giovanni Bellini und Dürers erstem Aufenthalt in Venedig," *Jahrbuch der Preussischen Kunstsam-mlungen* 61 (1940): 37–47. Julius Janitsch, "Dürer's Türkenzeichnungen," *Jahrbuch der Preussischen Kunstsammlungen* 4 (1883): 61–62, dates these drawings from the second visit; as does Luber, *Dürer*, 102.

16. Julian Raby, *Venice, Dürer, and the Oriental Mode* (London: Sotheby's Publica-tions, 1982), 17–18; Stefano Carboni, ed., *Venice and the Islamic World, 828–1797*, exh. cat., Metropolitan Museum of Art, New York (New Haven, Conn.: Yale University Press, 2007).

17. Caroline Campbell and Alan Chong, eds., *Bellini and the East*, exh. cat., Isabella Stewart Gardner Museum, Boston (New Haven, Conn.: Yale University Press, 2005), 98–105.

18. His *Adoration* (ca. 1503, B. 87), from the *Life of the Virgin* series, shows the soldiers in Ottoman dress, with banners decorated with recognizably Ottoman devices; seven of the *Large Passion* woodcuts, created between 1497 and 1499, contain Ottoman attire. In works executed after Dürer's second visit, details of Mamluk costume appear for the first time, a fact that follows the timing of the appearance of such features in Venetian paintings. Raby, *Venice, Dürer, and the Oriental Mode*, 30, 35–52.

19. Anzelewsky, *Dürer-Studien*, 187 and 264 n. 34.

20. Erwin Panofsky, "Albrecht Dürer and Classical Antiquity," in *Meaning in the Visual Arts* (Garden City, N.Y.: Doubleday Anchor Books, 1955), 236–94.

21. Dürer's drawing of two naked male abductors and their female victims, dated 1495 (W. 82, Musée Bonnat, Bayonne), copies a painting by a follower of Antonio Pollaiuolo.

22. Compare with the *Female Nude*, dated 1493 (W. 28, Musée Bonnat, Bayonne).

23. Compare with Giovanni Bellini's *Young Woman with a Mirror* (Kunsthistorisches Museum, Vienna) of some twenty years later, where the body is adapted from an antique torso fragment onto which, with some awkwardness, the arms have been grafted. On Bellini and antique sculpture from the Grimani collection, see Warren Tressider, "A Borrowing from the Antique and Giovanni Bellini's *Continence of Scipio*," *Burlington Magazine* 134 (1992): 660–62.

24. Strauss, *Drawings*, no. 1495/3.

25. Aikema and Brown, *Renaissance Venice and the North*, no. 46. The unusual motif of the brick wall occurs in the early Nativity scenes of Giorgione.

26. Rupprich, *Nachlass*, 1:101–2.

27. This is the date on Nicoletto Rosex da Modena's copy of Dürer's *Four Witches*; see Christine Vogt, *Das druckgraphische Bild nach Vorlagen Albrecht Dürers (1471–1528)* (Munich: Deutscher Kunstverlag, 2008), 60–61, fig. 5.9.

28. On their history and location, see Rupprich, *Nachlass*, 1:41–60.

29. In the letter of August 28, 1506, Dürer tells Pirckheimer: "As to the historical pieces, I see nothing extraordinary in what the Italians make that would look especially useful in your study. It is always the same thing. You yourself know more than they paint." This suggests that he was looking out for paintings of historical or classical themes. Rupprich, *Nachlass*, 1:53.

30. Rupprich, *Nachlass*, 1:43 and 46.

31. Ibid., 44.

32. Ibid., 309; Alistair Smith, "Dürer and Bellini, Apelles and Protogenes," *Burlington Magazine* 114 (1972): 326–29; Peter Parshall, "Camerarius on Dürer: Humanist Biography as Art Criticism," in *Joachim Camerarius (1500–1574)*, ed. Frank Baron (Munich: Fink, 1978), 11–29.

33. In his life of Pontormo, Vasari praises Dürer's powers of invention and composition, but censures Pontormo for adopting the German artist's style when adapting his figures for his own work; see Giorgio Vasari, *Le vite de più eccellenti pittori, scultori ed architettori*, ed. Gaetano Milanesi, 9 vols. (Florence: G. C. Sansoni, 1878–85), 6:270.

34. Letter of January 6, 1506: "As soon as God helps me to get home I will pay you

honorably, with many thanks; for I have to paint a picture for the Germans, for which they are giving me 110 Rhenish gulden, which will not cost me more than five. . . ." Rupprich, *Nachlass*, 1:42.

35. In a letter to Pirckheimer of February 12 or 16, 1507, Konrad Fuchs says he will not hold on to Dürer for so long on his return journey. Rupprich, *Nachlass*, 1:253. Joachim von Sandrart, *Teutsche Academie der Bau-, Bild- und Mahlerey-Künste*, 3 vols. (Nuremberg, 1675–80; reprint [with intro. by Christian Klemm], Nördlingen: Verlag Dr. Alfons Uhl, 1994), 1:225, part 2, book 3.

36. Peter Humfrey, "Dürer's *Feast of the Rosegarlands*: A Venetian Altarpiece," *Bulletin of the National Gallery in Prague* 1 (1991): 21–33.

37. Vasari, *Le vite*, 5: 405–6; Lisa Pon, *Raphael, Dürer, and Marcantonio Raimondi: Copying and the Italian Renaissance Print* (New Haven, Conn.: Yale University Press, 2004).

38. Louisa C. Matthews, "Working Abroad: Northern Artists in the Venetian Ambient," in Aikema and Brown, *Renaissance Venice and the North*, 61–69.

39. Rupprich, *Nachlass*, 1:43–44.

40. Ibid., 49.

41. Ibid., 45–46.

42. Ibid., 57.

43. Fedja Anzelewsky, *Albrecht Dürer: Das malerische Werk*, rev. ed. (Berlin: Deutscher Verlag für Kunstwissenschaft, 1991), nos. 92, 95–97, 99. Of these, the *Portrait of a Venetian Woman* (A. 92) is dated 1505. Its provenance is not known before the eighteenth century, when it appears in Danzig (Gdansk). The *Portrait of a Young Man* (A. 97), signed and dated 1506, is identifiable as Burkhard von Speyer, whose features recur in the *Feast of the Rose Garlands*. The *Portrait of a Young Man* (A. 96), signed and dated 1506, can be traced to the Vendramin Collection. Klára Garas, "Bildnisse der Renaissance II: Dürer und Giorgione," *Acta Historia Artium* 18 (1972): 125–35, suggested the sitter is the same as that in Giorgione's portrait in the Crocker Art Gallery in Sacramento. The *Portrait of a Venetian Woman* (A. 95) is undated but is painted on poplar, which supports the suggestion that it was painted in Venice. The *Portrait of a Young Man* (A. 99), dated 1507, has also been thought to have been painted in Venice. The allegorical figure of Avarice, with its grotesquely exposed breast, painted on the reverse, has been associated with the woman of Giorgione's *Col tempo* (Gallerie dell'Accademia, Venice). It is, however, painted on a limewood panel, which suggests that it was executed in Nuremberg after the artist's return.

44. The *Feast of the Rose Garlands*, its popular title, is misleading since this festival was only instituted in 1716. Fedja Anzelewsky, *Dürer: His Art and Life* (New York: Alpine Fine Arts Collection, 1980), 122.

45. Francesco Sansovino, *Venetia, città nobilissima et singolare* (Venice: I. Sansovino, 1581), fol. 48v.

46. Sansovino stated that the commission was given to Dürer by Christoph Fugger ("christoforo Foccari Tedesco"). Though there is no mention of his name in the Fugger archives, he is recorded as being in Venice, and in 1504 his tomb in San Bartolomeo was

decorated with garlands. See Garas, "Bildnisse der Renaissance II," 130. Any link between the altarpiece and Christoph Fugger, however, is rejected; see Andrew John Martin, " 'Dan hat sich ain quater befunden, in vnserer Capeln, von der Hand des Albrecht Dürers': The *Feast of the Rose Garlands* in San Bartolomeo di Rialto (1506–1606)," in *Albrecht Dürer: The Feast of the Rose Garlands, 1506–2006*, ed. Olga Kotková, exh. cat. (Prague: Národní Galerie, 2006), 53–67, here 55–56.

47. Kotková, *The Feast of the Rose Garlands*, 82.

48. In a letter of September 8, 1506, Dürer alludes to the alliance of the papacy, France, and Venice against Germany and to the buildup of troops in Venice. He says people ridicule "our king" (Maximilian) a great deal. Rupprich, *Nachlass*, 1:55.

49. On the possible identities of the men, including Burkhard Speyer, the almoner of San Bartolomeo, and Master Hieronymus, who was rebuilding the nearby Fondaco dei Tedeschi, see Kotková, *The Feast of the Rose Garlands*, 86–87.

50. Rupprich, *Nachlass*, 1:57.

51. Ibid.

52. Luber, *Dürer*, 112.

53. Ibid., 81–84.

54. Rupprich, *Nachlass*, 1:57.

55. Cited by Martin Kemp, "The Mean and Measure of All Things," in *Circa 1492: Art in the Age of Exploration*, ed. Jay A. Levenson, exh. cat., National Gallery of Art, Washington, D.C. (New Haven, Conn.: Yale University Press, 1992), 107.

56. Aikema and Brown, *Renaissance Venice and the North*, no. 52 (Eva Manikowska).

57. Four studies (W. 404–7) for the head and hands of Christ and of hands holding a book (one of which did not make it into the finished painting) show the care that went into the conception. The head of Christ once formed the right side of a larger sheet on which was also the study for the angel (W. 385) of the *Feast of the Rose Garlands*, suggesting that the two works were conceived concurrently. See Isolde Lübbeke, *The Thyssen-Bornemisza Collection: Early German Painting, 1350–1550*, trans. Margaret Thomas Will (London: Sotheby's Publications, 1991), 218–41.

58. Albert Boesten-Stengel, "Albrecht Dürers *Zwölfjähriger Jesus unter den Schriftgelehrten* der Sammlung Thyssen-Bornemisza, Lugano: Bilderfindung und *prestezza*," *Idea* 9 (1990): 43–66.

59. Anzelewsky, *Das malerische Werk*, 206–10.

60. In a fragment of his *Gedenkbuch*, he later wrote, "Also someone died in Rome with the loss of my goods. That is why, when I was in the thirteenth year of my marriage [i.e., between July 1506 and July 1507], I paid a large debt that I had incurred in Venice." Rupprich, *Nachlass*, 1:36.

61. Rupprich, *Nachlass*, 1:50.

62. Ibid., 290–91.

63. Strauss, *Drawings*, nos. 1506/44–48; Anzelewsky, *Art and Life*, 128 and 132.

64. Euclid, *Opera latinae*, ed. Bartolomeo Zamberti (Venice: Johannes Tacuinus, 1505; today in the Herzog August Bibliothek, Wolfenbüttel, no. 2.5 Geom. 2.

65. Preface to *Underweysung der messung mit dem zirckel und richtscheyt in Linien, ebnen unnd gantzen corporen durch Albrecht Dürer zu samen getzoge[n]* (Nuremberg, 1525), fol. A IV.

CHAPTER 7. THE ARTIST, HIS HORSE, A PRINT, AND ITS AUDIENCE

1. Hans Schwerte, *Faust und das Faustische: Ein Kapitel deutscher Ideologie* (Stuttgart: Ernst Klett, 1962); Heinrich Theissing, *Dürers Ritter, Tod und Teufel: Sinnbild und Bildsinn* (Berlin: Mann, 1978); Jan Białostocki, *Dürer and His Critics* (Baden-Baden: Verlag Valentin Koerner, 1986).

2. Białostocki, *Critics*, 211–12. The identification of the rider as a knight (strictly understood as a member of the nobility) needs to be reconsidered given the historical changes in the strategies and technologies of warfare as conducted under Maximilian I. This will be argued in a future article.

3. See note 1 for overviews of centuries of interpretation.

4. Joachim von Sandrart (*Teutsche Academie*, 1675) first referred to the print as "der christliche Ritter"; however, Hermann Grimm first connected this print with Erasmus's writings. Hermann Grimm, "Dürers Ritter, Tod und Teufel," *Preussische Jahrbücher* 36 (1875): 543–49; Białostocki, *Critics*, 217 and 212.

5. Sten Karling, "Riddaren, dödden och djävulen," *Konsthistorisk Tidskrift* 39 (1970): 1–13; Ursula Meyer, "Political Implications of Dürer's 'Knight, Death and Devil,'" *Print Collector's Newsletter* 9 (1978): 35–39. See also Patricia Emison, "Dürer's Rider," *Renaissance Studies* 19/4 (2005): 511–22 for a further untraditional but evocative interpretation in light of Machiavelli.

6. For both Nietzsche and Waetzoldt, see Białostocki, *Critics*, 225 and 240.

7. For the interpretation of the rider as Julius II, see Maria Lanckoronska "Die zeitgeschichtliche Komponente in Dürers Kupferstich 'Der Reiter,'" *Gutenberg Jahrbuch* (1974): 228–46; and as Savonarola, see Antonie Leinz von Dessauer, "Savonarola und Albrecht Dürer: Savonarola, der Ritter in Dürers Meisterstich," *Das Münster* 14 (1961): 1–45.

8. The results of Dürer's study of human proportions were published posthumously in 1528 as *Vier Bücher von menschlicher Proportion*.

9. British Museum, London; MSS 5229, fol. 164a and 5230, fol. 3a. Both are transcribed in Hans Rupprich, *Dürer: Schriftlicher Nachlass*, 3 vols. (Berlin: Deutscher Verein für Kunstwissenschaft, 1956–69), 2:94–96.

10. Rupprich, *Nachlass*, 2:94–96.

11. Ibid., 99.

12. Ibid., 55.

13. Colin Eisler, *Dürer's Animals* (Washington, D.C.: Smithsonian Institution Press, 1991).

14. Elisabeth M. Trux, *Untersuchungen zu den Tierstudien Albrecht Dürers* (Würzburg: Ergon, 1993), 61–65.

15. Harold Barclay, *The Role of the Horse in Man's Culture* (London: J. A. Allen, 1980), 120–21.

16. Walter L. Strauss, *The Complete Drawings of Albrecht Dürer*, 6 vols. (New York: Abaris Books, 1974), no. 1517/14. Strauss seems unaware that the drawing's inscriptions refer not only to the grooms but also to the horses, which, in the sixteenth century, were referred to not by breed names but by their place of breeding; see Charles Gladitz, *Horse Breeding in the Medieval World* (Dublin: Four Courts Press, 1997).

17. Erwin Panofsky, *The Life and Art of Albrecht Dürer*, rev. ed. (Princeton, N.J.: Princeton University Press, 1955), 273–80.

18. Hans Baldung Grien understood the theoretical aspects of Dürer's equine aesthetic yet his images of horses stress the animals' utterly wild, literally unbridled, and demonic energy. Baldung's depictions challenged Dürer's assumptions regarding the control of nature through the theoretical constraints of mathematical harmony. Linda Hults Boudreau, "Hans Baldung Grien and Albrecht Dürer: A Problem in Northern Mannerism" (Ph.D. dissertation, University of North Carolina, 1978); Thomas DaCosta Kaufmann, "Hermeneutics in the History of Art: Remarks on the Reception of Dürer in the Sixteenth and Early Seventeenth Centuries," in *New Perspectives on the Art of Renaissance Nuremberg: Five Essays*, ed. Jeffrey Chipps Smith (Austin, Tex.: Archer M. Huntington Art Gallery, 1985), 22–39, here 30–33; Joseph Leo Koerner, *The Moment of Self-Portraiture in German Renaissance Art* (Chicago: University of Chicago Press, 1993), 426–41. See also Johann Eckart von Borries, "Die Tier- und Pflanzenstudien Hans Baldung Griens," *Jahrbuch der kunsthistorischen Sammlungen in Wien* 82/83 (1987): 69–78, esp. 72–76.

19. Stadtbibliothek, Nuremberg, Cent. V. App. 34aa, fol. 81a, in Rupprich, *Nachlass*, 2:352–53.

20. Bibliotheca Ambrosiana, Milan; see *Albrecht Dürer, 1471–1971*, exh. cat., Germanisches Nationalmuseum, Nuremberg (Munich: Prestel, 1971), no. 502. For a sensitive study of the attribution of this drawing to Dürer, see Josef Kurthen, "Zum Problem der Dürerschen Pferdekonstruktion: Ein Beitrag zur Dürer- und Behamforschung," *Repertorium für Kunstwissenschaft* 44 (1924): 77–99, here 81–87.

21. For studies of Dürer's use of the grid to construct idealized horses rather than simply for copying and transferring images, see Harry David, "Zum Problem der Dürerschen Pferdekonstruktion," *Repertorium für Kunstwissenschaft* 33 (1910): 310–17; Erwin Panofsky, *Dürers Kunsttheorie, vornehmlich in ihrem Verhältnis zur Kunsttheorie der Italiener* (Berlin: G. Reimer, 1915), 200–204; and Kurthen, "Pferdekonstruktion."

22. Rupprich, *Nachlass*, 2:100, 121, 126 n. 10. Rupprich (126 n. 10) maintains that Dürer uses the word *Vergleichung* to mean the same thing as "harmony," as of one part to another. I believe, however, that the term also connotes "comparison" and "equivalency." You cannot discern harmony between parts if you cannot compare them; if the parts are in harmony with one another, then they are in some ways equivalent. Consequently, I have translated Dürer's term *ungleich* as meaning something like "opposite" and "contrasting."

23. Although Panofsky and Theissing also note the print's contrastive structure, their

metaphysical readings differ from mine with its stress on the hippological context and contemporary audience. They view the print as about the heroic artist. Panofsky sees the rider as a "scientific paradigm" conveying the "idea of unconquerable progress." Theissing believes it is a self-portrait of the artist, engaged in a Promethean struggle between good and evil, conquering nature through art, chaos through order, and ultimately, the late Gothic style through the Italian Renaissance. Panofsky, *Dürer*, 154; Theissing, *Dürers Ritter*, 117–39.

24. The light color of Death's horse contrasts with the knight's darker horse, while also referring to Death riding on "a pale horse" (Revelation 6:8).

25. Keith Moxey, *Peasants, Warriors, and Wives* (Chicago: University of Chicago Press, 1989), 90–91; and J. R. Hale, *War and Society in Renaissance Europe, 1450–1620* (Baltimore: Johns Hopkins University Press, 1985), 147.

26. I interpret the devil's gesture as an attempt to hail the man-at-arms rather than the standard reading that he reaches out to grab the rider from behind. The extended arm seems more gestural than active, and the devil's body lacks all tension and strain that would accompany such an action. For a later example of a standing lansquenet hailing his passing lord, see Jörg Breu the Elder's woodcut series of the arrival of Charles V in Augsburg (ca. 1530), where the soldier raises his arm and hand to acclaim the passing elector Johann the Steadfast of Saxony.

27. For the interpretation of the dog, see Panofsky, *Dürer*, 153; for the lizard, see Theissing, *Dürers Ritter*, 90.

28. In his life of Marcantonio Raimondi, Vasari claims that Dürer created this print as part of his competition with the Dutch printmaker Lucas van Leyden. Heinz Lüdecke and Susanne Heiland, *Dürer und die Nachwelt* (Berlin: Rütten & Loening, 1955), 79.

29. Heinrich Wölfflin, *Die Kunst Albrecht Dürers*, 2nd ed. (Munich: F. Bruckmann A. G., 1908), 227–28.

30. David Landau and Peter Parshall, *The Renaissance Print, 1470–1550* (New Haven, Conn.: Yale University Press, 1994), 351.

31. Ibid., 354.

32. For Dürer as businessman, see Wolfgang Schmid, *Dürer als Unternehmer* (Trier: Porta Alba Verlag, 2003).

33. Theissing, *Dürers Ritter*, 72.

34. Sebald Beham, *Dises buchlein zeyget an und lernet ein maß oder proporcion der Ross . . .* (Nuremberg, 1528). See Pia F. Cuneo, "Beauty and the Beast: Art and Science in Early Modern European Equine Imagery," *Journal of Early Modern History* 4 (2000): 269–321, esp. 279–81, 283–87.

35. Kurthen, "Pferdekonstruktion," 77–79.

36. Erhard Schön, *Underweisung der Proportion und stellung der bossen . . .* (Nuremberg, 1538). The 1542 edition of this book is reproduced in *The Illustrated Bartsch*, vol. 13, pt. 1, ed. Walter Strauss (New York, 1981), 139–76. See Cuneo, "Beauty," 281, 287–88.

37. *The Illustrated Bartsch*, vol. 13, pt. 1, ed. Walter Strauss (New York: Abaris Books, 1981), 173.

38. Heinrich Lautensack, *Perspectiva und Proportion der Menschen und Rosse/* . . . (Frankfurt, 1563); Cuneo, "Beauty," 281–83, 288–89. South of the Alps, artists such as Leonardo da Vinci, Michelangelo, Bramante, and Vincenzo Foppa explored ways to define and render the ideal horse. See Diane Cole Ahl, ed., *Leonardo da Vinci's Sforza Monument Horse: The Art and the Engineering* (Bethlehem, Pa.: Lehigh University Press, 1995); Giorgio Vasari, *Lives of the Artists* (1568), trans. George Bull, 2 vols. (London: Penguin, 1987), 1:418 (on Michelangelo); and Giovanni Paolo Lomazzo, *Idea del tempio della pittura*, commentary by Robert Klein, 2 vols. (Florence: Istituto nazionale di studi sul Rinascimento, 1974), 1:43–53 (on Bramante, Foppa, Dürer, and Beham).

39. Among the many studies of the impact of the horse on culture and society, see Peter Edwards, *Horse and Man in Early Modern England* (London: Continuum, 2007).

40. British Museum, London, MS 5230, fol. 16a; reproduced in Rupprich, *Nachlass*, 2:127.

41. Peter Offenbach's introduction to Carlo Ruini, *Anatomia & medicina Equorum Nova* (Frankfurt, 1603), ii verso.

42. Laura Camins, *Glorious Horsemen: Equestrian Art in Europe, 1500–1800*, exh. cat. (Springfield, Mass.: Museum of Fine Arts, 1981); *Die Pferde von San Marco* (Berlin: Frölich & Kaufmann, 1982); and Walter Liedtke, *The Royal Horse and Rider: Painting, Sculpture and Horsemanship, 1500–1800* (New York: Abaris, 1989).

43. Dürer's Netherlandish diary as reproduced in Albrecht Dürer, *Schriften und Briefen*, ed. Ernst Ullmann (Berlin: Verlag das europäische Buch, 1984), 64 and 91, in which he comments on magnificent stallions he saw in Antwerp while visiting a branch of the Fugger firm and while attending the annual local horse market.

44. Jane Campbell Hutchison, *Albrecht Dürer: A Biography* (Princeton, N.J.: Princeton University Press, 1990), 3.

45. I agree with Theissing that Dürer's rider is meant to be regarded positively based on the image's iconographic derivation from equestrian monuments whose function was to honor the hero/victor/ruler. Theissing, *Dürers Ritter*, 57.

46. Such books, albeit later, include Marx Fugger, *Wie und wo man ein Gestüt von gutten edlen Kriegsrossen aufrichten und erhalten* . . . *soll* (1578); *Ritterliche Reutterkunst* (Frankfurt, 1584); Hanns Friderich Hörwart von Hohenburg, *Von der Hochberhümpten/ Adelichen und Ritterlichen Kunst der Reyterey* (Tegernsee, 1577); Johann Geissert, *Ein Ritterlich und Adelich Kunstbuch: Darinnen von Reiten/ Zeumen auch Roßarzney* . . . (Coburg, 1615); Federico Grisone, *Kunstlicher Bericht und aller zierlichste Beschreybung* . . . *Wie die streitbarn Pferdt* . . . *volkommen zu machen*, trans. Johann Fayser the Younger (Augsburg, 1599).

47. For an analysis of early modern riding techniques and their social functions, see Pia F. Cuneo, "Das Reiten als Kriegstechnik, als Sport und als Kunst: Die Körpertechniken des Reitens und gesellschaftliche Identität im frühneuzeitlichen Deutschland," in *Bewegtes Leben: Körpertechniken in der Frühen Neuzeit*, ed. Rebekka von Mallinckrodt, exh. cat. (Wolfenbüttel: Herzog August Bibliothek, 2008), 167–87 and 328–29.

48. On the social and technological changes in methods of warfare, see Eugene F.

Rice Jr., *The Foundations of Early Modern Europe, 1460–1559* (New York: Norton, 1970), 10–18; and Bert Hall, *Weapons and Warfare in Renaissance Europe* (Baltimore: Johns Hopkins University Press, 1992).

49. During the 1510s, Emperor Maximilian I and his allies were involved in military engagements on almost every border of the German lands. See Hermann Wiesflecker, *Kaiser Maximilian I: Das Reich, Österreich und Europa an der Wende zur Neuzeit*, 5 vols. (Munich: R. Oldenbourg, 1971–86), here vol. 4.

50. Fedja Anzelewsky, *Albrecht Dürer: Das malerische Werk*, rev. ed. (Berlin: Deutscher Verlag für Kunstwissenschaft, 1991), 167–202; and Larry Silver, *Marketing Maximilian: The Visual Ideology of a Holy Roman Emperor* (Princeton, N.J.: Princeton University Press, 2008).

51. Walter L. Strauss, ed., *The Book of Hours of Emperor Maximilian the First* (New York: Abaris Books, 1974).

52. Strauss, *Book of Hours*, fol. 37v; also Theissing, *Dürers Ritter*, 81, fig. 25.

53. Theissing, *Dürers Ritter*, 30–32.

54. Marx Fugger commissioned Mang Seuter, *Ein schönes und nützliches Bißbuch* (Augsburg, 1584), and by the same author, *Hippiatria: Ein fast Schönes und Nutzliches Buech von der Roßartzney* (Augsburg, 1599). Fugger himself wrote *Wie und wo man ein Gestüt von gutten edlen Kriegsrossen aufrichten und erhalten . . . soll* (1578), and *Von der Gestüterey* (1584 and 1611). He also commissioned the first German translation of Grisone, undertaken by Veit Tufft and published in Augsburg in 1566.

55. Xenophon's treatise on horsemanship, *Peri hippikes*, appeared circa 370 B.C.E.; Camerarius's Latin translation was published in 1539. On Fayser and Camerarius, see Pia F. Cuneo, "(Un)Stable Identities: Hippology and the Professionalization of Scholarship and Horsemanship in Early Modern Germany," in *Early Modern Zoology: The Construction of Animals in Science, Literature, and the Visual Arts*, ed. Karl A. E. Enenkel and Paul J. Smith (Leiden: Brill, 2007), 344–48.

CHAPTER 8. CIVIC COURTSHIP

1. Martin Warnke, *The Court Artist*, trans. David McLintock (Cambridge: Cambridge University Press, 1993), 71–72. The perfect counterpoint to Dürer's distance from his court assignments is his Italian doppelgänger, Jacopo de' Barbari, who migrated northward to work in Nuremberg for Emperor Maximilian and then to Frederick the Wise's court, chiefly in Wittenberg.

2. The alternate track of Saxon dukes was the Albertine line, whose capital was Dresden. Hajo Holborn, *A History of Modern Germany*, 3 vols. (Princeton, N.J.: Princeton University Press, 1959), 1:32, claims that Saxony was financially stronger than other German principalities because of revenue from mining of both metal and salt. On Frederick, see Robert Bruck, *Friedrich der Weise als Förderer der Kunst* (Strasbourg: J. H. E. Heitz, 1903); Ingetraut Ludolphy, *Friedrich der Weise: Kurfürst von Sachsen, 1463–1525* (Göttingen: Vandenhoeck & Ruprecht, 1984).

3. Ludolphy, *Friedrich der Weise*, 101–12 (on art), esp. 102–4 (on Dürer), and 337–66 (on piety). Frederick's bound copy of Dürer's *Engraved Passion* (B. 3–17, published in 1512, Princeton University Museum) includes handwritten prayers on the facing verso of each print; see Charles W. Talbot, ed., *Dürer in America*, exh. cat. (Washington, D.C.: National Gallery of Art, 1971), 138–39, figs. 40a–c.

4. Bruck, *Friedrich der Weise*, 56.

5. Diane Wolfthal, *The Beginnings of Netherlandish Canvas Painting: 1400–1530* (Cambridge: Cambridge University Press, 1989).

6. Erwin Panofsky, *The Life and Art of Albrecht Dürer*, rev. ed. (Princeton, N.J.: Princeton University Press, 1955), 33–34, 91, discusses the relation of the form of the hero to classical and Italian models, chiefly of Hercules by Pollaiuolo.

7. Ludolphy, *Friedrich der Weise*, 121–23. Jay Alan Levenson, "Jacopo de' Barbari and Northern Art of the Early Sixteenth Century" (Ph.D. dissertation, New York University, 1978), 16–17, asserts that Jacopo was the probable artist for the now-lost classical decorations in the Wittenberg castle interior decorations, which included the Labors of Hercules. However, Peter Strieder, "Ein Traum von Göttern und Heroen: Andreas Meinhardis Dialog über die Schönheit und den Ruhm der hochberühmten Stadt Albioris, gemeinhin Wittenberg genannt," *Anzeiger des Germanischen Nationalmuseum* (2005): 25–34, argues that Meinhard's description was purely a fictional literary exercise.

8. In general, see Erwin Panofsky, *Hercules am Scheidewege* (Leipzig: B. G. Teubner, 1930); Karl Galinsky, *The Herakles Theme: The Adaptations of the Hero in Literature from Homer to the Twentieth Century* (Oxford: Blackwell, 1972).

9. Panofsky, *Dürer*, 73–76, and *Hercules am Scheidewege*, 166–73; Joseph Leo Koerner, *The Moment of Self-Portraiture in German Renaissance Art* (Chicago: University of Chicago Press, 1993), 318, 385–94. Also see the deconstructive rereading of Panofsky's accepted interpretation by Fedja Anzelewsky, *Dürer-Studien* (Berlin: Deutscher Verlag für Kunstwissenschaft, 1983), 66–89.

10. On Dürer's nature studies and landscapes, see Fritz Koreny, *Albrecht Dürer und die Tier- und Pflanzenstudien der Renaissance*, exh. cat., Albertina, Vienna (Munich: Prestel, 1985), esp. 112–27 and no. 66; Walter Koschatzky, *Albrecht Dürer. The Landscape Water-Colours* (New York: St. Martin's Press, 1993), esp. no. 15.

11. Anzelewsky, *Dürer-Studien*, 57–65, to which could be added several drawings (W. 77–81, 86–87), as well as the unfinished engraving *The Sultan*, after a preliminary drawing (W. 77; National Gallery of Art, Washington, D.C.).

12. Arthur Saliger, "Aspekte zur künstlerischen Autorschaft des 'Ober St. Veiter Altares,'" in *Hans Schäufelein: Vorträge* (Nördlingen: Verein Rieser Kulturtage, 1990), 171–82.

13. Conrad Celtis died in Vienna on February 4, 1508. On their relationship, see Dieter Wuttke, "Dürer and Celtis: Von der Bedeutung des Jahres 1500 für den deutschen Humanismus, 'Jahrhundertfeier als symbolische Form,'" *Journal of Medieval and Renaissance Studies* 10 (1980): 73–129.

14. Larry Silver, "Shining Armor: Maximilian I as Holy Roman Emperor," *Art Institute of Chicago Museum Studies* 12 (1985): 8–29; David Landau and Peter Parshall, *The Renaissance Print, 1470–1550* (New Haven, Conn.: Yale University Press, 1994), 184–91.

15. The relations between the two princes, though initially cordial, became more tense after the imperial diet of 1500. Frederick had served in the 1490s as an official or lieutenant for Maximilian, *Statthalter, Hofrat,* and *Hofmeister,* with a (promised) annual stipend as honorarium. But he became the princely leader of the political resistance to Maximilian's attempted consolidation of imperial power, including taxation. Ultimately, Frederick's political sheltering of Luther against the interdict of Emperor Charles V in 1521 can be seen against this smoldering contest by the Saxon elector against imperial authority for political supremacy. Ludolphy, *Friedrich der Weise,* 137–238; Hermann Wiesflecker, *Kaiser Maximilian I: Das Reich, Österreich und Europa an der Wende zur Neuzeit,* 5 vols. (Munich: R. Oldenbourg, 1971–86), 5:5–9, 35–42.

16. On Maximilian's art projects, see Larry Silver, *Marketing Maximilian: The Visual Ideology of a Holy Roman Emperor* (Princeton, N.J.: Princeton University Press, 2008). See this text for additional literature, which is often too extensive to be cited fully in this chapter's notes.

17. Katherine Crawford Luber, "Albrecht Dürer's Maximilian Portraits: An Investigation of Versions," *Master Drawings* 29 (1991): 30–47.

18. On the literary works associated with Maximilian, see Jan-Dirk Müller, *Gedechtnus: Literatur und Hofgesellschaft um Maximilian I* (Munich: W. Fink, 1982). On Maximilian's large woodcut projects and on Dürer's *Formschneider* Hieronymus Andreae, see Landau and Parshall, *Renaissance Print,* 206–11, 217–18.

19. Tilman Falk, *Hans Burgkmair: Studien zu Leben und Werk des Augsburger Maler* (Munich: Bruckmann, 1968), esp. 69–73; Tilman Falk et al., *Hans Burgkmair: Das graphische Werk,* exh. cat. (Stuttgart: Staatsgalerie, 1973).

20. The thirty-five double-sided drawings, encompassing multiple groups on each page, are not securely dated. Eckert and Imhoff, *Pirckheimer,* 100; *Albrecht Dürer, 1471–1971,* no. 659. On Maximilian's pastimes, see Larry Silver, "*Caesar Ludens*: Emperor Maximilian I and the Waning Middle Ages," in *Cultural Visions: Essays in the History of Culture,* ed. Penny Schine Gold and Benjamin Sax (Amsterdam: Rodopi, 2000), 173–96.

21. Larry Silver, "Paper Pageants: The Triumphs of Emperor Maximilian I," in *"All the World's a Stage . . .": Art and Pageantry in the Renaissance and Baroque,* 2 vols., ed. Barbara Wisch and Susan Scott Munshower (University Park: Department of Art History, Pennsylvania State University, 1990), 1:292–331; Thomas Schauerte, *Die Ehrenpforte für Kaiser Maximilian I* (Munich: Deutscher Kunstverlag, 2001), with a full discussion of the *Arch*'s sources, iconography, and artistic attributions.

22. Campbell Dodgson, *Catalogue of Early German and Flemish Woodcuts . . . in the British Museum,* 2 vols. (London: British Museum, 1903), 1:311–33, nos. 130–36.

23. The program, recorded by Treitzsaurwein as "delivered orally" (*müntlichem angeben*) by Maximilian, is preserved in Vienna (Österreichische Nationalbibliothek, Cod. Vind. 2835). For a translation, see Stanley Appelbaum, *The Triumph of Maximilian I* (New York: Dover, 1964).

24. Müller, *Gedechtnus,* 59; Wiesflecker, *Maximilian,* 5:321, 327–29, 365.

25. Walter L. Strauss, *Albrecht Dürer: The Woodcuts and Woodblocks* (New York: Abaris, 1980), 500–507, no. 175, and 726–31 for a translation of the program.

26. A watercolor copy after a lost Dürer original of the hieroglyphic tabernacle survives in Vienna (Österreichische Nationalbibliothek, Cod. 3255); see Panofsky, *Dürer*, fig. 227.

27. The traditional Latin praise of Habsburg marital diplomacy goes: *Bella gerant alii / Tu felix Austria, nube* ("Let others war, As you, fortunate Austria, marry").

28. Dated June 5, 1517; translation by Strauss, *Woodcuts*, 500–502.

29. Along with the German-language versified romance adventure *Teuerdank*, published in Augsburg in 1517 by Hans Schönsperger the Elder, illustrated with 118 woodcuts by Burgkmair, Schäufelein, and Leonhard Beck. Müller, *Gedechtnus*, 108–30.

30. Hans Rupprich, *Dürer: Schriftlicher Nachlass*, 3 vols. (Berlin: Deutscher Verein für Kunstwissenschaft, 1956–69), 1:77, 79 for the letters. See the general discussion in Warnke, *Court Artist*, 71, with a translation of Maximilian's letter of December 12, 1512.

31. The proximate cause was the coronation of Charles V at Aachen. Panofsky, *Dürer*, 10, 205; J.-A. Goris and Georges Marlier, *Albrecht Dürer: Diary of His Journey to the Netherlands, 1520–1521* (Greenwich, Conn.: New York Graphic Society, 1971), 8, 64, 72.

32. The commissions to Nuremberg sculptors Vischer and Veit Stoss were given around 1513/14. The figure of Albrecht of Habsburg was cast in 1518 by Stefan Godl, who assumed subsequent responsibility for the entire tomb project figure production. Vinzenz Oberhammer, *Die Bronzestandbilder des Maximilian-Grabmales in der Hofkirche zu Innsbruck* (Innsbruck: Tyrolia, 1935); Karl Oettinger, *Die Bildhauer Maximilians am Innsbrucker Kaisergrabmal* (Nuremberg: Hans Carl, 1967); Erich Egg, *Die Hofkirche in Innsbruck* (Innsbruck: Tyrolia, 1974), 19, 24, 32, 35–39 (including fig. 8, a working drawing after the Dürer model, ascribed to Jörg Kölderer, now in Herzog-Anton-Ulrich Museum, Braunschweig).

33. Quirin von Leitner, *Freydal des Kaisers Maximilian I: Turniere und Mummereien*, 2 vols. (Vienna: A. Holzhausen, 1880–82); Campbell Dodgson, "Die Freydal-Holzschnitte Dürers," *Repertorium für Kunstwissenschaft* 25 (1902): 447–50; Strauss, *Woodcuts*, 522–32, nos. 182–86; Müller, *Gedechtnus*, 104–8 (on the text); Rainer Schoch, Matthias Mende, and Anna Scherbaum, eds., *Dürer: Das druckgraphische Werk*, 3 vols. (Munich: Prestel, 2001–4), vol. 3, no. 272.

34. Talbot, *Dürer in America*, 80–82, no. xxiv. On W. 678–79 (Albertina, Vienna), see also Walter Koschatzky and Alice Strobl, *Dürer Drawings in the Albertina* (Greenwich, Conn.: New York Graphic Society, 1972), nos. 103–4. A further pair in Berlin (W. 681–82) is discussed by Fedja Anzelewsky and Hans Mielke, *Albrecht Dürer: Kritischer Katalog der Zeichnungen* (Berlin: Kupferstichkabinett, 1984), nos. 87–88. The armor designs have been associated with the (lost) "silver armor" commissioned by the emperor from the Augsburg armorer Colomon Kolman, or Helmschmied (1470–1532), shortly after May 16, 1516.

35. Karl Gichlow, *Kaiser Maximilians I. Gebetbuch mit Zeichnungen von Albrecht Dürer und anderen Künstlern* (Vienna: Privately published, 1907); Hans Christoph von Tavel, "Die Randzeichnungen Albrecht Dürers zum Gebetbuch Kaiser Maximilians," *Münchner Jahrbuch der Bildenden Kunst* 16 (1965): 55–120; Ewald Vetter and Christoph Brockhaus, "Das Verhältnis von Bild und Text in Dürers Randzeichnungen zum Gebetbuch Kaiser

Maximilians," *Anzeiger des Germanischen Nationalmuseums* (1972): 70–121; Walter L. Strauss, *The Book of Hours of Emperor Maximilian the First* (New York: Abaris Books, 1974), with earlier bibliography. Also Panofsky, *Dürer*, 182–90; Diane Claire Strickland, "Maximilian as Patron: The 'Prayerbook' " (Ph.D. dissertation, University of Iowa, 1980).

36. Silver, "Shining Armor," with references. St. George was the patron saint of his father Frederick III's palace church at Wiener Neustadt, as well as the patron saint of crusaders.

37. Panofsky, *Dürer*, 183–84; Landau and Parshall, *Renaissance Print*, 204–5, 207, figs. 216–17 for the Munich *Lamentation* block. Strickland agrees these drawings were not solely for personal enjoyment, since (1) only a single color was employed for the drawings on each page by each artist, (2) all of the artists on the project were closely associated with the production of woodcuts, an inherently collaborative process (most were almost never solo producers of engravings except for Dürer), and (3) Augsburg, the location of both Peutinger and Schönsperger, was a major site of multicolor printing of both texts and images. Strickland, "Maximilian as Patron," 139.

38. Panofsky, *Dürer*, 185, 189–90, discussing some images (one of them Dürer's chosen theme for Frederick the Wise, namely Hercules and the Stymphalian Birds; another that contrasts Hercules with a drunkard attacked by a goose) that "express the same idea—the victory of spiritual forces over the dangers and temptations of the world." Also Michael Camille, *Image on the Edge: The Margins of Medieval Art* (London: Reaktion, 1992), esp. 99–127 (for the court), 129–52 (for the underclass and counterculture of the city).

39. Jean Michel Massing, "Early European Images of America: The Ethnographic Approach," in *Circa 1492*, ed. Jay Levenson, exh. cat., National Gallery of Art, Washington, D.C. (New Haven, Conn.: Yale University Press, 1991), 514–20, esp. 515–16. Dürer's image, dated 1515, appears on folio 41 and illustrates Psalm 24 ("The earth is the Lord's and the fullness thereof; the world and they that dwell therein").

40. Franz Schestag, "Kaiser Maximilians I. Triumph," *Jahrbuch der Kunsthistorischen Sammlungen der allerhöchsten Kaiserhauses* 1 (1883): 154–81; Karl Giehlow, "Dürers Entwürfe für das Triumphrelief Kaiser Maximilians im Louvre," *Jahrbuch der kunsthistorischen Sammlungen des Allerhöchsten Kaiserhauses* 29 (1910–11): 14–84.

41. Recall that Altdorfer's woodcut images on the flanking columns of the *Arch* also celebrate princely interests, qualities, and pastimes.

42. Strauss, *Woodcuts*, 532–34, no. 187; Schoch, Mende, and Scherbaum, *Das druckgraphische Werk*, vol. 2, no. 239. Burgkmair's large role surely resulted at least in part from Dürer's current commitment to the *Arch* project, so it is unlikely that any Dürer woodcuts for the *Procession* predate this fixed moment.

43. Stabius's program of the *Arch* explains the emblem as "chosen by the Emperor in his youth." Strauss, *Woodcuts*, 731.

44. Franz Winzinger, *Albrecht Altdorfer Graphik* (Munich: R. Piper, 1963), 74–78, 122–25, nos. 209–40, with good discussion of surviving blocks, thirty-two designs attributed to Altdorfer and workshop.

45. Giehlow, "Dürers Entwürfe," 39–59; Koschatzky and Strobl, *Dürer Drawings*, nos. 83 and 114.

46. Quoted by Strauss, *Woodcuts*, 536, no. 188, datable before the March 29, 1518, reply from Maximilian; Eckert and Imhoff, *Pirckheimer*, 109–15, 173–77; Larry Silver, "Prints for a Prince: Maximilian, Nuremberg, and the Woodcut," in *New Perspectives on the Art of Renaissance Nuremberg: Five Essays*, ed. Jeffrey Chipps Smith (Austin, Tex.: Archer M. Huntington Art Gallery, 1985), 7–21, here 17–18.

47. Giehlow, "Dürers Entwürfe," 42; and for most of these drawings, now in Vienna (Albertina), see Koschatzky and Strobl, *Dürer Drawings*, nos. 99–101, 105–10. The first of these equestrian figures is Stabius himself (W. 690), a fine and deserved tribute for his extended services to Maximilian, particularly in overseeing the production in Nuremberg of both the *Arch* and the *Procession*; however, neither this drawing of him nor those of the laurel-bearing or trophy-bearing (Hungarian, Italian, French, and Bohemian) horsemen behind him were ever made into woodcuts on account of the emperor's untimely death in the winter of 1519.

48. Silver, "Prints for a Prince," 18–20; Matthias Mende, *Das alte Nürnberger Rathaus*, exh. cat. (Nuremberg: Stadtgeschichtliche Museen, 1979), 178–81, 226, no. 110; Jeffrey Chipps Smith, *Nuremberg: A Renaissance City, 1500–1618*, exh. cat., Archer M. Huntington Art Gallery, Austin (Austin: University of Texas Press, 1983), no. 213. The Kress letter appears in translation in William Martin Conway, trans. and ed., *The Writings of Albrecht Dürer* (New York: Philosophical Library, 1958), 81–82. For further Dürer designs, not carried out on the Nuremberg City Hall walls (but showing accommodations to the shapes of the window openings), see the 1521 Morgan Library drawing (W. 921) with admonitory themes of the "Power of Women," Talbot, *Dürer in America*, no. xxix.

49. Silver, "Prints for a Prince," 8–9; Luber, "Maximilian Portraits"; Vinzenz Oberhammer, "Die vier Bildnisse Kaiser Maximilians I von Albrecht Dürer," *Alte und Moderne Kunst* 14 (1969): 2–14; *Albrecht Dürer, 1471–1971*, no. 258; Fedja Anzelewsky, *Albrecht Dürer: Das malerische Werk*, rev. ed. (Berlin: Deutscher Verlag für Kunstwissenschaft, 1991), nos. 145–46.

50. Koschatzky and Strobl, *Dürer Drawings*, no. 115. In all likelihood the hands depicted are from a model other than the emperor.

51. Ludwig von Baldass, "Die Bildnisse Kaiser Maximilians," *Jahrbuch der Kunsthistorischen Sammlungen der allerhöchsten Kaiserhauses* 31 (1913): 247–334, here 266–71. Dürer also utilizes a similar crown for St. Maximilian in the marginal drawing for the *Prayerbook*, fol. 25v; see Strauss, *Book of Hours*, 50.

52. *Albrecht Dürer, 1471–1971*, no. 259. For Lucas van Leyden's reversed copy in engraving and etching after Dürer, see Landau and Parshall, *Renaissance Print*, 332–33, figs. 363–64. Three other blocks, often of differing size, were made after the Dürer prototype; Strauss, *Woodcuts*, no. 190, mentions the presence of a second, gilded version in Gotha.

53. Landau and Parshall, *Renaissance Print*, 320. Frederick was in Nuremberg for the imperial diet in the winter of 1522–23. *Albrecht Dürer, 1471–1971*, nos. 546–47.

CHAPTER 9. DÜRER AND THE NETHERLANDS

I wish to thank Larry Silver, Jeffrey Chipps Smith, and Matthias Mende for their helpful comments and their collegial support.

1. Hans Rupprich, *Dürer: Schriftlicher Nachlass*, 3 vols. (Berlin: Deutscher Verein für Kunstwissenschaft, 1956–69), 1:160.

2. Only a single folio of Dürer's original text still exists; two old replicas made after yet another copy have survived in Bamberg (Staatsbibliothek, 246. J.M.Msc.art I) and Nuremberg (Stadtarchiv, S.I, L.78, Nr. 15, Fasz. 18). See also Jan Veth and Samuel Muller, *Dürers niederländische Reise*, 2 vols. (Berlin: Grote, 1918); J.-A. Goris and Georges Marlier, *Albrecht Dürer: Diary of His Journey to the Netherlands, 1520–1521* (Greenwich, Conn.: New York Graphic Society, 1971); and Gerd Unverfehrt, *Da sah ich viel köstliche Dinge: Albrecht Dürers Reise in die Niederlande* (Göttingen: Vandenhoeck & Ruprecht, 2007).

3. Peter Strieder, *Albrecht Dürer: Paintings, Prints, Drawings* (New York: Abaris, 1982), 133.

4. Filip Vermeyen, *Painting for the Market: Commercialization of Art in Antwerp's Golden Age* (Turnhout: Brepols, 2003). In 1500, the Guild of St. Luke counted 338 members; in the course of the sixteenth century, the number rose to 1,925 members, 694 of them registered painters; see Leon Voet, "Antwerp" in *The Dictionary of Art*, ed. Jane Turner, 34 vols. (London: Grove, 1996), 2:194.

5. His differentiated assessment of Jan Gossaert's deposition altarpiece in Middleburg is a good example for this practice; see Rupprich, *Nachlass*, 1:162: "do hat in der abte Johann Abüs eine grosse taffel gemacht, nit so gut im hauptstreichen als in gemähl." Rupprich interprets this passage as a comparison between the less satisfactory modeling of the faces and the application of color, which pleased Dürer more.

6. Dagmar Eichberger, *Leben mit Kunst, Wirken durch Kunst: Sammelwesen und Hofkunst unter Margarete von Österreich, Regentin der Niederlande* (Turnhout: Brepols, 2002), 300–301.

7. Rupprich, *Nachlass*, 1:168: "Afterwards they took me to St. James and let me see the paintings by Rudiger and Hugo, both of whom had been great masters. . . . Afterwards they took me to many (other) churches and let me see all the good paintings, of which there is abundance" (April 8, 1521).

8. Ibid., 1:155.

9. It is surprising that he does not mention Hieronymus Bosch's *Garden of Earthly Delights*, which was also displayed in this residence.

10. Rupprich, *Nachlass*, 1:173–74.

11. Eichberger, *Leben mit Kunst*, 354.

12. Chiyo Ishikawa, *The 'Retablo de Isabel la Católica' by Juan de Flandes and Michel Sittow* (Turnhout: Brepols, 2004).

13. Rupprich, *Nachlass*, 1:151.

14. Jane Campbell Hutchison, *Albrecht Dürer: A Biography* (Princeton, N.J.: Princeton University Press, 1990), 130.

15. Dürer was equally interested in meeting Italian artists and art dealers and developed close relations with Tommaso di Andrea Vincidor, a draftsman and painter who had been sent to the Netherlands by the Pope Leo X to supervise the weaving of tapestries for the Vatican.

16. Rupprich, *Nachlass*, 1:52, 169 and 175 n. 652.

17. Ibid., 172. Although Dürer felt that he was cheated by the Brussels goldsmith, he dined with him three times before his departure from Brussels and presented his wife with an *Engraved Passion*; ibid., 176–77.

18. Stefano Capello, an Antwerp jeweler and goldsmith, was not formally part of the ducal household but frequently worked for Margaret of Austria; see Eichberger, *Leben mit Kunst*, 295; and Josef Duverger, "Margareta van Oostenrijk (1480–1530) en de Italiaanse Renaissance," in *Relations artistiques entre les Pays-Bas et l'Italie à la Renaissance: Études dédiées à Suzanne Sulzberger* (Brussels: Institut Historique Belge de Rome, 1980), 130.

19. Dürer calculated the value of these items at thirty guldens; see Rupprich, *Nachlass*, 1:158, 175–76.

20. Dürer's large silverpoint *Portrait of Lucas van Leyden* (W. 816; Musée des Beaux-Arts, Lille) reflects the men's good relationship; see *Albert Dürer aux Pays-Bas, son voyage (1520–21), son influence*, exh. cat. (Brussels: Palais des Beaux-Arts, 1977), no. 82.

21. Jeffrey Chipps Smith, "Netherlandish Artists and Art in Renaissance Nuremberg," *Simiolus* 20 (1990–91): 153–67, here 165 and fig. 22.

22. Perhaps the only exception is Dürer's drawing of a small female bronze figure from the *Tomb of Isabella of Bourbon* (W. 766; British Museum, London), the first wife of Charles the Bold, which was erected by his daughter, Mary of Burgundy, in 1476; see John Rowlands and Giulia Bartrum, *Drawings by German Artists and Artists from German-speaking Regions of Europe*, 2 vols. (London: British Museum, 1993), no. 217, pl. 145.

23. I will not discuss in more detail the numerous portrait drawings of male acquaintances. The silverpoint drawings in his sketchbook were designated for his own use and reflect his interest in these sitters.

24. Rupprich, *Nachlass*, 1:151.

25. *Three Women from Bergen-op-Zoom* and *Woman from Goes* (W. 770–71; Musée Condé, Chantilly); see David Mandrella, *Dessins allemands et flamands du musée Condé à Chantilly: De Dürer à Rubens*, exh. cat., Musée Condé, Chantilly (Paris: Editions de la Reunion des musées nationaux, 1999), no. 10.

26. Kupferstichkabinett, Berlin. Made on their twenty-seventh anniversary, the large drawing is inscribed, "das hat albrecht dürer noch seiner hawsfraen Conterfet zw antorff in der niderlendischen Kleidung im Jor 1521 do sy aneinander zw der e gehabt hetten XXVII Jor."

27. Matthias Mende, "Albert Dürer et ses rencontres avec les artistes des Pays-Bas," in *Albert Dürer aux Pays-Bas*, 145–51.

28. Ethan Matt Kavaler, "Renaissance Gothic in the Netherlands: The Uses of Ornament," *Art Bulletin* 82 (2000): 226–51.

29. Eichberger, *Leben mit Kunst*, 345–67; Dagmar Eichberger, "Stilpluralismus und

Internationalität am Hofe Margaretes von Österreich (1506–1530)," in *Wege zur Renaissance*, ed. Norbert Nussbaum, Claudia Euskirchen, and Stephan Hoppe (Cologne: SH-Verlag, 2003), 261–83; and Ariane Mensger, "Blick zurück nach vorne. Jan Gossaert kopiert Jan van Eyck," in *Porträt—Landschaft —Interieur: Jan van Eycks Rolin-Madonna im ästhetischen Kontext*, ed. Christiane Kruse and Felix Thürlemann (Tübingen: G. Narr, 1999), 273–90.

30. Rudolf Preimesberger, "Zu Jan van Eycks Diptychon der Sammlung Thyssen-Bornemisza," *Kunst* 4 (1991): 459–89.

31. *Der hübsche Martin: Kupferstiche und Zeichnungen von Martin Schongauer*, exh. cat. (Colmar: Musée d'Unterlinden, 1991); and Albert Châtelet, ed., *Le beau Martin: Études et mises au point* (Colmar: Musée d'Unterlinden, 1994); Jan Piet Filedt Kok, ed., *Livelier than Life: The Master of the Amsterdam Cabinet or the Housebook Master, ca. 1470–1500*, exh. cat., Rijksmuseum, Amsterdam (Maarssen: G. Schwartz, 1985). Since the identity of the Housebook Master is still a mystery, we are unable to say whether he trained in the Netherlands or whether he was born there and migrated to the Middle Rhine later in his life.

32. Peter Strieder, "Albrecht Dürer in Carel van Manders Schilder-Boeck," in *Festschrift Otto Schäfer zum 75. Geburtstag am 29. Juni 1987*, ed. Manfred von Arnim (Stuttgart: E. Hauswedell, 1987), 11–19, here 14.

33. Leonie von Wilckens and Peter Strieder, eds., *Vorbild Dürer*, exh. cat., Germanisches Nationalmuseum, Nuremberg (Munich: Prestel, 1978), nos. 2, 22, 32.

34. Ibid., nos. 30, 48, 81, 91, 95, 103, 116, 120, 122, 126, 182, 188, 190, 195, 198, 203, 214, 220, 223.

35. Julius Held, *Dürers Wirkung auf die niederländische Kunst seiner Zeit* (The Hague: M. Nijhoff, 1931), 112–26.

36. In contemporary literature, art from Italy is generally described as *mode d'Italie* or as *welsche art*.

37. On this point, Erwin Panofsky remarks, "Gossaert translates the antique from the German (Dürer) into the Dutch style." Held, *Dürers Wirkung*, 113, citing Panofsky, "Dürers Stellung zur Antike," *Jahrbuch für Kunstgeschichte* 1 (1921–22): 43–92.

38. Ariane Mensger, *Jan Gossaert. Die niederländische Kunst zu Beginn der Neuzeit* (Berlin: Reimer, 2002), 23–30; Kavaler, "Renaissance Gothic."

39. Gossaert's version serves itself as a model for another Flemish artist, identified as Adriaen Ysenbrant; see Max J. Friedländer, *Early Netherlandish Painting*, vol. 11, *The Antwerp Mannerists, Adriaen Ysenbrant*, rev. ed. (Leiden: A. J. Sijthoff, 1974), no. 145 a–b, pl. 122.

40. With his extensive series of Adam and Eve paintings and drawings, Gossaert fundamentally changed and modernized the image of the *Fall of Man* in the Netherlands. Up to this point it had been dominated by Jan van Eyck's interpretation of the same subject on the *Ghent Altarpiece*; see Larry Silver, "Figure nude, historie e poesie: Jan Gossaert and the Renaissance Nude in the Netherlands," *Nederlands Kunsthistorisch Jaarboek* 37 (1986): 1–40.

41. Musées des Beaux-Arts, Brussels. See Eliane De Wilde, ed., *Le musée caché, à la découverte des réserves*, exh. cat. (Brussels: Musées Royaux des Beaux-Arts de Belgique, 1994).

42. Henri Pauwels, Hendrik R. Hoetink, and Sadja J. Herzog, *Jan Gossaert genaamd Mabuse*, exh. cat. (Rotterdam: Museum Boijmans Van Beuningen, 1965), no. 3; *Albert Dürer aux Pays-Bas*, no. 350; Colin Eisler, *Early Netherlandish Painting: The Thyssen-Bornemisza Collection* (London: Sotheby's Publications, 1989), no. 21.

43. SMPK, Gemäldegalerie, Berlin; see Sadja J. Herzog, "Tradition and Innovation in Gossaert's *Neptune and Amphitrite* and *Danae*," *Bulletin Museum Boymans van Beuningen* 19 (1968): 25–41. In his final comments, Held states that Gossaert's response to Dürer can rather be described as a "Verwerten" than as a "Lernen"; see Held, *Dürers Wirkung*, 125.

44. Jan Gossaert, *The Mocking of Christ*, etching, 19.3 x 14.5 cm, ca. 1525, Museum Boijmans Van Beuningen, Rotterdam. The masonry arches and the unusual position of the Roman soldier may have been inspired by Dürer's woodcut *Christ in Limbo* in the same series. Pauwels, Hoetink, and Herzog, *Gossaert*, no. 75. In his study on printmaking in Antwerp, Van der Stock argues that Gossaert and others adopted Dürer's commercial attitude to printmaking. Jan Van der Stock, *Printing Images in Antwerp: The Introduction of Printmaking in a City, Fifteenth Century to 1585* (Rotterdam: Sound & Vision Interactive, 1998), 97, fig. 57.

45. Colegio del Patriarca (Corpus Christi), Valencia; see Max J. Friedländer, *Early Netherlandish Painting*, vol. 8, *Jan Gossaert and Bernart van Orley*, rev. ed. (Leiden: A. J. Sijthoff, 1972), 31, pl. 25; see also Held, *Dürers Wirkung*, 123–24.

46. Held, *Dürers Wirkung*, 56–58, 132–33.

47. Wim Blockmans and Walter Prevenier, "The Second Flowering, 1492–1530," in *The Promised Lands: The Low Countries under Burgundian Rule, 1369–1530*, ed. Wim Blockmans and Walter Prevenier (Philadelphia: University of Pennsylvania Press, 1999), 206–34.

48. Dieuwke De Hoop Scheffer, *The Graphic Art of Albrecht Dürer and Its Influence in the Netherlands*, exh. cat. (Amsterdam: Rijksmuseum, 1971); Friso Lammertse and Jeroen Giltaij, *Vroege hollanders, schilderkunst van de late Middeleeuwen*, exh. cat. (Rotterdam: Museum Boijmans Van Beuningen, 2008).

49. *Albert Dürer aux Pays-Bas Dürer*, no. 384.

50. Karin Orchard, *Albrecht Dürer und Lucas van Leyden: Ein Vergleich*, exh. cat. (Hamburg: Kunsthalle, 1990); Strieder, "Carel van Manders Schilder-Boeck," 11–19.

51. Orchard, *Dürer*, 14–15.

52. Fedja Anzelewsky, *Albrecht Dürer: Das malerische Werk*, rev. ed. (Berlin: Deutscher Verlag für Kunstwissenschaft, 1991), 52–53; Held, *Dürers Wirkung*, 87, 139–40; see also Klaus Demus, Friderike Klauner, and Klaus Schütz, *Flämische Malerei von Jan van Eyck bis Pieter Bruegel d. Ä.* (Vienna: Das Museum–Herold, 1981), 223–24.

53. Anzelewsky, *Das malerische Werk*, no. 162; Matthias Mende, "Albrecht Dürers Lissaboner Hieronymus," in *Museu Nacional de Arte Antiga Lissabon*, ed. Alexandra Curvelo, exh. cat., Kunst- und Ausstellungshalle der Bundesrepublik Deutschland, Bonn (Munich: Hirmer, 1999), 164–65.

54. Dürer's model was copied or quoted many times. Friedländer lists forty copies, Julius Held names twenty-four copies, Anzelewsky added a few more to Held's list, Mende even speaks of one hundred paintings influenced by the Lisbon *St. Jerome*; see Held, *Dürers Wirkung*, 87, 139–40; Anzelewsky, *Das malerische Werk*, no. 162; Mende, "Hieronymus," 164.

55. Ernst H. Gombrich, "Dürer, Vives and Bruegel," in *Album Amicorum J. G. van Gelder*, ed. Josua Bruyn et al. (The Hague: Nijhoff, 1973), 132–34.

56. Jan van Damme, "Portrait Bust of Albrecht Dürer," in *Antwerp: Story of a Metropolis*, ed. Jan Van der Stock, exh. cat., Hessenhuis, Antwerp (Ghent: Snoeck-Ducaju, 1993), no. 16, 165–66.

57. Ibid.; most scholars have attributed these two sculptures to the Mechelen artist Willem van den Broeck; see Jozef Duverger and M. J. Onghena, "Beeldhouwer Willem van den Broecke alias Gulielmus Paludanus (1530 tot 1579 of 1580)," *Gentsche Bijdragen tot de Kunstgeschiedenis* 5 (1938): 75–121, here 83, 90–100, with J. Linnig's etching of the *Facade of Cornelis van Dalem's House in Antwerp* (1849), illustrated on 91.

58. Matthias Mende, "GERMANORUM DECUS. Zur Bildnisbüste Albrecht Dürers im Museum Vleeshuis in Antwerpen," in *Beständig im Wandel. Innovationen—Verwandlungen—Konkretisierungen*, Festschrift für Karl Mösenender zum 60. Geburtstag, ed. Christian Hecht (Matthes & Seitz: Berlin, 2009), 121–28. Mende questions the attribution to Paludanus.

59. This may be of particular interest in the light of the growing tensions between two rivaling forces, namely Italian and Netherlandish art; see Mark Meadow, "Bruegel's 'Procession to Calvary': Æmulatio and the Space of Vernacular Style," *Nederlands Kunsthistorisch Jaarboek* 47 (1996): 180–205. See also Ariane Mensger, "Jan van Eyck, *Belgarum Splendor*, und der Anfang einer niederländischen Geschichte der Kunst," *Pantheon* 58 (2000): 44–53.

60. Strieder, "Carel van Manders Schilder-Boek," 15–16.

61. De Hoop Scheffer, *Dürer*, fig. 1.

62. Rupprich, *Nachlass*, 1:157 n. 246.

63. On the various terms used as epithets by Dürer himself, see Dagmar Eichberger, "ALBERTVS · DURER · NORICVS. Un artista europeo en el contexto de su ciudad natal, Nuremberg," in *Durero y Cranach. Arte y Humanismo en la Alemania del Rinascimiento*, ed. Fernando Checa, exh. cat. (Madrid: Thyssen-Bornemisza Museum, 2007), 65–81 and 482–88 (English translation).

CHAPTER 10. AGONY IN THE GARDEN

Dedication: For Ann, and in memory of our Benjamin, again.

1. Stephen Greenblatt, *Renaissance Self-Fashioning: From More to Shakespeare* (Chicago: University of Chicago Press, 2005), 45–46.

2. Ibid., 72. Also see James Monti, *The King's Good Servant but God's First: The Life and Writings of Saint Thomas More* (San Francisco: Ignatius Press, 1997), 362–404.

3. Greenblatt, *Renaissance Self-Fashioning*, 72.

4. The expression "personal trials" is from Peter Parshall, "Albrecht Dürer's *Gedenck-buch* and the Rain of Crosses," *Word and Image* 22 (2006): 202–10, here 210.

5. Hans Belting, *Likeness and Presence: A History of the Image before the Era of Art*, trans. Edmund Jephcott (Chicago: University of Chicago Press, 1994), 458–90; Alexander Nagel, *Michelangelo and the Reform of Art* (Cambridge: Cambridge University Press, 2000), 18–19. For a wide-ranging discussion, see Donald McColl, "Through a Glass Darkly: Dürer and the Reform of Art," *Reformation and Renaissance Review* 5 (2003): 54–91.

6. David Hotchkiss Price, *Albrecht Dürer's Renaissance: Humanism, Reformation, and the Art of Faith* (Ann Arbor: University of Michigan Press, 2003), 244, writes that when "Dürer wrote that Luther had helped him 'overcome so many anxieties' [aws grossen engsten gehollfen hat], he was not attesting a personal spiritual crisis as all previous schol-ars have maintained, so much as he was echoing the Lutheran critique of justification."

7. On the issue of overdetermination in scholarship, see Richard E. Spear, *The Divine Guido: Religion, Sex, Money, and Art in the World of Guido Reni* (New Haven, Conn.: Yale University Press, 1997), 4 and 16.

8. Ibid., 5. Also see John Martin, "Inventing Sincerity, Refashioning Prudence: The Discovery of the Individual in Renaissance Europe," *American Historical Review* 102 (1997): 1309–42.

9. Corine Schleif, "Nicodemus and Sculptors: Self-Reflexivity in Works by Adam Kraft and Tilman Riemenschneider," *Art Bulletin* 75 (1993): 599–626.

10. Joseph Leo Koerner, *The Moment of Self-Portraiture in German Renaissance Art* (Chicago: University of Chicago Press, 1993), xviii.

11. Carl C. Christensen, *Art and the Reformation in Germany* (Athens: Ohio University Press, 1979), 177; see also Jeffrey Chipps Smith, "Netherlandish Artists and Art in Renais-sance Nuremberg," *Simiolus* 20 (1990–91): 153–67, here 153.

12. Andrew Cunningham and Ole Peter Grell, *The Four Horsemen of the Apocalypse: War, Famine, Disease, and Gospel in Reformation Europe* (Cambridge: Cambridge Univer-sity Press, 2000); and Arthur E. Imhoff, *Lost Worlds: How Our European Ancestors Coped with Everyday Life and Why Life Is So Hard Today,* trans. Thomas Robisheaux (Charlottes-ville: University of Virginia Press, 1996).

13. Nina German, "Ottoman Shock-and-Awe and the Rise of Protestantism: Luther's Reactions to the Ottoman Invasions of the Early Sixteenth Century," *Seminar: A Journal of Germanic Studies* 41 (2005): 226–45.

14. Robert Scribner, *The German Reformation* (Atlantic Highlands, N.J.: Humanities Press International, 1986), 1, citing Bernd Moeller. On the issue of choice in the Reforma-tion, see Andrew Pettegree, *Reformation and the Culture of Persuasion* (Cambridge: Cam-bridge University Press, 2005), 3.

15. William Martin Conway, trans. and ed., *The Writings of Albrecht Dürer* (New York: Philosophical Library, 1958), 156–57.

16. Conway, *Writings of Albrecht Dürer*, 158–59.

17. Philipp Melanchthon wrote in 1540, "I thank God for the legacy of Dürer's widow." Price, *Albrecht Dürer's Renaissance*, 7–9 and passim.

18. Pettegree, *Culture of Persuasion*, 6–7, bemoans the state of our knowledge of the how as opposed to the why of the Reformation. He offers a model, "The Protestant Conversion Process," which, while not meant be a chronology as such, consists of four stages: Awareness, Identification, Understanding, and Activism. Luther writes, "The reader must take into account that I am not one of those who suddenly, out of nowhere, achieve perfection and penetrate the Scripture"; as cited in Heiko A. Oberman, *Luther: Man between God and the Devil*, trans. Eileen Walliser-Schwarzbart (New Haven, Conn.: Yale University Press, 1989), 157.

19. H. C. Erik Midelfort, "Religious Melancholy and Suicide: On the Reformation Origins of a Sociological Stereotype," in *Madness, Melancholy, and the Limits of the Self*, ed. Andrew D. Weiner et al. (Madison: University of Wisconsin Law School, 1996), 41–56.

20. For a "counterfactual" view of the Reformation, see Geoffrey Parker, "Martin Luther Burns at the Stake, 1521," in *The Collected What If? Eminent Historians Imagining What Might Have Been*, ed. Robert Crowley (New York: Putnam, 2005), 507–19.

21. Keith Moxey, *Peasants, Warriors, and Wives: Popular Imagery in the Reformation* (Chicago: University of Chicago Press, 1989), 29–34.

22. David Landau and Peter Parshall, *The Renaissance Print, 1470–1550* (New Haven, Conn.: Yale University Press, 1994), 217.

23. Moxey, *Peasants, Warriors, and Wives*, 31.

24. Dorothea Klein, *St Lukas als Maler der Maria. Ikonographie der Lukas-Madonna* (Hamburg: Oskar Schloss 1933); and on images of the Virgin in the Reformation, see Bridget Heal, *The Cult of the Virgin Mary in Early Modern Germany: Protestant and Catholic Piety, 1500–1648* (Cambridge: Cambridge University Press, 2007).

25. On images and indulgences, with reference to the Man of Sorrows, see Jeffrey Chipps Smith, *German Sculpture of the Later Renaissance, c. 1520–1580: Art in an Age of Uncertainty* (Princeton: Princeton University Press, 1994), 10–12, and Nagel, *Michelangelo and the Reform of Art*, 51.

26. Lee Palmer Wandel, *Voracious Idols and Violent Hands: Iconoclasm in Reformation Zurich, Strasbourg, and Basel* (Cambridge: Cambridge University Press, 1999), 198.

27. Carlos Eire, *War against the Idols: The Reformation of Worship from Erasmus to Calvin* (New Haven, Conn.: Yale University Press, 1996), 151–55.

28. Craig Harbison, "Dürer and the Reformation: The Problem of the Re-dating of the *St. Philip* Engraving," *Art Bulletin* 56 (1976): 368–73.

29. McColl, "Though a Glass Darkly," 62–64, and Wandel, *Voracious Idols and Violent Hands*, 26.

30. Gerald Strauss's review of Erika Rummel, *The Confessionalization of Humanism in Reformation Germany* (Oxford: Oxford University Press, 2000), in *American Historical Review* 106 (2001): 1055–56.

31. Herbert Kessler, "Face and Firmament: Albrecht Dürer's *Angel with the Sudarium* and the Limits of Vision," in *L'immagine di Cristo da van Eyck a Bernini*, ed. Gerhard Wolf (Rome: Vatican, 2005), 165.

32. Kristen Zapalac, "'Item Perspectiva ist ein lateinisch Wort, bedeutt ein Durchse-

hung': A Reformation Re-Vision of the Relationship between Idea and Image," in *Meaning in the Visual Arts: Views from the Outside*, ed. Irving Lavin (Princeton, N.J.: Institute for Advanced Study, 1995), 131–49, here 138.

33. Martin Luther, "Appeal for Prayer against the Turks (1541)," in *Luther's Works*, vol. 43, *Devotional Writings II*, ed. Gustav K. Wiencke (Minneapolis: Fortress Press, 1968), 216–41, here 223.

34. McColl, "Through a Glass Darkly," 54–55, 90.

35. Donald McColl, "*Ad fontes*: Iconoclasm by Water in the Reformation World," in *The Idol in the Age of Art: Objects, Devotions, and the Early Modern World*, ed. Michael Cole and Rebecca Zorach (Aldershot: Ashgate, forthcoming).

36. Peter Parshall, "Hans Holbein's *Pictures of Death*," in *Hans Holbein: Paintings, Prints, and Reception*, ed. Mark Roskill and John Oliver Hand (New Haven, Conn.: Yale University Press, 2001), 88, 90–92.

37. Pettegree, *Culture of Persuasion*, 102–27; McColl, "Through a Glass Darkly," 79–85.

38. Larry Silver, "The Influence of Anxiety: The Agony in the Garden as Artistic Theme in the Era of Dürer," *Umeni* 45 (1997): 420–29; Jeffrey Hamburger, *Nuns as Artists: The Visual Culture of a Medieval Convent* (Berkeley: University of California Press, 1997), 84–85; Smith, *German Sculpture*, 29–30, 37; Herbert Kessler, *Seeing Medieval Art* (Orchard Park, N.Y.: Broadview Press, 2004), 24.

39. Daniel T. Lochman, "Colet and Erasmus: The *Disputatiuncula* and the Controversy of Letter and Spirit," *Sixteenth Century Journal* 20 (1989): 77–88.

40. Silver, "The Influence of Anxiety," 424 and 427, following Fritz Saxl, sees the Agony in the Garden as part of a "revisionist 'Christ-bearer' theology adapted for a new Lutheran use of traditional Catholic imagery." At the core of these scenes is an existential crisis in which "salvation lies in complete submission to faith," in accord with Luther's theology of the cross.

41. Hamburger, *Nuns as Artists*, 88–92.

42. Joseph Leo Koerner, *The Reformation of the Image* (Chicago: University of Chicago Press, 2004), fig. 65.

43. Hamburger, *Nuns as Artists*, 90.

44. Tanya Jung, "The Phenomenal Lives of Movable Christ Sculptures" (Ph.D. dissertation, University of Maryland, College Park, 2006).

45. Hamburger, *Nuns as Artists*, 82, echoing Psalm 101:2-3.

46. Hamburger, *Nuns as Artists*, 14.

47. Fiona J. Griffiths, *The Garden of Delights: Reform and Renaissance for Women in the Twelfth Century* (Philadelphia: University of Pennsylvania Press, 2006), 139–41.

48. Austra Reinis, *Reforming the Art of Dying: The Ars Moriendi in the German Reformation (1519–1528)* (Aldershot: Ashgate, 2007), 40–45.

49. Maximilian I had his hair shorn, his teeth knocked out, and his body scourged in preparation for meeting his maker. Oberman, *Luther*, 26. As late as 1523, Dürer had no qualms in recording that his own mother was granted a plenary indulgence before she died. Price, *Albrecht Dürer's Renaissance*, 22,

50. See the examples in Roland H. Bainton, "Dürer and Luther as the Man of Sorrows," *Art Bulletin* 29 (1947): 269–72. The many editions of the *Imitatio Christi* demonstrate its appeal across sectarians lines. Max von Hapsburg, "Catholic and Protestant Editions of the *Imitatio Christi* of Thomas à Kempis, 1450–1650" (Dissertation, University of St. Andrews, forthcoming).

51. Robert W. Scribner, "Ritual and Reformation," in *The German People and the Reformation*, ed. R. Po-chia Hsia (Ithaca, N.Y.: Cornell University Press, 1988), 122–44, here 132.

52. Schleif, "Nicodemus and Sculptors," 599.

53. Koerner, *Moment of Self-Portraiture.*

54. Jordan Kantor, *Dürer's Passions*, 2 vols., exh. cat. (Cambridge, Mass.: Harvard University Art Museums, 2000), 17.

55. Parshall, "Albrecht Dürer's *Gedenckbuch*," 202.

56. Philip Sohm, *The Artist Grows Old: The Aging of Art and Artists in Italy, 1500–1800* (New Haven, Conn.: Yale University Press, 2007), 66; Erin J. Campbell, "The Art of Aging Gracefully: The Elderly Artist as Courtier in Early Modern Art Theory and Criticism," *Sixteenth Century Journal* 33 (2002): 321–31, here 326–28, notes that artists' concern with their eyes and hands was a trope among early modern theorists like Giulio Mancini and Raffaello Borghini.

57. R. F. Timken-Zinkmann, "Medical Aspects of the Art and Life of Albrecht Dürer (1471–1528)," in *Proceedings of the XXIII International Congress of the History of Medicine, 1972*, 2 vols. (London: Wellcome Institute of the History of Medicine, 1974), 2:870–75.

58. Peter Matheson, *The Imaginative World of the Reformation* (Minneapolis: Fortress Press, 2001), 121.

59. Jeffrey Chipps Smith, "Die Kunst des Scheiterns: Albrecht von Brandenburg und das Neue Stift in Halle," in *Der Kardinal Albrecht von Brandenburg: Renaissancefürst und Mäzen*, ed. Thomas Shauerte, exh. cat., Stiftung Moritzburg, Halle (Regensburg: Schnell and Steiner, 2006), 17–51, here 31, and nos. 79–80.

60. David Price, "Albrecht Dürer's *Last Supper* (1523) and the Septembertestament," *Zeitschrift für Kunstgeschichte* 59 (1996): 578–84. This makes all the more striking the artist's foreshadowing of Luther's formulation in 1530 that "the gracious and merciful Lord has instituted a remembrance of His wonderful works" (*Commentary on Psalm 111*), which he suggested be painted in gold letters around pictures of the Last Supper on altars. See John Dillenberger, *Images and Relics: Theological Perceptions and Visual Images in Sixteenth-Century Europe* (Oxford: Oxford University Press, 1999), 93.

61. For a possible parallel in Leonardo, see Leo Steinberg, *Leonardo's Incessant Last Supper* (New York: Zone Books, 2005).

62. J. B. Ross, "Gasparo Contarini and His Friends," *Studies in the Renaissance* 17 (1970): 192–232, here 213.

63. Jane Campbell Hutchison, *Albrecht Dürer: A Biography* (Princeton, N.J.: Princeton University Press, 1990), 179.

64. Koerner, *Reformation of the Image*, figs. 130 and 211.

65. Kantor, *Dürer's Passions*, 35–40.

66. Monti, *The King's Good Servant*, 384.

67. Karl Arndt und Bernd Moeller, *Albrecht Dürers Vier Apostel: Eine kirchen- und kunsthistoriche Untersuchung* (Göttingen: Vandenhoeck & Ruprecht, 2003); and Price, *Albrecht Dürer's Renaissance*, 258–75.

68. Price, *Albrecht Dürer's Renaissance*, 273. On a parallel development in Italy, see Nagel, *Michelangelo and the Reform of Art*, 143–68.

69. Price, *Albrecht Dürer's Renaissance*, 264–65.

CHAPTER 11. ALBRECHT DÜRER BETWEEN AGNES FREY AND
WILLIBALD PIRCKHEIMER

This chapter draws on material from a book in progress, "Agnes Frey Dürer: The Roles of the Artist's Wife and Widow in History and Historiography." I am especially grateful for the suggestions of Pia Cuneo. Unless otherwise indicated, the translations are those of the author.

1. I wish to thank Karl Kohn for identifying the house and calling my attention to the illustration. The house was one of two owned by the Imhoff family on Egidien Place. In the nineteenth century it was often misrepresented as the house in which Willibald Pirckheimer himself had lived and written.

2. Hans Rupprich, *Dürer: Schriftlicher Nachlass*, 3 vols. (Berlin: Deutscher Verein für Kunstwissenschaft, 1956–69), 1:58–60.

3. Laurinda Dixon, "Some Penetrating Insights: The Imagery of Enemas in Art," *Art Journal* 52 (1993): 28–35.

4. See *Deutsches Wörterbuch von Jacob Grimm und Wilhelm Grimm* (Leipzig: S. Hirzel, 1854–1960). Andreas Schmeller quotes a passage in the *Wildshutter Ehehaft*, in which an officer of the court is allowed to break into (*einbrechen*) the stove of a debtor who cannot pay a fine, or in the event that he has no stove then the officer is allowed to have intercourse with (*prautten*) the debtor's wife; see Schmeller, *Bayerisches Wörterbuch*, ed. G. Karl Frommann, 2nd ed. (Munich: R. Oldenbourg, 1872–77).

5. On the role of Agnes Dürer in managing the workshop during Albrecht's stay in Italy, see Karl Oettinger and Karl-Adolf Knappe, *Hans Baldung Grien und Albrecht Dürer in Nürnberg* (Nuremberg: Hans Carl, 1963), 19.

6. Rupprich, *Nachlass*, 1:45–46.

7. Ibid., 52–53.

8. For a discussion of Dürer's idiomatic usage, see ibid., 60 n. 34.

9. Ibid., 43.

10. These pictograms have been discussed extensively in the literature. For a reproduction of the drawings, summary of the explanations, and further references, see Rupprich, *Nachlass*, 1:45 n. 25.

11. Emil Reicke, "Albrecht Dürers Gedächtnis im Briefwechsel Willibald Pirckheimers," *Mitteilungen des Vereins für Geschichte der Stadt Nürnberg* 28 (1928): 363–406, here 366.

12. Ibid. See the letters from March 1, 1507, March 7, 1507, March 8, 1507, March 4, 1520, and April 18, 1520.

13. Erwin Panofsky, *The Life and Art of Albrecht Dürer*, rev. ed. (Princeton, N.J.: Princeton University Press, 1955), 117.

14. Lawrence Kramer, *After the Lovedeath: Sexual Violence and the Making of Culture* (Berkeley: University of California Press, 1997), 1.

15. Reicke, "Dürers Gedächtnis," 381–82; Julius Leisching, "Johann Tschertte, königlicher Baumeister der niederösterreichischen Lande († 1552)," *Zeitschrift des deutschen Vereins für die Geschichte Mährens und Schlesiens* 4 (1900): 279–302, 331–46, esp. 290. Leisching perceives a heartfelt confidence in Tscherte's friendship with Dürer and a more distanced reverence and respect in his relationship with Pirckheimer.

16. Rupprich, *Nachlass*, 1:283–88.

17. Leisching, "Johann Tschertte," 300.

18. According to the inventory taken at the time of Pirckheimer's death, the antlers that were displayed in the hall were worth twenty-five guilders, about half the annual salary of the average vicar or priest; see Moriz Thausing, "Dürers Hausfrau. Ein kritischer Beitrag zur Biographie des Künstlers," *Zeitschrift für bildende Kunst* 4 (1869): 33–42, 77–86, here 82.

19. Moriz Thausing, *Dürer: Geschichte seines Lebens und seiner Kunst*, rev. ed., 2 vols. (Leipzig: E. A. Seemann, 1884), 1:131–68, esp. 160.

20. Rupprich, *Nachlass*, 1:252–89, published 144 letters from contemporaries in which Dürer is mentioned.

21. Thausing, *Dürer. Geschichte*, 1:158.

22. Reicke, "Dürers Gedächtnis," 374.

23. For a fuller discussion of this veiling through the negative treatment of artists' wives, see Corine Schleif, "The Many Wives of Adam Kraft: Early Modern Artists' Wives in Legal Documents, Art-historical Scholarship, and Historical Fiction," *Georges-Bloch-Jahrbuch* 4 (1998): 61–74; revised version reprinted in *Saints, Sinners, and Sisters: Gender and Northern Art in Medieval and Early Modern Europe*, ed. Jane L. Carroll and Alison G. Stewart (Aldershot: Ashgate, 2003), 202–20.

24. To compare the drafts of the text preceding Pirckheimer's Latin translation of Lucian's dialogues *Navis seu Vota*, see Reicke, "Dürers Gedächtnis," 378–80.

25. The earliest writings that appropriate the text credit it to other authors. For a history of this reception and speculations as to the possible channels through which it moved, see Corine Schleif, "*Das pos weyb* Agnes Frey Dürer: Geschichte ihrer Verleumdung und Versuche der Ehrenrettung," *Mitteilungen des Vereins für Geschichte der Stadt Nürnberg* 86 (1999): 47–79.

26. Johann Gabriel Doppelmayr, *Historische Nachricht von den Nürnbergischen Mathematicis und Künstlern* (Nuremberg, 1730), 56–58; Schleif, "*Das pos weyb*," 59.

27. Theodor Hampe, "Albrecht Dürer als Künstler und als Mensch," *Mitteilungen des Vereins für Geschichte der Stadt Nürnberg* 28 (1928): 69–154, here 43–44. See the letter to Jakob Heller from August 26, 1509, Rupprich, *Nachlass*, 1:72–73.

28. Johann Friedrich Roth, *Leben Albrecht Duerers, des Vaters der deutschen Kuenstler* (Leipzig, 1791), 17–22; Schleif, *"Das pos weyb,"* 62.

29. Schleif, *"Das pos weyb,"* 64.

30. Rupprich, *Nachlass,* 1:27–34.

31. Wilhelm Buchner, "Frau Agnes Dürer," *Anzeiger für Kunde der deutschen Vorzeit,* n.s., 17 (1870): cols. 392–95, here 394. For another view, see Thausing, "Dürers Hausfrau," 35.

32. On Dürer's family chronicle in comparison with others, see Heike Sahm, "Dürer als Autor," in *Autor und Autorschaft im Mittelalter,* ed. Elizabeth Andersen, Jens Haustein, Anne Simon, and Peter Schneider (Tübingen: Max Niemeyer, 1998), 397–408; Heike Sahm, *Dürers kleinere Texte: Konventionen als Spielraum für Individualität* (Tübingen: Max Niemeyer, 2002); and the new research in Michael Roth, ed., *Dürers Mutter. Schönheit, Alter und Tod im Bild der Renaissance,* exh. cat. (Berlin: Kupferstichkabinett, 2006).

33. Buchner, "Frau Agnes Dürer," col. 392. On the letter of September 8, 1506, see Rupprich, *Nachlass,* 1:55; and Thausing, "Dürers Hausfrau," 39–41. For newly discovered sources on the person called the *Rechenmeisterin* and her relationship to Pirckheimer see Corine Schleif and Volker Schier, *Katerina's Windows: Donation and Devotion, Art and Music as Heard and Seen Through the Writings of a Birgittine Nun* (University Park: Penn State Press, 2009), 294.

34. Rupprich, *Nachlass,* 1:60; and compare Konrad Lange and Franz Fuhse, *Dürers schriftlicher Nachlass* (Halle: Max Niemeyer, 1893), 41.

35. In his review of Lange and Fuhse's *Dürers schriftlicher Nachlass* in *Christliches Kunstblatt* (37 [1895]: 172–76), Markus Zucker discusses the passage and validates the causal usage, citing contemporary examples. Nonetheless in 1956, in the explanation in his critical edition of Dürer's writings, Rupprich returns to the conditional usage; see *Nachlass,* 1:60 n. 18.

36. William Martin Conway, trans. and ed., *The Writings of Albrecht Dürer* (New York: Philosophical Library, 1958), 58.

37. Georg Andreas Will, *Der nürnbergischen Münz-Belustigungen 1. Theil* (Altdorf, 1764), 369–76; Corine Schleif, "Agnes Frey Dürer verpackt in Bildern und vereinnahmt in Geschichten," in *Am Anfang war Sigena: Ein Nürnberger Frauengeschichtsbuch,* ed. Gaby Franger and Nadja Bennewitz (Cadolzburg: Ars vivendi, 1999), 67–77, here 70–73.

38. Maurice Hamel, *Albrecht Dürer* (Paris: Librairie de l'art ancien et moderne, 1904), 26–27.

39. Will, *Der nürnbergischen Münz-Belustigungen,* 371.

40. Various observers have perceived at least fourteen different figures in drawings and paintings as portraits or identificational images of Agnes Dürer. See Thausing, "Dürers Hausfrau," 77–79; Schleif, *"Das pos weyb,"* 51–53, 73–74, and the literature cited.

41. Gustav Pauli, "Die Bildnisse von Dürers Gattin," *Zeitschrift für bildende Kunst* 50 (1915): 69–76; and compare Buchner, "Frau Agnes Dürer," col. 394.

42. Willehad Eckert and Christoph von Imhoff, eds., *Willibald Pirckheimer Dürers Freund* (Cologne: Wienand, 1982), iv, ix.

43. Christoph Scheurl, *Libellus de laudibus Germaniae et ducum Saxoniae* (Leipzig, 1508), as cited in Willehad Eckert, "Willibald Pirckheimer und Albrecht Dürer: Dokumente einer Freundschaft und Zusammenarbeit," in Eckert and Imhoff, *Pirckheimer*, 69–118, here 73.

44. Hans Rupprich, "Dürer und Pirckheimer: Geschichte einer Freundschaft," in *Albrecht Dürers Umwelt* (Nuremberg: Verein für Geschichte der Stadt Nürnberg, 1971), 78–100, here 79; Ernst Rebel, *Albrecht Dürer: Maler und Humanist* (Munich: C. Bertelsmann, 1996), 134.

45. Jane Campbell Hutchison, *Albrecht Dürer: A Biography* (Princeton, N.J.: Princeton University Press, 1990), 51–52; Franz Machilek, "Albrecht Dürer und der Humanismus in Nürnberg," in *Albrecht Dürer: Ein Künstler in seiner Stadt*, ed. Matthias Mende, exh. cat., Museen der Stadt Nürnberg (Nuremberg: Verlag W. Tümmels, 2000), 44–76, here 57. The notion that the Dürer family rented a house behind that of the Pirckheimers cannot be verified through any known document but appears to stem from the assertions of Georg Andreas Will in his *Der Nürnberger Münz-Belustigungen* (1764). I wish to thank Karl Kohn, author of the Nürnberger Häuserbuch der Kernstadt: St. Sebald (accessible through the Nuremberg Stadtarchiv), for this information.

46. Reicke, "Dürers Gedächtnis," 368–69.

47. Niklas Holzberg, *Willibald Pirckheimer: Griechischer Humanismus in Deutschland* (Munich: W. Fink, 1981), 68; Robert Smith, "Dürer, Sexuality, Reformation," in *Culture and History: Essays Presented to Jack Lindsay*, ed. Bernard Smith (Sydney: Hale & Iremonger, 1984), 309; and Machilek, "Dürer und der Humanismus," 58.

48. Hans Rupprich, "Willibald Pirckheimer," in *Fränkische Lebensbilder* (Würzburg: Schöningh, 1967–), 1:94–108; Holzberg, *Willibald Pirckheimer*; Eckert and Imhoff, *Pirckheimer*.

49. Albert Gümbel, "Agnes Dürerin und ihre Stipendienstiftung," *Kunstchronik*, n.s., 14 (1903): cols. 126–30, 142–47.

50. Fedja Anzlewsky, "Dürers theoretische Schriften und ihre Leserschaft," in *De captu lectoris: Wirkungen des Buches im 15. und 16. Jahrhundert dargestellt an ausgewählten Handschriften und Drücken*, ed. Wolfgang Milde and Werner Schuder (Berlin: de Gruyter, 1988), 29–38.

51. Erwin Panofsky, *Dürers Kunsttheorie, vornehmlich in ihrem Verhältnis zur Kunsttheorie der Italiener* (Berlin: G. Reimer, 1915).

52. On Dürer and the Reformation, see Wilhelm Mauerer, "Humanismus und Reformation im Nürnberg Pirckheimers und Dürers," *Jahrbuch für fränkische Landesforschung* 31 (1971): 19–34; Gottfried Seebass, "Dürers Stellung in der reformatorischen Bewegung," in *Albrecht Dürers Umwelt*, 101–29.

53. The vast array of individuals offering intellectual stimulation to Dürer is especially clear in the following: Panofsky, *Dürer*; Dieter Wuttke, "Dürer und Celtis: Von der Bedeutung des Jahres 1500 für den deutschen Humanismus' Jahrhundertfeier als symbolische Form," *Journal of Medieval and Renaissance Studies* 10 (1980): 73–129; Jan Białostocki, *Dürer und die Humanisten* (Pforzheim: Stadt Pforzheim, 1983); Jan Białostocki, *Dürer*

and His Critics (Baden-Baden: Verlag Valentin Koerner, 1986); Machilek, "Dürer und Humanismus."

CHAPTER 12. IMPOSSIBLE DISTANCE

A longer version of this essay appeared in *Art Bulletin* 86 (2004): 750–63.

1. The issue of historical distance has become especially important for historical writing since the "linguistic turn." The view that language constitutes a mediating filter that serves to separate an author from the object of study has served to dramatize the opacity of the historical record. The literature on the subject is too vast to be surveyed here. The following books are typical of this approach to the enterprise of historical writing: Hayden White, *Tropics of Discourse: Essays in Cultural Criticism* (Baltimore: Johns Hopkins University Press, 1978) and *The Content of the Form: Narrative Discourse and Historical Representation* (Baltimore: Johns Hopkins University Press, 1987); and Dominick LaCapra, *Rethinking Intellectual History: Texts, Contexts, Language* (Ithaca, N.Y.: Cornell University Press, 1983) and *History and Criticism* (Ithaca, N.Y.: Cornell University Press, 1985). This historiographic tradition has been challenged by authors such as Frank Ankersmit who argue for an unmediated experience of the past based on a view of language as performative—as responsible for creating rather than recording the past. See his *Sublime Historical Experience* (Stanford, Calif.: Stanford University Press, 2005). Some of the consequences of this philosophy of language for our understanding of the past are explored by Eelco Runia in "Presence," *History and Theory* 45 (2006): 1–29, and "Spots of Time," *History and Theory* 45 (2006): 305–16.

2. For the most influential theories of historical distance in the study of the art of the past, see Erwin Panofsky, *Perspective as Symbolic Form*, trans. Christopher Wood (New York: Zone Books, 1991) and *Renaissance and Renascence in Western Art* (New York: Harper and Row, 1969); Michael Baxandall, *Patterns of Intention: On the Historical Explanation of Pictures* (New Haven, Conn.: Yale University Press, 1981); and T. J. Clark, *Image of the People: Gustave Courbet and the 1848 Revolution* (London: Thames and Hudson, 1973). For recent discussions that argue the essential "anachronism" of art history, see Mieke Bal, *Quoting Caravaggio: Preposterous History* (Chicago: University of Chicago Press, 1999); and Georges Didi-Huberman, *Devant le temps* (Paris: Minuit, 2000).

3. A broad ranging analysis of different responses to images is found in David Freedberg, *The Power of Images: Studies in the History and Theory of Response* (Chicago: University of Chicago Press, 1989).

4. David Carrier has recently described some of the difficulties that confront those who would write about images in *Writing about Visual Art* (New York: Allworth Press, 2003).

5. Pierre Nora, "Between Memory and History: *Les Lieux de mémoire*," *Representations* 26 (1989): 7–25; Patrick Hutton, *History as an Art of Memory* (Hanover: University Press of New England, 1993); Jacques Le Goff, *History and Memory*, trans. Steven Rendall and Elizabeth Claman (New York: Columbia University Press, 1992). For accounts of the

memory moment in historical historiography, see Kerwin Lee Klein, "On the Emergence of Memory in Historical Discourse," *Representations* 69 (2000): 127–50; and Gabrielle Spiegel, "Memory and History: Liturgical Time and Historical Time," *History and Theory* 41 (2002): 149–62.

6. For Derrida's notion of the "supplement," see Jacques Derrida, *Of Grammatology*, trans. Gayatri Spivak (1967; Baltimore: Johns Hopkins University Press, 1976).

7. See, among others, Edward Casey, *Remembering: A Phenomenological Study* (Bloomington: Indiana University Press, 1987) and "Forgetting Remembered," *Man and World* 25 (1992): 281–311; Daniel Schacter, *Searching for Memory: The Brain, the Mind, and the Past* (New York: Basic Books, 1996) and *The Seven Sins of Memory: How the Mind Forgets and Remembers* (New York: Houghton Mifflin, 2001). For trauma's relation to historical writing, see Cathy Caruth, *Unclaimed Experience: Trauma, Narrative, and History* (Baltimore: Johns Hopkins University Press, 1996); and Dominick LaCapra, *History and Memory after Auschwitz* (Ithaca, N.Y.: Cornell University Press, 1998) and *Writing History, Writing Trauma* (Baltimore: Johns Hopkins University Press, 2001).

8. Joachim von Sandrart, *Teutsche Academie der Bau-, Bild- und Mahlerey-Künste*, 3 vols. (Nuremberg, 1675–80; reprint [with intro. by Christian Klemm], Nördlingen: Dr. Alfons Uhl, 1994), 2:236–37.

9. For accounts of German writing on German art history in the nineteenth and twentieth centuries, see Hans Belting, *Identität im Zweifel: Ansichten der deutschen Kunst* (Cologne: DuMont, 1999) and *The Germans and Their Art: A Troublesome Relationship*, trans. Scott Kleager (1993; New Haven, Conn.: Yale University Press, 1998). For the history of art and art production in Germany under National Socialism, see, for example, Reinhard Merker, *Die bildenden Kunste im Nationalsozialismus: Kulturideologie, Kulturpolitik, Kulturproduktion* (Cologne: DuMont, 1983); and Heinrich Dilly, *Deutscher Kunsthistoriker, 1933–1945* (Munich: Deutscher Kunstverlag, 1988). For Dürer historiography during this period, see Jan Białostocki, *Dürer and His Critics* (Baden-Baden: Verlag Valentin Koerner, 1986); Jane Campbell Hutchison, *Albrecht Dürer: A Biography* (Princeton, N.J.: Princeton University Press, 1990); Paul Münch, "Changing German Perceptions of the Historical Role of Albrecht Durer," in *Dürer and His Culture*, ed. Dagmar Eichberger and Charles Zika (Cambridge: Cambridge University Press, 1998), 181–99. For Grünewald, see Andrée Hayum, *The Isenheim Altarpiece: God's Medicine and the Painter's Vision* (Princeton, N.J.: Princeton University Press, 1989), 118–49; Ingrid Schulze, *Die Erschütterung der Moderne: Grünewald in 20. Jahrhundert* (Leipzig: E. A. Seemann, 1991); and Brigitte Schad and Thomas Ratzka, eds., *Grünewald in der Moderne: Die Rezeption Matthias Grünewald im 20. Jahrhundert* (Cologne: Wienand, 2003).

10. Heinrich Schmid, *Die Gemälde und Zeichnungen von Matthias Grünewald*, 2 vols. (Strasbourg: Heinrich, 1907–11). See also Wilhelm Worringer, *Form in Gothic*, trans. Herbert Read (1911; New York: Schocken Books, 1957). For the racist dimension of Worringer's ideas, see Carlo Ginzburg, "Style as Inclusion, Style as Exclusion," in *Picturing Science, Producing Art*, ed. Caroline Jones and Peter Galison (New York: Routledge, 1998), 27–54, here 41–42.

11. Heinrich Wölfflin, *The Art of Albrecht Dürer*, trans. Alastair Grieve and Heide Grieve (1905; London: Phaidon, 1971), 18. In his later, racially inflected account of Italian and German art, Wölfflin nuanced this position by arguing that Dürer had borrowed what he needed from Italian art, while never abandoning the quintessentially German nature of his art. See his *Italien und das deutsche Formgefühl* (Munich: F. Bruckmann, 1931), 6.

12. Wölfflin, *Dürer*, 10.

13. For an account of the *Isenheim Altarpiece*'s stay in Munich, see Ann Stieglitz, "The Reproduction of Agony: Toward a Reception-History of Grünewald's Isenheim Altar after the First World War," *Oxford Art Journal* 12 (1989): 87–103; also Hayum, *Isenheim*, 140–41. For Grünewald's reputation in German art historical writing during these years, see Margarethe Hausenberg, *Matthias Grünewald im Wandel der deutschen Kunstanschauung* (Leipzig: J. J. Weber, 1927), 103.

14. Stieglitz, "Reproduction of Agony," 93.

15. Ibid., 99.

16. Ibid. See also Beth Irwin Lewis, *George Grosz: Art and Politics in the Weimar Republic* (Princeton, N.J.: Princeton University Press, 1991), 219–25; and Ralph Jentsch, *George Grosz: The Berlin Years* (Milan: Associati, 1991), 167–73.

17. Oskar Hagen, *Matthias Grünewald* (Munich: R. Piper, 1923), 23.

18. Ibid., 27.

19. Friedrich Haack, *Albrecht Dürer: Deutschlands grösster Künstler* (Leipzig: Quelle and Meyer, 1928), 11, my translation. Grünewald's role in the history of Expressionism has been acknowledged by, for example, Peter Selz: "Grünewald . . . became the ideal of the new generation, which saw in his Isenheim altarpiece a freedom of creation following the intrinsic logic of content and composition rather than nature. Grünewald, it was felt, penetrated to the core of human emotion and created a truth that went far beyond the doubtful truth of reality. Young artists recognized in Grünewald the fervent religious faith for which many of them had been searching." Peter Selz, *German Expressionist Painting* (Berkeley: University of California Press, 1957), 17.

20. Haack, *Dürer*, 12.

21. For the fate of Expressionism in National Socialist party politics, see Hildegard Brenner, *Die Kunstpolitik des Nationalsozialismus* (Rembeck bei Hamburg: Rohwolt, 1963), 63–86; Stephanie Barron, "1937: Modern Art and Politics in Prewar Germany," in *"Degenerate Art": The Fate of the Avant-Garde in Nazi Germany*, exh. cat. (Los Angeles: Los Angeles County Museum of Art, 1991), 9–23; Katharina Heinemann, "Entdeckung und Vereinahmung: Zur Grünewald-Rezeption in Deutschland bis 1945," in Schad and Ratzka, *Grünewald in der Moderne*, 8–17.

22. Hans Schwerte, *Faust und das Faustische: Ein Kapitel deutscher Ideologie* (Stuttgart: Ernst Klett Verlag,1962), 243–78.

23. Quoted in Białostocki, *Critics*, 240.

24. Panofsky, *Renaissance and Renascences*, 106.

25. Panofsky, *Perspective as Symbolic Form*.

26. Erwin Panofsky, "The History of Art as a Humanistic Discipline," *Meaning in the Visual Arts* (Garden City, N.Y.: Doubleday Anchor Books, 1955), 1–25.

27. For Panofsky's Hegelianism, see Ernst Gombrich, *In Search of Cultural History* (Oxford: Clarendon, 1969), 28.

28. Erwin Panofsky, *The Life and Art of Albrecht Dürer*, rev. ed. (Princeton, N.J.: Princeton University Press, 1955).

29. Panofsky, *Dürer*, 171.

30. See my "Panofsky's Melancolia," in Keith Moxey, *The Practice of Theory: Post-structuralism, Cultural Politics, and Art History* (Ithaca, N.Y.: Cornell University Press, 1994), 65–78.

31. Didi-Huberman, *Devant le temps*, 21.

32. Peter Strieder, *The Hidden Dürer*, trans. Vivienne Menkes (1976; Chicago: Rand McNally, 1978) and *Albrecht Dürer: Paintings, Prints, Drawings*, trans. Nancy M. Gordon and Walter L. Strauss (New York: Abaris Books, 1982); Fedja Anzelewsky, *Albrecht Dürer: Das malerische Werk*, rev. ed. (Berlin: Deutscher Verlag für Kunstwissenschaft, 1991) and *Dürer-Studien* (Berlin: Deutscher Verlag für Kunstwissenschaft, 1983).

33. Anzelewsky, *Dürer-Studien*.

34. An overview of the events with which this anniversary was commemorated in both West and East Germany is included in Günther Bräutigam and Matthias Mende, " 'Mähen mit Dürer': Literatur und Ereignisse im Umkreis des Dürer-Jahres 1971," *Mitteilungen des Vereins für Geschichte der Stadt Nürnberg* 61 (1974): 204–82.

35. *Albrecht Dürer, 1471–1971*, exh. cat., Germanisches Nationalmuseum, Nuremberg (Munich: Prestel, 1971).

36. Ines Bach et al., eds., *Ausstellungsdidaktik im Albrecht Dürer-Jahr 1971*, Technische Universität, Berlin, Lehrstuhl für Kunstgeschichte (Berlin: Technische Universität, 1972); Dieter Wuttke, *Nuremberg, Focal Point of German Culture and History: A Lecture* (Bamberg: H. Kaiser, 1987).

37. Rudolph Kober and Gerd Lindner, "Paradigma Grünewald: Zur Erbe-Rezeption in der bildende Kunst der DDR," in Schad and Ratzka, *Grünewald in der Moderne*, 32–43, here 35.

38. Ernst Ullmann, Günter Grau, and Rainer Behrends, *Albrecht Dürer: Zeit und Werk* (Leipzig: Karl Marx Universität, 1971), vii.

39. Ernst Ullmann, "Albrecht Dürer und die frühbürgerliche Revolution in Deutschland," in Ullmann, Grau, and Behrends, *Dürer: Zeit und Werk*, 55–90, here 82.

40. Wolfgang Hütt, *Deutsche Malerei und Graphik der frühbürgerlichen Revolution* (Leipzig: E. A. Seemann, 1973), 334.

41. Wolfgang Hütt, *Mathis Gothardt-Neithardt gennant "Grünewald": Leben und Werk im Spiegel der Forschung* (Leipzig: E. A. Seemann, 1968), 89–90.

42. Joseph Koerner, *The Moment of Self-Portraiture in German Renaissance Art* (Chicago: University of Chicago Press, 1993).

43. Ibid., xix.

44. For Panofsky's use of Cassirer's concept of "symbolic forms," see Michael Ann

Holly, *Panofsky and the Foundations of Art History* (Ithaca, N.Y.: Cornell University Press, 1984), 114–57.

45. For a recent history of the idea of objectivity, see Lorraine Daston and Peter Galison, *Objectivity* (New York: Zone Books, 2007).

46. Koerner, *Moment of Self-Portraiture*, xvi, n. 4.

47. Hayum, *Isenheim*, 3–12. For Michael Baxandall's approach to a "social history of art," see *Painting and Experience in Fifteenth-Century Italy* (Oxford: Clarendon Press, 1972), and *Patterns of Intention*. Baxandall self-reflexively addresses the strengths and limitations of his method in "Art, Society, and the Bouguer Principle," *Representations* 12 (1985): 32–43.

48. Hans Belting, *Likeness and Presence: A History of the Image before the Era of Art*, trans. Edmund Jephcott (Chicago: University of Chicago Press, 1994). For the argument that works of art determine their own reception, see Michael Ann Holly, *Past Looking: Historical Imagination and the Rhetoric of the Image* (Ithaca, N.Y.: Cornell University Press, 1996).

SHORT BIBLIOGRAPHY

Albert Dürer aux Pays-Bas: Son voyage (1520–1521), son influence. Exh. cat. Brussels: Palais des Beaux-Arts, 1977.

Albrecht Dürer, 1471–1971. Exh. cat Germanisches Nationalmuseum, Nuremberg. Munich: Prestel, 1971.

Albrecht Dürer Master Printmaker. Exh. cat Boston: Museum of Fine Arts, 1971.

Albrecht Dürers Umwelt. Nuremberg: Verein für Geschichte der Stadt Nürnberg, 1971.

Anzelewsky, Fedja. *Albrecht Dürer: Das malerische Werk.* Rev. ed. Berlin: Deutscher Verlag für Kunstwissenschaft, 1991.

———. *Dürer: His Art and Life.* New York: Alpine Fine Arts Collection, 1980.

———. *Dürer-Studien.* Berlin: Deutscher Verlag für Kunstwissenschaft, 1983.

Anzelewsky, Fedja, and Hans Mielke. *Albrecht Dürer: Kritischer Katalog der Zeichnungen.* Berlin: Staatliche Museen Preussischer Kulturbesitz, Kupferstichkabinett, 1984.

Bartrum, Giulia, ed. *Albrecht Dürer and His Legacy: The Graphic Work of a Renaissance Artist.* Exh. cat. London: British Museum, 2002.

Bartsch, Adam. *Le peintre-graveur.* 21 vols. Vienna: J. V. Degen, 1803–21.

Beck, Herbert, and Bernhard Decker, eds. *Dürers Verwandlung in der Skulptur zwischen Renaissance und Barock.* Exh. cat. Frankfurt: Liebieghaus, 1981.

Białostocki, Jan. *Dürer and His Critics.* Baden-Baden: Verlag Valentin Koerner, 1986.

Bonnet, Anne-Marie. *"Akt" bei Dürer.* Cologne: Walther König, 2001.

Checa, Fernando, ed. *Dürero y Cranach: Arte y Humanismo en la Alemania del Renacimiento.* Exh. cat. Madrid: Museo Thyssen-Bornemisza, 2007.

Conway, William Martin, trans. and ed. *The Writings of Albrecht Dürer.* New York: Philosophical Library, 1958. First published in Cambridge, 1889.

Eichberger, Dagmar, and Charles Zika, eds. *Dürer and His Culture.* Cambridge: Cambridge University Press, 1998.

Goldberg, Gisela, Bruno Heimberg, and Martin Schawe, eds. *Albrecht Dürer: Die Gemälde der Alten Pinakothek.* Munich: Braus, 1998.

Goris, J.-A., and Georges Marlier. *Albrecht Dürer: Diary of His Journey to the Netherlands, 1520–1521.* Greenwich, Conn.: New York Graphic Society, 1971.

Gothic and Renaissance Art in Nuremberg, 1300–1550. Exh. cat. Metropolitan Museum of Art, New York. Munich: Prestel, 1986.

Herrmann Fiore, Kristina, ed. *Dürer e l'Italia*. Exh. cat. Scuderie del Quirinale, Rome. Milan: Electa, 2007.

Hutchison, Jane Campbell. *Albrecht Dürer: A Biography*. Princeton, N.J.: Princeton University Press, 1990.

Koerner, Joseph Leo. *The Moment of Self-Portraiture in German Renaissance Art*. Chicago: University of Chicago Press, 1993.

Koreny, Fritz. *Albrecht Dürer and the Animal and Plant Studies of the Renaissance*. Boston: Little, Brown, 1988. First published as an exh. cat. for the Albertina, Vienna, by Prestel, 1985.

Koschatzky, Walter. *Albrecht Dürer: The Landscape Water-Colours*. New York: St. Martin's Press, 1973.

Koschatzky, Walter, and Alice Strobl. *Dürer Drawings: The Albertina Collection*. Greenwich, Conn.: New York Graphic Society, 1972.

Kotková, Olga, ed. *Albrecht Dürer: The Feast of the Rose Garlands, 1506–2006*. Exh. cat. Prague: Národní Galerie, 2006.

Luber, Katherine Crawford. *Albrecht Dürer and the Venetian Renaissance*. Cambridge: Cambridge University Press, 2005.

Mende, Matthias. *Dürer-Bibliographie*. Wiesbaden: Otto Harrassowitz, 1971.

Mende, Matthias, ed. *Albrecht Dürer: Ein Künstler in seiner Stadt*. Exh. cat. Nuremberg: Museen der Stadt Nürnberg, 2000.

Panofsky, Erwin. *The Life and Art of Albrecht Dürer*. Rev. ed. Princeton, N.J.: Princeton University Press, 1955. First published in 2 vols. in 1943. Reprinted in 2005 with introduction by Jeffrey Chipps Smith.

Price, David Hotchkiss. *Albrecht Dürer's Renaissance: Humanism, Reformation, and the Art of Faith*. Ann Arbor: University of Michigan Press, 2003.

Roth, Michael, ed. *Dürers Mutter: Schönheit, Alter und Tod im Bild der Renaissance*. Exh. cat. Berlin: Kupferstichkabinett, 2006.

Rupprich, Hans, ed. *Dürer: Schriftlicher Nachlass*. 3 vols. Berlin: Deutscher Verein für Kunstwissenschaft, 1956–69.

Sahm, Heike. *Dürers kleinere Texte: Konventionen als Spielraum für Individualität*. Tübingen: Max Niemeyer Verlag, 2002.

Schauerte, Thomas Ulrich. *Die Ehrenpforte für Kaiser Maximilian I*. Munich: Deutscher Kunstverlag, 2001

Schmid, Wolfgang. *Dürer als Unternehmer*. Trier: Portra Alba, 2003.

Schoch, Rainer, Matthias Mende, and Anna Scherbaum, eds. *Dürer: Das druckgraphische Werk*. 3 vols. Munich: Prestel, 2001–4.

Schroeder, Klaus Albrecht, and Maria Luise Sternath, eds. *Albrecht Dürer*. Exh. cat. Albertina, Vienna. Ostfildern: Hatje Cantz, 2003.

Schütz, Karl, ed. *Albrecht Dürer im Kunsthistorischen Museum*. Exh. cat. Vienna: Kunsthistorisches Museum, 1994.

Silver, Larry. *Marketing Maximilian: The Visual Ideology of a Holy Roman Emperor*. Princeton, N.J.: Princeton University Press, 2008.

Smith, Jeffrey Chipps. *Dürer*. London: Phaidon Press, 2010.

———. *Nuremberg: A Renaissance City, 1500–1618*. Exh. cat. Archer M. Huntington Art Gallery, Austin, Texas. Austin: University of Texas Press, 1983.

Strauss, Walter L. *The Complete Drawings of Albrecht Dürer*. 6 vols. New York: Abaris Books, 1974.

———, trans. and ed. *Albrecht Dürer: The Painter's Manual*. New York: Abaris Books, 1977.

Strieder, Peter. *Albrecht Dürer: Paintings, Prints, Drawings*. Trans. Nancy M. Gordon and Walter L. Strauss. New York: Abaris, 1982.

Talbot, Charles W., ed. *Dürer in America*. Exh. cat. Washington, D.C.: National Gallery of Art, 1971.

Thausing, Moriz. *Dürer: Geschichte seines Lebens und seiner Kunst*. Rev. ed, 2 vols. Leipzig: E. A. Seemann, 1884. English trans., London: John Murray, 1882.

Vogt, Christine. *Das druckgraphische Bild nach Vorlagen Albrecht Dürers (1471–1528)*. Munich: Deutscher Kunstverlag, 2008.

White, Christopher. *Dürer: The Artist and His Drawings*. London: Phaidon, 1971.

Wilckens, Leonie von, and Peter Strieder, eds. *Vorbild Dürer*. Exh. cat. Germanisches Nationalmuseum, Nuremberg. Munich: Prestel, 1978.

Winkler, Friedrich. *Die Zeichnungen Albrecht Dürers*. 4 vols. Berlin: Deutscher Verein für Kunstwissenschaft, 1936–39.

Wölfflin, Heinrich. *Die Kunst Albrecht Dürers*. 2nd ed. Munich: F. Bruckmann A. G., 1908. Translated as *The Art of Albrecht Dürer* by Alastair Grieve and Heide Grieve. London: Phaidon, 1971.

Zdanowicz, Irena, ed. *Albrecht Dürer in the Collection of the National Gallery of Victoria*. Melbourne: National Gallery of Victoria, 1994.

CONTRIBUTORS

Christiane Andersson is Samuel H. Kress Professor of Art History, Department of Art and Art History, Bucknell University, Lewisburg, Pennsylvania (http://www.bucknell.edu/X18015.xml)

Pia F. Cuneo is professor of art history, School of Art, University of Arizona, Tucson (http://www.arts.arizona.edu/arh/cuneo.html).

Dagmar Eichberger is Apl. Professor, Institut für Europäische Kunstgeschichte, Ruprecht-Karls-Universität, Heidelberg (http://www.khi.uni-heidelberg.de).

Katherine Crawford Luber is former curator of the John G. Johnson Collection, Philadelphia Museum of Art, and now co-founder and president of TSP Spices (http://www.tspspices.com).

Donald McColl is Nancy L. Underwood Chair in Art History and Director, Kohl Gallery, Washington College, Chestertown, Maryland (http://art.washcoll.edu/faculty_donaldmccoll.php).

Andrew Morrall is professor of art history, Bard Graduate Center for Studies in the Decorative Arts, Design, and Culture, New York (http://www.bgc.bard.edu/degree_programs/morrall/morall.shtml).

Keith Moxey is Ann Whitney Olin Professor, Department of Art History, Barnard College and Department of Art History and Archaeology, Columbia University, New York (http://www.barnard.edu/arthist/faculty.php).

Corine Schleif is professor of art history, School of Art, Arizona State University, Tempe (http://herbergercollege.asu.edu/directory/selectOne.php?ID = 365 &).

Larry Silver is Farquhar Professor, Department of Art History, University of Pennsylvania, Philadelphia (http://www.arthistory.upenn.edu/facultysilver .htm).

Jeffrey Chipps Smith is Kay Fortson Chair in European Art, Department of Art and Art History, University of Texas, Austin (http://www.finearts.utexas .edu/aah/art_history/faculty/jsmith. cfm).

Charles Talbot is Alice Pratt Brown Professor Emeritus (2007), Department of Art and Art History, Trinity University, San Antonio, Texas (ctalbot@trin ity.edu).

INDEX